# ART IN BELFAST
## 1760–1888

*Art Lovers or Philistines?*

The author and publisher would like to gratefully acknowledge the support of the Belfast Harbour Commissioners in the making of this book.

# ART IN BELFAST
## 1760–1888

## *Art Lovers or Philistines?*

EILEEN BLACK

Foreword by
William Laffan

IRISH ACADEMIC PRESS
DUBLIN • PORTLAND, OR

*First published in 2006 by*
IRISH ACADEMIC PRESS
44, Northumberland Road, Dublin 4, Ireland

*and in the United States of America by*
IRISH ACADEMIC PRESS
c/o ISBS, Suite 300, 920 NE 58th Avenue
Portland, Oregon 97213-3644

*WEBSITE*: www.iap.ie

British Library Cataloguing in Publication Data
An entry can be found on request

ISBN 0-7165-3361-8 (cloth)
ISBN 0-7165-3362-6 (paper)

Library of Congress Cataloging-in-Publication Data
An entry can be found on request

Typeset by Regent Typesetting, London

Printed by MPG Books Ltd., Bodmin, Cornwall

*To Stella, for her friendship and support*

*To my mother Mamie (1919–99),*
*a woman of wisdom, humour and much courage*

*And finally, to my cat Henry (d. 1998),*
*my constant companion through*
*many long hours in my study*

# Contents

# List of Illustrations

PLATES
Between pp 98–99

1. Strickland Lowry (1737–c.85), attributed to
   *The Family of Thomas Bateson, Esq. (1705–91) (1762)*
   Oil on canvas 163.7 × 264 cm
   Ulster Museum

2. Strickland Lowry (1737–c.85), attributed to
   *Thomas Greg (1721–96) and his Family (c.1765)*
   Oil on canvas 186.5 × 374.5 cm
   Private Collection, on loan to Quarry Bank Mill, Styal,
   Cheshire (National Trust)

3. Thomas Robinson (d. 1810)
   *The Battle of Ballynahinch (1798)*
   Oil on canvas 161 × 238 cm
   Office of Public Works, Dublin

4. Thomas Malton (1748–1804)
   *Internal View of the Assembly Rooms at the Exchange
   at Belfast*
   Ink, watercolour on paper 35.4 × 50.8 cm
   Ashmolean Museum, University of Oxford

5. Thomas Robinson (d.1810)
   *William Ritchie (1756–1834) (c.1802)*
   Oil on canvas 93.7 × 74.6 cm
   Ulster Museum

6. Thomas Robinson (d. 1810)
   *Review of the Belfast Yeomanry by the Lord Lieutenant,
   the Earl of Hardwicke, 27 August 1804 (1804–07)*
   Oil on canvas 162.5 × 244 cm (sight)
   Belfast Harbour Commissioners

7. James Atkins (1799–1833)
   *George, 3rd Marquess of Donegall (1797–1883) (1824)*
   Oil on canvas 233.7 × 145.4 cm
   Ulster Museum

8. Hugh Frazer (fl.1813–61)
   *View of Waringstown (1849)*
   Oil on canvas 63 × 76 cm
   Ulster Museum

9. Andrew Nicholl (1804–86)
   *Belfast from Newtownbreda Churchyard*
   Watercolour on paper 35.4 × 52.8 cm
   Ulster Museum

10. Andrew Nicholl (1804–86)
    *Bray and the Valley of the Dargle from Killiney Hill,*
    *Co. Dublin* (after 1835)
    Watercolour on paper 35.1 × 52.1 cm
    Ulster Museum

11. Joseph Molloy (1798–1877)
    *Tilbury Fort, River Thames*
    Oil on canvas on board 30.5 × 40.6 cm
    Ulster Museum

12. Joseph Peacock (c.1783–1837)
    *The Patron, or the Festival of St Kevin at the Seven*
    *Churches, Glendalough* (1813)
    Oil on panel 86.4 × 137.8 cm
    Ulster Museum

13. James Howard Burgess (c.1810–90)
    *View of Queen's Bridge, Harbour and Timber Pond, Belfast* (1858)
    Oil on canvas 68.5 × 95.2 cm
    Belfast Harbour Commissioners

14. Sir Edwin Landseer (1802–73)
    *Shoeing* (by 1844)
    Oil on canvas 142.3 × 111.8 cm
    Tate Britain, London

15. James Moore (1819–83)
    *Slieve Bernagh from the Trassey Bog, Mourne Mountains*
    Watercolour, bodycolour on paper 57.2 × 77.4 cm
    Ulster Museum

16. James Glen Wilson (1827–63)
    *Emigrant Ship leaving Belfast* (1852)
    Oil on canvas 71.4 × 91.3 cm
    Ulster Museum

17. John Martin (1789–1854)
    *Christ stilleth the Tempest (1852)*
    Oil on millboard 50.8 × 76.2 cm
    York Art Gallery

18. Sir Edwin Landseer (1802–73)
    *The Monarch of the Glen* (by 1851)
    Oil on canvas 163.8 × 169 cm
    Diageo plc

19. Sir Edwin Landseer (1802–73)
    *Scene from 'A Midsummer Night's Dream': Titania and Bottom* (1848–51)
    Oil on canvas 82 × 133 cm
    National Gallery of Victoria, Melbourne

20. Sir John Everett Millais (1829–96)
    *My First Sermon* (1863)
    Oil on canvas 92.7 × 72.4 cm
    Guildhall Art Gallery, London

21. William Powell Frith (1819–1909)
    *The Derby Day* (1856–58)
    Oil on canvas 101.6 × 223.5 cm
    Tate Britain, London

22. Thomas Jones Barker (1815–82)
    *The Secret of England's Greatness (Queen Victoria presenting a Bible in the Audience Chamber at Windsor)* (c.1863)
    Oil on canvas 167.6 × 213.8 cm
    National Portrait Gallery, London

23. William Holman Hunt (1827–1910)
    *The Finding of the Saviour in the Temple* (1854–55, 1856–60)
    Oil on canvas 85.7 × 141 cm
    Birmingham Museums and Art Gallery

24. William Powell Frith (1819–1909)
    *The Railway Station* (1862)
    Oil on canvas 116.7 × 256.4 cm
    Royal Holloway and Bedford New College, Surrey

25. Elizabeth Thompson (Lady Butler) (1846–1933)
    *The 28ᵗʰ Regiment at Quatre Bras* (1875)
    Oil on canvas 97.2 × 216.2 cm
    National Gallery of Victoria, Melbourne

26. Elizabeth Thompson (Lady Butler) (1846–1933)
    *The Remnants of an Army: Jellalabad, January 13ᵗʰ, 1842* (1879)
    Oil on canvas 132 × 234 cm
    Tate Britain, London

27. William Holman Hunt (1827–1910)
*The Shadow of Death* (1870–73, retouched 1886)
Tempera and oil on canvas 214.2 × 168.2 cm
Manchester Art Gallery

28. John Martin (1789–1854)
*The Great Day of his Wrath* (1851–53)
Oil on canvas 196.8 × 325.8 cm
Tate Britain, London

29. Richard Parks Bonington (1802–28)
*Sunset in the Pays de Caux* (1828)
Watercolour 19.8 × 26.4 cm
The Wallace Collection, London

30. Joseph Mallord William Turner (1775–1851)
*Scarborough Castle: Boys Crab-Fishing* (1809)
Watercolour 28 × 39.4 cm
The Wallace Collection, London

# Acknowledgements

This book was originally written as a doctoral dissertation for Queen's University, Belfast. For that project, I was greatly indebted to my employers, the Ulster Museum, Belfast, for their support of the undertaking. As curator of the museum's eighteenth- and nineteenth-century Irish oil paintings, I had long been curious about Belfast's artistic past: why did local art societies keep folding between the 1830s and the 1850s; why, in a prosperous community, was the School of Design forced to close in 1858, after a mere nine years in existence; why, indeed, did the town appear to be a cultural desert as regards the fine arts? Such questions and more were answered by the dissertation. This redraft is intended to make the topic more accessible, to place the art history of Belfast in the eighteenth and nineteenth centuries before a wider audience than the university sphere. Amongst numerous persons to be thanked in relation to the book, I should like to highlight William Laffan and Dr Susanne Lyle, both of whom read the manuscript and made useful comments on the text. Thanks also to Dr S.B. Kennedy, former Head of Fine and Applied Art in the Ulster Museum, who encouraged me in the task of rewriting and gave constant support. Particular thanks to the Chairman and Board of the Belfast Harbour Commissioners, for their generous financial assistance towards the book.

I am also grateful to the following, for assistance in various ways: Vivien Adams, Naomi Allen, Christine Ashfield, Heather Browne, Jeanette Castle, Mike Craig, Margaret Daly, Pauline Dickson, Mary Dornan, Martin Durrant, James Fell, Elaine Flanigan, Adriana Giordani, John Gray, Linda Greenwood, Ted Hickey, Christine Hopper, Linda Houston, Christine Jones, Professor Peter Jupp, Karen Lawson, Diane Leeman, Kellie Leydon, Jenny Lonergan, Gerard Lyne, Shan McAnena, Geraldine and Brian Macartney, Marianne McKeown, Pat McLean, Pippa McNee, Heather Marchant, Kim Mawhinney, Louise Morgan, Sue Moss, Melanie Oelgeschläger, Colette O'Flaherty, Alistair Rae, Bryan Rutledge, Allison Sharpe, Anna Sheppard, Sabrina Shimm, Dr Gerry Slater, Winnie Tyrrell, Tracy Walker, Teresa Watts, Lisa Hyde, Laura Whitton and Younis Zaman.

Finally, my special thanks to my partner Stella Mahon, for her friendship over many years and her companionship through life's ups and downs.

Eileen Black
Belfast, 2006

# Abbreviations

| | |
|---|---|
| *BCC* | *Belfast Commercial Chronicle* |
| *BDM* | *Belfast Daily Mercury* |
| *BET* | *Belfast Evening Telegraph* |
| *BNL* | *Belfast News-Letter* |
| BL | British Library |
| *BT* | *Belfast Telegraph* |
| *ILN* | *Illustrated London News* |
| NALVA | National Art Library, Victoria and Albert Museum |
| NLI | National Library of Ireland |
| *NW* | *Northern Whig* |
| PRONI | Public Record Office Northern Ireland |
| RBAI | Royal Belfast Academical Institution |

# Foreword

Irish art history is currently moving in many different directions. However, after the pioneering survey work of Anne Crookshank and the Knight of Glin had mapped the broad framework of art in Ireland, there has sometimes been a rather impatient urge to jettison traditional approaches to art history, and instead, to transfer wholesale theoretical approaches taken from different disciplines to the study of Irish art. While this has led to several exciting thematic studies of well-known artists and re-readings of familiar pictures, it has sometimes been accompanied by a lack of awareness of historical context. There is a danger of seeing works of art as arising solely from aesthetic impulses on the artists' part and forgetting the complex chain of events which invariably leads to their creation.

At the same time, while local history studies are flourishing in Ireland, art historians have been slow to apply a similar detailed focus in examining regional differences in the practice of art. Areas which have long called out for more detailed scholarly analysis include the relationship between periphery and centre, both Dublin's relationship with London, in terms of art making and, even more so (and even less well-researched) the practice of art in provincial centres. While there have been several studies of artistic production in the English regions, Irish art history has remained distinctly centred on Dublin (with honourable exceptions such as Peter Murray's researches on Cork artists). In addition, what has long been needed has been further exploration of the workings of the art market, of art education, exhibitions and museums, in short, the whole gamut of the artistic scene. Art does not occur in a vacuum. Artists must be trained, have places to exhibit their work and patrons to buy it. Art dealers, curators, educators and collectors have a vital part in determining the kind of art produced and how it is displayed, but their role has, at least in an Irish context, been little discussed though, once again, an exception must be made for John Turpin's research on the Dublin School of Art. Romantic ideas of the solitary artist have, perhaps, led to the achievements of other practitioners of the art world being downplayed. A further area that has only recently begun to be researched in Irish art historical writing is the

relationship between wider socio-economic patterns and the work of individual artists; also of equal importance and equally neglected, is the symbiotic relationship between industry and design. In this wider historiographical context it is very pleasing then to introduce this study by Eileen Black, in which all of these issues of material and method are magisterially addressed. Making its appearance after many years gestation, this is a highly topical landmark in Irish art historical writing, which is greatly to be applauded.

Using a wide variety of source material, Dr Black discusses art making in Belfast from the mid-eighteenth century onwards. Hers is a wholly original exploration of an almost completely neglected subject. While it is certainly true, as Jonathan Bardon puts it with some understatement, that 'Belfast was not especially notable as a haven of culture in the nineteenth century', there were concerted efforts to remedy this situation, if sometimes for purely pragmatic and commercial reasons. Bardon devotes but a single page to the subject in his otherwise excellent study of Belfast. In contrast, Dr Black has left no stone unturned in tracking down details of every attempt made in the period to justify the description of Belfast (derided at the time) as 'the Northern Athens'. Culturally, Belfast was no Edinburgh – or even Dublin – and the book presents an, at times, sorry tale of failed cultural ventures, highlighting the lack of patronage and educational opportunities for artists for most of the eighteenth and nineteenth centuries. Dr Black contrasts the situation with that prevailing elsewhere in Ireland and in provincial towns in Britain. She chronicles the few individuals who battled to bring the fine arts to Belfast, whilst at the same time exploring the interaction between industry (particularly linen) and the desire for good locally-based design. The burghers of Belfast seem to have tolerated art if it could be seen to have some concrete use. The practical and aesthetic often went hand in hand; certainly, there was little room in Belfast for an art for art's sake philosophy. Dr Black, however, very much leaves it up to the reader to decide on the twin epithets set out in her title, 'Art Lovers or Philistines?'

Pleasingly the book has a happy, if ambivalent, ending, as it culminates in the creation of the Belfast Art Gallery and Museum, now the Ulster Museum. This is very appropriate as the institution is where Dr Black has spent her professional life. Her various catalogues of the museum's pictures and series of tightly focused articles have, for many years, shone a light into the gloom of art in Ulster. Her knowledge both of the sources (particularly early newspapers and exhibition catalogues) as well as of the pictures themselves, puts her in a unique position to offer the highly contextualised reading of the subject this volume displays. While very much a work of cultural

history, it will also long be a standard art historical volume serving as the main repository of information on artists such as Thomas Robinson and Joseph Wilson, Hugh Frazer and Andrew Nicholl. At last Belfast artists (and their supporters) have received their due. The nature of art production in Ulster in the nineteenth century is seen as rather different from that in Dublin, although there are similarities with the rise of exhibiting societies and art institutions in, for example, Cork and, to a lesser extent, Limerick.

Indeed, it is as true today as in the period covered by this study that the practice, patronage and collecting of art in Ulster are still subtly different from those in the rest of the country. While Ulster artists such as William Conor, Dan O'Neill and Gerard Dillon are eagerly collected and contemporary artists like Basil Blackshaw enjoy ready patronage, several of the same issues regarding the appreciation of the visual arts still apply. Paradoxically, the visiting exhibitions of the nineteenth century offered Belfast artists and the public alike perhaps a broader array of international artistic practice than is shown in the city today. While the University of Ulster's School of Art and Design is greatly respected, there are still relatively few outlets for young artists to exhibit their work, although in a nice historical continuity, Lady Dufferin, with her gallery at Clandeboye, continues the support of art in Belfast initiated by her husband's great-grandfather, The 1st Marquess of Dufferin and Ava, very much one of the heroes of the book. As with so many things in Belfast, for all that changes, even more stays the same. Art Lovers or Philistines? The question, even now, is unresolved and Dr Black's study has, at times, uncanny, contemporary resonances. At the same time, her microscopic analysis makes her book essential reading to all those interested in Irish art and also provides a fascinating social history of many different aspects of Belfast life. It is warmly to be welcomed.

<div align="right">
William Laffan
January 2006
</div>

# Introduction

The parameters of this study of art in Belfast require explanation. The first resident artist of consequence known to have worked in the town, the English-born portrait painter Strickland Lowry, was active in the early 1760s. It seems reasonable, therefore, to denote this as the period at which art began to be of significance within the community. In the matter of the cut-off point, 1888 was decided upon as this saw the opening of the town's first rate-supported art gallery, the rooms on the top floor of the Free Public Library. From 1826 there had been periodic calls in the local press for the establishment of an art institute or art gallery. The realisation of this in 1888 marked the fulfilment of past aspirations and heralded a new beginning.

The approach taken in researching the subject also requires clarification. The few extant sources on art in Belfast in the eighteenth and nineteenth centuries follow the usual art historical method of highlighting artists and their works to explain the art of the time. However, placing an emphasis on individuals when dealing with Belfast results in a skewed picture, as only a small number of artists were active in the town during the period under review: nine major figures at most. Pursuing such an approach leads to the impression of a town where art was of little importance and where high quality works were seldom seen.

Adopting a different method – researching the art world of the town rather than individual artists – reveals that the above scenario was not the case; far from being a cultural desert as regards the fine arts, Belfast was a lively centre for the exhibiting and trading of much exceptional work. This new insight was obtained through a detailed search of local newspapers (the main primary source), exhibition catalogues and various other sources cited in the Notes and Bibliography. Other material sought, but unfortunately not found, included papers of artists and persons involved in the promotion of art schemes and the business records of local auctioneers, printsellers and commercial galleries. Despite these gaps, the overall result yielded the broader picture missing from the 'established' art history of Belfast, as, for example, the extent to which socio-economic developments were interlinked, notably in the establishment of art institutions such as

**1** Strickland Lowry
*Portrait of a Lurgan Volunteer*
(1780)

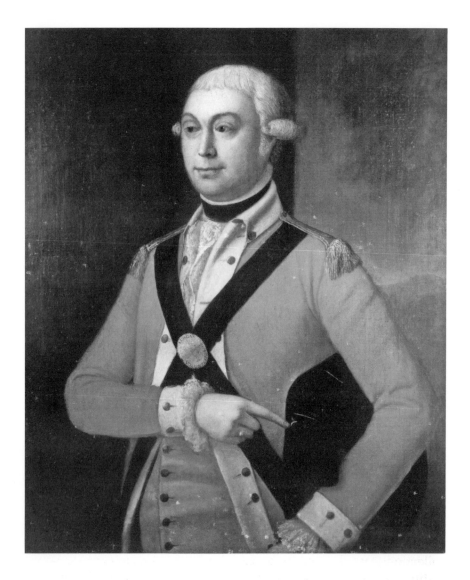

the School of Art of 1870 and the Belfast Art Gallery and Museum. Also revealed was the existence of an extremely lively art market and the connection between the print trade and the display of many well-known and sometimes famous paintings as one-picture exhibitions.

Studies in the development of regional centres of art have been appearing occasionally since Trevor Fawcett's pioneering work on the rise of English provincial art between 1800 and 1830, published in 1974. An examination of the spread of societies and institutions committed to the encouragement of the arts in provincial centres across England, Fawcett's book underlined the value of enquiry into this hitherto neglected aspect of art history. Overall, the effect of his work was to open up whole new areas of study in relation to

attitudes to the fine arts in the provinces in the early decades of the nineteenth century. He too drew upon newspapers as an important means of evidence. However, he was fortunate in having a wide range of other primary sources at his disposal. As such, therefore, his use of newspapers was in conjunction with this other material and not generally in lieu of it. A balance of materials was therefore struck which was not possible for Belfast.

Besides Fawcett, two other studies were of particular interest and value to this exploration of Belfast's art world, namely, a thesis concerning the development of Plymouth and Exeter as centres of art between 1820 and 1865 by Samuel Smiles (1982) and an article by Dianne Sachko Macleod on public and private patronage in Victorian Newcastle (1989). In the case of Smiles, he too used newspapers as evidence and from these discovered that Plymouth and Exeter, like Belfast, played host to many of the one-picture exhibitions being toured around the British Isles by print publishers. Indeed, a large number of these shows had already been held in Belfast or were to come at a later date. Of wider concern, he also examined the importance of factors such as population, mercantile strength and civic prosperity – issues which were likewise of consequence in the development of the art world of Belfast. Of particular interest was his use of statistics regarding various towns, which revealed that in 1851, centres such as Plymouth and Newcastle, with populations of about 90,000 and 87,000, supported thirty-six and thirty-two artists respectively. Belfast, on the other hand, with a similar population to Newcastle in 1851, supported a mere eight. The value of regional studies lies in providing explanations for variations like these.

Macleod's article on patronage in Newcastle was also of relevance in that it posed a question also pertinent to Belfast, namely – why did the wealthy of Newcastle, a number of whom owned impressive collections, not do more to assist with the establishment of local art institutions? Her answer is that in Newcastle, an expanding industrial centre from the mid-nineteenth century, art ranked below science and manufacturing to the town's cultural elite. Whilst this group devoted money to charities and parks, its members did not include art in their philanthropic gestures. Furthermore, those who had large collections such as Sir William Armstrong, Charles Mitchell and James Leathart indentured their paintings to their heirs or sold them in times of recession. When the Laing Art Gallery opened in 1904, established through the benevolence of a businessman not involved in the arts, it did not own any works of art whatsoever and was forced to rely on loans. Overall, the situation in Newcastle was not dissimilar to that of Belfast, where the generous impulses of the town's wealthy industrialists likewise did not extend to art institutions. In Belfast,

art also ranked below manufacturing to those affluent citizens with power to effect change in the local art world.

Topics covered by the various regional studies referred to here have ranged from patronage to the founding of art societies and institutions, from purchasing patterns to the ties between industry and art, issues of considerable importance to the development of provincial centres of art. However, with this examination of Belfast, a broader landscape has been opened up for, besides the above themes, it also discusses the establishment of two schools of art and the opening of the Free Public Library, major events in the art history of the town. In contributing to knowledge of Belfast's artistic past, the study should also be of benefit to the art history of Britain and Ireland.

# ∼ 1 ∼

# The beginnings of art in Belfast

## 1760–1810

*'The little fashion of the little place'*[1]

### ART IN DUBLIN

The fine arts first blossomed in Ireland between 1660 and 1690, during the almost thirty years of peace which followed Charles II's accession to the throne in 1660.[2] Prior to that time, the development of art had been impeded by periods of warfare and political turbulence. However, under the first viceroy of the Restoration, James Butler, 1st Duke of Ormonde, in office between 1661 and 1669, the situation changed. A leading patron of the arts, Ormonde decorated his principal residence, Kilkenny Castle, with tapestries, fine furniture and paintings and, by his example, helped create a greater awareness and appreciation of the fine arts. His viceroyalty also ushered in a period of prosperity to Dublin. Between 1660 and 1685, the population doubled, extensive building schemes were carried out and the city became a Mecca for artists and craftsmen.[3] In these changed times, a number of portrait painters were able to pursue careers in the city, figures such as Garret Morphey (d.1716), the first Irish-born artist of consequence and visiting painters such as the Scotsman John Michael Wright (1617–94), resident between 1679 and 1680. Appropriately, given the heightened artistic climate, the first corporate society for artists in Ireland, the Cutlers, Painter Stainers and Stationery Company of Dublin, known as the Guild of St Luke, was established in 1670.

During the first half of the eighteenth century, the arts continued to flourish, with advances in the standard of portraiture and the development of landscape painting. The leading portrait painter of the time

1

was an Irishman, James Latham (1696–1747), who had studied abroad and developed a style based upon Continental influences. His work raised Irish portraiture to a new level of sophistication. With landscape, the painting of views for aesthetic rather than purely topographical reasons did not begin to emerge until the 1720s; previously, the depiction of Irish scenery had been the preserve of map makers, engravers and travellers. The first landscapist of note was a Dutch immigrant, William van der Hagen (d.1745), whose output included imaginary views, classical landscapes and port scenes. Besides the example set by these and others, more formal efforts were made to promote the arts, as when the Dublin Society, founded in 1731 to improve 'Husbandry, Manufactures and other Useful Arts', established a committee specifically for the arts.[4] In 1746 the Society forged links with a drawing school run by the artist Robert West (d.1770) and, four years later, assumed control of it. The Society's school, which eventually comprised schools of figure drawing, landscape, ornament and architecture, was supported by government grant. In effect, this was the first state-supported art education in Ireland. The schools' influence was considerable for they not only trained fine artists, but also taught design, with particular emphasis on the textile industry.[5] In addition to these facilities, there were numerous private drawing academies in the city.

During the second half of the eighteenth century, the artistic life of the capital was enlivened by the founding of the Society of Artists in Ireland in 1765.[6] The group's exhibitions, held on a regular basis until 1780, were an important vehicle for artists to show their works and helped foster an atmosphere in which art could flourish. Exhibitors with the Society of Artists included William Ashford (d.1824), Jonathan Fisher (d.1809) and Thomas Roberts (1748–78), well-known figures in the canon of Irish art. These, together with others such as George Mullins (fl.1763–75) and Thomas Sautell Roberts (1760–1826) formed the resident artists' community in the city. A number of visiting painters also came and went, the most notable being Francis Wheatley (1747–1801), whose sojourn in the early 1780s produced such memorable images of this period – the age of the Volunteers and Grattan's parliament – as *The Dublin Volunteers in College Green, 4th November 1779* (1780) (National Gallery of Ireland) and *The Irish House of Commons* (1780) (Leeds City Art Gallery). Overall, Dublin, the political and cultural capital of Ireland, with its fine buildings and grandiose town houses of the nobility and gentry, had considerable allure for established artists and students in pursuit of the fine and applied arts.

The fine arts did not begin to flourish in Belfast until the second half of the eighteenth century.[7] The town was then a small but expanding centre with a port, a closely-knit merchant and business community and an economy which owed much to the linen and cotton industries and to trade with Britain, North America and the Caribbean.[8] The character of the place was essentially Presbyterian, a consequence of the large influx of Scottish Presbyterians in the seventeenth century.[9] Presbyterians dominated the property-owning class in the town; however, they had no voice in its government nor a say in the choosing of its representatives in parliament.[10] That prerogative belonged to the Chichester family, earls of Donegall and owners of the land on which the town was built. This exclusivity caused resentment amongst the Presbyterian majority and helped fuel the radicalism rife in the town during the last few decades of the century.

As the town's population grew from 8,549 in 1757 to 22,095 by 1806, so too did its sense of civic pride and achievement.[11] This was seen in the establishment of institutions for the promotion of commerce and trade: the Chamber of Commerce in 1783 and the Ballast Board (or the Corporation for Preserving and Improving the Port and Harbour of Belfast) in 1785.[12] The White Linen Hall, the marketing centre for Ulster's linens, was opened in 1784.[13] The erection of the hall marked a significant shift in the trading pattern – Dublin had hitherto been the centre for the selling of linen – and was one of the most potent symbols of Belfast's growing belief in itself.

Whilst there was neither any kind of formal drawing school nor exhibiting society in the town, the small community supported three resident artists, namely, Strickland Lowry, Joseph Wilson and Thomas Robinson, the first two of whom worked concurrently between the mid-1760s and 1780. Portraiture was the chief means by which all three earned a living. A number of other painters passed through, those of the type referred to by the journalist and art critic William Paulet Carey, in his memoirs of 1826, as 'straggling adventurers of the brush'.[14] Most of these were artistic nonentities, obscure portrait and miniature painters who are now lost to history. A few better-known artists also visited, such as the Dublin-based landscape painter Jonathan Fisher (d.1809) around 1772, the miniaturist Gustavus Hamilton (1739–75) in 1775, the English landscape painter John Nixon (c.1750–1818) in 1786 and the landscape and portrait painter Thomas Clement Thompson (c.1780–1857), who may have been Belfast-born, from 1802.[15] There were also a few resident drawing masters, notably Stafford Wilson, who opened a class in 1778 and the map maker and surveyor James Williamson (c.1756–1832), whose classes commenced in 1790.[16]

Strickland Lowry (1737–c.85), the first artist of consequence to reside in the town for a lengthy period, came from Whitehaven in Cumberland.[17] Though details of his career are obscure, he is known to have worked in Staffordshire, Shropshire and Dublin before settling in Belfast c.1762. Whilst little information is available concerning his years in town, his paintings reveal that he was patronised by members of the prosperous merchant class such as Stewart Banks, sovereign (that is, mayor) intermittently between 1755 and 1778, Thomas Bateson, one of three partners of the first bank to be established in town (in 1752) and Thomas Greg, a merchant, trader and entrepreneur. Portraits of Banks and of the family of Thomas Bateson are in the collection of the Ulster Museum. The latter work (Plate 1), painted in 1762, shows Bateson's children standing in the hall of the family seat at Orangefield, Co. Down, not far from Belfast. Lowry used a similar composition, of figures posed in a row, in his portrait of the Greg family, painted c.1765 (Plate 2). Both works, which are extremely large, display considerable competence, despite a certain naivety and stiffness in the treatment of the figures.

In addition to their overall appeal, the paintings are of particular interest as they are amongst the few in eighteenth-century Irish art to show contemporary interiors. Furthermore, the rooms depicted are the only known interiors of Belfast houses of the period. The opulence of the background surroundings in both homes is especially noteworthy. The hall at Orangefield (Plate 1), wainscoted and with tiled floor, is richly decorated with fine furnishings, engravings and paintings, one of which depicts the house itself. Greg's residence (Plate 2) is equally luxurious, with the walls coloured a deep, rich blue and the panels and decorative motifs picked out in gilt. The floor is tiled, as at Orangefield and the walls are hung with engravings and a ship portrait, symbolic of Greg's trading interests. Both portraits exude wealth and a feeling of pride in place and position in society. The interiors shown in both paintings reveal a level of sophistication somewhat surprising in Belfast's merchant class of the time.

The length of Lowry's stay in Belfast is unknown. He remained in the north of Ireland certainly until 1780, when he painted portraits of a Lurgan Volunteer (Fig. 1) and his wife, both in the Ulster Museum. The former work is the only Volunteer portrait known by him though it seems likely that he painted more; being portrayed in the uniform of one's Volunteer corps was a fashionable trend in the late 1770s and 1780s. Founded in Belfast in 1778, the Volunteers were a civilian army set up to provide protection against foreign invasion whilst regular troops went off to fight in America.[18] However, the call to arms was never sounded in earnest and the movement, which was countrywide, became instead a kind of political pressure group,

4

committed to bringing about the legislative independence of Ireland and parliamentary reform. The former goal was realised in 1782; the latter the Volunteers never achieved. Large numbers in the north (many of whom were Presbyterians) joined, as did many thousands in the country as a whole.

Contrasting the Lurgan Volunteer's portrait with the works of the 1760s, it is evident that Lowry's abilities had declined in the intervening years for the 1780 painting is wooden and lifeless compared with the earlier pictures. Poor health was perhaps a contributory factor in the falling off of his powers. Besides the above-mentioned works, little else is known of his life. That he was dead by the summer of 1785 is certain as his widow advertised in the *Belfast News-Letter* of 19–23 August of that year for a position as a lady's or children's maid. Intriguingly, there appears to have been a family link, as yet unclear, between Lowry and his chief rival for business, Joseph Wilson, for Lowry is said to have named his son, the engraver Wilson Lowry (1762–1824) after Wilson. As further evidence of a possible connection, Lowry's grandson was christened Joseph Wilson Lowry.

**2** Joseph Wilson
*Lieutenant Hugh Hyndman* (c. 1782)

Fortunately for posterity, a fuller profile can be gleaned of Wilson's career, though his origins and training remain a mystery.[19] Established in Belfast by June 1766 (by which point he felt obliged to deny that his prices were overly high, in an advertisement in the *Belfast News-Letter* of the 13th of that month), he worked in both Belfast and Dublin during the 1770s and 1780s, painting sitters mainly from the professional and merchant classes. Less gifted than Lowry, his works are the stock-in-trade likenesses of the provincial portrait painter and are characterised by an almost primitive stiffness and lack of animation, as seen in his portrait of a Volunteer officer of c.1782, Hugh Hyndman (Fig. 2). He seems to have been a popular painter with the Volunteer movement for he is known to have painted at least five other members. Amongst these were Randal William, 6th Earl of Antrim (collection the Earl of Antrim) and John Brown, a future sovereign of the town (whereabouts unknown). It is possible that he himself was a Volunteer. George Benn's *History of Belfast* lists a Joseph Wilson amongst the members of the 3rd division of the Belfast First Volunteer Company in 1781.[20] Belonging to the movement would doubtless have provided him with an opportunity for gaining commissions. Coincidentally, a Joseph Wilson is also recorded as being a member of Orange Lodge of Belfast no. 257, a Masonic lodge closely linked to the Volunteers.[21] A number of Wilson's sitters also belonged, namely the Earl of Antrim, John Brown, Amyas Griffith and Hugh Hyndman.[22] Being part of this circle would probably also have brought him commissions. Whether for business reasons or by personal conviction, Wilson seems to have been involved in organisations at the centre of Belfast's political life.

**3** Joseph Wilson
*Miss Maxwell* (c. 1782)

Besides standard-sized portraits of about thirty by twenty-five inches, Wilson also painted likenesses on small oval panels, of which that of Miss Maxwell, also of c.1782 (Fig. 3), is a typical example. Producing such works would seem to indicate a pragmatic attitude to business, for paintings on this scale were perhaps aimed at less affluent patrons. A second factor in their execution may have been their portability. Throughout Wilson's career there were few miniature painters working in Belfast – at the most, probably only seven or eight visiting artists for brief periods between 1766 and 1792 – thus his small panels may have been intended to fill this gap in the market.[23] In addition to portraits, Wilson is said to have painted landscapes, though none by him are known to have survived.[24] His sole foray into history painting, a work entitled *Daniel interpreting to Belshazzar the Writing on the Wall*, appears to have been problematic. According to a notice in the *Belfast News-Letter* of 28 June–2 July 1782, a raffle he planned to hold to dispose of the picture had failed to attract sufficient subscribers and he appealed for more. The subsequent history of the painting is unknown, as indeed are details of the last years of his life. He died at Echlinville, Co. Down on 13 March 1793, being described in his death notice as 'a very worthy honest man'.[25]

The career of Thomas Robinson (d.1810), the third artist resident in Belfast during the last few decades of the eighteenth century, is much more fully documented than those of Lowry and Wilson.[26] His talents, too, were on a fuller scale; not only could he produce animated and naturalistic portraits, he was also capable of painting historical subjects of a large format. A native of Windermere, he studied in London with the portraitist George Romney (1734–1802) before going to Dublin about 1790. About three years later he moved north, firstly to Lawrencetown, near Gilford, Co. Down, then to Lisburn and finally to Belfast. His sojourn at Lawrencetown was particularly fruitful for during his residence there he became acquainted with the Bishop of Dromore, Thomas Percy, the leading figure of the Enlightenment in the county.[27] The association of the two men was based on common interests. Robinson had had early ambitions to be a poet and had literary leanings, as had Percy.[28] The resultant friendship between the two led to Robinson being accepted into Percy's intellectual circle. Percy subsequently became one of Robinson's most committed patrons. The support he gave was both wide-ranging and valuable for he not only purchased Robinson's work, he also promoted it on occasion and assisted the Robinson family at times.[29] Such was his friendship that he acted as one of the chief promoters of *Juvenile Poems*, a book of verse by the artist's gifted young son, Thomas Romney Robinson, published in 1806.[30] Percy also involved Robinson in his landscape gardening projects at Dromore.[31] A group portrait of Percy

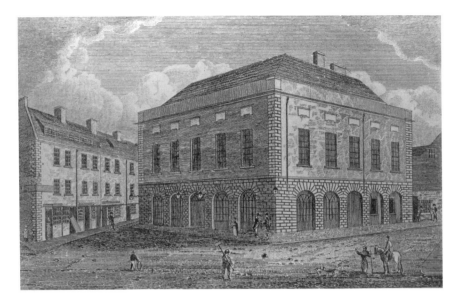

4 The Exchange in Waring Street, erected in 1769 at the expense of the 1st Marquess of Donegall and converted into Assembly Rooms in 1776, likewise at Lord Donegall's expense. The building became the centre of Belfast's social and cultural life.

and his coterie, painted by Robinson in 1807, is at Castleward near Strangford, Co. Down (National Trust).

By 1798 Robinson had moved to Lisburn, perhaps to be closer to Belfast and a wider selection of patrons. There he painted his best-known work and his earliest recorded historical subject – *The Battle of Ballynahinch* (1798) (Plate 3). The picture was produced with some speed, being completed only four months after the battle between government forces and the United Irishmen at Ballynahinch on 12–13 June. In executing the work so soon after the battle, Robinson appears to have acted from opportunism and with an eye to the market, for the subject matter, a major event not long before and recorded by him in the manner of grand history painting, would doubtless have aroused much curiosity and interest. Passages in the painting, especially the central dying figure, reflect the influence of Benjamin West's famous work, *The Death of General Wolfe*, which Robinson probably knew from William Woollet's engraving of it, published in 1776. The picture and others by Robinson were exhibited in November 1798 in the Belfast Assembly Rooms (Fig. 4 and Plate 4), the hub of the town's social and cultural life and the main venue for balls, card games, art exhibitions and meetings of various kinds.[32] The painting was raffled during or after its display (with tickets at one guinea each) and was won by the Marquess of Hertford, who planned to hang it in his home in Lisburn, 'to be viewed … by all who were at the Battle of Ballynahinch, many of whom have their portraits drawn in it'.[33] Unfortunately, a key to the identity of the various figures, by Robinson, is missing.

Robinson eventually settled in Belfast in 1801 and remained there for seven years. During his sojourn he acquired a number of important

patrons, notably Dr William Bruce, minister of the First Presbyterian Church in Rosemary Street and principal of Belfast Academy, the shipbuilder William Ritchie and the 2nd Earl of Massereene. Robinson painted three portraits of Ritchie, one of which, a full-length, showed him standing by a statue of Neptune, his shipyard in the background (Plate 5).[34] Robinson and Ritchie appear to have become firm friends, as did also Ritchie and the artist's son Thomas, generally known as 'Tom' (Fig. 5). The young boy became a frequent visitor to Ritchie's shipyard and even addressed a poem 'The Triumph of Commerce', to the shipbuilder.[35] Friendship was also a factor in the Earl of Massereene's patronage for he and Robinson also appear to have been on close terms. In March 1804 Robinson was one of four witnesses to the earl's will.[36] The following May he painted two pictures for the earl and also received commissions for others.[37] An important element in Robinson's friendly relations with Ritchie and the earl appears to have been young Tom, whose precocious talents and obviously winning ways seem to have won the admiration and esteem of both men. Apparently as popular with the earl as he was with Ritchie, Tom remained at Antrim Castle, on the invitation of the earl, for a further three months in 1804 after Robinson had completed his commissions there.[38] On the earl's death in 1805, Tom composed an elegy to his memory, which was published in *The Gentleman's Magazine*.[39]

In addition to his portrait practice, Robinson maintained a drawing school at his Belfast home during the second half of 1804 and early 1805.[40] This would appear to have had limited success as it seems to have remained in existence for a mere six months or so. During this period, in October 1804, he commenced his second major historical subject, *Review of the Belfast Yeomanry by the Lord Lieutenant, the Earl of Hardwicke, 27 August 1804* (Plate 6).[41] Robinson conceived the work on a grandiose scale. Writing to Percy on 9 November of that year, he explained that he planned to include almost 300 figures in the picture.[42] In his initial advertisement for the painting, published in the *Belfast News-Letter* of 9 October, he explained that he hoped to defray the cost by receiving 'subscriptions from one guinea upwards … all persons so subscribing may have their portraits introduced without further expense'. He continued further:

> [he] has reason to expect that most of the Nobility and gentry of the country will do him the honour of sitting for this purpose. It will be curious to hand down to other generations, the likenesses of the principal inhabitants of the present day, assembled in one of the most beautiful parts of the town. An additional increase to the undertaking [is] that the ladies will be introduced as gracing this interesting scene.

Robinson had obviously seen in the Lord Lieutenant's visit of the previous August an opportunity to appeal to the vanity of Belfast's upper and middle classes. His only stipulations were payment of 150 guineas, permission to exhibit the painting for two months and the sole right to have it engraved. Thereafter, the picture was to become the property of the subscribers, who could hang it in Belfast wherever they wished.

The painting, probably the most important to be produced in town between 1760 and 1810, contains a fascinating cross-section of the upper and middling ranks of Belfast society, from the Marquess of Donegall to Robinson himself and young Tom.[43] However, by the time the work had been completed, in July 1807, Robinson's original scheme had been radically altered. Instead of almost 300 persons – or even 150 – there were now only 44 main figures, with numerous unidentifiable Yeomanry. Such a reduction in figures was probably the result of compositional problems and insufficient

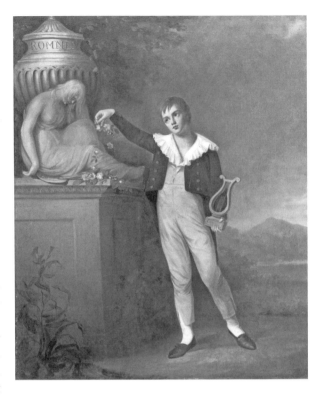

**5** Thomas Robinson
*Thomas Romney Robinson (1792–1882)*

subscribers. An indication of the difficulties surrounding the commission can be gleaned from local personage Martha McTier, whose correspondence with her brother, Dr William Drennan provides a fascinating glimpse of late eighteenth- and early nineteenth-century Belfast.

In February 1807, Mrs McTier visited Robinson's studio to view the painting and was told of the artist's disillusionment with the project. Her account of the history of the work, as relayed to her by Robinson, casts an interesting light on the art world of Belfast at the time. According to Robinson, the idea for the painting:

> arose from the talk and puffing of that taste for the fine arts which was said to have arisen here; that his plan had been mentioned to the Donegalls, who appeared so pleased with it that he had little doubt they would be the purchasers; *that* was now over; it had cost him much time and trouble, and he had told W[illia]m. Sinclaire he believed he would not finish it. S[inclaire]. desired him to do it and that he would take care he should not be a loser, probably meaning to be himself the purchaser. *This* also was over, and I believe his only hope is that *somehow* it will be bought for the Exchange Room [the Assembly Rooms].[44]

Robinson had obviously viewed the Donegalls as potential purchasers. Unfortunately, by December 1806, their affairs in Belfast were in ruin, with the contents of their home seized to pay off debts.[45] The possibility that they would acquire the painting was finished. Robinson's remaining hope, that William Sinclaire might buy the picture, had likewise been dashed as the latter died on 11 February (1807), a few weeks before Martha McTier's visit to the studio.

Shortly after Sinclaire's death, a notice appeared in the *Belfast News-Letter*, stating that a subscription list had been opened to help remunerate Robinson for the time and effort he had expended on the painting. The wording used was intended to appeal to the public's vanity: 'As this is the first Work of an Historic Character that this highly improving Town has had an opportunity to encourage, the Names of the Subscribers, as Patrons of the Arts, will be inserted in a compartment, intended to be added for the purpose.'[46] The number of subscribers to come forward remains unknown. The picture and others by Robinson were exhibited firstly in the Assembly Rooms and then at the artist's home during July and August 1807.[47] Robinson thereafter planned to raffle the collection on 1 September. Whether he did or not is unclear; what is certain is that he failed to dispose of the Hardwicke painting. Obviously anxious to sell, he altered the background, which had originally shown Donegall Place, added a statue of Nelson – there never was such in Belfast – and exhibited the picture in Dublin in 1809 with a new title: *A Military Procession in Belfast in Honour of Lord Nelson*. Notwithstanding the latter's popularity, the painting still failed to find a buyer. It remained in the Robinson family's possession until 1852, when it was presented to the Belfast Harbour Commissioners by Thomas Romney Robinson. That Robinson badly needed to sell the picture seems apparent from Martha McTier's observations on meeting him in 1807: 'an interesting, sensible man, of great simplicity, and *very poor*'.[48] Whatever the talk of a taste for the fine arts having arisen in Belfast by 1804 – and despite the fact that the middling ranks were commissioning portraits and buying paintings and prints – the fate of the work indicates that those with money were neither sufficiently interested nor public spirited enough to purchase the painting for public display. The fact that the picture showed numerous well-known citizens and that Robinson appears to have been highly thought of, with influential friends, counted for nothing. Perhaps disillusioned by the lack of support for the painting or simply to be near Tom, then attending Trinity College, Robinson left Belfast in 1808 and spent his last few years in Dublin, where he died in July 1810.

# ART ON DISPLAY

During the period covered by this chapter, the Belfast public had an opportunity to see a wide range of art of reasonable quality. Of the three resident artists discussed above – Lowry, Wilson and Robinson – the latter two used exhibitions as a means of promoting their work. By 1782, for example, Wilson is known to have opened an exhibition room in his house in Waring Street, a probable indication that his practice was flourishing so widely that he required a display area of his own for his paintings.[49] Such a necessity seems likely as this was the period of his involvement with the Volunteers and with the Orange Lodge of Belfast no. 257. Robinson, as has already been seen, used the Assembly Rooms and his home for his exhibitions of 1798 and 1807. Of visiting artists, Thomas Clement Thompson regularly showed in town. In 1804 he exhibited two of his best-known works, *View of Belfast from Cromac Water Mill* and *View of Belfast from the Banks of the Lagan* (Fig. 6) at his lodgings in High Street, to help promote sales of engravings of them by Francis Jukes.[50] Though the whereabouts of the original paintings is unknown, the engravings are now prized as valuable records of early nineteenth-century Belfast. In 1805 and also in 1808, by which point he was advertising himself as a portrait painter, he again used his lodgings in High Street and later in Church Street as an exhibition venue.[51] Overall, therefore, through

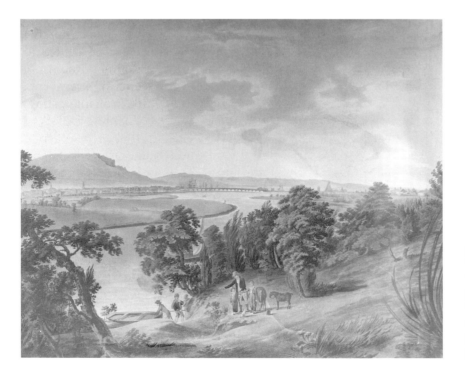

**6** Francis Jukes, after Thomas Clement Thompson *View of Belfast from the Banks of the Lagan* (1805) Thompson's painting (from which this engraving was taken) was exhibited in Belfast in 1804.

the enterprise of Wilson, Robinson and Thompson, the Belfast public had an opportunity to view a selection of the fine art produced in the locality.

In addition to work by resident and visiting artists, the public was also able to see art from elsewhere. In 1786, for example, a portrait of George Washington, which had been painted in America, was in town and advertised as 'the first painting of the kind that has been brought to Ireland'.[52] Copies were made by Wilson, one of which was raffled in the Assembly Rooms on 28 September 1787.[53] Given that there had been considerable admiration amongst Belfast's Presbyterians for the American colonists and their struggle for independence from Britain, the portrait and Wilson's copies probably attracted considerable attention. The main centres for the display and sale of non-local art, however, were printsellers' shops and auction rooms, though as yet, these lines of business were little developed in Belfast. Prints, more so than paintings, were readily available. In 1766, the firm of H. and R. Joy advertised a large collection for sale, including a number published by the well-known London printseller, John Boydell.[54] The auction house of James Hyndman held print sales in 1807 and 1808, as did that of C. Birnie in 1809.[55] This end of the art market, comprising moderately priced reproductions, must have appealed to those wishing to decorate their homes at reasonable cost. The exhibition of such prints helped place art of a wide variety and good quality before the Belfast public, even in these early days.

A more popular art medium with wider appeal, the phenomenon known as the panorama, made its first appearance in town during these years. Invented in Edinburgh by the portrait painter Robert Barker (1739–1806) about 1785, the panorama became a popular form of entertainment in Edinburgh, Glasgow and London by the mid-1790s.[56] Executed upon hundreds of square feet of canvas and comprising a full 360°, the painted images of the panorama were viewed by a spectator from the inside of a huge cylinder. Barker's aim with his invention was to emancipate landscape art from its traditional picture format. In his opinion, the panorama was an 'Improvement on painting, Which relieves that sublime Art from a Restraint it has ever laboured under'.[57] Subject matter ranged from places of interest in Britain and overseas to incidents from history. Besides creating visual effects through images, panoramas were also intended to be instruments of instruction, a means of conveying material facts about the world to the spectator.[58] Their audience – in Belfast as elsewhere – belonged essentially to the middling orders, those who could afford the admission charge of one shilling. (This price remained standard for all panorama exhibitions during the late-eighteenth and nineteenth centuries.) Though visitor numbers to the

various displays in Belfast are unknown, panoramas appear to have been as popular here as in other British towns and cities and were to continue so certainly until the mid-1880s.[59]

The Belfast public 'experienced' its first panorama during February and March 1798, when a view of London, painted upon 3,500 square feet of canvas, was exhibited in a specially-erected building in Arthur Street.[60] The identity of its creator remains unknown. Another followed in May of the same year, a naval subject by the marine artist Robert Dodd (1748–1816), containing two scenes of action: *The Burning of His Majesty's Ship the Boyne* and *Escape of the Grand Fleet from the Flames*.[61] A further two came in 1802, both by Robert Ker Porter (1777–1842). The first, *The Storming of Seringapatam*, was painted in 1800 and was toured around various towns and cities in Britain before being exhibited in Belfast between April and June (1802).[62] Painted upon 2,550 square feet of canvas and supposedly executed in only eight weeks, it was Porter's most popular panorama.[63] Whilst it no longer exists (most panoramas produced during the first half of the nineteenth century have not survived), engravings of its three action-packed scenes, by John Vendramini, give some idea of its quality and content (Figs. 7–9). Porter's second panorama, *The Siege of Acre*, was displayed in a purpose-built structure in South Parade (now Wellington Place) during the following August (1802).[64] Larger than *Seringapatam*, it comprised almost 3,000 square feet of canvas. The impact of these various panoramas on the Belfast public's perceptions of art, whilst impossible to quantify, must surely have been considerable; persons who had perhaps paid little attention to art before, now had it presented to them in a popular form.

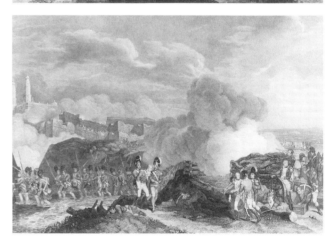

**7–9** John Vendramini, after Robert Ker Porter
*The Storming of Seringapatam*
Porter's panorama, of which only these engravings by Vendramini remain, was in Belfast between April and June 1802.

By the early nineteenth century, the fine arts had become firmly established in the cultural fabric of Belfast, as shown by the artists and exhibitions discussed above and by the beginnings of a commercial trade in art. The type of work most frequently produced by the town's few resident painters – portraiture – was in response to demand by middle- and upper-ranking families, who wished to commemorate their line and had little desire to travel to Dublin for sittings with artists there. Lowry, Wilson and Robinson produced likenesses sufficiently pleasing for local patrons. To an extent, the political culture of the late 1770s and 1780s buoyed up the demand for portraiture; during these years, when being a Volunteer was both a political stance and glamorous, having one's picture painted in the uniform of one's corps was extremely fashionable. Part of Wilson's success lay in the fact that he acted as visual reporter of the personalities in a political movement which figured largely in the life of the town.

The commissioning of art for luxury or decoration seldom happened. None of the town's resident artists supported themselves by landscape painting and the sole major work produced on an historical theme, Robinson's Hardwicke painting, failed to find a buyer. The first family, the Donegalls, who might have become its owners had circumstances permitted, were, in fact, indifferent patrons of local artists and had few pictures in their Belfast home, according to an inventory of 1803.[65] The demand for art as luxury or decoration appears to have been adequately met by the few print and painting sales held by James Hyndman and others. In general, the reason for the commissioning of locally-produced art during these years, therefore, was to commemorate family links or political affiliations. Not until the late 1820s, with the advent of Hugh Frazer and Andrew Nicholl, did Belfast artists support themselves by landscape painting. This situation was almost certainly related to the increasing wealth of the middling ranks, the professional and merchant classes, who desired attractive scenes to display in their living and drawing rooms. The industrial success of the first few decades of the nineteenth century was partly responsible for this development, as the following chapter will show.

# ~ 2 ~

# The consolidation of the arts in Belfast

## 1811–35

*'The introduction, or the improvement of the Fine Arts, is certain proof of the refinement and increasing wealth of a people'*

### ART EDUCATION: DRAWING SCHOOLS AND DRAWING MASTERS

The comment quoted above, published in a leading local newspaper, the *Northern Whig* of 6 November 1834, not only extols the civilising influence of the fine arts in general but, in the context of this particular issue of the paper, reveals pride in the progress of Belfast and in the cultural aspirations of its more genteel citizens. By the mid-1830s, at which point the population numbered over 53,000, the town had, indeed, undergone a remarkable industrial and commercial expansion, based largely on developments in the cotton and linen industries and on the growth of trade.[1] Such was the extent of the latter that Belfast had become, by this time, the leading Irish port in value of trade, £7.9 million as compared to Dublin's £6.9 million.

Nevertheless, despite the demands of business, the professional and merchant classes still found time to improve the intellectual tone of the town and the lives of its less fortunate inhabitants. By the 1830s, a large number of societies and benevolent institutions had been founded, such as the Anacreontic Society (1814), the General Hospital (1817), the Belfast Medical Society (1822), the Mechanics' Institute (1825), the Society for the Relief of the Destitute Sick (1826) and the Lunatic Asylum (1827).[2] Of particular concern to these affluent classes was the education of their children, especially their

15

**10** The Academical Institution in the early 1820s. The Institution's drawing school, opened in 1814, was the foremost in Belfast until the late 1840s.

sons. Towards that end, the town's premier seat of learning, the Academical Institution (Fig. 10) was opened in 1814, established by a number of wealthy merchants and enlightened liberals. Seven years later, eight of its students founded the Belfast Natural History Society, whose museum (Fig. 11), the first in Ireland to be erected by public subscription, was opened in 1831.[3] In such an enterprising community, whose wealthy middle ranks aspired to culture and the finer things of life, the pursuit of learning, including instruction in art, assumed a greater significance than it had had in the past.

Although a number of drawing masters had taught periodically in Belfast from the 1760s, their schools had been small-scale concerns, often simply a room in their houses or lodgings. The early decades of the nineteenth century brought a new development in the provision of art education in the town, namely, the establishment of a number of more formal 'mini-academies', sometimes situated in premises other than the master's home. The most important of these, that in the Academical Institution, was opened in the autumn of 1814.[4] Part of a recognised academy and not privately owned like the other drawing schools in Belfast, it operated outside the normal school hours of the Institution and took only male pupils. During the fifty-six years of its existence, it was managed by three successive masters: Gaetano Fabbrini, Ferdinand Besaucele and Joseph Molloy.[5]

Fabbrini (fl.1814–49), a Florentine who had resided in Belfast since 1811 or before, was appointed in September 1814 and commenced teaching on 1 November following.[6] Although his career at the Institution eventually ended in disaster – he was dismissed in 1820 – he appears to have been a highly conscientious teacher, determined upon improving the drawing school despite a marked lack of support by the school's board of managers and visitors.[7] By March 1815 there were twenty pupils on the register.[8] The school continued to expand and improve over the next few years, according to a memorial from Fabbrini to the board of proprietors in December 1817, although the number of pupils attending is not recorded.[9] True to his origins and training, Fabbrini modelled the school on the Florentine Academy. As detailed in the Institution's prospectus of 1818:

> The taste of the young artist is formed on Grecian models, and the best paintings. Civil architecture is taught on the proportions fixed by Vignola; and the theory of Perspective on the improved plan of Padre Pozzi. Portrait painting, with the study of Physiognomy, forms another department of the same school; and the science of Ornamental drawing, on the Roman plan, is about to be added to it.[10]

From the winter of 1819, relations between Fabbrini, the other masters and the board of managers became strained when he resigned from the masters' board because of a disagreement over examinations.[11] Thereafter, his behaviour at the school became increasingly argumentative and erratic. He accused the masters, collectively and individually, of cruelty, impropriety, inaccuracy and inconsistency.[12] After an inquiry by the managers, who found his claims false and malicious, he was dismissed on 19 August 1820.[13] Although his career at the Institution ended in disgrace, he appears to have been a highly competent teacher, for three of his pupils – James Atkins, Samuel Hawksett and Joseph Molloy, all discussed below – became professional painters of repute in the locality. His fiery Italian temperament seems to have clashed badly with the staid Presbyterian ethos of the Institution; nevertheless, his Continental training and outlook appear to have been an inspiration to aspiring young artists in the provincial world of Belfast. Surprisingly, given that he resided in the town for almost forty years and maintained a drawing school of his own for a lengthy period, there are no works by him known to exist.

11 The museum of the Belfast Natural History Society (later the Belfast Natural History and Philosophical Society) in College Square North, opened in 1831. A number of local art societies held their exhibitions here: the Belfast Association of Artists between 1836 and 1838, the Northern Irish Art Union in 1842 and the Belfast Fine Arts Society in 1843.

Fabbrini's successor, Ferdinand Besaucele (fl.1820–30) was appointed by 6 November 1820.[14] A Frenchman who had served as a lieutenant in the French army, he had taught in Newry for some time prior to taking up the position at the school.[15] During his ten years as master, he also gave private tuition, taught in a few female boarding schools and, in 1826, established a lithographic press in Castle Street.[16] This particular printing process had been promoted in England from 1816 by the publisher, Rudolf Ackermann, who had recognised its potential for commercial purposes.[17] According to Besaucele's advertisement, this first known use of the invention in Belfast was aimed at merchants and traders. Though the success of the enterprise remains unknown, it seems probable that it met with a good response, given the commercial ethos of the town. Besaucele resigned from the Institution on 1 May 1830.[18] His replacement, Joseph Molloy (1798–1877), a former pupil at the school, was appointed the following month.[19] A conscientious and able teacher, he was employed by the school until 1870 and was also known in the locality as a portrait and landscape painter (see below). As such, therefore, he is the only drawing master amongst those in the town during the early decades of the nineteenth century to have left any kind of artistic legacy. His best-known pupil was Richard Hooke, one of the foremost portrait painters in the town from the 1840s to the late 1880s, who attended his classes during 1843, at the age of twenty-three.[20] (By this point, the drawing school was obviously open to others than students at the Institution.)

Of the other drawing schools in Belfast, three in particular stand out, namely Fabbrini's own establishment and those of Peter Giles and John Campbell. Fabbrini's school, which he opened by the beginning of February 1821 in one of the central rooms of the White Linen Hall, after his dismissal by the Academical Institution, was conducted on the plan of the Royal Academy of Florence, according to an advertisement in the press.[21] There he taught figure and portrait painting in oil, civil and military architecture and the 'inferior' branches of art, that is, landscape painting and flower and ornamental drawing. These latter classes were probably aimed at attracting female students, who tended to pursue subjects like flowers and decorative art as a genteel occupation. In 1832 he extended the range of his curriculum to include an anatomical museum, using models in wax, probably to supplement the teaching of figure drawing.[22] By 1836 he had moved the drawing school to Little May Street.[23] Always enterprising, he remodelled it in 1839 as the Belfast Italian School of Design, a venture probably inspired by the opening of the School of Design in London in 1837, a government-supported institution and the first of its kind in Britain.[24] In Fabbrini's school, particular emphasis was placed on ornamental drawing and design for manufacture. In 1847, in response to the government's intention of shortly establishing a School of Design in Belfast, he organised an evening class specifically for 'industrious Mechanics, anxious to improve their taste in the Arts, Decorative and Ornamental'.[25] For this particular sector of the community, many of whom worked in the linen industry, there had been no opportunity for artistic training of any kind in Belfast, prior to the commencement of this class. That Fabbrini acted upon the need says much for his practicality and pragmatism. His school is known to have remained in operation until December 1848 and may have continued until his death in July 1849.[26]

Peter Giles (fl.1820–35) opened his school in December 1820 at 30, King Street.[27] A portrait painter from Glasgow, he had first visited Belfast in the previous September with a large collection of his work, in the hope of making a favourable impression on the Belfast public.[28] This he must have accomplished as he subsequently left Glasgow to settle in the town. By April 1831 he had forty pupils 'of the first respectability'.[29] Besides running his academy, he taught at schools in Antrim, Crumlin, Holywood and Lisburn for a number of years.[30] An impression of the academy can be gleaned from the reminiscences of Robert Young, an architect and amateur artist who attended in the early 1830s:

What sort of people were there after such a lapse of years 70 or more [Young was writing in about 1906] only a dim blurred

image remains like this ... the little drawing room with a few young ladies and gentlemen seated at their respective tables ... young ladies mostly painting roses and leaves from copies not from the real ... The youths of [the] other sex at pencil, chalk, indian ink or sepia copies or rarely in colours.[31]

Amongst Giles' numerous pupils was James Moore, who later became well known in the locality as an amateur landscape painter.[32] Nothing further is known of Giles or his academy after 1835 and, as with Fabbrini, paintings by him are no longer to be found.

The third privately-owned drawing school of consequence was that run by John Campbell (1800–35), a young Manchester artist who moved to Belfast, from Dunfermline, in the winter of 1834 and opened an academy in Fountain Street on 18 November of that year.[33] In the week preceding, probably in an effort to promote his establishment, he delivered an introductory lecture on the utility and general principles of drawing and painting in the assembly room of the Commercial Buildings (Fig. 12), which was allegedly so well attended that numbers had to be turned away.[34] A popular and articulate young man and the author of several pieces in the *Belfast News-Letter*, under the initial 'C', he appears to have been held in high regard in Belfast.[35] He died on 2 March 1835 of heart disease.[36] Only one work attributed to him is known, namely, a sketch of the Egyptian mummy Takabuti (Fig. 13), presented to the museum of the Belfast Natural History Society and unwrapped in January 1835.[37] (She is now to be seen in the Ulster Museum.) Unfortunately, the slightness of the work gives little indication of his artistic powers. Nevertheless, his presence at the special unwrapping ceremony is perhaps an indication that his artistic ability was more considerable than shown by this single sketch.

Another aspect of art education – the lecture – also became a feature of Belfast's cultural life during these early decades of the nineteenth century. Campbell's lecture of 1834, allied to the opening of his drawing school, has already been referred to above. This, however, was not

**12** The Commercial Buildings, opposite the Exchange and Assembly Rooms in Waring Street. Erected 1819–20, the building contained a commercial hotel, shops, offices, news-room and coffee room. Numerous lectures, art sales, auctions and exhibitions were held in it over the years, including displays of panoramas.

**13** John Campbell, attributed to *The Egyptian Mummy Kabouti* (Takabuti)

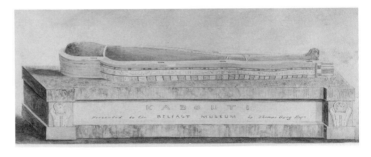

**14** William Paulet Carey (1759–1839), journalist and art critic, gave a series of lectures on the fine arts in the Commercial Buildings during September 1828.

**15** Unknown, Irish School *William Tennent (1760–1832)* (c. 1810) Tennent, a wealthy merchant and landowner, was a patron of the arts and is known to have owned a collection of paintings.

the first time that such an event had been held in Belfast; a much more important speaker, the well-known journalist and art critic William Paulet Carey (1759–1839) (Fig. 14) had already given a series of lectures in 1828. These talks, of which there were six, were held in the Commercial Buildings on 1, 3, 6, 8, 10 and 13 September and were under the patronage of the Marquess of Donegall.[38] Carey had already delivered them in Leeds and Dublin and was to do so again in a number of towns in England and Scotland during the winter of 1828 and throughout 1829.[39] The talks focused upon the utility and progress of the fine arts from the earliest times, through the Greeks and Romans to the Renaissance. Carey had given the Dublin lectures in association with the Royal Irish Institution, which was celebrating the opening of its new art gallery in College Street and the Belfast talks were in connection with the same body.[40] The aim of the Belfast lectures, which were addressed not only to devotees of the fine arts but also to local traders, manufacturers and merchants, was to awaken a taste for art in the north, where 'the subject [had] not occupied that prominent place in public attention to which its importance should have entitled it'.[41] The only lecture of the six to be reported in the press, that held on 8 September, was apparently attended by a large and fashionable audience.[42]

Though few details are known of Carey's visit, it is evident that he desired to encourage change through more active means than lectures for he contacted at least one prominent businessman, William Tennent (Fig. 15), possibly in the hope that the latter would consider promoting the fine arts in some positive way.[43] Tennent (1760–1832), a wealthy merchant and landowner, was senior partner in the Belfast Commercial Bank, a founder member of the Belfast Chamber of Commerce and of the Academical Institution and was on the committees of several charities.[44] Interested in the fine arts, he had been one of a group of patrons who had sent the young Belfast artist James Atkins to Italy in 1819 (see below).[45] He had also a collection of landscapes in the parlour of his Belfast home, which Carey had either seen or heard of mid-way through his Belfast visit, and owned an impressive library.[46] Carey initiated the acquaintance by lending Tennent books on the fine arts and, in return, received an invitation to dine. Nothing, however, came from Carey's contact with Tennent or from his mission to Belfast. Carey's few surviving letters to Tennent are interesting in that they provide a glimpse of the method of his approach to an influential patron: create a common ground, in this case by the loan of books on art, and praise the patron's benevolence and art collection. (It is worth speculating that this was a tactic Carey may have used in other towns and cities as a means of reaching the rich and powerful.) In appealing thus to at least one member of

Belfast's business community and to local art lovers, he obviously hoped to create an atmosphere in which each would help the other raise a greater awareness of the value of the fine arts in the north. This latter situation, unfortunately, was not to come about for many years.

## THE EMERGENCE OF LOCAL ARTISTS

During these first three decades of the nineteenth century a number of locally-born artists began to establish reputations in the community, namely, James Atkins, Samuel Hawksett, Hugh Frazer, Andrew Nicholl and Joseph Molloy. The most gifted of the group was Atkins (1799–1833).[47] A pupil of Fabbrini at the Academical Institution from 1817, he was awarded a medal for portraiture the following year and was considered an outstanding student.[48] Such was the extent of his talent that in early 1819, a number of local nobility and gentry raised a subscription to send him to Italy to further his artistic studies.[49] Amongst those who contributed were the Marquess and Marchioness of Downshire, the Marchioness of Donegall, the merchant and banker Narcissus Batt (Fig. 16) and William Tennent.[50] Batt personally organised the young artist's trip.[51] Unfortunately, little is known of Atkins' career thereafter except that he remained in Italy until late 1832, working generally in Rome or Florence. It was in the former city in 1824 that he painted an impressive full-length portrait of the 3rd Marquess of Donegall (Plate 7), an extremely large work in the manner of Sir Thomas Lawrence. That he was also equally capable of painting on a small scale is evident from his exquisite portrait of a young girl in a white dress (Fig. 17), measuring only nine inches by seven, likewise dating from his Italian sojourn. Both works indicate that he possessed a considerable talent. In December 1832 he left Rome for Constantinople, to paint the Sultan.[52] Whilst there, his health began to fail and he travelled to Malta in the hope of recovery but died in December 1833.

The contents of his studio in Rome were subsequently taken charge of by Narcissus Batt. In a timely gesture of benevolence and foresight, Batt organised the transport of the paintings from Rome to Belfast at his own expense in 1834 and exhibited the collection at premises in Donegall Place in late December of that year.[53] This was the first large-scale one-man show to be held in town. The aim of the event, which comprised some ninety oils, including portraits, landscapes, historical subjects and copies of the Old Masters, was to raise funds for Atkins' sister. Fortunately, as virtually all of the paintings are now lost, a press review of the exhibition by fellow artist Hugh Frazer contained details of many of the works.[54] Amongst the Old Master

**16** Narcissus Batt (1767–1840), a merchant and banker, was a patron of the artist James Atkins. On Atkins' death in 1833, Batt organised the return of the contents of the artist's studio from Rome to Belfast.

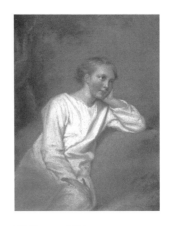

**17** James Atkins
*Young Girl in a White Dress*

copies was a self-portrait of Rubens, *The Marriage of St Catherine*, after Correggio, and *The Murder of St Peter Martyr*, after Titian. This latter painting was presented to Queen's College, Belfast (now The Queen's University of Belfast) in 1847 and can be seen in the Great Hall.[55] It is of particular interest as the original, which was in the Basilica of St John and St Paul in Venice, was destroyed by fire in August 1867.

For reasons unknown, the sale of the collection was deferred until 31 March and 1 April 1835.[56] Nothing further is known of it, neither the amount raised nor the number of works sold. Surprisingly, as the collection was of a considerable size, only five works by Atkins are known: *The Murder of St Peter Martyr* referred to above and three portraits and a landscape in the Ulster Museum, two of which are illustrated here. As an instance of committed and thoughtful patronage, Batt's retrieval of the collection from Rome stands out as a shining example; in a town not overly generous in its support of artistic causes, his action was both commendable and far-sighted. Of Atkins himself, his early death was a sad loss for Belfast. Had he returned, he might have helped raise the status of the fine arts in the locality by his experience and example.

In contrast to Atkins, who spent his career abroad, the working life of Samuel Hawksett (1801–59) was firmly rooted in Belfast. The leading portrait painter in town by the mid-1830s, he, like Atkins, had been a pupil of Fabbrini in the drawing school of the Academical Institution.[57] Though not so gifted as Atkins, as can be seen from his somewhat pedestrian portrait of the Belfast shipowner Robert Langtry (Fig. 18), he was able, nevertheless, to capture likenesses sufficiently accurately to satisfy the town's middling and upper ranks.[58] Amongst his numerous sitters were the Marchioness of Donegall, Sir James Emerson Tennent and Joseph Stevenson, secretary of the Academical Institution. He first came to notice in 1824, when a copy he painted of *St Catherine of Alexandria*, after Federico Barocci, was exhibited in the coffee room of the Commercial Buildings and was greatly praised in the local press.[59] During the 1820s he lived in London but returned to Belfast by 1831.[60]

In that year he accepted what seemed to be a prestigious commission: to paint a portrait of William IV for the Academical Institution.[61] Unfortunately, the undertaking brought him instead considerable anxiety and embarrassment. The project had originated with the Earl of Belfast and was intended to commemorate the changing of the school's name to 'Royal Belfast Academical Institution' in December 1831, by permission of the king. With royal consent, Hawksett was allowed to copy the best of the king's portraits and accordingly, paid two visits to London for the purpose. Unfortunately, the painting, completed by 1835 and described as 'a successful imitation of

Lawrence', became the subject of a pro-
tracted dispute.[62] Unknown to Hawksett,
it had been decided that the portrait was
to be paid for by subscriptions from board
members and others, and not officially by
the school. However, the amount raised
by this means and given to him in Febru-
ary 1836 came to only £29 – whereas, in
fact, his bill had been £100.

Later that year and again in 1838,
Hawksett pleaded with the board to
settle the account, only to be informed
eventually that this was not possible,
as the commission had been given 'by
several Individuals in their private
capacity' and not officially by the board.
An attempt in late August 1838 to collect
additional subscriptions failed to raise
the outstanding £71. Further efforts were
made in 1841 and 1842 but these also
failed. Thereafter, the issue of the portrait
disappeared from the board's records. It
seems likely that Hawksett reclaimed the
painting in lieu of payment, as a notice in
the *Northern Whig* of 10 June 1859 stated
that the picture was to be raffled on 18

**18** Samuel Hawksett
*Robert Langtry (d. 1859)*
(c. 1843)
Hawksett showed this
portrait in the Belfast Fine
Arts Society exhibition of
1843.

July following, for the benefit of his widow. Its location is unknown.

The episode is an example of the uncertainties of a career in art in
the early nineteenth century. Hawksett, perhaps a trifle gullible and
obviously without a written contract, ended up considerably out of
pocket because of the time spent on the painting and the cost of his
trips to London. As for the Institution, it was deprived of an allegedly
fine portrait in consequence of its bureaucratic attitude. That the school
was unwilling to pay the outstanding amount is surprising, given
the celebratory motive of the commission. Perhaps more surprising
is the apparent lack of loyalty to the monarch; expenditure on a
royal portrait was obviously of little moment to the business-minded
members of the board. Notwithstanding this unfortunate incident in
his career, Hawksett remained the foremost portrait painter in town
until the mid-1840s.[63] Thereafter, nothing is known of him until his
death in February 1859.

A notable feature of the first three decades of the century was the
emergence of locally-born artists who chose to specialise in landscape,
particularly scenes of their native Ulster. This phenomenon was

almost certainly related to the increasing wealth of Belfast's expanding middle ranks, who sought attractive views with which to decorate their homes. The first Ulster landscape painter of consequence was Hugh Frazer (fl.1813–61) of Dromore, who was admitted to the drawing school of the Dublin Society in 1812 and first exhibited at the Royal Hibernian Academy in 1826.[64] Until 1834, he lived periodically in Dromore, Belfast and Dublin.

By this time, he had assumed a major role in the art world of the north, not through the work he produced – which was generally uneven in standard – but on account of his attempts to promote the cause of art in Ulster, a pursuit he began in 1826. This aspect of his career deserves particular mention before turning to a discussion of the paintings themselves. His efforts to champion the fine arts in Ireland as a whole commenced in 1825, when he published an essay on painting and on the civilising influence of art on society.[65] In the essay, which he described as a 'feeble effort to forward the culture of the fine arts in my native country', he discussed firstly the chief characteristics of the foremost Old Masters and then directed his attention to art in Ireland.[66] He advised Irish portrait painters and students to look to the English school of painting and, like the leading artists of this latter school, make nature, the Antique and the Old Masters the basis of their art. He stressed to the Irish public that painting was an important branch of human culture and that the advantage of having a national academy – by which he meant the Royal Hibernian Academy, founded in 1823 – was the fact that it created a fixed and high standard of taste, which would eventually influence the works of Irish artists. To those who had little time for the fine arts, he pointed out that art had an important effect on the morals, sentiments and taste of society.

Whether the essay – somewhat rambling and with passages of purple prose – was well received or had any influence on public sentiment, remains unknown. Its more immediate value lies in its uniqueness, in being the only work of the kind known to have been published by a Belfast artist during the period covered by this book. However, the written word was not Frazer's only foray into the field of art appreciation. In 1827, perhaps in an effort to raise the artistic awareness of the lower ranks, he advertised that he was planning to publish a series of lithographs of the scenery of Ireland, at a price 'so moderate as to be within reach of all classes; which, indeed, is the peculiar object and advantage of this work'.[67] When completed, the series would show the differences and variety in the Irish landscape. However, it is not known if the project actually materialised as the lithographs remain untraced.

Frazer's concern for art in Ulster took a practical direction in May

1830, when he applied for the post of drawing master at the Academical Institution in Belfast, a few weeks after Besaucele's resignation.[68] Though living in Dublin at the time, the prospect of a move back to his native province obviously appealed to him. Perhaps he felt he could effect change more speedily than his current habit of publishing letters in the *Northern Whig* on the need for a Belfast Institute of Fine Arts, a course he had begun to pursue in 1826, as discussed below. In his application to the Institution, he detailed at some length the method of instruction to be adopted in the teaching of art. In his view, there were two goals to be aimed for: to render nature accurately and to develop in pupils a sense of artistic taste. Towards these ends, he proposed to give an annual course of lectures on the history of art (to be open also to the public by invitation) and suggested that the school acquire a small collection of casts from the Antique and engravings of works by the Old Masters.[69] With becoming modesty, he added that:

> independent of all personal interest I feel anxious to lend all aid in my power to forward any object which may tend to diffuse sound and discriminating principles of taste among the intelligent youth of the north of Ireland. Distinguished in every other branch of intellectual culture, it must be admitted that in respect to the elegant refinements which a proper cultivation of taste for the Fine Arts brings in its train, the Metropolis of the North is still very backward.[70]

As further proof of his suitability for the post, he referred to his election to associate membership of the Royal Hibernian Academy a few days earlier. Amongst his referees he named Francis Dalzell Finlay, owner of the *Northern Whig* and one of his major patrons, and the Belfast shipbuilder William Ritchie, who has already been referred to in Chapter One. As noted above, however, the position was given to Joseph Molloy.

Dublin was to remain Frazer's base for the next four years, until he eventually settled in Belfast in May 1834, at which point he advertised his services as a teacher of portraiture, historical subjects and landscape in oil, watercolour and chalks.[71] Whilst his reasons for returning can only be guessed at, he may have decided that the time had finally come for him to take positive action regarding the fine arts in Belfast. Perhaps to draw attention to his homecoming, he placed one of his works, a *View of Belfast from the Botanical Gardens*, on display in the news-room of the Commercial Buildings at the same time and raffled it on 19 June following.[72] Its whereabouts remains unknown. Shortly afterwards, he announced his intention of publishing a coloured lithograph of the work, to appear in early

**19** Hugh Frazer
*View of Belfast from the Old Park Hill* (1855)

August and promised free copies to those who had subscribed to the raffle.[73] There are no copies of the print known to exist so the project may never have materialised.

Fortunately, considering Frazer's important position in Belfast's artistic past, there are numerous examples of his work in the locality, in collections such as those of the Belfast Harbour Commissioners and the Ulster Museum. The standard of his known paintings, all landscapes, varies considerably, with most being marred to some extent by weak draughtsmanship and a lack of atmosphere and light. Despite such faults, however, his works remain valuable topographical records of Belfast and the north of Ireland in the first half of the nineteenth century. *View of Belfast from the Old Park Hill* (1855) (Fig. 19) is typical of his style, in being somewhat crudely painted and with little evidence of the effects of light and shade. Nevertheless, the scene itself is a striking one, with its contrast between fertile countryside and the tall chimneys of an advancing industrialization. Of much greater merit is his *View of Waringstown* (1849) (Plate 8), with its uncharacteristic depiction of sunlight, atmosphere and lively use of colour. The painting, the best of his known works, shows him to have been more talented than generally supposed.

Frazer's chief competitor in landscape painting was the water-colourist Andrew Nicholl (1804–86). Born in Belfast, of humble origins and probably self-taught, he was apprenticed as a compositor to the Belfast printer Francis Dalzell Finlay in 1822 and worked for Finlay's newspaper, the *Northern Whig*, from 1824 until c.1830.[74] Despite the demands of his trade, he managed to pursue his chief interests of drawing and painting in his spare moments. In 1828, whilst still serving his time, he produced his earliest known series of watercolours, 101 views of the Antrim Coast.[75] The MacDonnell family, Earls of Antrim, may have been involved in some way with this ambitious project, for one of Nicholl's early patrons, Dr James MacDonnell, was also a clansman of the Antrims. Stylistically, the main impression of these early works, with their use of hard outline and flat washes of colour, is an attractive naivety and freshness. *West View of the Giant's Causeway from the Stookans* (c.1828) (Fig. 20) epitomises these qualities. In April 1829, in what was undoubtedly a gesture of support from Finlay, the *Northern Whig* paid particular praise to the series and to Nicholl's talents, describing him – prophetically – as 'an artist of great promise'.[76] (By this point, the paper had become a staunch advocate for the improvement of the fine arts in Belfast.)

**20** Andrew Nicholl
*West View of the Giant's Causeway from the Stookans* (c. 1828)

In 1830 Nicholl went to London, probably taken by his major patron James Emerson, later Sir James Emerson Tennent.[77] There he studied in the Dulwich College gallery, at that time the only collection of Old Master paintings open to the public. Amongst the artists whose works he copied and whose styles he absorbed were Aelbert Cuyp, Antony Vandyke Copley Fielding, Peter de Wint and Turner. The result of this experience was a complete transformation of his style. Thereafter, he began to handle paint more freely and displayed a greater interest in the depiction of sunlight and atmosphere. He also ceased to use pencil outlines for definition. *Belfast from Newtownbreda Churchyard* (Plate 9), its blue distant hills and foreground trees recalling the Italianate landscapes of Turner, is typical of this more mature work. Another development during the 1830s – and the most strikingly original in his entire output – were his bank of flower paintings such as *Bray and the Valley of the Dargle from Killiney Hill, Co. Dublin* (after 1835) (Plate 10). Vivid-toned and painstakingly detailed, these works have an almost surreal quality, due to the irrational difference in scale between the foreground flowers and the background scenes. Anne Crookshank and the Knight of Glin, in *The Watercolours of Ireland*, describe them as being amongst the most memorable and beautiful watercolours the country has ever produced.[78]

Nicholl's first London visit was relatively brief, as he was back in Belfast by June of the same year (1830).[79] On his return, he advertised his services as a teacher of watercolour painting and showed a few of his works to acclaim in the news-room of the Commercial Buildings. Around this time, he established a pattern which was to become a feature of his career until the mid-1860s, namely, spending the first six months of each year in London and the remainder in the north of Ireland, generally teaching in Belfast and sometimes in Ballycastle, Coleraine and Derry.[80] He also spent occasional periods in Dublin.[81] The early 1830s saw his breakthrough into the print market. Amongst the publications for which he produced scenes were *Five Views of the Dublin and Kingstown Railway* (1834), *Fourteen Views in the County of Wicklow, from Original Drawings by H. O'Neill and A. Nicholl* (1835) and *Hall's Ireland*. For this latter commission, he supplied the authors, Mr and Mrs S.C. Hall, with over one hundred drawings and archaeological information between 1834 and 1840. Such publications obviously helped make his art known to a wide audience. What with his willingness to travel, teach and work for the print trade, Nicholl – even at this early stage of his career – displayed the pragmatism and adaptability which was to make him *the* landscape painter of Belfast during the course of the next fifty years. More will be heard of him in subsequent chapters.

The third landscape painter to emerge during these years was

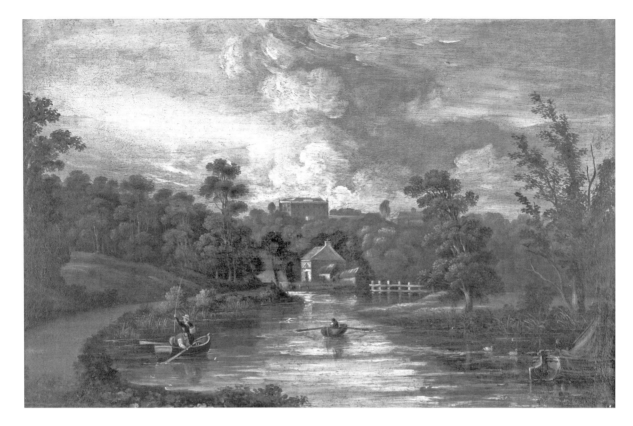

Joseph Molloy (1798–1877), the least well known of the group of local artists discussed here, largely because most of his time was devoted to teaching.[82] Little is known of his early life except that he was educated at the Academical Institution and was giving private drawing lessons in Belfast in 1827.[83] His formal teaching career, which commenced at that time and lasted for forty-three years, centred upon the town's two foremost schools: Belfast Academy from 1827 until about 1867 and the Academical Institution from 1830 until 1870.[84] Despite the mystery of his early years, his reputation as a landscapist was sufficiently established by 1828 to warrant his involvement in an important publishing venture, E.K. Proctor's *Belfast Scenery in Thirty Views*, a volume of illustrations of seats of the nobility and gentry in the neighbourhood.[85] Molloy painted the views in sepia wash, after which Proctor etched and aquatinted the series in London.[86] *Belvoir – Seat of Sir Robert Bateson, Bt, MP* (1830) (Fig. 21) is an example of Molloy's original watercolours for the book. To raise subscriptions towards the cost of the volume, described as 'the first Work of the kind ever offered for the support of the spirit and liberality of Belfast', one of Proctor's etchings was placed on display in the news-room of the Commercial Buildings in July 1828.[87] The success of this marketing

**21** Joseph Molloy
*Belvoir – Seat of Sir Robert Bateson, Bt, MP* (1830)

29

strategy remains unknown; however, the fact that the book did not appear until 1832 suggests that the project may have run into financial difficulties or that the Belfast nobility and gentry did not support it as they should have done.

Besides his watercolours for Proctor, there are only three other known paintings by Molloy: two seascapes and a portrait, each oil on canvas and owned by the Ulster Museum. More so than his watercolours, these works, of which *Tilbury Fort, River Thames* (Plate 11) is one, show him to have been skilled at creating atmosphere and depth by a fresh and spontaneous brushwork and delicate use of colour. Molloy's was a quiet talent, which remained in the background of the local art world; indeed, the scarcity of his paintings is reflective of this. Perhaps not surprisingly, the lack of forwardness in his career seems to accord with the architect Robert Young's description of him at Belfast Academy in the 1830s as 'a little, intelligent, unassuming modest man and as different to the present day school of art trained teacher as one could imagine both in personal learning and method of instruction. He never posed as the art critic or gave expression to opinion injurious to others, but contented himself with showing you the way he went about landscape work.'[88]

## TOWARDS AN INSTITUTE OF FINE ARTS

As indicated by the spread of drawing schools and the emergence of local painters, art was on a sound footing in Belfast by the early 1830s. Furthermore, that its importance to the community had been recognised is evident from the columns of the *Northern Whig*. There, between 1826 and 1833, the issue as to how the fine arts could best be encouraged in the town came to be heard more and more often. The subject was first raised by the paper's owner, Francis Dalzell Finlay – perhaps on the prompting of Hugh Frazer – in an editorial on 12 January 1826. The immediate inspiration for the piece was the proposed erection of a building for the town's Anacreontic Society (a music society), although the construction and imminent opening of the Royal Hibernian Academy's new premises in Dublin may also have played a part.[89] In the article, Finlay praised the Belfast venture, which was to contain a ballroom and rooms for Anacreontic Society meetings, but urged the inclusion of another amenity which had been overlooked in the town so far – a gallery for the encouragement, improvement and exhibition of the works of Belfast's artists.

In his argument for the establishment of a gallery, Finlay pointed out that there were art galleries or churches decorated with works of art in almost every town in Italy and that the visual stimulation derived from these helped produce an artist in nearly every village

in the country. France, Germany and Holland also had galleries to encourage the arts. Even in Britain, which had lagged behind in the provision of such amenities, there were exhibitions organised to help advance British art and artists, such as those of the Royal Academy at Somerset House.[90] Had Belfast a gallery, where copies and casts of famous works could be seen and where students could study and exhibit, the end result would be a rise in artistic awareness and a fostering of talent in the north of Ireland. It had been suggested (by whom he did not say) that Belfast was too small to support such an institution; also, that the cost of setting it up would be considerable and that its usefulness would be limited by its proximity to art collections in Dublin and London. Refuting these claims, Finlay argued that the size of the town was irrelevant to its artistic pursuits and pointed out that a few hundred pounds would be sufficient to purchase a collection of copies and casts. As regards the gallery's utility, its location in Belfast would enable those who could ill afford to study in Dublin or London to pursue their artistic training at home. He concluded by suggesting that a room be set aside in the Anacreontic Society's proposed new building for use as a fine art institution. However, the idea was wishful thinking on Finlay's part for, when the building finally opened in 1840, it was to contain no such amenity.[91]

A few months after Finlay's editorial, Frazer launched his crusade on behalf of art in Ulster. In a lengthy article in the *Northern Whig* of 26 March (1826), he praised the newspaper for its support of the fine arts and offered advice, drawn from his own experience, on the establishment of an art institution. The main object of such a venture, he believed, was to improve public taste through lectures on the theory and principles of the fine arts. The secondary aim was to train future generations of artists, by including a teaching department within the institution. A building should be fitted up, to encompass a gallery, teaching area, a drawing and painting room and an apartment for an assistant teacher, who would live on the premises. The gallery should contain copies and casts of famous works and be open to the public. When the work of local artists had improved sufficiently, annual exhibitions could be held. Profits arising from these displays and from art classes for the public could then be used to buy copies and models for the students. The setting up and running of the institution should be left to a committee composed of managers and visitors.

The first step in the founding of this 'Belfast Institute of Fine Arts', as Frazer called it, should be the appointment of a professor of painting, who would be responsible for selecting the assistant teacher. Having given so much thought to the scheme, it seems likely that Frazer envisaged himself in the professorial role. Belfast, he believed, needed a fine art institution for, although the town had

flourished commercially, such success did not breed culture and refinement – only support of the arts could bring this about. Whilst it was unfortunate that there were no collections of Old Masters in the locality, the situation could, in fact, be advantageous to young artists in that it would encourage them to study 'the fresh beauties of actual nature' and not be influenced by outdated examples and ideas. In short, Belfast was untilled but fertile soil for the implanting of principles of good taste.

The theme of a fine art institute for Belfast was one to which Frazer was to return a number of times over the next ten years or so. In 1828, a lengthy article in the *Northern Whig* of 18 December – though signed only as by 'H' – certainly bears his stamp. The piece was perhaps written at this particular point because of William Paulet Carey's art lectures of a few months earlier, already referred to above. The author began by stating that whilst a taste for the fine arts had been gradually growing in Belfast, the level of patronage accorded to them was much less than in other British towns of a similar size. In point of fact, demand for paintings, engravings, sculpture and elegant architecture had arisen in the north only recently. However, the situation was gradually improving, particularly in Belfast; there, a number of fine new buildings had been erected and people had begun to collect works of art of various kinds.[92] That Dublin, Liverpool, Glasgow and Cork had institutes to promote the arts and Belfast had not, seemed inexplicable.[93] He placed the blame for this shortcoming squarely on the town's resident artists; it was up to them to establish an institution. As a further suggestion, he called upon Belfast's artistic community to form a properly organised body for the holding of annual exhibitions. Such efforts, he predicted, would be assisted 'by the rank, wealth and liberal spirit' of the north.

Whether Frazer was the author of the piece, the similarity of the ideas to the proposals he was to make over the next eight years, until 1836, renders it highly likely. That the subject was one which continued to engross him deeply is evident from his next known article on the theme, published in the *Northern Whig* in September 1833.[94] Stating that he had spent a number of years preparing himself to run an Institute of Fine Arts, he outlined his plan for Belfast. His proposal was both business-like and practical. He suggested that a house or suite of rooms be rented for a trial period of two years, for the teaching of drawing, painting and modelling and for the history and theory of the fine arts. Annual courses of lectures at a popular level and open to the public would also be part of the curriculum. Given the experimental nature of the venture, his plan was relatively modest: there should be only fifty shareholders, with shares set at £5 each. The £250 capital raised would be used to fit up rooms and purchase books

and art materials for the students.[95] The principal was to be employed on a two-yearly contract, renewable by a majority vote by the shareholders and was to be paid out of the pupils' fees. He was to have the choosing of the assistant teachers and deal with their salaries. Fine details such as the institute's opening hours were also included in the plan.

Frazer ended the article on an optimistic note. Were a building 'worthy … of the liberal spirit of Belfast' to be erected, its sculpture gallery could be adapted to house annual displays and sales of the works of British artists. The profits from

these events could then be used to promote local talent. He concluded by stating that when he had obtained the fifty shareholders, he would organise a meeting to discuss the project. However, no record of such a gathering has been found in the press, nor did the institute materialise. The reason for this is unknown; one can only surmise that lack of support by Belfast's art lovers was the primary cause.

Frazer's idea for an Institute of Fine Arts probably owed its inspiration to two societies flourishing in Dublin: the Royal Irish Institution and the Royal Hibernian Academy. The former had been founded in 1813.[96] Aimed at promoting the fine arts in Ireland, its objective was to hold exhibitions of Old Master paintings, in order to encourage native talent and raise support for resident artists.[97] The Institution held eight exhibitions in Dublin between 1814 and 1832, initially at the Dublin Society's house in Hawkins Street and, from 1829, at the Institution's new gallery in College Street (Fig. 22). These displays of Old Masters owned by the Irish nobility, gentry and wealthy were the earliest loan exhibitions held in Ireland. The Institution made a considerable impact on art in the country, as the success of its first exhibition led to the founding of the Cork Society for Promoting the Fine Arts in 1816.[98]

The Royal Hibernian Academy, however, was probably the real model for Frazer's proposed institute, being closer in type than the Royal Irish Institution. The oldest established art institute in the British Isles after the Royal Academy in London, it had been founded in 1823 with the object of staging annual exhibitions and providing tuition for young artists.[99] The desire by Irish artists to exhibit in annual exhibitions had grown steadily since the Act of Union of 1800, when a number of important patrons left Dublin and, as a result, the buying and commissioning of art received a setback.[100] A number of

**22** An exhibition at the Royal Irish Institution's gallery in College Street, Dublin (c. 1829–32). The Institution's exhibitions of Old Masters, of which there were eight in Dublin between 1814 and 1832, were the earliest loan exhibitions in Ireland.

**23** Pompeo Batoni
*Portrait of Wills Hill, Earl of Hillsborough, later 1st Marquess of Downshire (1718–93) (1766)*

exhibitions had been held between 1809 and 1817 and again in 1819 but the artists depended upon the Dublin Society for rooms. By the latter year their need to organise formally as a body and found a national academy had become paramount, as had the necessity for premises of their own, for exhibition and teaching purposes. The Academy's inaugural exhibition was held in 1826 in premises erected in Abbey Street by its president, the eminent Irish architect Francis Johnston, at his own expense.[101] Included in the building were exhibition rooms, drawing schools, a council room and apartments for the keeper. In 1830 Johnston's widow purchased ground adjacent to the building and erected a sculpture gallery, this time at her expense. Various persons also donated Old Master drawings, prints and books. By the early 1830s, therefore, the Academy school was well equipped to fulfil its teaching functions.

The Academy was quickly seized upon by a number of Belfast artists as an exhibiting platform. Hawksett and Frazer showed on several occasions from 1826 and Nicholl from 1832. The latter two became academicians in time, Frazer in 1837 and Nicholl in 1860. It is worth speculating that Frazer's involvement with the Academy may indeed have fuelled his ambitions for Belfast; seeing Dublin's example may possibly have encouraged him to draw up his proposal of 1833. Regrettably for Belfast, there was no local equivalent of Francis Johnston to erect an institute nor patrons interested enough to band together to rent rooms, despite Frazer's urging. Nevertheless, the latter remained determined to push ahead with some kind of artistic forum for the town, as the following chapter will show.

As noted in the previous section, Frazer settled in Belfast in May 1834 and resumed his championship of art in the locality by publishing a series of articles in the *Northern Whig* between May and October, entitled 'Retrospect, present condition, and prospects of Irish art'. Rambling and somewhat flowery, as were all his writings, the aim of the essays (four of which have been located) was to help the public

reach a better appreciation of Irish art.[102] The first two articles dealt with the monastic art of early Christian Ireland and the eventual emergence of Irish artists in the eighteenth century, notably with such as William Ashford, Hugh Douglas Hamilton, Thomas Sautell Roberts and Robert West. The third article, probably the most interesting in the light it sheds on Frazer himself, focused upon the unhappy social position of the Irish artist, who was considered 'an unproductive member of the social hive' by the 'artificer and trader' and intellectually inferior by the learned professions. However, whilst there may have been instances of artists being extravagant or wayward, the piece concluded that painters and sculptors were generally of a temperate and studious disposition and that 'a considerable degree of mental cultivation' was necessary for their calling. (In this boosting of the artistic profession, one is tempted to see Frazer keen to portray himself as cultivated and learned, a fitting leader of culture and the arts in Belfast.) The piece ended with a tribute to the Dublin Society schools and to the Royal Irish Institution. The fourth article continued the discussion of painting in Ireland and dealt with the work and influence of the Royal Hibernian Academy.

The *Northern Whig*'s extensive coverage of these articles on Irish art history, together with Frazer's earlier proposals for an art institute, reveal the extent to which the paper's owner, Francis Dalzell Finlay and Frazer were keen to promote the fine arts in Belfast. Furthermore, the articles indicate that Frazer still felt a missionary zeal to raise artistic awareness in the community, despite the collapse of his art institute scheme of September 1833. However, besides his desire to see art on a firmer footing in Belfast, he seems to have been motivated by another factor, namely, strong feelings for the north, as his writings are imbued with sentiments of northern patriotism, of a belief in the value of Belfast and the north as distinct cultural centres, at a remove from Dublin and the rest of Ireland.

## ART IN THE LOCALITY

Although information on paintings in local collections is scanty, it is nevertheless possible to gain some idea of the contents of a few grand houses in the vicinity from estate records. Around 1810, Hillsborough Castle, seat of the Hill family, Marquesses of Downshire, contained mostly Hill family portraits, together with a few assorted works including a landscape and an interior.[103] Though almost none of the artists can be identified, picture number eleven in the house contents' inventory is known to have been a full-length portrait of Wills Hill, Earl of Hillsborough and later 1st Marquess of Downshire, by the Italian portrait painter Pompeo Batoni (1708–87) (Fig. 23), formerly

**24** Francis Holl, after
Charles Brocky
*Sir Robert Bateson, Bt*
*(1780–1863)*
Bateson had an impressive
collection of art, including
works by the Old Masters,
at his mansion at Belvoir
Park.

on loan to the Ulster Museum. A splendid example of Batoni's *oeuvre* and drawing on Antique references, the painting shows the widowed earl lamenting over a portrait of his deceased wife in a touching display of marital love and fidelity. Another important residence in the district, Mountstewart, home of the Marquess of Londonderry, contained over ninety pictures in 1821, most of which appear to have been engravings, together with thirteen busts and a statue of a figure.[104] Regrettably, details of the works are vague and, again, there are no facts given regarding the various painters and sculptors represented.

Whilst inventories of the contents of grand houses can sometimes provide information on the works of art owned by the leading families concerned, details of paintings in middle-class homes are often lost to history. In view of this latter situation, a number of articles in the *Belfast News-Letter* of 1828 by a visiting art critic called Mariette are of particular interest, as they contained references to paintings which he saw in houses in the centre of town.[105] His first introduction to the Belfast public came in the newspaper's issue of 5 August, which published his review of the recently-closed Royal Hibernian Academy exhibition in Dublin. He followed this up by further reviews of the show in August and then in September, published a lengthy piece on the Royal Irish Institution and on the beneficial effect which it had had on art in Cork.[106] About the same time he also turned his attention to Belfast and between late August and December, issued a series of articles on local artists, details of whom he obtained by visiting people's homes and inspecting their collections.[107] Unfortunately, he supplied almost no details of those he called upon and simply stated that he had visited homes in Arthur Street and Donegall Place. Amongst the paintings he saw, there and elsewhere, was a self-portrait by James Atkins and works by Samuel Hawksett, Joseph Molloy, Andrew Nicholl and the brothers J. and Robert Warrington (about whom very little is known). The pictures he viewed – and the apparent support given to local artists by the various owners – seem to have impressed him considerably. In his opinion, 'The public taste and feeling for the Fine Arts, which have increased, are increasing and will … continue to spread and flourish in Belfast, have brought forth excellent fruit.'[108]

Besides visiting various homes of the middle ranks, he also called at Belvoir Park, the imposing mansion of Sir Robert Bateson, situated on the outskirts of town, in the picturesque Lagan valley (Figs. 21 and 24). The observations he made there are particularly valuable as no inventory of Belvoir's contents has been found dating from as early as the 1820s.[109] According to his reports, the house contained an impressive collection of art at this time. There were, apparently, a number of

works by Old Masters such as Sebastian Bourdon, Antonio Cavallucci, Guido Reni and Giovanni Franceso Romanelli.[110] There were also four portraits by Sir Thomas Lawrence, two by Robert Home and various other unspecified works by British and Irish artists.[111] Amongst paintings by the latter were two now in the collection of the Ulster Museum: Strickland Lowry's portrait of the family of Thomas Bateson (Plate 1) and *The Patron, or the Festival of St Kevin at the Seven Churches, Glendalough* (1813), by Joseph Peacock (c.1783-1837) (Plate 12), a work full of fascinating details of scenes of everyday life, despite the devotional sentiments of its title.[112] Judging by the enthusiastic tone of Mariette's comments, Bateson's collection seems to have impressed him considerably.

The viewing of paintings in the homes of the upper ranks and gentry, such as those mentioned above, would have been restricted to family friends, acquaintances, connoisseurs and art critics like Mariette. However, the wider public had also the chance to see works of art from time to time. Probably the most noteworthy painting on public display in the town during these years was a portrait of Napoleon, by the French artist Robert Lefèvre (1755–1830) (Fig. 25).[113] Exhibited at a ballroom in Telfair's Entry during September and October 1816, the picture had apparently been shown in Paris, London and Edinburgh and, after Belfast, was destined for Dublin.[114] At the commencement of the show, the admission charge was one shilling and eight pence, an amount which must have limited visitors to the wealthier classes. Towards the closing date, the cost was reduced to ten pence, probably to attract a wider audience. The portrait, a striking and well-executed work, showed Napoleon resplendent in his general's uniform. Lefèvre is known to have painted a number of versions of the picture, in a variety of formats. According to a visitor's account, the work exhibited in Belfast was full-length and portrayed the emperor standing in a sculpture gallery.[115] Although there is no record of visitor numbers in the local press, the painting probably

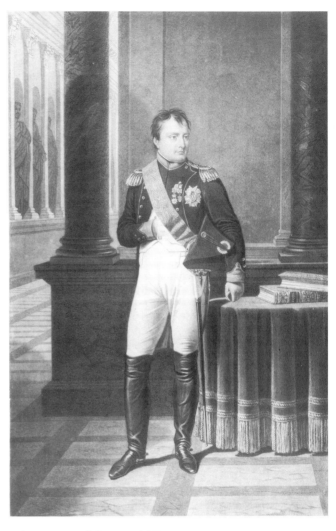

**25** Thomas Lupton, after Robert Lefèvre *Napoleon Bonaparte (1769–1821)* (c. 1812) Lefèvre's painting from which this engraving was taken, was exhibited in Belfast during September and October 1816.

**26** James Thom
*Tam O'Shanter and Souter Johnny* (1828)
These sculptures of Robert Burns' popular characters were on display in Belfast during April and May 1831.

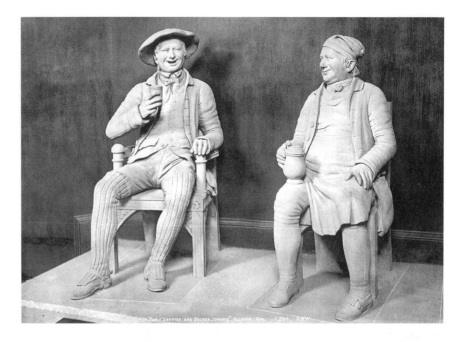

attracted a large audience, curious to see an image of Napoleon in this, the year after his final defeat at Waterloo. It seems reasonable to assume that the owner of the picture raised a considerable amount from exhibition charges, given the topicality of the subject.

A more popular form of art than easel paintings, the entertainment known as the panorama (see Chapter One) was also to be seen occasionally. During September and October 1824 there were two rival panoramas competing for business in town: Barker, Sinclair and Co.'s *Waterloo* and another of the same subject, owned by Messrs Marshall.[116] The former was exhibited in the Commercial Buildings, whilst Marshall's was housed in a specially erected pavilion in Chichester Street.[117] Others which came thereafter dealt with subjects such as Captain Parry searching for the North West Passage and the battle of Navarino, topics to engross and entertain an audience.[118] In all, there were seven in town between 1824 and 1835, each trying to be the biggest and the most interesting.[119] Their regular appearance from 1824 and, indeed, throughout the next sixty years, indicates their enduring popularity with the Belfast public.[120]

In contrast to the flamboyance of these various panoramas was the display, during April and May 1831, of two figures by the self-taught Scottish sculptor, James Thom (?1802–50): *Tam O'Shanter* and *Souter Johnny* (Fig. 26).[121] The exhibition of these popular characters from a poem by Robert Burns was held at 1, Castle Place, the admission charge being one shilling. Though somewhat crude as works of art, certainly to sophisticated modern-day audiences, their homespun

appeal attracted great praise during the late 1820s and early 1830s. Their Belfast showing appears to have been the last in a tour which took in Edinburgh, Glasgow and London in 1829 and a number of other venues thereafter.[122] According to press reports, they had been seen by over 80,000 people, including the king and queen, during their exhibition in London.[123] It seems likely that their Belfast display also attracted large attendances, given the considerable popularity of Burns in the north of Ireland.[124] Since 1933 the figures have been exhibited at the Burns monument in Ayr.[125]

## BEGINNINGS OF THE ART TRADE

Besides the above-mentioned exhibitions and panoramas, the public could see a wide variety of art in commercial outlets like printsellers' shops and auction rooms. These years between 1811 and 1835 saw the beginning of the art trade in Belfast, a trend which reflected the rising prosperity and aspirations of the town's middle ranks and their growing desire for refinement and culture. Whilst art sales had occasionally been held between 1760 and 1810, they had been few in number.[126] Now, however, there was a great upsurge in trade, as dealers from London, Dublin, Glasgow and elsewhere began to pay regular visits with collections of paintings and engravings. Amongst these was a Mr Cave of London, who operated from the Commercial Buildings in May 1825, and a Mr Barker of London and Dublin, who came in January 1826 and returned in February 1828, selling his works from shops in Donegall Street and High Street.[127] Others included James Dowling Herbert, an artist turned dealer, who visited in 1811, 1813, 1815 and 1823, L. Witt, who came in 1825, and C. Fleming, in 1831.[128] Most dealt in oils and engravings though a few traded solely in the latter.

A locally-generated art market also began to develop. Of the few Belfast auction houses in existence, that of Hyndman increased its volume of business considerably from the late 1820s, and by the mid-1830s had become the main auctioneer in town, with an extensive trade in Old Master and contemporary oils and engravings.[129] Printsellers, too, now became a more important part of the local art world. By 1835, John and Robert Hodgson, booksellers and stationers of High Street since at least 1818, had become agents for a number of London print publishing concerns including the well-known firm of Rudolph Ackermann.[130] During the next few years, the Hodgsons were to play a leading role in the expansion of the art market in Belfast, as will be discussed in the following chapter. Printsellers occasionally turned dealer. In 1835 Robert Gaffikin, in business as a carver, gilder, printseller and publisher since 1832, exhibited twelve oil paintings

and watercolours by the celebrated Irish landscape painter James Arthur O'Connor (1792–1841), which the artist had forwarded for sale in Belfast, through an unnamed local gentleman.[131] One can only speculate that O'Connor had heard that Belfast was a good place to sell. From these and other instances, it is evident that commercial activity in the fine arts was in a flourishing state in town and on the increase.

As is clear from this discussion of events, the years between 1811 and 1835 saw the consolidation of the fine arts in Belfast. The teaching of drawing and painting was in greater demand than ever before, a number of local artists were practising in the community, efforts were being made by a few key figures, notably Francis Dalzell Finlay and Hugh Frazer, to improve the position of the fine arts in the north and there was a considerable growth in the art trade, by both local and visiting dealers. Such activity indicates a greater awareness of the value of art by the middling and wealthier ranks, with children to educate in the finer things of life and surplus money to spend on paintings and other luxuries.

Nevertheless, behind this positive facade, matters augured less well for the future. Whilst a few fortunate artists like Atkins, Frazer and Nicholl received encouragement from patrons such as Narcissus Batt and Francis Dalzell Finlay, such benevolence was the exception rather than the rule. General support for the actual promotion of the fine arts was poor, as shown, for example, by the failure of Frazer's carefully considered and straightforward plan of 1833 to use rented accommodation for his proposed Institute of Fine Arts. Those with means preferred to devote their energies to the building up of their collections and cared little for the artistic welfare of the town. It was this latter trend that Frazer sought to reverse during the course of the next few years. The founding of the Belfast Association of Artists in 1836 – almost certainly his brainchild – called yet again upon the wealthier ranks to play a part in the town's artistic development.

# ～ 3 ～

# The failure of exhibiting societies

## 1836–48

*'Belfast is not yet prepared for maintaining a local art union'*[1]

### THE BELFAST ASSOCIATION OF ARTISTS 1836–38

The establishment of the Belfast Association of Artists in 1836 was the first of a number of attempts to found a successful and permanent art society in the town, to institutionalise the fine arts and give them direction and impetus. At the beginning of the century, only London and Dublin, within the whole of the British Isles, had such bodies.[2] By the 1830s, however, numerous societies and institutions for the encouragement of the fine arts had been established in towns and cities throughout Britain and Ireland. Cork had had a Society for Promoting the Fine Arts since 1816.[3] Centres of industry such as Birmingham, Liverpool and Manchester had similar facilities. The former had two societies by 1836: the Birmingham Academy of Arts, founded in 1814 and which held its first exhibition in the same year and the Birmingham Society of Arts, established in 1821.[4] This latter had its first show in 1827. In Liverpool the Liverpool Academy, founded in 1810, held its first exhibition in the same year, whilst the Associated Artists of Manchester, formed in 1823, put on their first show in 1827.[5] Norwich, Leeds and Bristol inaugurated annual exhibitions in 1805, 1809 and 1824 respectively.[6] Edinburgh and Glasgow also had institutions and societies, Edinburgh by 1808 and Glasgow by 1821.[7] Belfast's efforts to found an art society were thus in line with the trend of the times.

Reasons for this spread of art societies and institutions were

41

varied.[8] One of the principal factors was the close relationship between commerce and the fine arts.[9] Imaginative design and attractive decoration made goods more appealing, which in turn increased their saleability. In industrial centres such as Birmingham, commerce and the arts were strongly interlinked. The promoters of the Birmingham Society of Arts stated in 1821 that 'The due cultivation of the Fine Arts is essential to the Prosperity of the Manufactures of this Town and Neighbourhood.'[10] By the 1820s British goods faced a serious threat from Continental competition, a situation eloquently summed up by the journalist and art critic William Paulet Carey (see Fig. 14) in 1829: 'The Artists, Artisans and Manufacturers of France, Italy, Switzerland, Germany, and Holland are incessantly straining every nerve to rival the British in every foreign market, and to deprive this country of a portion of her commerce and profits.'[11] Art societies were partly a response to this problem. There were, nevertheless, other reasons for their proliferation besides commercial considerations, such as their use as exhibition platforms by artists and their role as teaching forums and social clubs.[12] Also important was their value as instruments to help raise taste and exert a moral and civilising influence on society at large. These latter concerns were chiefly those of the nobility and gentry, the main founders of most of the societies and institutions. The artists themselves were generally more interested in practical issues such as selling their works and receiving recognition for their efforts.

The Belfast Association of Artists was founded on 23 April 1836, at a meeting of resident artists held in the Temperance Hotel.[13] The idea for the Association almost certainly belonged to Hugh Frazer, who had been advocating the establishment of a fine art institute and annual exhibitions since 1826. The gathering, chaired by Frazer, passed a number of resolutions, the principal one being to hold an exhibition during the following August. Newspaper coverage of the meeting stressed the disadvantages under which the town laboured as regards the fine arts – 'We believe Belfast is the only town, of equal wealth and population in the United Kingdom, in which there is not an annual exhibition of works of art' – and cited cities in Britain and Ireland in which there was.[14] The paper's report ended with the query – was Belfast prepared to lag behind these places in the fostering of native talent – and expressed optimism concerning the outcome of the venture. A committee, comprising mostly well-known local artists, was appointed five days later, at another meeting in the same place.[15] Frazer became president, Nicholas Joseph Crowley, a visiting painter, secretary and Samuel Hawksett treasurer. Crowley, Hawksett, Joseph Molloy, Andrew Nicholl and Robert Warrington made up the management committee. Shortly thereafter, the Belfast

Natural History Society made available the lecture hall of its museum in College Square North as exhibition premises (Fig. 11).[16]

The Association's main objectives, as stated in the exhibition catalogue, were the promotion of the fine arts in the north of Ireland and the founding of an Institution of Fine Arts in Belfast.[17] The establishment was to contain an exhibition room, a collection of casts, 'standard works of painting' (presumably copies of famous pictures) and a library, the whole to form a school where annual lectures on the principles of painting could be given. Surplus proceeds from the exhibition were to go towards the institution. Realising that it would be unable to bring the building scheme about itself, the Association appealed to subscribers for financial assistance. If its efforts were successful and an institution erected, the Association wished to be in charge of it, as 'non-professional interference, in the direction of institutions of a similar kind, has, in all cases, been found to be rather injurious … to the great object of forwarding the interests of Art'.[18] Other than in matters of management, however, the Association would seek to comply with whatever the subscribers wished. As for the exhibition, the Association viewed it as an experiment, a means to gauge the extent of public support for an annual exhibition and for this particular manner of promoting local art.

The exhibition, admission to which was one shilling, ran from early September until mid-October and contained 218 works, the majority of which were by local artists.[19] There were fifteen paintings by the late James Atkins, comprising portraits, animal subjects and landscapes. Samuel Hawksett was well represented with twenty-four portraits, one of which was his ill-starred painting of William IV for the Royal Belfast Academical Institution, discussed in Chapter Two. Hugh Frazer contributed twenty-five works, all but three of which were landscapes, the others being two subject pictures and a portrait. Andrew Nicholl showed nineteen landscapes and his brother William, a gifted amateur, twelve. Other local contributors included Gaetano Fabbrini and Joseph Molloy. Roughly 90 per cent of the works on display were portraits and landscapes, with the remainder consisting of fruit, flower and game pieces and history and subject pictures. These latter two genres were the least well represented. One of the most interesting exhibits, considered in retrospect, was a design for the hoped-for institution by John Miller, a local architect. His drawing, one of a series for 'the proposed Ulster Gallery of Fine Art', showed 'the interior of the Public Entrance Hall, and Statue Vestibule leading to the Staircase of Antique Sculpture'.[20] Unfortunately, none of the designs can be located.[21] Of non-resident artists who contributed, the best known was the Irish landscape painter James Arthur O'Connor, who sent eleven works from London.

Although the exhibition appears to have been well received, only one painting had been sold by the end of September, a situation deplored by the *Northern Whig*, which complained:

> we would ask, and ask seriously, can the people of Belfast expect another exhibition, unless some of the present works meet with purchasers? We say, decidedly, they never ought ... Is this honourable to the taste and the liberality of the town? ... Edinburgh, Glasgow, Liverpool, Manchester, Birmingham, Bristol, Dublin, and Cork, have their annual exhibitions. – Will Belfast, rising, wealthy Belfast, be behind these places in encouraging the arts?[22]

This impassioned plea seems to have pricked a few consciences for, two days later, the same newspaper reported that a number of local gentlemen had arranged a lottery of ten of the choicest works in the show.[23] Of the group, four were landscapes by Frazer, four were local scenes by Andrew Nicholl and the other two were subject pictures by Nicholas Joseph Crowley and Arthur Joy. Of the 260 lottery tickets issued at ten shillings and six pence each, most were sold before the draw on 10 October.[24] None of the local newspapers contain details of the result of the ballot.

Despite this disappointing response, the Association decided to hold another exhibition the following year.[25] In his foreword to the second exhibition catalogue, Frazer maintained an optimistic front and stated that the first show had been a success in terms of visitor numbers and sales.[26] (He appears to have been overly sanguine on this latter point, as only eleven or so works had actually been disposed of.) However, no profits had accrued from the first exhibition to help with the establishment of the institution and none could be anticipated from future shows, once the practice of paying carriage expenses of works by non-resident artists had been put into effect. 'Hence', he declared:

> it must rest with the wealthy and influential of the lovers of Art, and of those of the enlightened classes who recognise, in the liberal cultivation of Painting, Sculpture and Architecture, an essential element of high civilisation, whether a building, worthy of its rational and refined purposes, and of the general intelligence and public spirit of the Metropolis of the North, is to be realized.

In concluding thus, Frazer acknowledged the futility of the town's resident artists attempting to raise money towards the building. Faced with such a situation, the association thenceforth relinquished its aim of founding an Institution of Fine Arts in the town.

The 1837 exhibition comprised 182 works and continued from early September until late October, again in the museum and with admittance still at one shilling.[27] Frazer remained as president, whilst William Nicholl acted as secretary. As regards the content, over half of the exhibits cannot be identified, as a catalogue cannot be found. However, from press reports, it would seem that the selection was more varied than that of 1836. Local artists included Gaetano Fabbrini, Frazer, Samuel Hawksett and the Nicholl brothers. The most distinguished non-resident Irish contributor was Martin Cregan, president of the Royal Hibernian Academy, whose name undoubtedly lent prestige to the show. A number of English artists also took part, the best known being the marine painter John Wilson Carmichael.[28] An interesting innovation was the inclusion of loans from local owners, in order to make the display more varied. Sir Robert Bateson of Belvoir (Fig. 24) lent portraits of himself and his wife by Sir Thomas Lawrence, whilst James Emerson Tennent contributed sculptures by the rising Belfast-born sculptor Patrick MacDowell. Other lenders included the Marchioness of Donegall, Francis Dalzell Finlay and Francis McCracken.[29]

Shortly after the opening date, the Association decided to hold another lottery, presumably because of the events of the previous year.[30] In this it was wise, as sales were to be almost non-existent yet again. Indeed, three days before the intended closure on 28 October, the *Belfast Commercial Chronicle* reported that only two paintings had been sold – both to the same person – and that the lottery had also been very poorly supported.[31] The exhibition was subsequently kept open for a few more days and the draw deferred until 31 October, to give the public further opportunities to purchase works and tickets.[32] Whether any additional sales were made remains unknown. The lottery, of 480 tickets at ten shillings and six pence each, comprised twenty-three paintings, three-quarters of which were by local artists, a selection probably designed to boost the morale of the town's artistic community, who must have been disheartened by the turn of events.[33] All of the works were won; however, the winners' names are unknown.[34]

Seemingly undaunted by the conspicuous lack of success of its first two exhibitions, the Association held a third, in 1838, again in the museum and with the usual shilling admission charge. Frazer continued as president, James W. Millar was secretary and William Nicholl treasurer. The exhibition, which opened in late September and lasted for a month, contained 208 works.[35] The usual local contributors were represented – Frazer, Hawksett and the Nicholls, amongst others – whilst non-resident Irish artists included Bernard Mulrenin and James Arthur O'Connor. English artists were few:

David Cox and Samuel Prout were the best known of the small band. Unlike the previous year, there were no loans from local owners. The general consensus in the three main local newspapers, namely, the *Belfast Commercial Chronicle, Belfast News-Letter* and *Northern Whig*, was that the exhibition was not as good as in previous years and that it contained too many portraits.[36] The latter, in fact, made up almost a third of the total, with the remainder comprising landscapes, historical and subject pictures and the inevitable fruit and flowers. Oddly, there is little further information on the exhibition in the local press, save that it closed earlier than planned and that a selection of the paintings was auctioned after the closure.[37]

However, that it was a resounding failure is evident from a letter Frazer addressed to the committee of the Royal Irish Art Union in Dublin in June 1839:

> This Society [the Association] … succeeded in getting up three annual exhibitions … But there were found only a few zealous non-professional lovers of art … the consequence was that last year's exhibition was closed without any sales being effected. The only just conclusion to be drawn from the experiment … is, that Belfast is *not yet* prepared for maintaining a *local art union* [by this, he meant an art society] for the encouragement of native art, that nothing else, but the *centralization* of the patronage of the rank, wealth, and enlightened taste of the kingdom in a metropolitan institution, such as the Royal [Irish] Art Union of Dublin, seem to realize, can raise Irish art from its present low and depressed condition.[38]

Presumably because of this sad end to its third exhibition, the Association disbanded, for nothing more is heard of it after 1838. As for Frazer's struggles for local art and for the art world of Belfast, these also ended, as indicated by his comments above. Thereafter, he turned his back on local effort and left it to societies in Dublin to effect an improvement in the art of the country, including the north.

In the matter of the Institution of Fine Arts for Belfast, the subject did not die with Frazer's acknowledgement after the 1836 exhibition that the Association would be unable to bring it about. Instead, the issue remained before the public for some time. In March 1837 the *Belfast Commercial Chronicle* called for the establishment of a public art gallery and urged 'patriotic individuals' to lend to it.[39] The idea was still current in February 1838, when the *Belfast News-Letter*, in its issue of the 27th of that month, suggested that a room for fine art exhibitions be set aside in the proposed new Music Hall of the Anacreontic Society, eventually opened in 1840.[40] (This notion of shared premises with the society was not new, having first been raised by Francis Dalzell Finlay

in 1826, as discussed in Chapter Two.)The newspaper's suggestion was probably derived from the prospectus for the Music Hall, issued the week before, on 17 February 1838.[41] According to this source, the society planned to let rooms in the building for private meetings and exhibitions. Sadly, nothing came of the *News-Letter*'s proposal, possibly because the society was unwilling to allocate a permanent gallery space within the building. A few months later, in April, the *Northern Whig* announced that a subscription had been commenced in the town for the erection of a painting and sculpture gallery.[42] Unfortunately, no further details can be found concerning this project – which likewise failed to materialise – and the subject of a fine art gallery did not become a public issue again until the early 1870s.

## THE NORTHERN IRISH ART UNION OF 1842

The failure of the Belfast Association of Artists highlighted ever more strongly the community's indifference to the work and efforts of local artists. This problem had been growing since the mid-1820s, when an art market in Old Masters and contemporary oils and engravings began to develop in the town, but also during which Frazer's attempts to improve local art fell on deaf ears and came to nothing. The conclusion to be drawn from such apathy is obvious: Belfast's middling and upper ranks desired works by artists from beyond the community and indeed Ireland, either practising or deceased, if the sizeable number of ancient and modern masters for sale at auction can be taken to reflect demand. Furthermore, it seems clear that local collectors wanted paintings of a higher quality and perhaps more varied subject matter than local artists were able to provide. The next exhibiting society to be established in the town, the Northern Irish Art Union, catered more for these requirements and was thus somewhat more successful in the number of works sold.

The Art Union, initiated by a group of local and professional figures, was established at a public meeting in the museum on 30 August 1842.[43] Significantly, considering the failure of the Belfast Association of Artists, there were no artists amongst its officers or on its management committee. Instead, rank, position and professional standing predominated throughout the various strands of its organisation. The Marquess of Donegall was president, whilst of its eighteen vice-presidents, fourteen were from the nobility and gentry. Included were the Marquess of Londonderry, the Earls of Belfast and Hillsborough, Sir Robert Bateson and James Emerson Tennent.[44] These positions were probably titular, with the various personages lending their names to add prestige to the undertaking. The management committee comprised twenty-six well-known local figures, many of

whom were professionals and intellectuals with links to the Belfast Literary Society and the Belfast Natural History and Philosophical Society. James Lawson Drummond was secretary and G.T. Mitchell, an employee of the Belfast Bank, treasurer.[45]

The inspiration for the Art Union was probably the London Art Union, the premier body in the British Isles, although the Royal Irish Art Union, established in Dublin in 1839, may have also served as a model.[46] The former society had been founded in 1837, as a result of a recommendation made in 1835 by the Select Committee on the State of the Arts and Manufactures in England.[47] This parliamentary committee, of which more will be heard in the following chapter, had been set up to examine ways in which a greater knowledge and appreciation of the fine arts could be spread amongst the population, particularly the inhabitants of manufacturing districts. One of the speakers to address the committee was Dr Gustav Waagen, director of the National Museum of Berlin. Of the details he supplied concerning the arts in Germany, the system of art unions – *Kunstvereine* – was particularly well received. As he explained, 'These associations, for the purchase of pictures to be distributed by lot, form one of the many instances in the present age, of the advantages of combination. The smallness of the contribution brings together a large number of subscribers, many of whom, without such a system of association, would never have been patrons of the Arts.'[48] The committee, impressed by the scheme, concluded in its report that art unions seemed an ideal means of spreading a love of art amongst the populace and recommended their establishment.[49]

After the founding of the London Art Union, several others were set up in cities across the British Isles. Art unions operated in one of two ways: a selection committee purchased works of art at various exhibitions using money from the members' subscriptions, placed the works on annual display and held a ballot and prize distributions *or* cash vouchers (also financed by members' subscriptions) were awarded as prizes, winners chose paintings from various approved exhibitions and the art union then held an annual exhibition of the works acquired by the prize winners. The former system, that of a selection committee, was the one more frequently used and was approved by the Board of Trade, which was made responsible for the regulation of art unions in 1846.[50] The Northern Irish Art Union followed the latter system, that of freedom of choice for prize winners, and awarded cash vouchers as prizes.[51] Prize winners selected the paintings they desired from the 1842 exhibition and were permitted to add to the amount they had won, if they wished to obtain works costing more than the value of their vouchers. However, this was the only art union feature of the exhibition as works could also be purchased

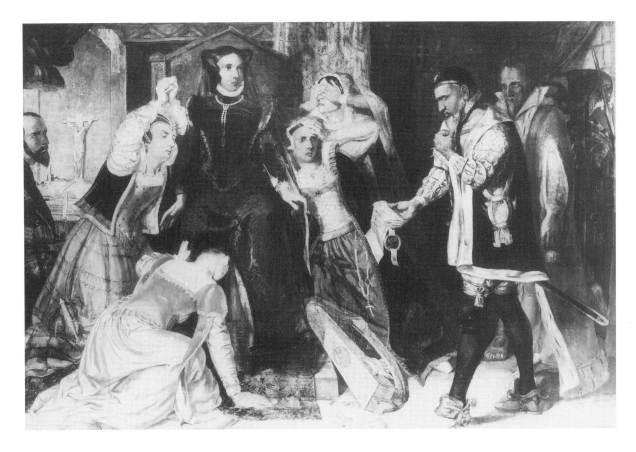

27 David Scott
*Mary, Queen of Scots receiving the Warrant for her Execution* (1840)
This large and dramatic work was shown in the Northern Irish Art Union exhibition of 1842.

privately, that is, outside the art union scheme. Understandably, there were no free engravings or other gifts for members, as was the case with large and wealthy art unions like the London Art Union and the Royal Irish Art Union. Membership of the Northern Irish Art Union was one pound. Its aim, as stated in its prospectus, was 'to give all possible encouragement to Modern Art, by purchasing the Works of Living Artists, and to promote a more general and better taste and feeling for the Fine Arts than at present exists in the North of Ireland'.[52] The establishment of an annual exhibition was also one of its aspirations.

The exhibition ran from late October to early December, with the museum once again as the venue.[53] Admittance was a shilling during the day and sixpence in the evening, with Art Union members gaining free entry.[54] Of the 423 exhibits, only 131 works can be identified, as no catalogue can be found.[55] Subject and narrative paintings made up roughly half of the known paintings. The usual panoply of local artists was represented – James Howard Burgess, Hugh Frazer, Samuel Hawksett, Andrew Nicholl and others – together with Irish artists such as Nicholas Joseph Crowley, Michael Angelo Hayes and

**28** The scene at the drawing of prizes at the Royal Irish Art Union exhibition at the Royal Dublin Society in 1843. The bustle and excitement is almost palpable, as the crowds anxiously await the results of the ballot.

Richard Rothwell.[56] English and Scottish artists predominated, however, although their exact numbers are unknown. Amongst the most illustrious were Thomas Creswick, William Etty and Cornelius Varley, major names in the Victorian art world.[57] Less renowned figures included Frederick Richard Lee, Horatio McCullough and David Scott, whose large and dramatic exhibit, *Mary, Queen of Scots Receiving the Warrant for her Execution* (1840) (Fig. 27) is now in Glasgow Art Gallery and Museum.[58]

The results of the exhibition were discouraging. Thirteen paintings were purchased privately, the amount for these totalling £343.[59] Of the group – a poor return out of an exhibition of over 400 works – one was by Frazer and the other twelve by English and Scottish artists.[60] The art union side of the exhibition was equally disappointing, with members' subscriptions amounting to only £242. Money from visitors and catalogue sales came to £98, thereby making a total of £340 raised through the exhibition. However, after freight and carriage charges for the various exhibits had been paid – a sum of £270 – only £70 remained. This was divided into eleven money prizes, at the prize draw allotment on 15 December (1842).[61] (The crowds and excited atmosphere at an Art Union lottery draw can be seen in Fig. 28.) Of the eleven paintings chosen by the prize winners, three were by northern Irish artists.[62] Three of the winners, amongst whom were Sir Robert Bateson and the architect Charles Lanyon, added extra money to their vouchers – £52 in all – thus a sum of £122 was spent on pictures as prizes. In total, therefore, £465 was spent on works at the exhibition, namely £122 on Art Union prizes and £343 on private sales.

Whilst the management committee seemed pleased with the results of its efforts and optimistic about the future of the society and the holding of further annual exhibitions, the *Art-Union*, the leading British art periodical of the day, took a different view.[63] In its opinion, the exhibition had been badly managed, otherwise the returns would have been very different. In the event, the management committee appears to have realised finally that the Art Union side of the venture had been less than successful, for this was the end of the Northern Irish Art Union. At best, it had gained only 242 members (as £242 had been raised through the membership fee of one pound), hardly enough to render it financially viable.[64] Competition from other art unions, notably the Royal Irish Art Union in Dublin, with its free

engravings for members and wide range of prizes, was also probably a contributory factor to the Art Union's folding.[65] Nevertheless, despite the society's dismal outcome, its establishment indicates that members of Belfast's middling and upper ranks – like the town's resident artists – wished to bring about an improvement in the artistic and cultural standing of the north.

## THE BELFAST FINE ARTS SOCIETY OF 1843

Although the Northern Irish Art Union had proved to be a failure, fourteen of its management committee of twenty-six refused to accept defeat in their mission to promote the fine arts in the north and, in 1843, founded the Belfast Fine Arts Society.[66] William Thompson (Fig. 29), the eminent Belfast naturalist, was president and John Clarke, Charles Lanyon, Cortland McGregor Skinner and Robert James Tennent vice-presidents. Amongst the fifteen-strong management committee were W.J.C. Allen, William Dunville, George C. Hyndman and Francis McCracken.[67] William Bottomley was secretary and G.T. Mitchell treasurer. As had been the case with the Northern Irish Art Union, a number of those involved were professionals and intellectuals belonging to the Belfast Literary Society and the Belfast Natural History and Philosophical Society. However, no members of the nobility held titular roles or lent their names to the venture, an indication, perhaps, that the Society viewed itself in a more modest light that had the Northern Irish Art Union. As a possible reflection of this, the Society's exhibition received comparatively little coverage in the press – unlike the Art Union's show of the previous year.

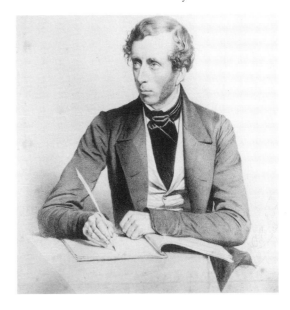

**29** William Thompson (1805–52), the distinguished Belfast naturalist, was also a patron of the arts and president of the Belfast Fine Arts Society for a time.

The exhibition, which opened in the museum in late August 1843 and ran until late October, contained at least 198 works, of which only 36 can be identified.[68] Besides the usual shilling admission charge, there was evening admittance for sixpence and an innovative feature – entry for the working classes on Saturday evenings for three pence.[69] Amongst local artists represented were Hugh Frazer, Samuel Hawksett, who sent a portrait of the shipowner Robert Langtry (see Fig. 18), miniature painter Elish Lamont, the watercolourist Dr James Moore (described in the *Belfast Commercial Chronicle* of 9 September 1843 as 'a second Nicholl') and Nicholl himself. Non-resident Irish artists included Nicholas Joseph Crowley and Richard Rothwell, whilst amongst English contributors were Antony Vandyke Copley Fielding, Samuel Prout and

Alfred Vickers. Despite attracting well-known names like these last, the exhibition appears to have been a low-key affair, evident from the lack of information surrounding it. The number of works sold remains unknown, as also money raised and expenditure. Whatever the anti-climax of the event, the Society continued in existence for several years and held further exhibitions in 1854 and 1859. These will be discussed in Chapter Five.

## THE FORTUNES OF LOCAL ARTISTS

The various exhibitions detailed above were useful platforms for local artists to remain before the public. Some appear to have lived in reasonable circumstances whilst others were not so blessed. Samuel Hawksett appears to have maintained a steady portrait practice until the mid-1840s but thereafter ceased to exhibit and may have fallen on difficult times, perhaps partly as a result of competition from the rising young portraitist, Richard Hooke (see below).[70] Hugh Frazer, during the 1840s, appears to have experienced problems selling his work and, in 1840, 1842 and 1848, held subscription sales of his paintings (mini-lotteries of small numbers of pictures), presumably to help entice purchasers.[71] He also continued to augment his income by teaching, as he had done in the mid-1830s.[72] That he was in dire financial straits by 1845 is evident from comments made by the Belfast art collector Francis McCracken to George Petrie, an artist and Royal Hibernian Academician. Writing to Petrie in Dublin on 11 March of that year, McCracken suggested that Frazer be appointed librarian to the Academy. According to McCracken, Frazer was:

> 'steeped in poverty to the very lips', at this moment confined to bed without *one shilling*, and worse still without the prospect of any sales before art union time [presumably the Royal Irish Art Union], *if even then*! Many a time have I heard him say he would think himself *rich* in the possession of one shilling a day!!! This, from a *gentleman*, in the highest sense of the word, is most deplorable ... Believe me my dear Sir nothing would induce me to interference in any case of the sort except the conviction that without some such aid a member of your academy [the Royal Hibernian Academy] may *die* of starvation.[73]

Though Frazer was not appointed to the librarianship, he seems to have recovered from his unfortunate circumstances and, by 1850, was acting as agent for McCracken in his picture-buying ventures.[74]

Andrew Nicholl fared much better, probably due to his willingness to travel between various places for work and also because of his illustrations for publishers like Rudolph Ackermann and authors

such as Mr and Mrs Samuel Carter Hall.[75] In 1838, having moved regularly between Belfast and London since the early 1830s, he left his home town to reside in Dublin.[76] Prior to his departure, his fellow artists and those interested in the promotion of the fine arts held a public dinner in his honour.[77] Amongst the artists present were Samuel Hawksett and Robert Warrington. Francis Dalzell Finlay, one of Nicholl's earliest patrons, chaired the proceedings. Nicholl's reply to Finlay's opening eulogy is a moving testimony to his feelings for his homeland: 'wherever it may be my fate to settle, I shall never forget the North of Ireland. My character, as an Artist, has, in a great measure, been identified with the sublime scenery of its bold and romantic coast.'[78] In his reply he also paid tribute to Dr James MacDonnell, likewise an early patron and the first to notice and promote his abilities.

In late 1839 Nicholl moved to London, although he continued to visit the north of Ireland until 1846, working for periods in Belfast and at Bryansford and Newcastle, Co. Down.[79] In the latter year he was appointed drawing master at Colombo Academy, Ceylon, undoubtedly the most challenging move of his career.[80] Before he left for Ceylon, his friends in Belfast gave him yet another farewell dinner, a further occasion for public praise of his achievements.[81] In his reply of thanks to the gathering, he paid tribute to his long-term patron, Sir James Emerson Tennent (who, as colonial secretary for Ceylon, may have helped him obtain his new post) and described his own artistic vocation. Direct and sincere, his speech is that rare instance, the voice of a nineteenth-century Belfast artist speaking across the years:

> The life of a landscape painter is solitary; his profession seldom brings him into the society of the admirers of his works; his business is the close and ardent study of nature, far removed from the busy scenes of every-day life. The solitude of the mountains, the glens, or the sea shore – here he passes the happiest hours of his life, with now and again a kindred spirit to cheer him on in the laborious struggles of his profession. Seldom are his labours appreciated – although I cannot say it has ever been the case with myself – [and he is] often allowed to suffer the pangs of misery and neglect.[82]

He remained in Ceylon for three years and returned to London in the summer of 1849.[83]

Two new faces appeared on the local art scene during the 1840s, the landscape painter James Howard Burgess (c.1810–90) and the portraitist Richard Hooke (1820–1908). Burgess, about whose early life nothing is known, returned to Belfast, from London, in 1840, to hold drawing classes and give private tuition.[84] Teaching was to

**30** Richard Hooke
*Professor Thomas Andrews*
*(1813–85)* (1880)

remain the basis of his livelihood, although he carried out a considerable amount of work for publication, notably with the firm of Marcus Ward.[85] A gifted painter, as can be seen from his *View of Queen's Bridge, Harbour and Timber Pond* (1858) (Plate 13), he made local scenery his speciality. His contemporary Richard Hooke, a carpenter by trade, appears to have been partly self-taught but also attended the drawing school of the Academical Institution for at least six months during 1843.[86] By the following year he had commenced in business as a portrait painter.[87] His Belfast clientele was composed mainly of merchants and professionals like Professor Thomas Andrews (Fig. 30), vice-president of Queen's College 1845–49.[88] Painted in 1880, the portrait is a fine example of Hooke's ability to catch humour and intelligence in the expression of his sitter. Both Burgess and Hooke were to remain in the forefront of Belfast's art circles for many years, probably helped by a pragmatic attitude to work and a willingness to adapt. Their careers are in sharp contrast to that of Frazer, who – deeply idealistic and caught up with the notion of high art and the special place of the artist in society – ended up in penury for a time.

## THE ART TRADE

Trade on the local art market expanded greatly from the late 1830s, due to an increased volume of business by the auctioneering firm of Hyndman, one of the few concerns of its kind in Belfast at the time.[89] Possibly because of this activity, the company opened new premises in Castle Place between 1840 and 1842.[90] (Prior to this, the firm had held its auctions at the old Exchange in Waring Street, Fig. 4.) Almost all of Hyndman's known sales during the late 1830s and 1840s were of picture collections, although a few also contained furniture and house contents.[91] Of the collections auctioned, a number were for local owners like Mr Burroughs, manager of the Belfast Theatre and the artist Andrew Nicholl (a sale necessitated by his move to London in late 1839).[92] Others were for a Mr Cochrane of Edinburgh, a dealer who sent at least six large consignments of pictures from Scotland between 1838 and 1846.[93] However, most of the auction advertisements lacked information regarding the owners' names or where the works had

come from. Of the many paintings to pass through the saleroom, the majority (according to advertisements) were by Continental painters – 'ancient masters' such as Caravaggio, Jacob Jordaens, Michelangelo and Rubens.[94] There were also cabinet pictures (small-sized works) by British, Dutch and Flemish artists, examples by 'modern masters' and engravings after painters of the British school.[95] Hyndman's only competitor during this period, John Devlin, commenced in business about 1839.[96] His enterprise, however, was on a much more modest scale and he advertised only three auctions during the following decade, likewise of 'ancient and modern masters' and engravings.

Of the many paintings auctioned by Hyndman during these years – and the many more sold through other local auction houses in the next decade – most of the modern works were probably genuine. The majority of the Old Masters, on the other hand, were as likely as not misattributions or fakes – a state of affairs in line with the pattern of the art market in Britain. The British trade in Old Masters had increased considerably since the mid-1790s, in consequence of the French Revolution and the social upheaval and wars which followed.[97] Enormous quantities of foreign paintings – often the best of French and Italian collections – ended up on the London art market, to be competed for by British dealers and collectors anxious for good quality works at reasonable prices. By the early nineteenth century, as a result of this dispersal, the number of Old Master paintings in Britain had grown dramatically. Whilst their existence may have 'roused an emulation and a taste for the acquisition of works of art, which had been almost dormant in England', as the art dealer William Buchanan claimed, it also resulted in many works of poor quality flooding the market.[98] The Irish artist Martin Archer Shee, living in London at the time, said of the situation: 'Thus, has the nation been glutted with pictures of every description and quality, from the best that genius can boast, to the worst that fraud can manufacture.'[99]

Unfortunately, the enthusiasm of British dealers and collectors for the Old Masters tended to have a deleterious effect on the careers of contemporary British artists, who frequently had to struggle for patronage and support. This situation was to continue until the 1840s, when dealers such as Ernest Gambart began to speculate in works by contemporary painters and the influential magazine of the arts, the *Art-Union*, commenced a crusade to alter collectors' buying habits.[100] Samuel Carter Hall, founder of the *Art-Union*, recollected in his memoirs of 1883 the situation as it had been in 1839, when he launched the magazine:

> There was literally no 'patronage' for British art. Collectors – wealthy merchants and manufacturers – did indeed buy pictures

… but they were 'old masters' with familiar names; canvases that had never been seen by the artists to whom they were attributed; copies or imitations by 'prentice hands', that were made to seem *old* by processes which I persistently exposed … I made manifest the policy of buying only such pictures as could be readily identified – certified by the artists who were living; urging the probability that they would increase and not decrease in value, while it was almost certain that so-called 'old masters' would ultimately be worth little more than the value of the panels and frames … I have lived to see such 'old masters' valued according to their worthlessness, and a thorough transfer of patronage to modern Art.[101]

Given this state of affairs – and in the absence of Hyndman's business records – it seems highly likely that the 'Caravaggio', 'Michelangelo' and other 'big' names which he auctioned, were, indeed, misattributions or fakes.

## LOCAL PRINTSELLERS AND THE WIDER ART WORLD

Another area of the Belfast art trade to expand during the 1830s was the practice by local printsellers of displaying popular paintings as one-picture exhibitions, in order to promote sales of their engravings. This trend was not confined to Belfast but was a common occurrence throughout the British art world. From the 1830s, demand for engravings of well-known pictures reached unprecedented heights, as the rising middle classes sought to emulate their social superiors in the collecting of art; indeed, such prints began to form the bulk of the British printselling and print publishing trade.[102] By this time, appreciation of the fine arts had permeated down through society, partly due to the spread of art institutions and academies in the provinces, as discussed at the beginning of the chapter. Print publishers in London and elsewhere – a new breed of entrepreneur – made it their business to ensure that the pictorial tastes of this changing society were satisfied.[103] Towards that end, they began sending to printsellers in the provinces popular paintings of repute, generally one at a time but sometimes more, in order to encourage sales of engravings of them. From 1836, Belfast became one of the centres for the display of these popular pictures.[104] As a result of this, art lovers in the town had the chance to view prestigious works which they would probably not otherwise have been able to see.

The first local printsellers to become involved with this traffic of paintings from London to Belfast were John and Robert Hodgson of High Street. Though little information on the firm can be found, the

business was long established, having been in existence in town from as early as 1818.[105] By 1836, the firm had formed a link, as yet unclear but possibly based on family connections, with one of the leading printsellers and publishers in London – Hodgson and Graves of Pall Mall. This company, which had originally been Moon, Boys and Graves and had traded as such from 1827 to 1834, became Hodgson and Graves in 1836, when a Richard Hodgson entered into partnership with Henry Graves.[106] The business remained in operation until Hodgson retired in 1841. The firm subsequently traded as Graves and Warmsley until 1843 and thereafter became Henry Graves and Co. That John and Robert Hodgson began, in 1836, to exhibit works connected with the publishers Hodgson and Graves seems not mere coincidence but directly related to Richard Hodgson's entry into the firm in that year. After the latter's retirement in 1841, Graves continued to send paintings to the Hodgsons in Belfast.[107]

Of the ten works displayed at Hodgson's as one-picture exhibitions between 1836 and 1848, admittance to which was always by ticket only, five stand out: *Queen Victoria in Robes of State* (1838), by Thomas Sully (1783–1872); *Prince Albert of Saxe-Coburg-Gotha (1818–61), Consort of Queen Victoria* (1840), by George Patten (1801–65); *The Waterloo Heroes assembled at Apsley House* (1838–42) and *The Heroes of the Peninsula* (1843–44), by John Prescott Knight (1803–81); and *Shoeing* (by 1844), by Sir Edwin Landseer (1802–73).[108] The portrait of the young queen (Fig. 31), the first major picture to come, was at the premises in May 1839.[109] One of five versions by Sully, the work shown in Belfast was almost certainly the painting now in the Wallace Collection, which Hodgson and Graves had commissioned expressly for engraving by C.E. Wagstaff.[110] Sully, an American who had received the commission to paint the queen from the Sons of St George in Philadelphia, described her as 'quite pretty' and likened her to a 'well-bred lady of Philadelphia or Boston'.[111] Oddly, considering the subject of the portrait, there was little mention of the display in the local press and no comment as to the public's response to it. There seem to have been no large crowds, as one might have expected.

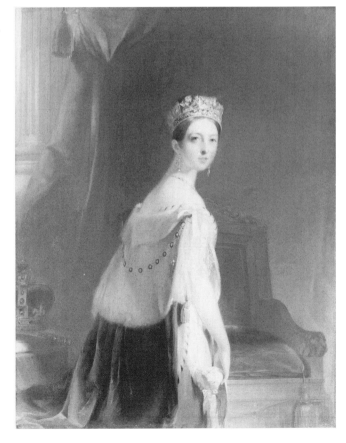

31 Thomas Sully
*Queen Victoria in Robes of State* (1838)
Of the five versions of the portrait by Sully, that below, in the Wallace Collection, is probably the painting exhibited by the Belfast printsellers, John and Robert Hodgson, in May 1839.

**32** Charles Edward Wagstaff, after George Patten
*Prince Albert of Saxe-Coburg-Gotha (1818–61), Consort of Queen Victoria* (1840)
Patten's painting, from which this engraving is derived, was displayed by John and Robert Hodgson in the Commercial Buildings in April 1840.

Whatever the numbers in attendance, the Hodgsons took no risks with visitors to their next major exhibition – George Patten's portrait of Prince Albert – for they held it in the spacious Commercial Buildings and not on their own premises, possibly anticipating throngs of curious spectators anxious to view a portrait of the queen's new husband.[112] The painting, full-length and completed by February 1840, had been commissioned specifically by Hodgson and Graves after the announcement of the royal engagement on 23 November 1839.[113] On completion, the picture was exhibited by the firm at their London gallery before being shown in Belfast in April 1840.[114] Like the portrait of the queen, the work was engraved by C.E. Wagstaff but in a three-quarters length format (Fig. 32), probably to match the size of Sully's picture.[115] Whilst obviously driven by commercial factors in commissioning these royal portraits and their engravings, Hodgson and Graves nevertheless showed themselves to be in touch with the mood of the time, namely, enthusiasm for the young queen and her equally youthful consort. The whereabouts of the portrait of the prince is unknown.

The royal portraits were the exception for the Hodgsons, as their one-picture exhibitions generally comprised historical, anecdotal or animal subjects. History painting was particularly well served during these years with the display of the works by John Prescott Knight referred to above: *The Waterloo Heroes assembled at Apsley House* and *The Heroes of the Peninsula. The Waterloo Heroes ...* , exhibited by Graves and Warmsley (the one-time Hodgson and Graves) at their London gallery in April 1842, was shown at the Commercial Buildings during late May 1843, under the care of the Hodgsons.[116] Painted from life and said to have taken almost four years to complete, the picture showed the Duke of Wellington greeting his erstwhile comrades-in-arms in his residence on the anniversary of the battle of Waterloo.[117] The most popular of Knight's historical paintings, the work became extremely well known through an engraving by Charles George Lewis, published by Henry Graves (Fig. 33).[118] Its Belfast display attracted large crowds – 'the elite of the nobility and

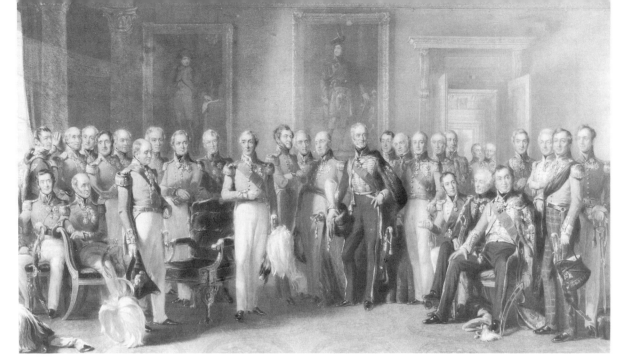

gentry of Belfast and its neighbourhood' – and continued for longer than planned, due to public interest.[119] Its companion, *The Heroes of the Peninsula*, was exhibited in the Commercial Buildings in May of the following year (1844), likewise under the Hodgsons' charge.[120] Received to acclaim in Dublin before its Belfast showing, it followed a similar format to *The Waterloo Heroes* … in depicting Wellington in the midst of a large group, in this case high-ranking officers who had served with him in Spain and Portugal. An engraving of the work, produced by Frederick Bromley, was also published by Graves.[121] Historical subjects like these, appealing to patriotic sentiment, became favourite themes for engraving from the 1830s.

Animal subjects were another highly popular genre. The above-mentioned *Shoeing* (Plate 14), by Sir Edwin Landseer, was exhibited during late October and early November 1845, not in the Hodgsons' own premises but in Mr Gilbert's Large Room in High Street, a location chosen presumably for reasons of space.[122] Prior to its Belfast display, it had been shown in Dublin, where it had been highly praised.[123] Whilst in Belfast, it was viewed by almost all of the nobility and gentry of the neighbourhood, according to the *Belfast Commercial Chronicle*.[124] The same newspaper considered it 'one of the most exquisite paintings it was ever our happiness to witness'.[125] As typical of Landseer's skill in the genre, the depiction of the mare, Old Betty, is a *tour de force* of animal painting, her glossy coat almost enticing the viewer to stroke the canvas. Whilst reaction to the picture in the main art and literary periodicals was mixed – the reviewers in the *Athenaeum*

and *Art-Union* regarded the work as lacking the improving element of high art – the critic of the *Literary Gazette* was more appreciative of Landseer's basic intention: 'there is the horse, and no mistake'.[126] After its exhibition in Belfast the painting was returned to London, presumably to its owner, the collector Jacob Bell.[127] An engraving of the work, by Charles George Lewis, was published in 1848.[128]

Not all of the Hodgsons' exhibitions were of major British paintings of repute. On occasion the firm also showed local portraits, such as those of Rev. Dr Henry Montgomery and William Sharman Crawford, both by John Prescott Knight; portraits of prominent figures like General Sir Robert Sale, by Henry Moseley and General Sir Henry Pottinger, by Sir Francis Grant; a series of watercolours of scenes in Belgium and Germany, by Louis Haghe; and pictures associated with the Dublin-based Royal Irish Art Union, the exhibition of which came about probably as a result of John Hodgson being its honorary local secretary.[129] As with the one-picture exhibitions, most of these paintings were displayed to help encourage the sale of their engravings. In showing such a variety of works, the Hodgsons catered to a wide range of tastes of the print-buying public.

Besides the Hodgsons, there were two other printsellers, with smaller-scale businesses, active during the 1830s and 1840s: William McComb and E.H. Lamont. The former, established about 1836, not only sold prints (and books) but published engravings on occasion.[130] He also exhibited and sold paintings from time to time.[131] The firm of Lamont, somewhat larger than McComb, appears to have commenced in business about 1843.[132] Like McComb, he too published engravings and exhibited and sold pictures now and then.[133] Displaying paintings for the print trade was another of his activities.[134] Amongst works he showed for print publishers were twenty-five watercolours by Joseph Nash for the latter's Windsor Castle views, lent to him by Thomas McLean of London in 1847 and published in volume format by McLean in 1848.[135] The series created quite a stir when displayed, the *Belfast Commercial Chronicle* describing the event as 'one of the finest exhibitions of watercolour drawings of the same extent ever seen in Belfast'.[136] Another work to reap acclaim in the local press was *Death of the Stag*, by Richard Ansdell, likewise exhibited in 1847.[137] In showing this, Lamont was perhaps attempting to compete with the Hodgsons, who had already held successful displays of two other animal paintings: *Shoeing* mentioned above, in 1845 and *Feeding the Horse*, by John Frederick Herring, Snr in 1846.[138] Admittance to these exhibitions at Lamont's appears to have been unrestricted, in contrast to displays at the Hodgsons', where shows for the print trade were confined to ticket holders only.[139]

## OTHER EXHIBITIONS AND POPULAR ART

Printsellers' shops were not the only venues for art exhibitions; works were also to be seen at a number of other locations, notably the Commercial Buildings. The organisers of these displays appear to have been independent entrepreneurs, from the town or elsewhere, not connected with local art dealers or printsellers. Amongst events at the above-mentioned centre was the exhibition in 1840 of three massive works entitled *The Beginning, The Progress* and *The End of Human Destruction*.[140] Each 10 feet x 14 feet and described in the press as having been 'executed for Belfast', they were perhaps by Gaetano Fabbrini, being typical of his subject matter. It is not known if they were for sale. Other exhibitions, likewise in the Commercial Buildings, included a display and subscription sale of nine landscapes by Hugh Frazer in 1840 and the showing and subsequent raffle of a painting entitled *Irish Pastime* by Hugh Talbot, a little-known local artist, in 1843.[141] The picture, described somewhat intriguingly as

34 Henry Thomas Ryall, after Claude-Marie Dubufe *The Temptation of Adam and Eve* Copies of Dubufe's paintings of Adam and Eve, almost certainly by John Beale Bordley, were exhibited in the Commercial Buildings in 1839, 1841 and 1846.

35 Henry Thomas Ryall, after Claude-Marie Dubufe *The Expulsion from Paradise*

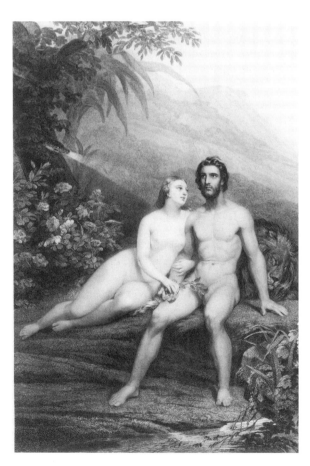

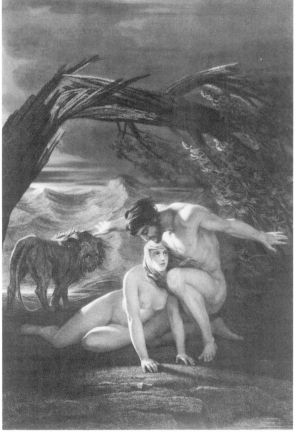

being 'genuinely Irish throughout' was presumably a genre scene of some kind.[142] Such displays possibly helped bring art to a broader cross-section of the Belfast public than that which frequented auction rooms and printsellers' shops.

The history of the pictures deserves a brief mention, in view of their enormous popularity.[149] Painted by Dubufe in 1828 for Charles X of France, the originals seem never to have entered the king's collection but were taken to the United States by two British art dealers in 1832. There followed a promotional tour of the works around America, under the management of James Creighton, a New York businessman. In 1835 the paintings were destroyed in a warehouse fire. Fortunately, copies had been made by an American artist, John Beale Bordley. These were almost certainly the works which were exhibited in Belfast and Dublin – and in other towns and cities across the British Isles – between 1839 and 1860.[150] The shows were again organised by Creighton (billed now as owner rather than manager). In 1857 Dubufe painted a second set, which were sent to America in 1860 for yet another round of exhibitions. Their whereabouts and those of the Bordley copies are unknown. However, records of the images still exist through engravings by Henry Thomas Ryall, published in 1860 and illustrated here. From these, it is evident that the works, though appealing in their dramatic content, may not have

Art of a more popular type was also on view from time to time. Undoubtedly the most significant works in this category were a pair of oil paintings depicting Adam and Eve – *The Temptation of Adam and Eve* and *The Expulsion from Paradise* (Figs 34 and 35) – by an unnamed artist but most likely John Beale Bordley, after a French painter, Claude-Marie Dubufe (1790–1864). So popular were they that they were exhibited in the Commercial Buildings on three separate occasions: in 1839, 1841 and 1846.[143] Shortly before the closing of the first display, after which they were taken to Dublin, their owner, James Creighton, stated that they had been seen by over 8,500 people in Belfast.[144] Whilst there were no figures given in the press for visitors to the second and third exhibitions, numbers to the 1846 event must have been considerable, as Creighton invited all of the town's charity and Sunday school 'scholars' and their teachers to the show, free of charge.[145] No doubt the teachers used the massive and dramatic paintings, each 12.5 feet by 10.5 feet, to instruct their young pupils in the meaning of right and wrong, of 'the delights of innocence, and the terrors and remorse of disobedience'.[146] Cost of admission was within the reach of a wide range of the public; initially a shilling (the standard panorama charge), it was reduced to six pence, for tradespeople only, in 1841 and to six pence for all adults in 1846.[147] Entry for children, six pence in 1839, was halved for the second and third exhibitions.[148]

62

been of particularly high quality as figure paintings, as Adam and Eve look somewhat stilted and unnatural in appearance.

Although popular, the paintings met with some criticism in America. Whilst the majority of viewers found them to have a 'decidedly moral' effect, many, like 'True Modesty' of New York, considered them 'splendid in licentiousness'.[151] Whether the works were castigated as indecent at any of their British and Irish venues is unknown; however, it is worth noting that there appear to have been no such charges levelled against them in the Belfast press.[152] Whatever the public reaction, the paintings were seen by many hundreds of thousands on both sides of the Atlantic: over 1,200,000 by mid-1846, if Creighton is to be believed.[153] Their appeal to American, British and Irish audiences was obviously considerable.

The popularity of Robert Burns in Belfast has been mentioned in the previous chapter, in connection with James Thom's statues of *Tam O'Shanter* and *Souter Johnny* (Fig. 26), exhibited in 1831. In 1846 a group of sculptures of the same type, fifteen life-size stone figures illustrative of Burns' poem 'The Cotter's Saturday Night', was on display in premises in High Street.[154] By an unnamed sculptor who was apparently self-taught, the works were said to have taken three years to complete and were described as 'truely and chastely executed'.[155] According to the *Belfast Commercial Chronicle* they had already been seen by over 100,000 persons in Glasgow.[156] After the Belfast exhibition, the show was destined for Dublin and London.[157] Admission charges were lower than usual, possibly to attract a greater number of visitors: six pence during the day, three pence in the evening and a special reduction for the working classes during the last few weeks.[158] The tenor of the various newspaper reports indicated that the event was well received.[159]

That perennially popular entertainment, the panorama, was also back in town yet again. Between 1838 and 1848, there were four to be seen, all displayed in the Commercial Buildings. These included *The Land of Burns*, the proprietor of which was unnamed, on show from August to December 1841 and *The Royal Panorama*, owned by John Baker, exhibited during June 1848.[160] The painter of the former, which comprised Scottish views and characters in Burns' poems, was an artist who seems to have specialised in panoramas, G.H. Stanley Steventon.[161] As was often the case with panoramas, *The Land of Burns* had new scenes added to it during its stay: two more Scottish landscapes by mid-October and seventeen other views, mainly of the Orient, in December, shortly before it closed.[162] Such new additions brought extra variety to the displays, an important factor given that panorama exhibitions tended to last several weeks. With *The Royal Panorama*, a series of fourteen subjects ranging from historical events

to a view of Edinburgh, a notable feature was a reduction in admission charges shortly before it closed, to enable 'all classes' to attend.[163] This was the first time such a concession had been made for panorama displays in town.

As this chapter has shown, there was an extremely wide range of art on view by the late 1840s, at art societies' exhibitions, commercial outlets like auction rooms and printsellers' shops and centres such as the Commercial Buildings. The various societies' shows, held for the idealistic notion of improving taste and promoting the fine arts, failed miserably – a situation in stark contrast to the sales and displays at auction houses and printsellers' shops, which were obviously successful and which lines of business continued to flourish and expand. The groan of despair from the editor of the *Belfast Commercial Chronicle* on 28 October 1837, shortly before the Belfast Association of Artists exhibition closed with very few sales having been made – what to do to 'try to wile a guinea or two from the well-filled purses of the Belfast Lieges' – was not applicable to commercial outlets, then or later. Perhaps nowhere is the triumph of commercialism over idealism seen more clearly than in the fact that when an art school was eventually established – the Belfast School of Design in 1849 – it was not set up to forward the artistic well-being of the town, on the lines of Frazer's proposed Institute of Fine Arts, but instead, was founded for monetary considerations, to promote the town's expanding textile industry.

# ～ 4 ～

# The Belfast School of Design

## 1849–58

*'What more delightful … than to see genius going hand in hand with industry'[1]*

Belfast in the late 1840s was an ideal site for a School of Design. On the one hand, there was an expanding textile industry, on the other, a shortage of skilled designers to service it and almost no local provision for training in the field. The only facilities available were the drawing classes for 'industrious mechanics' run by Gaetano Fabbrini, which commenced in 1847, as discussed in Chapter Two. These, unfortunately, were short-lived, as he died in 1849. By this time, linen had become central to Belfast's industrial development, through the power spinning of flax. In 1830, only two mills in the town had spun flax by power machinery; by 1846, the number had risen to twenty-four.[2] Ten years later, the York Street mill, the main centre of the industry in Belfast, was probably the largest of its kind in the world, with 25,000 spindles in operation. The linen industry was therefore of vital importance to Belfast's expansion by mid-century, on account of the enormous profits it made for mill owners and for the employment it provided for thousands in less fortunate circumstances. Local businesses interested in the establishment of a School of Design, according to a report compiled in 1848 by a number of persons supportive of the project, included the linen and sewed muslin trades, damask weaving, ornamental iron work, carving and cabinet work, bookbinding, engraving and lithography.[3] Commercial success in these fields depended upon imaginative and attractive designs. The need for an establishment to teach the principles of design was obvious.

# THE ORIGIN OF THE SCHOOLS OF DESIGN

The Schools of Design – also known as 'Government Schools of Design' – had their origin in the Commons Select Committee on the State of the Arts and Manufactures in England of 1835, promoted by the Radical member of parliament for Liverpool, William Ewart, to 'inquire into the best means of extending a knowledge of the Fine Arts and of the principles of Design among the people – especially among the manufacturing population of the country'.[4] The only state-funded art instruction available at this time was that provided in the Royal Military Academy at Woolwich and at the Royal Military College at Sandhurst.[5] In addition, the Trustees' Academy in Edinburgh maintained a drawing school through government funds, as did the Royal Dublin Society.[6] Other than these, the only art training available in Britain and Ireland was that given by drawing masters and professional painters to the wealthier ranks, on a fee-paying basis.[7] For those less affluent, instruction in drawing was to be had at mechanics' institutes, which, however, were not rated highly as centres for the teaching of art.

By the early 1830s, the lack of availability of art education in the British Isles had become a topic of debate, particularly amongst Radical members of parliament, many of whom had close acquaintance with the needs of industry or were in contact with the manufacturing interests of the country.[8] It had become evident that British-made goods, such as ribbons, textiles, wallpaper, furniture and pottery, were not popular with local consumers, despite being well produced and that employers were spending large amounts on foreign designs and on the importation of foreign labour. Countries such as France and Belgium and the states of Bavaria and Prussia spent considerable effort and money on the education of artists and artisans. French goods, in particular, posed the greatest threat to British industry, for French patterns, fashions and designers were the most popular and sought after. In France, the training of artists for industry was taken seriously and the Industrial School at Lyons became the model for all others. State-supported drawing schools were widespread and drawing was part of the curriculum of the *lycées*. This ensured a continuous supply of trained artists into the labour market and made France pre-eminent in the applied arts.

The Select Committee commenced its sittings in July 1835. The first to address it was Dr Gustav Waagen, director of the National Museum of Berlin, who has already been referred to in Chapter Three, in relation to the details he supplied on art unions (*Kunstvereine*). Besides facts on these, he also described the Prussian system of the teaching of art, discussed the organisation of art galleries, recom-

mended that artists be employed to decorate public buildings and was highly critical of academies of art.[9] A succession of merchants and manufacturers then gave evidence as to the poor quality of British design, a situation which was blamed upon lack of opportunities for artistic training, especially in the provinces. Member of parliament James Morrison declared, 'with regard to several of our large towns, though there are persons that are called designers, yet they have not been educated as such, and in point of fact they know little of the principles of art', a sentiment which was echoed by the artist John Martin in respect of glass painters and the china trade and by the architect C.R. Cockerell, with regard to wood carvers, ornamental plasterers, painters and casters and moulders of iron.[10] The history painter Benjamin Robert Haydon, called before the committee in May 1836, criticised art academies in the same vein as Waagen, maintaining that they employed and promoted mediocre talent, produced standardised works and used poor teaching methods.[11] Overall, there was a general feeling in favour of the establishment of art schools and art galleries. A few speakers also urged the setting up of museums and libraries. The committee's hearings ended in July 1836.

The committee's report, when it appeared the following month, covered a number of topics that had been discussed at the hearings. Art academies, for example, came in for considerable criticism, on the grounds that they 'gave an artificial elevation to mediocrity, degenerate into mannerism and fetter genius'; also, the Royal Academy was accused of being oligarchical and cliquish.[12] On a more constructive note, the committee recommended that experts be appointed to the governing body of the recently-opened National Gallery and suggested that it remain open during the summer months 'after the usual hours of labour', to enable the working population to attend.[13] Further recommendations included the establishment of art galleries and museums, aided by the government. However, the main thrust of the report concerned the sorry state of the fine and applied arts in Britain. The committee concluded that 'from the highest branches of poetical design down to the lowest connexion [sic] between design and manufactures, the Arts have received little encouragement in this country … Yet, to us, a peculiarly manufacturing nation, the connexion [sic] between art and manufactures is most important'.[14] In the matter of foreign competition:

> The want of instruction experienced by our workmen in the Arts
> is strongly adverted to by many witnesses … It has too frequently,
> if not uniformly, occurred, that the witnesses consulted by the
> Committee have felt themselves compelled to draw a comparison

more favourable (in the matter of design) to our foreign rivals, and especially to the French, than could have been desired.[15]

The report recommended the establishment of a central School of Design in London and branch schools in the provinces.[16] The task of setting them up fell to the Board of Trade, as there was no Ministry of Education or equivalent. The central school opened in Somerset House on 1 June 1837.[17] As its purpose was to train artisans in design and not to turn out artists, the study of the human figure, the basic foundation in the academic training of painters and sculptors, was excluded from the curriculum.[18] There was to be no drawing from antique casts. This policy was rescinded in August 1838, when the painter William Dyce became superintendent.[19] Under his administration, the drawing of the human form became part of the syllabus. This, he believed, would be of benefit to the students, even though the school's main aim was the application of art to industry.[20]

In 1841, parliament allocated £10,000 for the setting up of the branch schools.[21] Twenty-one were founded between 1842 and 1852: Spitalfields and the Female School, London, also Manchester and York (1842); Birmingham, Newcastle-upon-Tyne and Sheffield (1843); Coventry, Glasgow and Nottingham (1844); Norwich (1845); Leeds (1846); Hanley and Stoke, joint schools (1847); Paisley (1848); Belfast, Cork and Dublin (1849); Macclesfield (1850); Stourbridge and Worcester (1851); St Martin's, London and Waterford (1852).

## THE ESTABLISHMENT OF THE BELFAST SCHOOL

Plans to extend the schools to Ireland, including Belfast, were afoot from the mid-1840s.[22] In 1845, Ambrose Poynter, inspector of the branch schools in Britain, together with Henry Labouchere, chief secretary for Ireland, visited Dublin, to assess the possibility of the Royal Dublin Society schools being transformed into a School of Design.[23] Poynter reported favourably on the idea. The following year, he also visited Belfast to consider the feasibility of a school there and returned to London convinced of the efficacy of the project.[24] Two more years were to pass before parliament voted the necessary funds for the project: £1,500 for the establishment of *three* schools, to be located in Belfast, Cork and Dublin.[25] The Dublin school was linked to the Royal Dublin Society, whose schools it replaced.[26]

Moves to establish the Belfast school gathered momentum on 27 November 1848, at a public meeting in the Town Hall to discuss the undertaking.[27] By this point, the government grant of £500 to each of the three proposed schools had already been approved and the

onus was now on interested parties in the town to bring the project about.[28] Amongst those present were the mayor, leading merchants, manufacturers and prominent clergy from the main churches. One of the most interesting parts of the proceedings was the report already referred to at the beginning of this chapter. Read by James MacAdam, Jr, secretary of the Royal Flax Improvement Society of Ireland, it focused upon the lack of skilled designers in the community, particularly within the sewed muslin trade, which employed an extensive work force of between 150,000 and 200,000 people and which had to obtain patterns from the Continent and Britain, as few were to be had locally. A sum of £80,000 was spent annually on these imported designs for muslin goods and also for linenware. However, with the help of a School of Design, local manufacturers would eventually be able to use home-produced patterns, made either by themselves or others, which would in turn provide employment for large numbers.

Another difficulty highlighted by the report was the actual quality of the few designs which were produced in the town. Belfast manufacturers often received patterns from abroad to be used as models for artistic inspiration. Unfortunately, it had proved impossible to make designs locally which were of a similar standard and there was no alternative but to resort to copying them instead. Yet even these were executed clumsily. When the finished articles were eventually exported, they had often to be sold at reduced prices, as the designs on them were therefore already well known and outdated. Furthermore, even when meritorious designs were produced, they could not be sold as Belfast work, but had to be passed off as having been made elsewhere, owing to in-built prejudice against their quality and originality. Such were a few of the problems facing local manufacturers.

Yet another important commodity for which design was essential, not mentioned in the report but discussed by MacAdam in a paper he gave to the Dublin Statistical Society a few months later, were linen bands (or headings, as they were generally called) (see Fig. 41). His description is self-explanatory:

> The greater proportion of the linens exported to foreign countries is profusely ornamented with gaily coloured paper bands, figured and decorated in a great variety of ways, frequently with tasteful coloured engravings; and the cost of these ornaments often amounts to 2d per yard on the value of the linen. Every market has its fancy in the style of decoration … while, unless the linens are got up with attention to the caprice of the consumer and the custom of the market, they will not sell to advantage. The style

frequently varies, so that the manufacturer has to change his ornaments continually, and at considerable outlay ... London and Paris chiefly furnish these ornaments ... Attempts have been made in Belfast to produce the ornaments; but, although the manufacturer would prefer to produce them at home, they are so very inelegant, that, as yet, the sale is small.[29]

The decoration of these bands was to become an important feature of the Belfast school.

MacAdam concluded the report by stating that a number of branch schools in England had been given grants from municipal funds to help start up, aside from the government grant.[30] The promoters of the Belfast school felt that this was the course which should also be adopted by Belfast town council, as so many of the population were dependent upon the trades to be assisted by the school. As a positive example of municipal involvement, MacAdam cited the corporation of the city of Cork, which had recently voted an annual grant of £200 towards its school. The means whereby local promoters hoped to receive financial support from the town council was the Museums Act of 1845.[31] This legislation, which derived from the above-mentioned Select Committee of 1835, was likewise the work of William Ewart. Under it, councils of boroughs with populations of over 10,000 were permitted to levy a rate of not more than a halfpenny in the pound for the establishment and maintenance of museums. Whilst geared to the latter amenity, the act was capable of wider interpretation and was, in fact, used to set up museums combined with libraries.[32] The council therefore resolved to seek legal advice as to whether they could help finance the school through this particular means.[33]

Evidence provided by interested parties at the meeting was both relevant and revealing. Damask manufacturer James Brown of Donaghcloney reported that only the previous week, he had had some hundred pounds' worth of goods returned to him, as the designs used were not original. Mill owner S.K. Mulholland stated that he had to obtain designs for his linen from Paris and London and reiterated that the amount of money sent out of the country for the purpose was enormous. Sewed muslin manufacturer John Holden referred to even greater problems in his line of business, for example, that he needed to bring out about thirty new patterns each week, a more difficult situation than with damask, where patterns tended to be viable for six or eight months. All concerned hoped that the proposed school would alleviate problems like these.

The social and artistic advantages that the school would bring were also alluded to. Rev. Dr Thomas Drew emphasised the moral benefits; by generating employment for large numbers of needy young

women and girls, it would save them from 'the wiles of the seducer' and lives of misery from various causes. William Thompson (Fig. 29), president of Belfast Fine Arts Society, focusing upon the fact that Schools of Design were given collections of casts by the Board of Trade, stressed the advantage that a sculpture gallery would bring to the town, namely, that it would help improve general taste and encourage artistic creativity. Overall, there was considerable support for the school from numerous quarters. The meeting ended with a committee being appointed to bring the project about.[34]

The year 1849 began with disappointing news for the committee – although willing to raise a rate to help finance the school, the town council had no power to do so, according to legal opinion.[35] Nevertheless, despite this unfortunate start, the committee pressed ahead with its fund-raising efforts. By May, £376 had been raised, which included £25 from the Marquess of Downshire and £20 from Lord Dufferin.[36] Of the other donations received, large manufacturers tended to give amounts of £10 or £5, whilst smaller firms and private

individuals donated sums in the region of one to three guineas. Not all subscribers were local: the Drapers' Company of London became a staunch supporter, with an annual grant of £25. Moves to acquire premises were also put in train. On 25 May the committee met with Ambrose Poynter, who had been sent from London to make arrangements for the Irish schools.[37] Amongst the various matters dealt with by him was the inspection of a number of rooms in the Royal Belfast Academical Institution, which he felt could be adapted to house the school. He also urged the immediate formation of a permanent management committee and announced that the headmaster of the school was to be Claude Lorraine Nursey, previously headmaster of the School of Design in Leeds.

According to his wishes, a management committee and officers were elected at a meeting of subscribers held a few days later.[38] Lord Dufferin (Fig. 36) became president, Charles Lanyon and William Thompson vice-presidents, W.J.C. Allen treasurer and James MacAdam, Jr, honorary secretary. Of the thirty-three committee

**36** Lord Dufferin (1826–1902), president of the Belfast School of Design, worked tirelessly for the school from its opening in 1849 to its final closure in 1858.

members, at least thirteen were involved with the textile industry whilst another eight represented trades that would benefit from the school, such as printing, room paper production, house decorating and jewellers.[39] The school was thus truly representative of a wide cross-section of the Belfast community.

Though the school's administrative structure was in place by the early summer, the matter of the premises was not finally settled until mid-September, when it was resolved to rent the north wing of the Academical Institution, at £150 per year.[40] Poynter's first choice had been the south wing.[41] However, the joint boards of the Institution, whilst anxious to assist the school, had nevertheless refused to relinquish this part of the building. Not only would it have caused accommodation problems – 'it would also be objectionable to have Classes of Mechanics coming into contact with the boys attending the School [the Institution] and especially to have them coming for evening classes into the front grounds'.[42] Renting out the north wing instead solved this problem, as it was separate from the main building (Fig. 37). The proximity of the school – and obliquely, of the lower ranks who would form the bulk of its pupils – had been a subject of concern to the Institution for some months, as reported at its annual meeting of proprietors, held on 3 July (1849): 'The new North wing presented the means of affording abundant accommodation … as the portion of it required could be isolated, giving the persons attending the new establishment a distinct entrance, and keeping them apart from the other departments.'[43] Financial considerations were also behind the Institution's offer of this part of its premises. The north wing had housed the collegiate department, which had closed due to

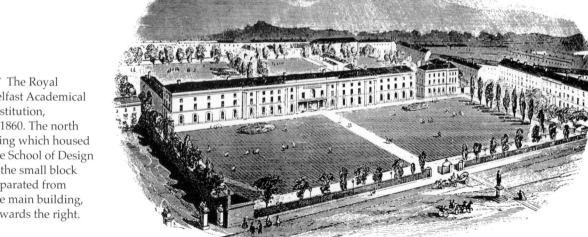

**37** The Royal Belfast Academical Institution, *c.* 1860. The north wing which housed the School of Design is the small block separated from the main building, towards the right.

the impending opening of Queen's College.[44] The Institution had lost its government grant because of the closure. The rent from the school would therefore help offset this reduction in income.

As it transpired, the decision to rent the north wing proved to be unfortunate. By late October, after the school had taken possession of the building, it became apparent that the premises were unsuitable to house a sculpture gallery, as the floors of the first and second storeys were too weak and the ceilings too low; also, the space on the ground floor was too restricted for the purpose.[45] The school therefore inquired if the Institution would erect a separate sculpture gallery for its use, to adjoin the north wing. This particular amenity, the school maintained, was not only important for its pupils – it was also a means of refining public taste. Furthermore, it was a vital component of the school's long-term plan, namely, the establishment of a museum of art and industry, the core of which would be the sculptures provided by the Board of Trade. If the Institution was unable to erect the gallery, the school stated that it would have no alternative but to give up the premises. The school therefore requested the Institution to regard its communication with it on the subject as equivalent to the required six months' notice to leave. As time would prove, there seems to have been more bravado than intention in this announcement, as the school was to remain in the building for the duration of its existence, despite the fact that the sculpture gallery problem was never resolved.

## FIRST PHASE AND TEMPORARY CLOSURE 1849–54

The school opened on 6 December (1849) with 130 pupils in the public classes and, by Christmas, twenty-seven in the private.[46] As an incentive, Lord Dufferin offered a prize of £50 for the best design for a damask tablecloth, a gesture aimed primarily at those in the public classes. His hope was that the prize-winning design would be taken up by a Belfast manufacturer and the finished product shown in the forthcoming Great Exhibition. With his approval, the prize money was later divided into a number of smaller amounts for designs for various items in linen and its packaging – a much more practical use of the money, considering the various branches of local manufacture dependent upon decorative art.[47] As an incentive to the parents of private pupils, pupils from the same family, after the first student, were to be charged only half-a-guinea a quarter, instead of a guinea.[48]

The school's first annual general meeting of subscribers was held on 25 January 1850.[49] James MacAdam, Jr, in his role as honorary secretary, described the progress made to date. Of the 137 pupils in the public classes at that point, 119 were male and eighteen female,

with 119 in total being under the age of thirty. The overall age ranged from twelve to fifty. Amongst the male students there was a selection of trades – bookbinders, cabinet makers, carvers and gilders – but only six designers or would-be designers of sewed muslin. Of the female students, three were muslin embroiderers and three teachers. Thirty-eight students in all were unclassified as to trade. Whether students were sponsored by their employers is unclear; furthermore, there were no details given of their social background. However, the fact that the admission charge to the public classes was relatively low – 1s 6d for males per month and 9d for females – suggests that a wide spectrum of the artisan class would have been able to attend. As an incentive to help improve the standard of textile design, the chief purpose of the school, MacAdam announced a number of new prizes: £10 from John Henning of Waringstown for the second best design for damask, this then to be shown at the Great Exhibition; £5 from the same donor for the best design for the centre of a damask tablecloth, to be competed for by amateurs throughout Ulster; £20 from the school itself, to be distributed in a number of small amounts for a variety of excellence. Such money prizes were doubtless a great incentive to the students. He also referred to the school's own financial situation and appealed for assistance with the rent and sundry expenses, as there was little balance in hand.[50]

The inauguration of the school on 10 April (1850) was a glittering occasion, attended by a large and select audience which included the mayor and town council.[51] Appropriately, an exhibition of locally manufactured ware – furniture, crystal ornaments, fine book bindings and damask and muslin goods – filled one of the rooms. Lord Dufferin, who gave the inaugural address as president, described the origin of the Schools of Design and the reason for their foundation. Besides details like these, he broached a topic he was to stress in future years: female students in the private classes. With flirtatious jocularity, he impressed upon his middle- and upper-ranking audience the existence of 'an especial room for ladies' and referred to Nursey, the headmaster, as 'a kind of Apostle of Beauty', with 'a number of lovely disciples'.[52] This reference to female students was more than mere flattery, for income from private pupils was important to the school's finances. There were probably many young women in the locality with leisure time to devote to the polite arts of drawing and painting. Dufferin, behind this teasing facade, was thinking in practical terms. As a further example of his commonsense approach, he announced his intention of founding a scholarship worth £20 a year and called on others to do the same. This met with results for, after the speeches, Robert Blakiston Houston of Orangefield declared he was going to do likewise, to the value of £10 a year.

Though the school was now endowed with a number of prizes and scholarships, it had not been so fortunate in its appeal for donations for its proposed museum of art and industry. Gifts of statues and objects of *vertu*, reported in the press as having been promised by late October 1849, seem not to have materialised to any great extent – by this point (April 1850), only two people had given items: William Bottomley of Fortbreda, who had donated a cast of a statue of Achilles, and Dr William Magee, who had presented a set of books on anatomy and art.[53] The *Northern Whig*, in its report on the gifts, urged others to follow suit.[54] This lack of generosity by supporters was to bode ill for the formation of the hoped-for museum of art and industry, which, in fact, never came about. It is worth speculating that had owners of collections come forward with donations, Belfast might have had an art gallery and museum in the 1850s, instead of having to wait until 1890.

By the autumn of 1850, the school was producing work of an impressively high standard, as illustrations of items shown in the Great Exhibition indicate. (It was for designs for these that Lord Dufferin had donated the £50 prize the previous December, as detailed above.)[55] The exhibits, their decorative patterns derived from plant and flower forms, reflect with great credit on the school. The prizes were awarded in September, November and December 1850.[56] Lord Dufferin's first prize of £15 for the best damask tablecloth (Fig. 38) went to Hugh Blain, whilst his second, of £10, also for a tablecloth (Fig. 39) went to John Mackenzie. A third tablecloth (Fig. 40), designed by Joseph Blain, also received a prize – £10 from damask manufacturer John Henning. Prizes were also awarded for a range of other items:

38 Damask tablecloth design by Hugh Blain, which was awarded Lord Dufferin's £15 first prize. The cloth, manufactured by John Henning of Waringstown, was shown in the Great Exhibition of 1851.

39 The 'Ardoyne exhibition pattern' tablecloth design by John McKenzie, awarded Lord Dufferin's £10 second prize. The cloth was produced by Michael Andrews of Ardoyne and shown in the Great Exhibition of 1851.

**40** Design by Joseph Blain for the centre of a damask tablecloth, awarded a £10 prize from damask manufacturer John Henning. Was manufactured by Messrs Corry, Blain and Co. of Belfast and shown in the Great Exhibition of 1851.

**41** Linen band designed by Samuel McCloy and awarded a prize of £3 by Lord Dufferin. Was shown in the Great Exhibition of 1851. Decorated paper bands, used in the wrapping of linen for export, were an important sideline of the linen trade.

a linen band and a decoration for a box of muslin (Figs 41 and 42), both by Samuel McCloy, an embroidered chemisette (Fig. 43) by Isaac Waugh and an embroidered vest (Fig. 44) by James B. Williamson. No material produced at the school, neither drawings, designs nor linen bands, is known to have survived. These illustrations from the Great Exhibition catalogue are therefore of considerable interest and value.

The first official report on the school, issued by Ambrose Poynter in October 1850, in his capacity as inspector of the Schools of Design, was both positive and illuminating.[57] The production of linen bands received a particular mention for improvement had already been seen in this area. In 1847 a Belfast stationer had begun their manufacture and employed a press to emboss them. Now, he had nine embossing presses in operation and other local stationers had also started to produce them.[58] Whilst the Belfast bands were still inferior to those designed in Paris, their quality had begun to improve and demand for them was increasing. With the help of the school, it was hoped that they would become 'a home manufacture, and secure to the town … an annual expenditure of £60,000, now paid to strangers and foreigners'.[59] Although it was too soon to comment upon the progress of the classes, the industry of the students was undoubtedly stimulated by the prizes and scholarships to be competed for. Poynter praised those who had funded these and stated that Belfast was ahead of the other provincial schools in this respect.

Such criticism as he had was reserved mainly for the school building, which was not best suited to the exhibition and lighting of the cast collection. His hope was that better accommodation would be found

for the casts, before their unsatisfactory display became a problem for the progress of the advanced classes, who studied the human form in depth. His comments on this issue were especially apt for the question of the sculpture gallery had been raised repeatedly throughout 1850. At the beginning of the year, the school had made an unsuccessful appeal to the government for an extra £600–£700, to complete work on the premises and erect the gallery.[60] The matter then reverted to the Institution, which, by May, had also made a fruitless approach to government for funds for the purpose.[61] Still anxious for some form of settlement, the school then requested the Institution to reduce the rent and provide sufficient ground for the erection of the building.[62] Negotiations concerning this were to drag on until November 1850, when the Institution finally agreed to reduce the rent by £50 a year,

43 Embroidered chemisette design by Isaac Waugh, awarded a £5 prize by Lord Dufferin. Was manufactured in muslin by John Holden of Belfast and shown in the Great Exhibition of 1851.

42 Design by Samuel McCloy for the top of a box of muslin, which gained a £2 prize from Lord Dufferin. Was shown in the Great Exhibition of 1851. Attractive packaging was an important aspect of the textile trade.

44 Embroidered vest design by James B. Williamson, which gained a £5 prize from Messrs John G. McGee and Co. of Belfast. Was manufactured by Messrs McGee and shown in the Great Exhibition of 1851.

gave ground rent-free for the proposed gallery and also permitted the school to continue to use a ground floor lecture room as a temporary exhibition space.[63]

These concessions appear to have given the project greater impetus for, a month later, the school informed the Board of Trade that plans were under way to raise the £400–£500 needed for the gallery by local subscriptions, in the certainty that 'its establishment will add greatly to the efficiency of the School both as a direct means of educating designers and as tending to encourage among the people of Belfast a taste for art'.[64] The provision of this amenity was to become one of the major issues of the next few years.

The following year – 1851 – saw the emergence of another topic which was to become well-aired during the course of the school's

existence: the lack of female students in the public classes. The issue was the sole subject of disquiet in the *Annual Report*, published by early March.[65] The school's main concern was the fact that whilst the number of male students in these classes had reached 150 at times, the greatest number of female students had been only seventeen so far. This figure was inexplicable to the committee, given 'the great extent to which the latter sex is employed in the sewed muslin manufacture, and in fancy needlework of various kinds'.[66] Even though these women and girls were not involved in the actual design process in their places of employment, the committee believed that the standard of their needlework would be improved by attendance at the school. It was hoped that by the following year, there would be many more female students on the register.

Shortly after the publication of the *Annual Report*, the scarcity of female entrants was again highlighted, this time at the annual *conversazione* and prize distribution on 18 March. (*Conversaziones* or social gatherings were to become a feature of the school year.) Committee member James Gibson, who presented the prizes to the female competitors, voiced his own ideas as to the cause, suggesting as reasons 'the extreme sensitiveness of the female character' and 'that shrinking diffidence and … sense of duty which confines woman to the domestic circle'.[67] The young Earl of Belfast (Fig. 45), the main speaker of the evening, was also at a loss to explain the low numbers. He hoped that the 'fair ones' would eventually realise their mistake and avail themselves of the training on offer. Of the real cause of the lack of female students in a town where large numbers of women and girls were employed in textiles, one can only speculate at this point. Many of those engaged in the textile industry probably had domestic commitments and were perhaps more concerned with earning a living than in studying design. The fact that they were not involved in the actual design process in their work places was possibly another reason, as was perhaps conditioning to the traditional passive female role. At the Dublin school, the situation was very different. There, the public classes in 1851 contained sixty-nine females who planned to be teachers, five to be artists, ten to be designers and a large number without any career intentions whatsoever.[68] There was also a noticeable absence of any kind of craft worker, a reflection of the city's lack of an industrial base. These figures, comprising a sizeable number of students for whom art would be part of their careers, together with many studying for pleasure, are perhaps a reflection of Dublin's position as the artistic centre of Ireland and of a greater awareness by its female population of the value of art and a training in the subject.

Proceeds from the *conversazione* and prize distribution were used

to launch the fund for the much-needed sculpture gallery.[69] The event was attended by about 500 people; unfortunately, the amount of money raised is unknown.[70] Whatever the sum, it was obviously large enough to drive the project forward, for by mid-May, arrangements had been made to obtain specifications for the building.[71] Another visit by Ambrose Poynter the following month, during which he expressed his wish to see the gallery completed, seems to have instilled a greater sense of urgency into the committee.[72] By the beginning of October, it had received a number of plans and tenders for the building and had had a succinctly-worded appeal printed to send to subscribers.[73] Its message was simple and direct: £650 was required to erect the gallery, without which the school could not provide an adequate education for designers.

As if this one project was not enough, a meeting was held in the school a few weeks later to consider a second – the establishment of a picture gallery or exhibition room in the town.[74] Amongst those present were figures well known in the Belfast art world, like the collectors John Clarke and Francis McCracken, the amateur watercolourist Dr James Moore and the school's headmaster, Claude Lorraine Nursey. A committee was appointed to pursue the proposal. It was also decided to send a memorial, via the Marquess of Donegall, to Prince Albert and the commissioners of the Great Exhibition, requesting a grant for the undertaking from the proceeds of the exhibition. Whether this petition was sent or replied to is unknown, as, indeed, are any further details of the venture. That it should have been broached at the same time as the sculpture gallery appeal seems both foolhardy and over-optimistic, given Belfast's lack of generosity in the promotion of large-scale fine arts projects.

The sculpture gallery itself fared little better than this mysterious art gallery, for when Poynter visited the school again a few months later, in December 1851, he was informed by the committee that no further steps were being taken to raise money for it until the spring of 1852, as funds were being asked of the public for several other purposes. Exactly what these were remains unknown. However, if the amelioration of winter destitution and hardship was part of the cause, this would almost certainly have met with much more sympathy than an art-related proposal.

Poynter's visit served to highlight the progress of the school thus far.[75] Two new prizes for the two best designs for chintzes had been funded by James Girdwood, owner of a carpet and damask warehouse.[76] Attendance figures for the public classes had increased by twenty-four since November 1850; there were now 119 male and sixteen female students. Evidence of rising standards was to be seen in the high quality of the students' designs submitted to the Great

**45** Charles Baugniet *Frederick Richard Chichester, Earl of Belfast (1827–53)* (1852)
The earl, a vice-president of the School of Design, was greatly interested in the education of the working classes. One of the objects closest to his heart – but which never materialised – was the establishment of an Athenaeum (or centre for the promotion of learning) in Belfast.

Exhibition; also in improvements in the work of the professional designers who had attended classes for a time. Poynter concluded by recommending that teachers of national schools and schools for the poorer ranks be admitted free, to enable them to impart sound methods of drawing to their pupils. Although some of the English Schools of Design had already provided this for teachers, with considerable success, it is unclear if it was ever put into effect in Belfast.

By March 1852, the school had built up a solid base of local support, and had had a considerable impact on certain locally-produced goods, according to details supplied by Lord Dufferin at the annual *conversazione*.[77] As regards the extent of support, he stated that in the year ending June 1851, over £400 had been collected in subscriptions, which was more than had been raised in Cork and Dublin and in a number of the leading schools in Britain.[78] Of the practical benefits of the institution, he quoted a recent official statement by Poynter:

> The progress of the Belfast school continues to be satisfactory, and it has identified itself with the manufacturers of the town to a degree which no other school has ever attained within the short period that has elapsed since its establishment. The manufacture of 'linen bands' and 'headings' has very greatly increased – probably threefold – since the establishment of the school, and the improvement of the quality of these articles in a still greater proportion is directly due to the pupils of this school. The embroidered waistcoat trade is also increasing, and the school has undoubtedly contributed to its advance.[79]

The £400 or so from local patrons must have been greatly reassuring to Dufferin and the committee, in view of a current proposal by Henry Cole, head of the recently-established Department of Practical Art, to make the branch schools self-supporting; in effect, to reduce their government grants.[80] In Cole's opinion, the government should give town councils the power to levy a moderate local rate for the upkeep of the schools, as 'a dependence on local, rather than general taxation, is calculated to awaken the greatest amount of local interest and attention to the subject'.[81] Nursey supported this approach. Writing to Dufferin in April (1852), he maintained that:

> The only sure way of freeing this School from the inconvenience and uncertainty of annual subscriptions … will be to empower the Town Council, and if possible compel them to levy a rate in aid, one ½d in the pound would give a sufficient income for this school. There appears to be some objection to this in Belfast, and I fear [it] never will be done without compulsion.[82]

Although it was to be another few years before Cole's new self-supporting system made an impact on the Belfast school, Nursey's belief that the town council would shy away from helping it, turned out to be the case.

Another important indicator of progress, in addition to the above-mentioned subscriptions and improvements in certain home-produced manufactures, was the competing for prizes in the local and London competitions. This was a high-profile feature of the establishment and a considerable incentive to students. That the school took much pride in this side of its operations is clear from the fact that, by the spring of 1852, it had formed a comprehensive collection of all of its prize-winning designs.[83] Unfortunately, the whereabouts of the collection – obviously formed for posterity – is unknown. Throughout 1852 the students continued to distinguish themselves in this way. In the summer, eight won medals in an exhibition of drawings submitted by pupils of a number of Schools of Design, held at Marlborough House in London.[84] One of the group, Samuel McCloy, was later awarded a scholarship to the central school in London, a considerable personal achievement and an honour for the Belfast school, as only eight such scholarships were granted in the whole of the United Kingdom.[85] Another student, Anthony Carey Stannus, also received an accolade, being appointed a trainee master by the Department.[86] All in all, by the end of 1852 the school had acquitted itself ably, both on the local scene and in a wider arena.

In the matter of the sculpture gallery, progress was finally made in this long-running saga in the spring of 1852. By March the committee had accepted a design by the eminent local architect Charles Lanyon for a building sixty feet long, thirty feet wide and twenty feet high.[87] Lanyon was one of the school's vice-presidents and the choice of him as architect may seem a trifle irregular to modern eyes; nevertheless, he was a keen supporter, had knowledge of the cast collection and its associated problems and may, indeed, have given his services at low or no cost. Having come thus far, the school now planned to begin fund-raising in earnest. Efforts got off to a happy start at the end of March, when Dufferin donated £50.[88] Unfortunately, a few months later, the project was shelved yet again, this time because of the well-meaning but somewhat misjudged intervention of the Earl of Belfast, ironically a keen supporter of the arts.

Amongst the earl's wide-ranging interests was the education and social improvement of the working classes. Motivated by this, he devoted much time during 1851 to the Belfast Working Classes' Association and, in March and early April 1852, delivered a series of lectures in the town to help raise funds for the Association's library.[89] His charitable impulses did not end there; what he really

wished to see was the establishment of an Athenaeum, a centre for the promotion of learning. Later in April, he called a public meeting to discuss the project.[90] Whilst he had no thoughts as to how the institution should be run, he was adamant that it should be 'on a scale commensurate with our city's importance ... that it shall be the parent shield under which the various societies that now separately strive to promote science and art shall join and be protected'.[91] Furthermore, he was convinced that if the building was handsome and in a good locality, people would 'gladly bequeath legacies of money, of books, of pictures, of collections, to an institution which they consider an ornament to the town'.[92] He urged the different societies to unite and pool their finances.

Though the earl may not have given much thought to the organisation of the Athenaeum, he had certainly devoted a great deal to its establishment for his proposal was both imaginative and radical: the School of Design should ally itself with the promoters of the Athenaeum and use the funds collected for the sculpture gallery to erect it in the Athenaeum, not 'in the concealed locality in which it was proposed to build it'.[93] In effect, what this proposal amounted to was the removal of the school to his projected new building. There was historical precedence for such an establishment; as he pointed out, in many towns Schools of Design were associated with mechanics' institutes – 'How much more in its place, then, would the institution [that is, the school] be if incorporated with the more comprehensive establishment of an Athenaeum!'[94] The proposal seems to have struck a chord for, almost immediately, John Mulholland of the York Street Flax Spinning Mill contributed £200 and several other supporters also promised large donations. In the light of these new developments, the school did not pursue the matter of the sculpture gallery any further during 1852. Unfortunately, the Athenaeum project was not taken any further either, as the earl was forced to winter abroad because of his health. His tragic early death in February 1853 appears to have been a severe setback for the movement, judging by a comment in the press the following April – 'Had the amiable and early-departed Earl of Belfast been now alive, there would have been, we are confident, no necessity for us to urge the promoters of erecting an Athenaeum in Belfast to greater activity in the forwarding of that object.'[95] The amount of money realised for the project is unknown.

The early months of 1853 saw no further movement with the sculpture gallery and by mid-April the issue was again to the fore, in press coverage of the school's annual meeting of subscribers:

> The important question of a gallery ... is still in abeyance. A number of gentlemen have already liberally contributed ... and

... a site directly adjoining the school has been obtained from the Royal [Belfast] Academical Institution. The chief cause of the delay ... was the movement originated by the lamented young Nobleman [the Earl of Belfast] ... having for its object the foundation of an Athenaeum ... Considerable difficulties surrounded this project, and it is the opinion of the majority ... that the movement was rather premature, or, at least, that the large sum requisite for the establishment of an Athenaeum on the extended plan proposed ... could now with difficulty be raised by voluntary subscription. Should this opinion ... prevail with those who were acting in concert with [the earl], and induce them, for the present, to relinquish the project of an Athenaeum, your Committee believe that there will be little difficulty in at once obtaining from the public the sum necessary for a Statue Gallery.[96]

From this point, unfortunately, the committee was forced to direct its attention to more pressing matters, namely, administrative changes which were to have damaging financial consequences for the school. As a result, the sculpture gallery project was set aside indefinitely; in fact, the building was never erected. As for the Athenaeum, its promoters obviously abandoned the plan, as the school committee wished, for it too was never built.

Despite impending problems, the committee presented a positive image at the above-mentioned annual meeting of subscribers. According to the *Annual Report*, there were 212 students on the register – 152 in the public classes and sixty in the private.[97] Two new scholarships had been established, funded by Charles Lanyon and S.K. Mulholland, owner of the Durham Street Mill, bringing the total of these up to five. A second student, James B. Williamson, had been appointed a trainee master by the Department. The government grant for 1852–53 had been £600 (it had been increased by £100 by this point), local subscriptions showed no signs of falling off and the school was completely out of debt.[98] Schools of Design were now to be designated 'Schools of Art'; however, to avoid confusion with the School of Art which opened in the town in 1870, the term 'School of Design' will continue to be used here when referring to the 1850s institution.

Behind the spirit of optimism evident at the meeting, the committee must nevertheless have felt considerable apprehension about the future because of a Board of Trade Minute of 25 March (1853). Relayed to the school in a circular of 14 April (1853), the document contained an ominous clause respecting the government grant for 1853–54:

It was understood, on the establishment of the Schools, that a Government Grant was promised for a limited period of three

years, upon the condition that a sum equivalent to it was raised in the locality; and, on the expectation that, after three years, the Schools would be so established and supported as not to require any further assistance from Government.[99]

The document also delivered a second major blow. In future, the grant was to be confined to matters relating to the masters' salaries, teaching, scholarships and training – and was not to be used for the upkeep of the school, payment of the rent, officers' salaries or prizes.

On 18 May the school secretary, James MacAdam, Jr, wrote to Henry Cole, head of the Department of Practical Art, concerning the content and implications of the document. MacAdam maintained that there had been no such time limit of three years regarding the grant, in the discussions he had had with officials and the Lord Lieutenant. 'On the contrary', he recalled:

> it was distinctly intimated to me, that the Annual Grant ... for the support of the Irish Schools, or at least of the Belfast School, was to be given free of any stipulation except that the salaries of the Masters should be the first charge upon it; and it was further expressly stated, that, if the town of Belfast would raise a sum adequate to the efficient establishment of the School, the amount of future years' Grants would be increased, without the town being called upon to continue subscribing in the same ratio.[100]

If the document was strictly adhered to, MacAdam pointed out, a sum of £315 would be needed annually to pay the rent, officers' salaries, prizes, fuel, gas and sundries. Whilst about £200 of this could be collected through local subscriptions and about £50 from fees, there would still be a deficit of about £65–£70. The committee was convinced that this could not be raised by public appeal; in its opinion, the school could not depend upon an increase in public support. Its reasoning is interesting and illuminating:

> It may appear strange, that a larger yearly subscription list could not be filled up in Belfast; but it is to be observed that local charities are very numerous; that public institutions, to meet the exigencies of a mercantile and manufacturing community of 100,000 souls, are equally so; and that Societies for the cultivation of Literature and Science are in fair proportion; all of these being held to possess the first claims to support, among the great mass of our fellow-citizens, who have, as yet, scarcely begun to appreciate the, to them, novel subject of Art Education.[101]

MacAdam's letter also contained an ultimatum: the committee would not hesitate to resign, if faced with mounting debts from year to year.

Despite this worrisome scenario, the school continued to function in its usual businesslike fashion. In June it was announced that five medals had been awarded in the competition of drawings from provincial schools, held in London.[102] This was a considerable achievement for Belfast and placed it ahead of Dublin and Cork in the winning of medals. However, such distinctions appear to have made little impression on Henry Cole, in his drive towards self-sufficiency. In December the school received a letter from the Board of Trade, in response to objections which the school had made to the above-mentioned Board Minute of 25 March.[103] Pointing out that the cost per student at the Belfast school was over £5 3s 7d per year, the Board criticised the fact that out of a population of 75,000 in the town, not even 200 persons were willing to avail themselves of the teaching on offer. Such figures would not justify the Belfast school being exempted from the document's various conditions; furthermore, other schools in Britain and Ireland were able to operate successfully on a self-supporting basis. It was the Board's opinion that the principle of self-sufficiency, already successful in schools in small towns, 'may be eventually applied with at least equal success to populous thronging Manufacturing towns'.[104] MacAdam queried the Board's figure of £5 3s 7d (which was considered high) and reckoned it to be about £3 19s 5d a head, inclusive of the private and governess classes. This was below the cost per student in eight other schools. Whatever the end result of the calculations, each side by this point regarded the other with disfavour; the school saw Cole as the villain and engineer of the Board's ruthless drive to cut costs, whilst Cole and the Board appear to have considered the school a drain on the public purse.

The following year, 1854, was in reality the beginning of the end for the school. Trouble began in the spring, when a row blew up between the committee and Cole, regarding Nursey's role on the former.[105] Apparently, Cole had stipulated that Nursey join the committee. This he did, and in a role akin to that of a chairman. The committee protested strongly against this for reasons of propriety and pointed out 'the inconvenience which must arise from any officer being constituted a co-ordinate member of a committee, which … was the party to superintend that officer's conduct amongst its other duties'.[106] In taking this stance, the committee intended no personal criticism of Nursey; rather, the complaint arose from its objection to the officer of an establishment sitting on its committee. At some point during March, a deputation headed by Dufferin visited Cole in London to plead the case. Cole conceded the point and Nursey was removed. In these manoeuvres, it is tempting to see Cole trying to impose direct control from London by stealthy means. Whether this was so, the incident heightened the ill-feeling between the committee and Cole

and gave the latter useful ammunition with which to score points over the committee a few months later.

Despite this dissension and fears for the future, the annual *conversazione* and prize giving on 6 April was, as always, a grand occasion.[107] The *Annual Report* was read to the gathering as usual. One of the most important issues highlighted was the fact that the ethos of the Schools of Design had changed during 1853–54. Formerly, they had been aimed at artisans – now, as Schools of Art (which they had become in 1853), their facilities were to be extended to all classes. The committee had therefore established a three-tier system of fees geared to the various social ranks: a rate 'sufficiently high to ensure only a select and limited number'; a cheaper rate for those unwilling or unable to pay the 'first-class' fee; and a rate comparable to that paid by artisans in the evening classes. It was hoped that the school would now be used by the children of the town's 'respectable and wealthy citizens', those who could afford the first or second category of fee. These children had apparently derived little benefit from the school as yet.

Of student progress, three pupils had been appointed masters: Samuel McCloy to Waterford, Anthony Carey Stannus to Dowlais in Wales and James B. Williamson to Newcastle-under-Lyme. A total of 245 pupils were in attendance: 100 males and nine females in the public classes, twelve in the governess classes and forty-three in the private (twenty-nine ladies and fourteen gentlemen). Eighty-one school children (the social standing of whom is unknown) were also included in the final figure. Following the *Annual Report*, the main speech of the evening was delivered by Hugh McCalmont Cairns, one of the school's vice-presidents and a member of parliament for the borough. He concluded by stressing the need for a museum of art and hoped to see one erected in the not too distant future, funded by the town's 'own unaided exertions'. Considering that the sculpture gallery had still not materialised and the Athenaeum project had already collapsed, his statement seems decidedly over-optimistic.

Within a few months of the *conversazione*, events took a turn for the worse. The immediate cause of the crisis was the announcement by the Department in June that it proposed to reduce the masters' salaries to a fixed amount of £50 (previously, the headmaster had been paid £300 and his assistant £143), leaving the remainder to be made up out of pupils' fees).[108] The proposition was greeted with derision by one particular local newspaper, the *Belfast Commercial Chronicle*, which expressed disgust 'with this cheese-paring economy' and claimed that 'there can be nothing more certain than that to pay one pound sterling a week to men of genius and practical talent … is a mockery'.[109] Probably hoping to calm the situation, Nursey immediately sent a

letter to the newspaper's editor, stating that the masters of the old-established schools (those which had been set up with large grants) had received guarantees that they would not suffer pecuniary loss under the proposed changes and that only schools about to be established would be affected.[110] Nursey appears to have been either misinformed or overly sanguine on this latter point for, as it transpired, all the schools, old and new, had to adhere to the new ruling.

What happened next was something of a mystery at the time and remains so today. In July (1854), Nursey was abruptly transferred to Norwich, to take charge of the school there. His removal and also that of the second master, without any prior notice to the committee, received little mention in the local press at the time but was reported in the *Belfast Daily Mercury* some six months later, in a résumé on the school's closure.[111] Apparently, according to the recollections of committee member Michael Andrews, Cole stated that he had been obliged to remove Nursey from Belfast because of a disagreement between Nursey and the committee. When Andrews asked Nursey if he had complained to Cole about the committee, Nursey denied it and declared that 'he wished to get a berth for himself' because of disagreements between the committee and 'head-quarters'. Amongst these mysterious events, one thing seems clear – whilst Nursey may have wished to leave, he did not actually resign, otherwise the committee would have been aware of it. That his going was unexpected is obvious from Dufferin's recollection of the occasion, written in 1855: 'Mr Nursey a most excellent instructor, was conjured away from us (in a manner I could never clearly understand) and located at Norwich.'[112] In the absence of further information, it seems not beyond the realms of possibility that Cole used the disagreement of the previous spring (when the committee had objected to Nursey being a member) to transfer Nursey and thus gain revenge for the committee's defiance of his machinations.

The school did not reopen after the summer recess, as there was no headmaster or second master. The cause of the vacancies lay with the committee, who steadfastly refused to believe that a competent master could be found for the small fixed salary to be paid under Cole's new system. According to the Department's report of 1855, the committee maintained that 'such an arrangement would be anything but likely to secure a person fit to take in charge such a school as Belfast'.[113] The committee had therefore decided to refuse any master unless he had been in charge of some considerable establishment – and so the school had remained closed. Moves to fill the post seem to have been initiated in September, as the *Belfast News-Letter* of 15 September referred to Andrew Nicholl as being a candidate. However, there was no appointment made and the position remained vacant.

The school continued in limbo during the next few months, nor was there much mention of it in the local press. Not until December was there a flurry of activity, when a special meeting was held on the 18th of the month, to explain the financial situation.[114] Apparently, there were debts of £150, an additional £150 was owed in rent and various other amounts had to be paid to those who had won scholarships. The deleterious financial consequences of the regulations Cole had put into place since assuming control of the Department were also highlighted, changes which were the cause of the current debt. A last-ditch attempt by Cole to help the committee was also discussed. Apparently, as an inducement to the committee to give his new system a year's trial, he had promised to make up any deficit for the year ending April 1854. He had done that. Since then, he had refused to help and the committee was now on its own.

The administrative changes and their implications, spelled out at the above meeting, are not particularly easy to follow. A clearer picture of the end result can be gleaned from the Department's reports, where the extent of the cut in the grant speaks for itself. In 1852, for example, the school used the £600 it had received from the government to pay the masters' salaries of £370 and the remainder for rent and general upkeep.[115] Any extra money needed was taken out of the pupils' fees and local subscriptions. However, for 1853–54, the government gave only £125 towards the masters' salaries and £182 4s 8d to help with scholarships and training – a substantial difference from the earlier grants.[116] Any additional funding needed had to be raised from local sources, which had proved an impossibility. In the position in which the committee now found itself, one of mounting debt and no guarantee of extra help from the Department, it resolved to close the school at a meeting on 29 December 1854.[117]

Belfast was not the only school to experience problems. The two other Irish establishments run on the old system of large grants, namely Dublin and Cork, also went through crises. The Dublin school was forced to lay off four assistant masters who did not have the required London certificates of competency (another stipulation of Cole's new system) and had to employ three pupil teachers out of its own funds.[118] Nevertheless, despite some difficult years, it managed to survive and flourish. The Cork school suffered the same fate as Belfast's and also closed in December 1854, as a result of the reduction in the government grant and the ending of an annual grant of £200 from the city corporation.[119] Undaunted, after a meeting of leading citizens and public representatives on 28 August 1855, the ratepayers of the city opted to raise a rate of one halfpenny in the pound towards the school's upkeep, under the Public Libraries Act (Ireland) of 1855. This permitted a maximum rate of one penny in the

pound to be raised for the establishment of free public libraries and Schools of Art and Science.[120] The school reopened on 8 January 1856, flourished and, in 1884, became the Crawford School of Art.[121]

It must be asked – why did Belfast not follow Cork's example and raise a rate to reopen its school? The main reason was probably the crisis in which the town council found itself in 1855. In 1853, a disaffected local solicitor, John Rea, had filed a suit against the mayor and council of Belfast, charging them with violating several local acts and accusing the town clerk of fraudulent practices.[122] The case was heard by the Lord Chancellor of Ireland in mid-June 1855 and all the main accusations were found proven: the council had borrowed in excess and illegally and had misapplied funds.[123] In the light of this event, which brought dishonour and shame to the council, it is hardly surprising that they chose not to take up the cause of the school.

Nevertheless, notwithstanding this upheaval, the council did in fact discuss the establishment of a library some six weeks after the June ruling, in consequence of the Patent Office offering 200 volumes on patents to the town, to be placed in a free public library, or in one which might be formed at a later date.[124] The mayor, Thomas Verner, whilst in favour of accepting the books, urged caution in the matter of a library. In his opinion:

> With regard to asking for a new rate, to be levied on the town of Belfast, I don't think this is the moment to do it. I don't think, in fact, that anything coming from the Town Council at the present moment would be well received by the public, particularly anything in the shape of an additional rate, and although this is a most worthy object, I should hesitate before I should call upon the inhabitants to tax themselves for the establishment of an Institution, however worthy of support.[125]

Thereafter, the subject was dropped. If the library project was not considered feasible by the council at this point, how much less so was the School of Design, an establishment with a more limited appeal and a specialist body of users.

### A SECOND SPRING 1856–58: REOPENING AND FINAL CLOSURE

At some point prior to September 1855, the committee requested the Department to send over 'some competent person' to help sort out the whole sorry business.[126] The emissary was Dr Lyon Playfair, Departmental secretary for science and art. For the meeting with Playfair, which took place in mid-September, Dufferin set out in draft

form the committee's position, namely, the impossibility of meeting an annual expenditure of £450 with an annual income of £120. He was adamant that there was no possibility of the school becoming self-supporting and that the maximum income the committee could hope for was £200 per year. If the Department refused to make up the difference between income and expenditure, the school would have to remain closed – the committee would not tolerate the prospect of an annual deficit. Finally, he stressed that permanent closure would be regarded by the committee members as a great calamity, as their personal credit and reputations were bound up with the school.

In the event, a deal was struck through Playfair's intervention. The Department agreed to provide and pay a first-class master at a salary of £150 a year and an assistant on a smaller scale, this latter to undertake teaching duties in the national schools.[127] This payment was a sizeable increase on the £50 officially allocated by the Department. For its part, the school guaranteed to augment the salaries by half of the fees paid by the students. The committee decided to accept the deal at a meeting in the Chamber of Commerce on 24 September and also resolved to raise £200 annually towards the school's upkeep, independent of the grant. Donations and subscriptions amounting to £170 promised at the gathering – of which Dufferin gave £100 – were to be used to help clear outstanding debts of £300. At a subsequent committee meeting in November, a five-strong finance committee was set up, comprising members involved in the business world, a sensible move given that lack of funds was the main problem.[128] At this same meeting, it was decided to reopen the school, as the 'School of Art', on 1 January following.[129]

Now that the school was about to recommence, a concerted effort was made to attract a greater number of pupils to the classes instituted for the wealthier ranks. In late December, Dufferin, possibly mindful of the large number of female pupils at the Dublin school, made a special address to the young ladies of Belfast to come forward and enrol. Taking as his opening gambit the benefits of the private classes, he pointed out that although gentlemen could avail of these, they seldom had time to linger over such pursuits. On the other hand, he declared – in passages of increasingly purple prose – the situation was quite different with young ladies:

> Sheltered from infancy by the arms of love from the rude buffets of the world … destined to leave one home, only that you may be more cherished in another – your young hearts untormented by the fever of competition, the burden of responsibility, the gnawing anxiety of success, there is no need that you should undertake that severe intellectual discipline which is necessary to nerve

a man's faculties for the struggle that awaits them. But, on the other hand, though released from these iron obligations, it would be a great mistake to suppose that there is not a corresponding culture appointed for your girlhood, and quite as necessary to fit you for the gracious offices of your maturer years.[130]

The mission of woman's life was to illustrate beauty; towards that end, it was 'necessary for her to cultivate those faculties consecrated by nature to this purpose, to take advantage of every means to attain a correct perception of the beautiful, until her whole being is alive with its inspiration'. The study of art was the pursuit of the beautiful. Schools of Art were 'places where those who wish can learn the secret of that mystery whereby we disentangle the innate beauty and harmony of our existence from the earthliness and vulgarity in which the vileness of mankind has enveloped it'. An essential element of woman's life was 'to embody and render visible those laws of Beauty of which Nature has constituted you the Priestesses'. The study of art would be of considerable benefit in many areas of a woman's life, from the domestic sphere such as fashion and interior decoration to the appreciation of art treasures in art galleries. Furthermore, the personal satisfaction in being able to paint or sculpt would be immense. Proficiency in art would require comparatively little time to attain; it would require but a little practice to turn out faithful portraits of family and friends. Such an accomplishment would be a source of amusement to oneself and of happiness to others. He concluded by promising every accommodation necessary for the comfort of young ladies 'and it will only rest with yourselves to realise the most attractive part of the picture, by enabling the Belfast School of Art to boast that it can reckon among its pupils some scores "Of sweet girl-graduates in their golden hair"'.

Though Dufferin meant well, the address was ridiculed by a leading local newspaper, the *Belfast Daily Mercury*, on account of the patronising tone displayed. In its editorial, the paper declared:

> His Lordship wishes, very properly, to bring the female classes in to increase the ranks of the pupils in the School; but in his long letter he hardly hints at the object really in view, but indulges in platitudes upon female beauty, as if it were the flatteries of some vain man. This is totally out of the way ... the School of Design is a practical establishment, and such mawkish compliments are more than useless ... Lord Dufferin might have found better materials for appeal and exhortation, by referring to the many benefits which girls and women might derive from pictorial art ... than in uttering eulogies upon 'sweet girl-graduates in their golden hair', or any other coloured hair.[131]

The school quickly sprang to Dufferin's defence and at a committee meeting on 1 January (1856), passed a resolution of thanks to him for his admirable address.[132] The *Northern Whig* took a similarly protective stance and described the *Mercury*'s comments as 'impertinent and unwarranted'.[133]

Following these various comments, the young ladies themselves made a point of having their say. The first riposte appeared in the *Mercury* of 5 January, when an anonymous correspondent, styling herself 'Angelica Kauffman [*sic*]', condemned Dufferin's address as 'a tirade of unmeaning trash' and 'inflated nonsense'.[134] A second letter, entitled 'Gay girl-graduates', from the pen of one 'Kitty Connor of Collin [*sic*] Mountain' appeared in the same newspaper a few days later. Less direct but with much more sarcasm than 'Angelica', 'Kitty' expressed her 'surprise' at the *Mercury*'s scathing comments on Dufferin's address:

> Judge of [my] surprize on reading your remarks! Why, Sir, they are perfectly shocking. Would you have his lordship address young ladies in the staid and sober, or *sensible* style … of your editorial writings? Would you have his lordship tell us in a manner 'short, sharp, and decisive', that he wants us to become pupils of the School of Art? Why, we would not listen to him, nor would we go to a school over which his lordship presides. His lordship, with exquisite taste, very wisely eschewed such a style, and spiced his address with the exact modicum of blarney to suit the taste of our sex; and, not withstanding your spiteful remarks, I venture to say that a prettier or more poetical address never was penned – apt in its illustrations and its quotations, and bearing internal evidence of having been composed by his lordship while sauntering romantically along the sea shore.[135]

Unable to comprehend the *Mercury*'s lack of appreciation of the address, 'Kitty' left the editor 'to choke in [his] spite'.

Two further letters appeared shortly afterwards but in the *Northern Whig*. The first, from a Clara Meredith, took Dufferin to task for claiming that women did not need to pursue intellectual study, as men did. Such ideas helped keep women in an inferior position in society:

> Yes, my Lord, it is your fault, and not ours, that we require to be sheltered 'from infancy in the arms of love' … that grace and natural tact and elegance are but too often our substitutes for nobler qualities of heart and intellect; and that, instead of being a companion, we are frequently looked upon, and learn to look upon ourselves, as pretty toys … as pets that are to be caressed and

dressed … Let those who can, become the 'Priestesses' of Art; give them the means and opportunity of sharing in that ministration … let female names be added to the list of poets, painters, and other creative artists, in which they are not be found, and then, such pleasant railleries as yours will be no longer dangerous; nor will such sudden transition from the sublime to the ridiculous as you were forced to illustrate be any longer necessary to fill your school with pupils.[136]

The second letter, from a Martha Mackenzie of Glasgow in reply to Meredith, upheld the status quo regarding women's role:

Man's mission is active; he is a County-meeting, Petty-Sessions-attending animal … Preaching in his pulpit, judging from the Bench … this 'vindication' is, or ought to be … man's object through life. This 'vindication' of the truth is not required of woman. It is sufficient that she passively illustrates its sacred meaning … Let us, then, content ourselves with our share of the great work assigned to all, remembering that, 'they also serve who only stand and wait'.[137]

Such spirited responses (three, at any rate) were presumably not what Dufferin envisaged when he penned the address. As a tactical ploy, the plea appears to have had little impact; only thirty-eight females were in attendance by the end of June 1856, many of whom were probably from the artisan class (the ratio is unknown).[138] Nevertheless, irrespective of the results, the letters are an amusing episode in the history of the school and a fascinating reminder of the little-heard voice of women in Belfast in the mid-1850s.

The school reopened on 4 February 1856 under the charge of a new headmaster, J.D. Croome.[139] About £350 had been collected to pay off outstanding debts.[140] A few weeks before the opening, a touring exhibition of prize drawings from thirty-three other schools was held for a few days, a timely encouragement, probably, to new students and long-term supporters.[141] Although the show appears to have been little advertised – according to the *Belfast News-Letter*, most people knew nothing about it – news obviously spread by word of mouth for, on the fourth and final day, visitor numbers amounted to almost 1,000.[142] Notwithstanding the committee's unbusinesslike approach to this event, the school, once opened, got off to a good start for, by the end of February, there were 130 pupils on the register and it had become necessary to seek an assistant master.[143] The reopening had not gone unnoticed in the wider world. February's issue of the *Art-Journal* reported on the occasion with satisfaction but made a veiled criticism of Belfast's inability to support the school:

we are of opinion ... that large and flourishing towns ought mainly to support their own schools, and not rely upon extraneous aid. The place in which the school is opened, alone, or almost alone, is benefitted by the institution; and if the inhabitants are not disposed to make the necessary sacrifices for its support, they have no right to expect the public at large, through the government, should help them, except to a certain extent.[144]

The request to the Department for an assistant master was eventually granted and at some point before September, the successful candidate, Robert Hale, was in post.[145]

Compared with the earlier years of the school's existence, there is a marked lack of information about its last eighteen months, a silence reflected in local newspapers, which contain relatively few details. That it was still performing a useful service by June 1857 is clear, as pupil numbers were 607, a figure which included 257 children in national schools.[146] (The teaching of school children was part of the deal struck with the Department in 1855.) There were, though, only twenty-three 'young ladies', despite Dufferin's plea of December 1855.[147] A visit by a government inspector in October 1857 found him well pleased with progress, to the extent that he considered the school to be in a more satisfactory state, in many respects, than under the old system.[148] What exactly these 'respects' were is unclear, as finance was still a major problem. In its report of his visit, the *Belfast News-Letter* appealed to the public to give more liberally to the school, otherwise it would collapse.

By the following spring, the *News-Letter*'s presentiment regarding public indifference had been proven correct, as indicated by the poor attendance figures at an important event held at the school during February and March 1858, namely, a display of decorative art from the South Kensington museum and Queen Victoria's own collection.[149] The aim of the exhibition, which travelled to provincial Schools of Art throughout Britain and Ireland, was to help raise funds for the schools and to encourage the formation of museums.[150] A number of stipulations were attached to the show, the most important being admittance for the general public at a charge and a lower evening rate set for artisans. A percentage of the final profits was to go to the host school. Amongst the items from South Kensington were clocks, Chinese curiosities and pottery, whilst the queen's collection included Sèvres porcelain and lacquer work from India.[151] Local people also lent items: examples of damaskware, objects in gold and silver and a number of paintings.[152] The exhibition, which lasted twenty-eight days, must have been extremely impressive – the South Kensington exhibits alone amounted to over 500 items – yet the public's response

was lukewarm, despite a low admission charge.[153] The extent of this apathy can be seen from the visitor numbers at the various Irish venues: Belfast (3,322); Dublin (55,322); Clonmel (13,998); Limerick (10,527); Waterford (15,685).[154] Though of shorter duration than the others, the Belfast exhibition nevertheless received a surprisingly low turnout.[155] The final profit for the school was only £36, as compared with almost £200 each for Clonmel, Limerick and Waterford, with Dublin netting over £1,000.

At some point before June, the committee decided that the school could never become financially viable. General dispiritedness at the hopelessness of the task ahead may have been behind the decision; also, perhaps, disappointment at the decorative art exhibition's poor response and meagre profit. A final plea to the Marquess of Salisbury, president of the Board of Trade, and to Henry Cole for a renewal of the grant went unheeded and, on 8 June, the decision was made to close.[156] A resolution to this effect was ratified at a meeting of subscribers and friends on 14 June, when the financial situation was clarified. In fact, the picture was not so very bleak. Debts up to May 1858 were only £177, inclusive of rent.[157] If the uncollected subscriptions for 1857 – £97 – were called in, the deficit would be only about £37. (It is unclear how this figure was arrived at.) Nevertheless, daunted by the certainty of mounting debt, the committee felt it could no longer carry on. The school continued to operate for another month and closed on 15 July 1858.[158]

Reaction in the local press to the resolution to close of 14 June was mixed. The *Northern Whig* reported on the event immediately but made no editorial comment nor expressed any regret whatsoever at the closure, a peculiar attitude for a paper normally supportive of the fine arts.[159] The *Belfast Daily Mercury*, on the other hand, was decidedly spirited in its response. In a lengthy editorial of 26 June, it took the opportunity to vilify Dublin, on account of it having been allocated £12,000 to erect the National Gallery of Ireland, and voiced considerable regret at what had happened in Belfast. Whilst the paper claimed that it did not begrudge Dublin the money, it expressed irritation that 'the deputation that waited on Mr Disraeli proceeded on the assumption that pampered, idle, thriftless, gossiping Dublin is everything to Ireland. That all favours bestowed upon it must be hailed as a great concession by all Ireland … If Dublin is to be pampered by hundreds of thousands of pounds, may not Belfast claim to some equity in its distribution.' Oddly, the *Belfast News-Letter* was not aware of the closure until 21 July, a peculiar state of affairs given the smallness of the community and the significance of the subject. When it found out, it too expressed regret and criticised the Department for its financial policies.[160]

Of the part played by Belfast in the sorry state of affairs, the only criticism to appear in print came from an outside source, the *Art-Journal*. A staunch advocate of Cole's self-supporting system, a comment it made in its issue for July that the closure was not very creditable to the town subsequently drew forth a rebuke from a Belfast reader, who took exception to the remark.[161] However, the journal had the last word on the matter. In a reply to the reader, published in its September issue, it claimed that he (or she) 'must have read our observations with a glass of large magnifying powers, for we neither said nor intimated one half of that we are charged with'. It then went on to stand by what it had said:

> it is unquestionably 'not very creditable' to a large and flourishing town like Belfast, that it will not free the institution from 'an accumulation of debts' amounting to the *large sum* of £180, which … are the chief cause of the dissolution of the establishment … Would it not be 'creditable' to the inhabitants if they followed the example of the Cork people, and taxed themselves? Their unwillingness to do this justifies our previous comment.[162]

In the light of the town crisis of 1855, the aftermath of which was still being felt in 1858, a tax to save the school was not an option.[163] The time was certainly not ripe for any kind of new tax, whatever the justness of the cause.

There are a number of question marks concerning the school. The rent was a crippling factor. Several committee members were wealthy businessmen – why did none of them offer to pay the rent outright, a gesture surely within the means of many? To help with running costs, why did not a group of wealthier supporters band together and pledge a substantial annual amount each, of perhaps £25 or £50? Many of the supporters were large manufacturers, yet their subscriptions tended to be small, generally sums of £5 or £10. As the section of the community that stood to gain the most from the success of the school and the proficiency of its students, they seem not to have supported the establishment as liberally as they should. To them belongs a large share of the blame for the closure, as the cause was ultimately lack of funds.

As for aristocratic support, this was almost entirely lacking, with the exception of Lord Dufferin, who was involved from beginning to end. The patronage of the Marquess of Downshire and the Earl of Belfast was limited, with the former donating a mere £25 and the latter two small prizes and a scholarship. Had the earl lived, his brief period as a vice-president might have developed into a deeper involvement. The support of the upper ranks might have given the

school a greater weight in the locality. Nevertheless, whether such patronage would have guaranteed success in the face of Cole's new system of self-sufficiency is doubtful.

Besides the damage wrought by Cole, another reason for closing may have been sheer weariness on the part of the committee, who were probably tired of trying to make the financial ends meet. No one, for instance, seems to have thought of more imaginative ways of raising funds than the standard appeal for subscriptions. There were no bazaars held nor sales of work. This lack of enterprise contrasts strongly with that shown by Limerick, which in 1860 required money to improve its Athenaeum and School of Art.[164] Accordingly, the establishment's committee organised a lottery on art union lines, with 2,500 tickets for sale at £1 each. Cash prizes totalling £1,000 were the incentive. The Belfast committee organised no such schemes.

No material produced by the school has been located. The whereabouts of the collection of prize drawings carefully built up as a record of achievement is unknown and there are no designs for linen bands or examples of the finished product in local museum collections.[165] This lack of material is carried over into the very history of the school, which is not recorded accurately in any source; the second struggle for existence between 1856 and 1858 has passed entirely unnoticed.[166] Even the *Northern Whig*, in a comment on the school some twelve years after its final closure, was confused as to its history, claiming that it suddenly collapsed after about two years.[167] However, this dearth of information is not unusual, as the provincial schools have tended not to merit individual histories of their own.

Probably the greatest legacy left by the school and its major contribution to art in Belfast is the fact that it was a training ground for four local artists whose reputations have flourished with the passing of time: Samuel Ferres Lynn, a sculptor of note; Samuel McCloy, whose watercolours of genre scenes and family life have become highly collectable and sought after; Anthony Carey Stannus, a fine portrait and landscape painter and an important figure in the Belfast art world of the later nineteenth century; and James Glen Wilson, a gifted marine and landscape painter, who probably attended the private classes at the school.[168] The tuition and encouragement they received was undoubtedly a factor in their later success.

Although the school ultimately failed, this was not the end of art education in Belfast. Valuable lessons were learnt from the closing and new management methods put in place to assure the success of a second school established in the same premises twelve years later. The closure, albeit unfortunate and not at all creditable to Belfast, was to be a vital incentive to those involved in the new school, as will be shown in Chapter Eight.

# ～ 5 ～

# Further attempts to establish annual exhibitions

## 1849–59

*'The time seems to have arrived … when an annual*
*Exhibition … would not fail in being liberally supported in*
*the Capital of the North'*[1]

### THE EXHIBITION OF MODERN WORKS OF
### PAINTING AND SCULPTURE 1850–51

Although the establishment of an annual exhibition had proved to be an impossibility during the 1830s and 1840s, a number of Belfast's art lovers continued to work towards this end during the 1850s. In the case of the above-mentioned exhibition of 1850–51, for example, almost half of its organising committee had already been involved in the staging of other exhibitions in town, namely, those of the Northern Irish Art Union of 1842 and of the Belfast Fine Arts Society of 1843.[2] The idea for this 1850–51 show, loosely entitled *Exhibition of Modern Works of Painting and Sculpture*, seems to have originated from within the School of Design, as the school's president and headmaster – Lord Dufferin and Claude Lorraine Nursey – were also president and secretary of the exhibition's organising committee. G.T. Mitchell of the Belfast Bank was treasurer.

That the committee of this latest event had learnt from the exhibition of 1842, when profits had been whittled away by expenses, is clear from the fact that it sought subscriptions in advance on this

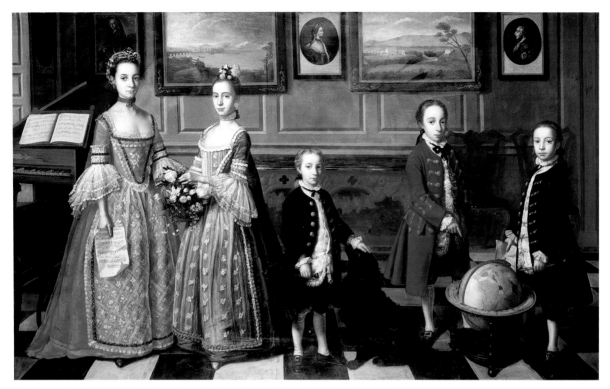

1 Strickland Lowry, attributed to *The Family of Thomas Bateson, Esq.* (1762)

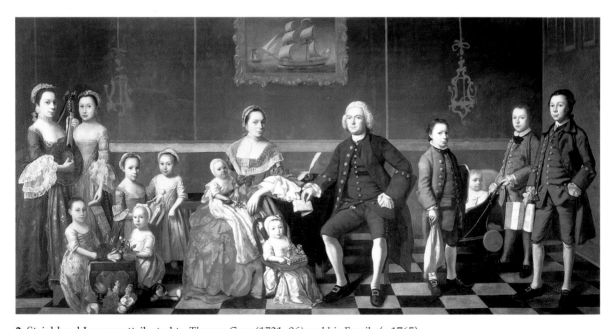

2 Strickland Lowry, attributed to *Thomas Greg (1721–96) and his Family* (c.1765)

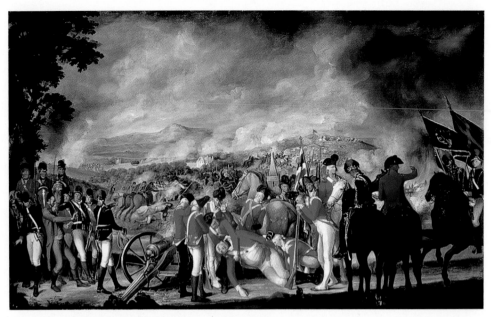

**3** Thomas Robinson *The Battle of Ballynahinch* (1798)

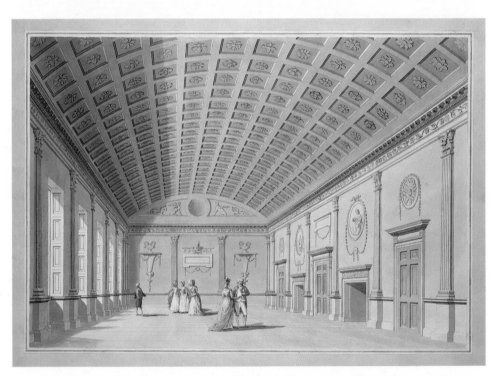

**4** Thomas Malton *Internal View of the Assembly Rooms at the Exchange at Belfast*
The elegant Assembly Rooms, situated on the first floor of the Exchange, were designed by
Sir Robert Taylor in 1776. During the late eighteenth and early nineteenth centuries, they
were the main venue for balls, card games, art exhibitions and meetings of various kinds.

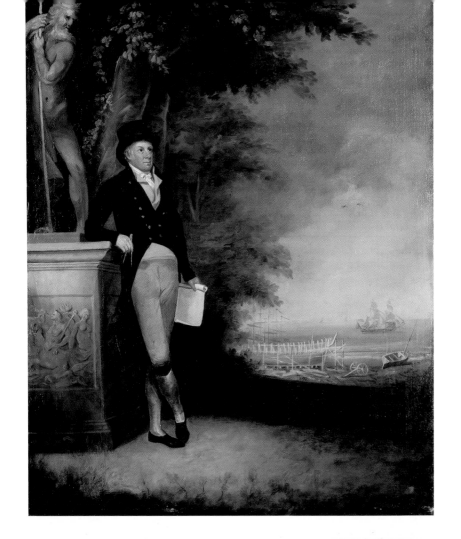

**5** Thomas Robinson
*William Ritchie (1756–1834)*
(c.1802)

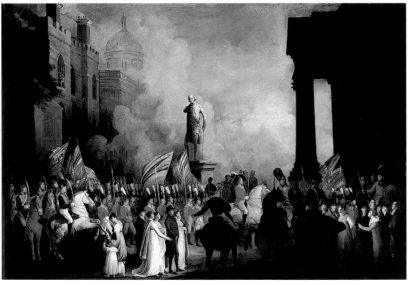

**6** Thomas Robinson
*Review of the Belfast Yeomanry
by the Lord Lieutenant,
the Earl of Hardwicke,
27 August 1804* (1804–7)

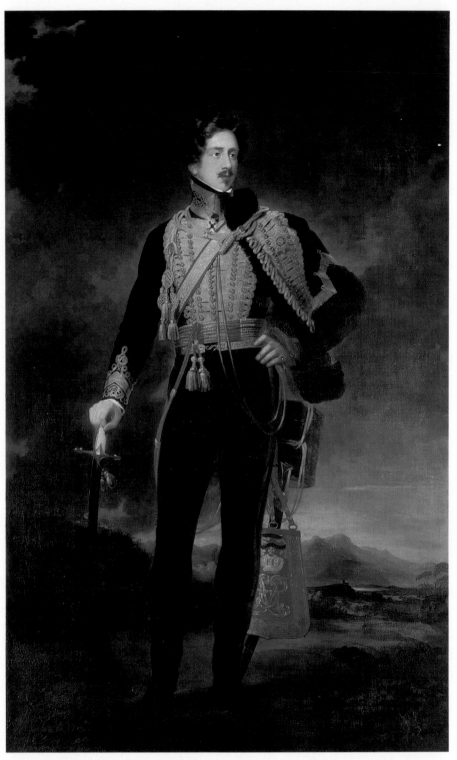

7  James Atkins *George, 3ʳᵈ Marquess of Donegall (1797–1883)* (1824)

8  Hugh Frazer *View of Waringstown* (1849)

9  Andrew Nicholl *Belfast from Newtownbreda Churchyard*

10 Andrew Nicholl *Bray and the Valley of the Dargle from Killiney Hill, Co. Dublin* (after 1835)

11 Joseph Molloy *Tilbury Fort, River Thames*

**12** Joseph Peacock *The Patron, or the Festival of St Kevin at the Seven Churches, Glendalough* (1813)

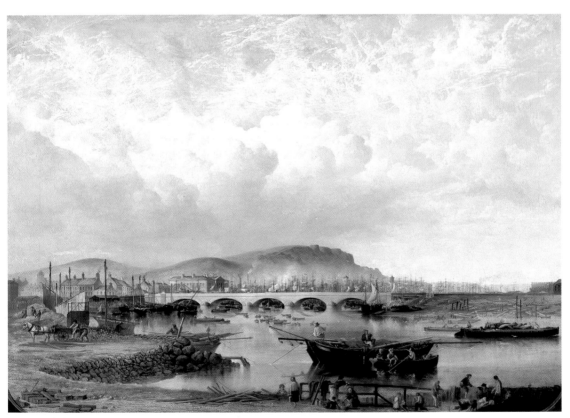

**13** James Howard Burgess *View of Queen's Bridge, Harbour and Timber Pond, Belfast* (1858)
This work was exhibited at the Belfast Fine Arts Society in 1859.

**14** Sir Edwin Landseer
*Shoeing* (by 1844)
One of Landseer's most
popular works, *Shoeing* was
displayed by the Hodgsons
in Mr Gilbert's Large Room
in High Street between late
October and early
November 1845.

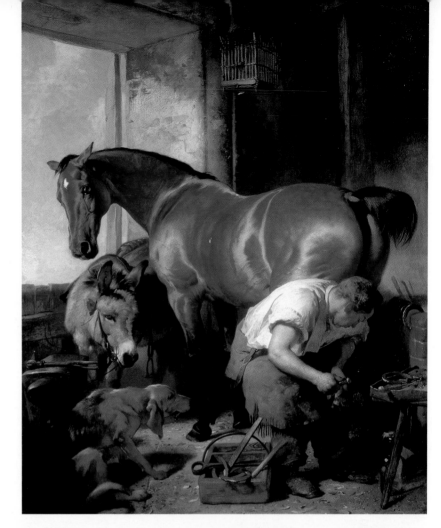

**15** James Moore
*Slieve Bernagh from the
Trassey Bog, Mourne
Mountains*

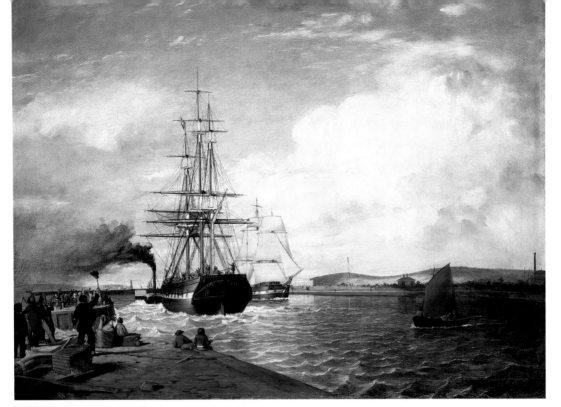

**16** James Glen Wilson *Emigrant Ship leaving Belfast* (1852)

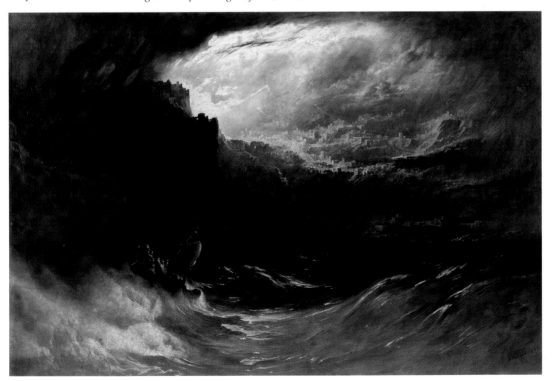

**17** John Martin *Christ stilleth the Tempest* (1852). A large version of this, also by Martin, was in Henry Wallis's Belfast exhibition and sale held between late February and late March 1850 and was almost certainly purchased by the Belfast collector Samuel Greame Fenton.

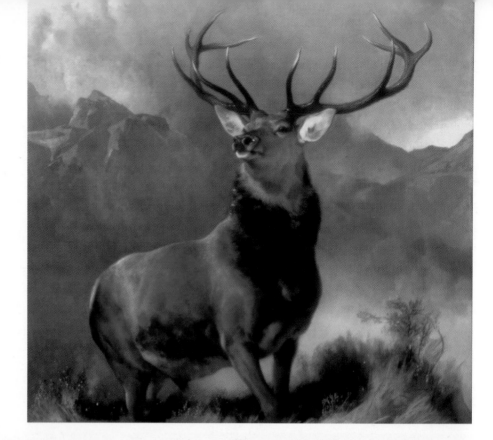

**18** Sir Edwin Landseer
*The Monarch of the Glen*
(by 1851)
One of the best
known of all Victorian
paintings, this was
exhibited by John and
Robert Hodgson in
August 1852.

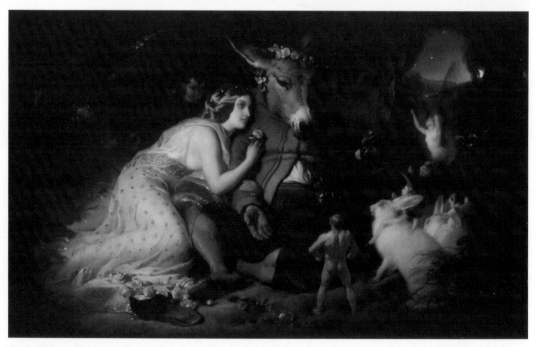

**19** Sir Edwin Landseer *Scene from 'A Midsummer Night's Dream': Titania and Bottom* (1848–51)
This work, Landseer's only illustration of Shakespeare, was exhibited by Magill in December 1856.

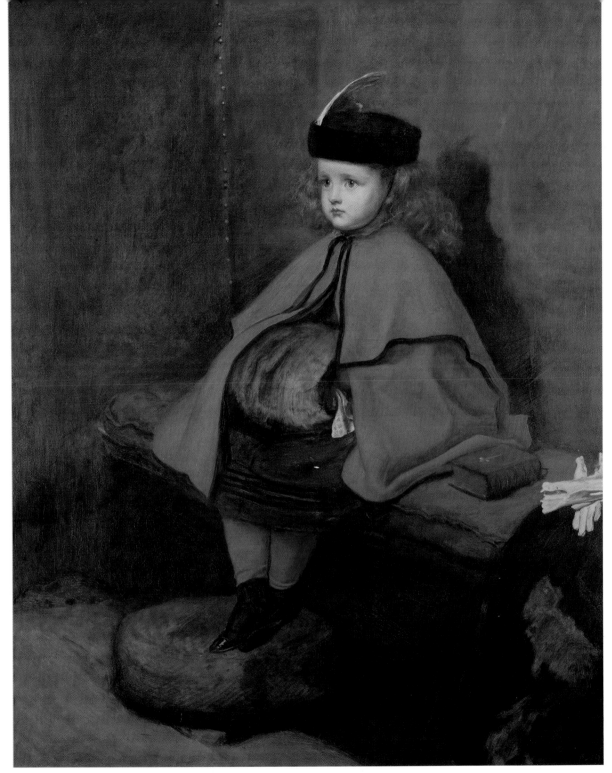

**20** Sir John Everett Millais *My First Sermon* (1863)
This painting of Millais's eldest daughter, Effie, was exhibited
at Marcus Ward's between early April and early May 1865.

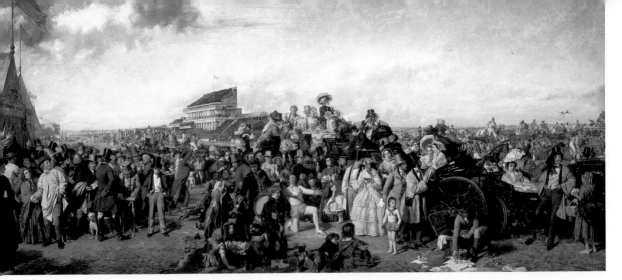

**21** William Powell Frith *The Derby Day* (1856–58). One of the most famous paintings of the Victorian age, the picture was exhibited in the Ulster Hall, under the care of Magill, in May 1863.

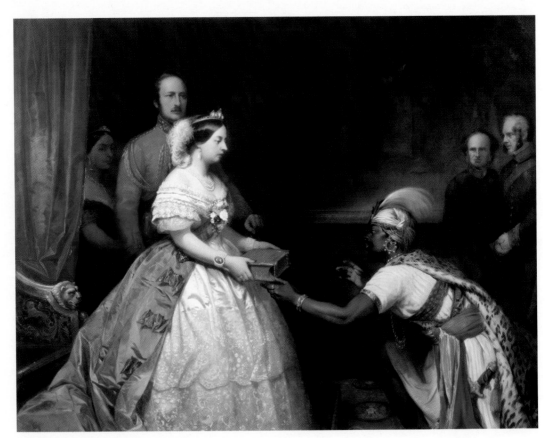

**22** Thomas Jones Barker *The Secret of England's Greatness (Queen Victoria presenting a Bible in the Audience Chamber at Windsor)* (c.1863). This work, one of several by Barker to be exhibited in Belfast, was on display at Magill's between late April and late May 1864.

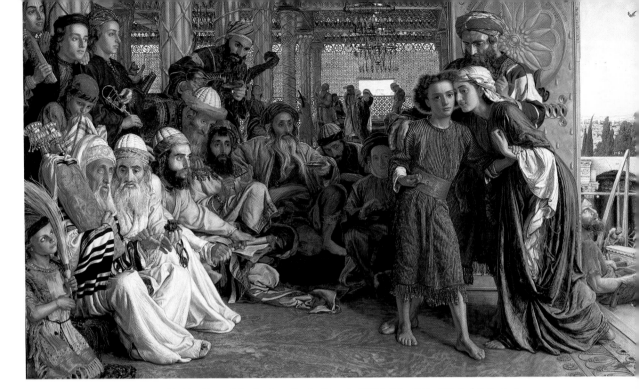

**23** William Holman Hunt *The Finding of the Saviour in the Temple* (1854–55, 1856–60). Exhibited at Magill's between early June and early July 1865, the picture was the first major Pre-Raphaelite painting to be seen by the general public in Belfast.

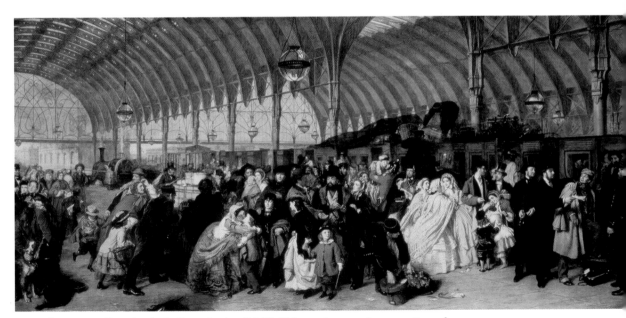

**24** William Powell Frith *The Railway Station* (1862). This work created a sensation when exhibited in London in 1862. Its display at Magill's in June 1866 was also a great success.

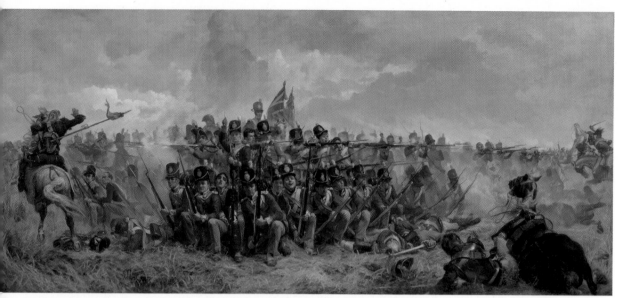

**25** Elizabeth Thompson (Lady Butler) *The 28th Regiment at Quatre Bras* (1875). This work, one of the highlights at the Royal Academy in 1875, was exhibited at Rodman's during February 1880. Thompson, one of the foremost battle painters of the day, was denied membership of the Academy because of her sex, the standard rule at the time.

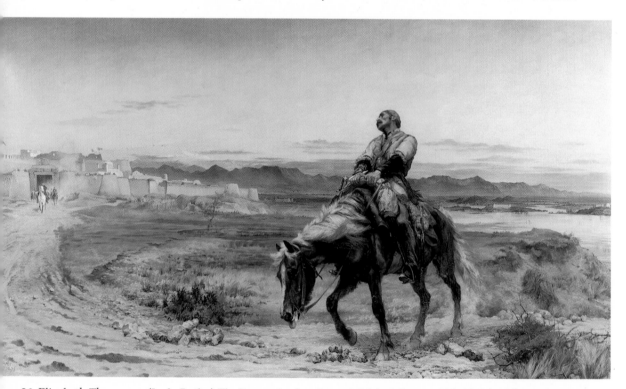

**26** Elizabeth Thompson (Lady Butler) *The Remnants of an Army: Jellalabad, January 13th, 1842* (1879) When this painting was exhibited at the Royal Academy in 1879, reports claimed that men were seen weeping before it. The picture was shown at Rodman's at the same time as *The 28th Regiment at Quatre Bras*.

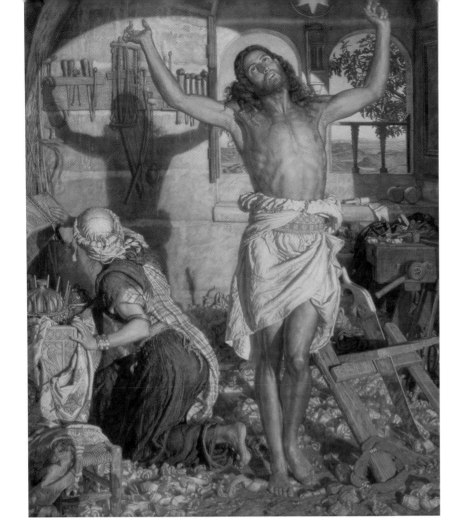

**27** William Holman Hunt
*The Shadow of Death*
(1870–73, retouched 1886)
A poignant presentiment of
Christ's future death upon
the cross, this was shown in
the Ulster Hall, under the
care of Magill, between late
June and late July 1875.

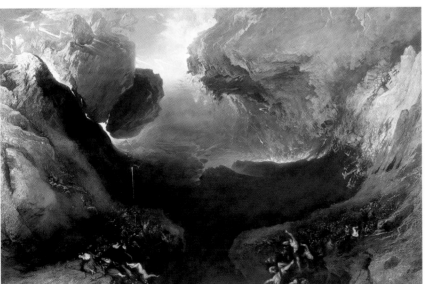

**28** John Martin
*The Great Day of his Wrath*
(1851–53)
Martin's three famous
Judgement paintings – *The
Great Day of his Wrath, The
Plains of Heaven* and *The Last
Judgement* – were auctioned
in Belfast in late September
1886 by local auctioneer
Hugh C. Clarke for London
dealer George Wilson.
Whether they found a buyer
in town remains unknown.

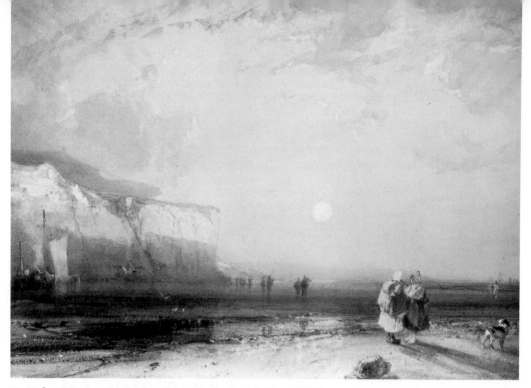

**29** Richard Parkes Bonington *Sunset in the Pays de Caux* (1828)
This and the following landscape by J.M.W. Turner were amongst the paintings lent to the
Industrial Exhibition of 1876 by Sir Richard Wallace.

**30** Joseph Mallord William Turner *Scarborough Castle: Boys Crab-Fishing* (1809)

occasion, to help cover costs.[3] Persons donating a guinea or more were promised free season tickets for themselves and their families. The idea seems to have met with a favourable response as, five days before the show opened, there were over seventy subscribers.[4] In the publicity leaflet distributed to advertise the exhibition, the committee remained optimistic regarding the venture, as the town had 'attained that advanced position in Wealth, Intelligence and Taste, which … created a demand for the cultivation of the Fine Arts'.[5] Kerns' Gallery in Donegall Place Buildings was the venue for the show, which opened on 20 December.[6]

The exhibition contained over 260 paintings and between thirty and forty sculptures, mainly marble busts.[7] Whilst about only a third of the pictures are known (as a catalogue cannot be found), over thirty of these were subject and narrative pieces, an indication that there was a certain amount of variety to the display; the show did not consist solely of landscapes and portraits. The usual local artists were to the fore – Hugh Frazer, Richard Hooke, Dr James Moore and Andrew Nicholl – together with a newcomer to the Belfast art scene, James Glen Wilson. There were also Irish painters of repute such as Matthew Kendrick, George Mulvany and Richard Rothwell. Amongst the many British artists were William Powell Frith, John Rogers Herbert and James Baker Pyne. Two paintings by Sir Thomas Lawrence were also included, namely, portraits of Sir Robert Bateson of Belvoir and his wife, lent by Bateson (who had already lent them to the Belfast Association of Artists exhibition of 1837).[8] As far as is known, these were the only loans in the show. Unusually, in view of newspaper criticism of other exhibition venues of the 1850s detailed below, Kerns' large room elicited a favourable response from the press: according to the *Belfast News-Letter*, 'The light was admirably distributed by means of the large windows in the ceiling; and, indeed, if the place had been previously constructed with a special view to the exhibition, it could have hardly been more suitably arranged'.[9]

By late December, the show was reported as being well attended, with over £200 worth of sales having been made and another £300 worth being negotiated.[10] Interestingly, it was also claimed that a group of James Atkins' admirers had banded together to purchase a copy by him, after Guido Reni, from the exhibition, to present to Queen's College as the nucleus of a public collection of paintings in the town. Unfortunately, there is no further information on this intriguing scheme and the project obviously failed to materialise, as the only work by Atkins at Queen's is the copy of Titian's *The Murder of St Peter Martyr*, discussed in Chapter Two.

To encourage the humbler classes to attend, the show opened in the evenings from mid-January, with admission reduced from six pence

to three pence and ultimately to two pence.[11] According to a press report published shortly before the exhibition closed on 8 March, evening visitors had been mostly mechanics and workmen from the mills.[12] Numbers in this category had been 2,748, whilst morning attendance had reached 3,421. The former figure was considered a positive result and a sign that the show had been appreciated by the less affluent in the community. Reports of sales range from amounts of about £540 to almost £800.[13] Of the twenty works recorded as having been purchased, half were subject and narrative paintings; however, the only purchaser known was Lord Dufferin, who acquired *Child with Fruit* by James Sant.[14] These sales figures were better than had been expected.[15] Nevertheless, almost all of the money raised from the venture, which came to a total of £278 7s 7d, went on expenses such as transport of works from exhibitors in London, Glasgow and Dublin, hire of premises and printing of catalogues.[16] After everything had been paid, the balance in hand came to only £3 3s 3d, a disappointing result for the committee, who, in seeking subscriptions towards expenses, had obviously hoped to finish with a reasonable profit.

## THE BELFAST FINE ARTS ASSOCIATION EXHIBITION OF 1852

Despite the paltry returns from this first exhibition of the decade, another was held in the spring of 1852. Generally referred to as the *Belfast Exhibition of Works of Art*, it was organised by a group calling itself 'The Fine Arts Association'.[17] Whether its committee members were connected with the Belfast Fine Arts Society of 1843 is unknown, as, indeed, are the identities of the group, with the exception of Claude Lorraine Nursey and William Tracy, who acted as joint honorary secretaries.[18] The show contained 224 works, including a few casts.[19] Unfortunately, only ninety-three paintings are known, of which the majority were landscapes.

Held in the Assembly Room of the Commercial Buildings and opened on 9 March, the exhibition was received with much enthusiasm by the press, with the *Northern Whig*, for example, seeming to see in two consecutive exhibitions hope that the town was perhaps becoming more intellectually aware: 'There is surely taste enough amongst us ... to render this annual exhibition almost a necessity; and Belfast cannot expose itself to the reproach, that whilst places of less pretensions have their regular yearly show ... we are not capable of appreciating anything that carries with it so much of taste and refinement.'[20] However, the same newspaper voiced regret that the town did not have a purpose-built top-lit exhibition space for such displays – the Assembly Room, being lit from only one side, was not ideal.[21]

The paper also hoped that a proper gallery would be provided in the proposed new Town Hall.[22] (This was not to be, when the building was finally designed in 1871.)

As with the exhibition of 1850–51, a number of local artists were included, such as Hugh Frazer, Richard Hooke and James Glen Wilson, as well as major Irish names like Martin Cregan, Edwin Hayes and Richard Rothwell.[23] British painters, though, formed the majority of the known exhibitors – well-established artists such as Thomas Sidney Cooper, James Baker Pyne and Alfred Vickers and several others of lesser standing.[24] Again, to encourage the operative classes, the exhibition was eventually opened in the evenings, at a reduced rate of three pence.[25] Such was the appeal of the event to this sector of the community that almost all of the 308 visitors on Easter Monday (a holiday given over to a variety of popular entertainments for the working population) were from the lower ranks.[26] All of the visitors 'took the liveliest interest in the works of art which they inspected – there was not a single instance of impropriety, and not the slightest injury was done to the large and valuable collection'.[27]

The exhibition closed on 15 May.[28] Unlike the previous show, there were no details of visitor numbers or sales in the local press. Fortunately, information on these was published by the *Art-Journal*.[29] Apparently, 2,788 single tickets, 300 family tickets and fifteen season tickets were sold; also, a number of local schools attended, as well as 430 students from the School of Design – figures 'sufficient to indicate that a taste for the fine arts is developing itself gradually among all classes of our townsfolk'.[30] Almost £700 was spent on paintings. Whether the exhibition made a profit remains unknown; nevertheless, the results of the venture were heartening enough to prompt the town's art lovers to organise yet another show.

## THE BELFAST FINE ARTS SOCIETY EXHIBITION OF 1854

This exhibition is unusual in that there is actually a catalogue in existence, a rare occurrence in the art history of nineteenth-century Belfast.[31] From this, it is clear that there was a strong continuity of personnel in these shows of the early 1850s; with this latest event, Lord Dufferin was president yet again, Claude Lorraine Nursey and William Tracy were joint honorary secretaries once more and G.T. Mitchell acted again as treasurer.[32] Indeed, of the remainder of the 1854 committee, half had served as members of the 1850–51 exhibition and four (including Mitchell) had been on the committee of the Belfast Fine Arts Society show of 1843, discussed in Chapter Three.[33]

The exhibition was larger than the other two detailed above, with

334 works on display, of which ten were sculptures. As regards the contents, there was a wide spread of subject and narrative pictures and only about thirty-five portraits. The overall standard appears to have been impressive, judging by the comment of the *Belfast Commercial Chronicle*: 'We looked for nothing of grandeur, yet singular to say ... since high art was known in Belfast there has never been such a display.'[34] The usual local artists were included – James Howard Burgess, Hugh Frazer, Richard Hooke and Dr James Moore – in addition to major Irish names such as Frederick William Burton, Nicholas Joseph Crowley, Edwin Hayes and Matthew Kendrick. There were also a few Continental artists, mainly Belgians. Most of the exhibitors, though, were British. Interestingly, at least three paintings were in the Pre-Raphaelite style, the artists being Robert Braithwaite Martineau, William Bell Scott and Henry Wallis, followers of the movement.[35] This was the first time works of this type had been exhibited in Belfast, although the local collector Francis McCracken had been acquiring Pre-Raphaelite paintings since 1851 (as discussed below) and his friends and associates had probably seen his collection.[36] Press reaction to them was mixed: the *Belfast News-Letter* was loud in its praise and found their inclusion interesting, whilst the *Belfast Commercial Chronicle*, on the other hand, regretted their display and considered the style abhorrent, especially in the use of colour and perspective.[37] Whatever the response of the press, it is interesting to think that the Belfast public saw examples of the style at the height of Pre-Raphaelite activity, when masterpieces such as Holman Hunt's *The Awakening Conscience* and *The Scapegoat* were being painted.[38]

The Music Hall was the venue for the event, which opened on 17 April.[39] This centre also came in for criticism because of the lack of top-lit rooms, a situation which met with a similar reaction from the press as in 1852: 'it is to be regretted that a gallery, expressly built for the purpose of setting off works of art to the best advantage ... is still one of the desiderata which the advancing intelligence and educated taste of our community must shortly take measures to supply'.[40] As with the two earlier exhibitions, the show was eventually opened in the evenings for the convenience of the working classes, with admission reduced to three pence as before.[41] However, by this point, late May, attendances had fallen off badly. Whatever the reason for this – the *Belfast News-Letter* thought that it was perhaps because of the changeable weather – the committee decided in early June to close earlier than planned.[42] The exhibition ended on the 21st of the month.[43]

Press reaction to such public apathy was as to be expected. The *Belfast News-Letter* maintained that:

It certainly seems strange that an exhibition, which would do credit to a metropolitan town … should, in a town like Belfast, where we had begun to think that a taste for pictorial art had progressed … be so thinly attended as to compel its directors to consign it to premature dissolution … However, such is the result of local indifference.[44]

Equally concerned, the *Belfast Commercial Chronicle*, in its comments, felt 'there is something in the taste of the people radically deficient when they do not give [the exhibition] tangible support' and concluded that, as regards Belfast's appreciation of the fine arts, 'the pear is not ripe'.[45] Despite the early closing, the show seems to have been more successful in terms of sales that the two previous events; according to the *Art-Journal*, thirty-four paintings were sold, to the value of £800.[46] There are no details of attendance figures.

## THE BELFAST FINE ARTS SOCIETY EXHIBITION OF 1859

After the 1854 exhibition, there were none for another five years. Though the reasons for such a lengthy interval are unknown, it seems possible that low morale on the part of the town's art lovers was part of the cause. Whatever the circumstances, in 1859 the Fine Arts Society decided to stage another display. With this venture, there was a secretary, Samuel Vance and also an honorary secretary, William Tracy once again.[47] The identities of the other members of the committee are unknown.

The exhibition, which opened on 17 May, was held in rooms in Donegall Place.[48] As was generally the case, the location was criticised in the press, this time because of overcrowding of the exhibits and a lack of public comfort. Though the rooms were the best to be had at the time, declared the *Northern Whig*:

the floors are uncarpeted, and there is no supply of long, well-stuffed sofas, where subscribers may, after taking a turn or two round the place, loll at their ease and contemplate the paintings … These improvements, absolutely necessary to the prosperity of a Fine Arts Exhibition, if it is intended to be annual, and to thrive and prosper, and give encouragement to the Fine Arts in the North of Ireland, cannot possibly be introduced into the present apartments. No gallery of arts will flourish which does not become – during the season at which it is open – a fashionable resort, a promenade and place of rendezvous, for admission to which subscriptions will readily be paid by both ladies and gentlemen who care nothing whatever about the Fine Arts.[49]

These comments were to be uncannily accurate, as the following chapter will show.

A catalogue of the exhibition cannot be found; however, press reports place the number of exhibits at between 244 and 440.[50] Prominent amongst the works by local artists was *View of Queen's Bridge, Harbour and Timber Pond* by James Howard Burgess (Plate 13), already mentioned in Chapter three.[51] Hugh Frazer, Richard Hooke and Andrew Nicholl were also represented, as were a number of Irish artists including Edwin Hayes and Jeremiah Hodges Mulcahy.[52] As with the 1854 exhibition, there were a few paintings by followers of the Pre-Raphaelites.[53] There were also works by mainstream British painters like James Baker Pyne and Edward Matthew Ward and by Continental artists such as Louis Coignard and Dielman.[54] Like the previous shows, there was eventually a reduced admission charge for the working population, firstly to three pence and then to two pence.[55] This concession was for both daytime and evening viewings.

For some reason, the exhibition appears to have had little impact, as there was scant reference to it in the press. There were no reports of visitor numbers or sales save a brief mention shortly before the show's closure on 23 July that most of the works remained unsold.[56] After this seemingly disappointing result, the Fine Arts Society appears to have wound up its affairs, for there is no further information to be found concerning it. Its closure brought to an end over twenty years of effort by a variety of art societies and committed individuals to place before the Belfast public regular displays of good quality art. It was to be a further twenty before another art society was established, namely, the Belfast Ramblers' Sketching Club.[57]

## LOCAL ARTISTS AND OTHERS

Despite the lack of support for the fine arts, evident in the failure of the above-mentioned societies, a small band of local artists continued to pursue their careers in Belfast or by regular visits, though living elsewhere. Such a one was Andrew Nicholl, who, on his return to London from Ceylon in 1849, revived his links with his home town during the early 1850s by visits and sales of his work through various local printsellers.[58] Indeed, he seems to have considered settling in Belfast for, in September 1854, he applied for the vacant post of headmaster at the School of Design.[59] Unsuccessful in this, as mentioned in Chapter Four, he nevertheless opened his own design school in Donegall Place the following November, 'for the purpose of giving instruction to the Working Classes'.[60] The school continued in business until at least the summer of 1855.[61] Though he appears not to have remained in town after 1856, he continued to visit the

north of Ireland until the mid-1860s.[62] With his businesslike approach and willingness to move around, his was *the* artistic success story of nineteenth-century Belfast.

Of the two other well-known painters in the locality, James Howard Burgess and Richard Hooke, the former continued to focus on his teaching career and seems not to have been overly ambitious for greater recognition. Hooke, by contrast, had become the leading portraitist in town by this stage, partly, it must be said, because of lack of competition in the field. In 1856 he widened his practice to include the painting of small oil portraits based on clients' daguerreotypes, photographs and miniatures, a tactic designed possibly to increase his clientele or ward off the threat of photography.[63] Though he left Belfast around 1857 to settle in Manchester, he paid regular visits for many years, generally during February and March. As a result of these painting forays, there are numerous portraits by him in Belfast and the north.

An artist who began to achieve greater local recognition, partly through the exhibitions detailed above, was the amateur landscapist, Dr James Moore (1819–83).[64] A successful surgeon and prolific watercolour painter, his work had been seen regularly at the Royal Hibernian Academy exhibitions in Dublin since 1840 but had been shown in Belfast on only one occasion prior to 1850 – namely, at the Belfast Fine Arts Society exhibition of 1843. Although described at that time as 'a second Nicholl', he was never a match for him, lacking his delicate touch and sense of atmosphere. Nevertheless, in a large finished work like *Slieve Bernagh from the Trassey Bog, Mourne Mountains* (Plate 15), it is evident that Moore was a painter of considerable ability, a fact acknowledged by the Royal Hibernian Academy, which elected him an honorary member in 1868.

An indefatigable sketcher, he took a keen interest in recording old buildings and ruins, partly with an eye to posterity. The *Northern Whig* has left an interesting picture of him as he went about his artistic pursuits:

> he [was] known, failing a supply of paper, to note a passing effect on his shirt cuff, or on a common sheet of brown paper, note, with some ink and stick for a brush, something that interested him when he had not his colour box; but, as a rule, he rarely went out without the latter and a sketch-book, all his coats having capacious pockets, especially made for the purpose of carrying his 'tools'.[65]

Besides his painting activities, he served on the committee of the School of Design for a time. Over the years, he was to play a significant role in the cultural life of the town.

An artist who first appeared on the scene in 1849 was James Glen Wilson (1827–63).[66] A mysterious figure, he is first recorded in an advertisement for a lithograph published by the Belfast firm of Marcus Ward and Co. in October 1849.[67] Apparently, he had made an on-the-spot sketch for the lithograph, which depicted the sectarian affray at Dolly's Brae, near Castlewellan, Co. Down on 12 July of that year. Whether he had been sent by Ward once the fighting started or had gone of his own accord, remains unknown. Described in the advertisement as self-taught, later newspaper references stated that he was from Co. Down and had studied at the Belfast School of Design. Unfortunately, it has proved impossible to corroborate any of these facts. The only reliable information on his life prior to 1849 is contained on his death certificate, which recorded that his father was a gentleman, that is, a man of independent means. Given that his background may thus have been affluent, his student period at the school – if, indeed, he did attend – was probably spent in the private classes established for the sons and daughters of the wealthier ranks.[68]

Between 1850 and early 1852, he is known to have been painting around Belfast and Downpatrick, as revealed by a small number of works in the collections of the Ulster Museum and Belfast Harbour Commissioners. These paintings, of a uniformly high standard, show him to have been equally at home with landscapes and seascapes, figures and shipping. The *Emigrant Ship Leaving Belfast* (1852) (Plate 16) is particularly impressive. A poignant scene of farewells at the quayside, executed with considerable mastery, it is one of the few paintings known to show emigration from Ireland. Sadly for the art world of the north, Wilson left Belfast shortly after painting it and joined the Royal Navy in the spring of 1852 as an artist and photographer with the survey vessel HMS *Herald*, about to make an expedition to the South Seas. The trip lasted until 1861. Wilson, however, did not return to his homeland, having left the Navy about 1858 to settle in Australia, where the *Herald* had been based at times. He died there on 6 August 1863. As a result of his travels, there are many examples of his work – pictures of natives, their tools and weapons, birds, plants and fish – in collections in London, Taunton, Canberra, Hobart and Sydney. Their number is in stark contrast to the few paintings from his earlier years in the north and adds to the enigma surrounding him, unquestionably one of the most gifted artists to emerge from Belfast in the nineteenth century.

Besides these locally-born painters, a small number of Italian artists also pursued careers in the town for a time. One such was the portrait and landscape painter Felice Piccioni (fl.1830–47), who had come to work for the firm of Marcus Ward at some point before

1840.[69] Although sketching local sitters around this time, he seems not to have exhibited in town until 1854, when he took part in the Belfast Fine Arts Society show of that year. He was still in the neighbourhood in 1876, when he lent a number of his paintings and photographs (these latter also by himself) to an Industrial Exhibition and Bazaar held in the Ulster Hall.[70] He is best remembered for his small-scale charcoal studies of James Moore and Andrew Nicholl, drawn in 1839 and c.1840 (Figs 46 and 47).[71] Though an obscure figure, with a low public profile, one of his works is very much in the public domain: the altarpiece in St Malachy's chapel in Alfred Street, Belfast, which building was completed in 1844.[72] Of a considerable size and competently executed, the piece shows Christ carrying the cross in the centre panel and the Virgin Mary and Pope in each of the side wings. Its strong colouring and sense of drama make a forceful impact in the church.

Sculptors predominated amongst this small band of Italians. Probably the best known in Belfast at the time, although forgotten now, was Giacomo Nannetti (fl.1829–51), who opened a statuary business in York Street in May 1849.[73] (He was already established in

**46** Felice Piccioni
*James Moore (1819–83)*
(1839)

**47** Felice Piccioni
*Andrew Nicholl (1804–86)*
(c. 1840)

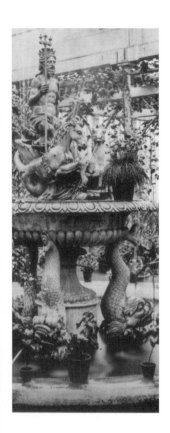

**48** Giacomo Nannetti
*Fountain of Neptune, Crystal Palace, Queen's Island, Belfast* (1851) (detail)
The fountain was a focal point in the Crystal Palace, built in 1851 and destroyed by fire in 1864. This is the only known photograph of the fountain and the building.

Dublin, having commenced in business there during the late 1820s.)[74] At his Belfast studio were sculptures in the Grecian, Gothic and other styles, in plaster and artificial stone. His setting up in Belfast (some six months before the opening of the School of Design) was lauded by the *Belfast News-Letter* as 'an important accessory to the development of the new spirit which is about to be awakened here in the cultivation of the useful, the decorative, and the ennobling arts'.[75] Unfortunately, commercial success appears to have eluded him, despite this 'new spirit' and in March 1850 he advertised a subscription sale (a lottery) of his collection, with 1,000 tickets at five shillings each, to be held the following month.[76] After two postponements due to lack of support, the event finally took place on 3 July.[77] Whether it was a success or not remains unknown. However, faced with a public seemingly indifferent to his efforts to 'infuse amongst [them] a taste for the noblest [art] of them all – that of Sculpture', he eventually closed the studio in November 1851, to concentrate on his business in Dublin.[78] One of his sculptures was a well-known feature in Belfast between 1851 and 1864: the fountain of Neptune (Fig. 48) in the conservatory or Crystal Palace on the Queen's Island, a man-made island near the harbour, named in honour of Queen Victoria's visit to Belfast in 1849.[79] The work, minus Neptune's figure, was still extant in Belfast in 1988, albeit in a dilapidated state.[80] Although there are probably other examples by him in the neighbourhood, this is the only one known of.

Another sculptor to the fore was Fo Ceccarini (fl.1849–55), who, according to the *Northern Whig* of 25 October 1851, had fled his native city of Rome in 1849 when it fell to the French and arrived in Liverpool as a refugee. He had since settled in Belfast, where he produced busts of local worthies and memorial and allegorical tablets. In 1852 he showed a few such portrait busts in the Belfast Fine Arts Association exhibition, which the newspaper's art correspondent regarded as admirable.[81] His talents were obviously not confined to the small scale for, by January 1854, he had completed a 'colossal' statue of Queen Victoria, over seven feet high excluding the base.[82] What became of it is unknown; however, it seems possible that it ended up in the Crystal Palace on the Queen's Island, as a statue of the queen, by Ceccarini, was presented to it by local tailor William Spackman in 1858.[83] Ceccarini moved to London in the summer of 1855, with the contents of his studio (including a statue of the queen similar in description to the one above) advertised as being sold on 31 May.[84] One of his sculptures, *Orphans of the War*, designed by a Signor Grispi, was on display at the gallery of the printseller and publisher James Magill a few months later.[85] The idea for the work may have stemmed from Grispi, a portraitist who produced cameo

medallions, or the piece may have been a joint venture between the two artists. Grispi, like Ceccarini, a native of Rome and also probably a refugee, was in Belfast intermittently between 1854 and 1856.[86] He seems to have severed his links with the town in the spring of the latter year. Though he and his two compatriots have sunk into almost total oblivion, their presence in Belfast must undoubtedly have lent a touch of Continental colour to the artistic milieu of the town.

Of the local art scene at this time (and, indeed, later), what surprises is how few artists participated in it. Considering the extent of Belfast's population in 1851 – 87,000 – the number of painters and sculptors supported by the town was extremely small, only eleven, in fact, who could be considered resident or partly so at the time: Burgess, Ceccarini, Frazer, Hawksett, Hooke, the miniaturist Elish Lamont, Moore, Nannetti, Nicholl, Piccioni and Wilson.[87] By comparison, Newcastle-upon-Tyne, with a population of a similar size (87,784) in the same year, supported thirty-two, whilst Plymouth, with 90,401, in 1851, maintained thirty-six.[88] Such a low figure for Belfast has helped give the misleading impression that the town was an artistic wasteland in the nineteenth century, a fact proven otherwise by the various exhibitions and lively art market detailed here.

## LOCAL AUCTIONS

This decade saw a continued growth in the art trade, with the firms of George C. Hyndman and John Devlin now joined by those of John Cramsie, founded in 1848, Hugh C. Clarke, active from 1849, William Dale, also in operation from the same year, Patrick McShane, who commenced in business in 1853 and John H. Gowan, who opened his firm in 1857; also two minor businesses which flourished briefly, those of E. Magee and Robert Martin.[89] Of these newcomers, Cramsie was the most significant. Besides selling for local persons (including the contents of Ceccarini's studio in 1855), he sold for owners and dealers in Scotland and, in 1859, established links with a Belgian dealer, Henri Everard, auctioning several collections of Old Master and modern pictures for him.[90] In the same year, he appears to have opened a picture gallery at his 'auction mart' in Waring Street, where he held previews of his sales, presumably with an eye to improving his turnover.[91] Clarke's firm likewise dealt with local collections but on a smaller scale, notable sales being the possessions of Gaetano Fabbrini after his death in 1849 and the contents of Galgorm Castle, Co. Antrim for A.W. Cleverly.[92] He also sold for persons from further afield, such as the Earl of Mountcashel.[93] William Dale's business, the smallest in town, confined its operation to the local art market, with the exception of a major collection of engravings auctioned for

a Liverpool publisher and printseller in 1853.[94] The firm appears to have closed in 1857.[95] McShane dealt mainly with house clearances, whilst Gowan's concern did not really become active until the 1860s.

Although the number of Old Masters passing through these various salerooms by the late 1850s remains unknown – auctioneers' advertisements contain only limited details and there are no other known records – a notice in the *Art-Journal* of October 1859 indicates that the Belfast art market, like that in London referred to in Chapter Three, had had its share of suspect paintings:

> A collection of 'old masters' has found its way to Belfast; but we suspect the connoisseurs of the town are too shrewd now-a-days to pay more than they are worth for these 'high-class' pictures, as they are called in the catalogue forwarded to us. Raphael, Andrea del Sarto, and Guido, Paul Veronese, Correggio … and others which stand high in the vocabulary of Art, are not names to conjure guineas untold from the pockets of Irish connoisseurs, in these times … Nevertheless, it is well to give our friends on the other side of the Irish Channel a hint not to pay 'too dearly for their penny whistles', if they will have such.[96]

The sale alluded to was probably Cramsie's auction of Henri Everard's collection of ancient and modern masters, advertised as being sold on 28 September (1859).[97] Implicit in the magazine's somewhat condescending remarks are hints that Belfast's 'connoisseurs' had formerly paid high prices for dubious paintings and might still be tempted to do so. Also implied is a lack of appreciation of art by the town's collectors, to whom pictures were 'penny whistles' – baubles to be acquired for superficial pleasure. The overall tone of the piece – the only reference of its kind to have been found – is uncomplimentary to the discriminatory faculties of the town's connoisseurs.

Whilst evidence is lacking as to the identity of the buyers at these numerous auctions, it seems reasonable to assume that they were members of the middle ranks – to whom John Clarke, Samuel Greame Fenton and Francis McCracken belonged (see below) – with income and inclination for the finer things of life. This section of Belfast society was reasonably small in the late 1850s. If one includes doctors, attorneys, and various other professionals, merchants and manufacturers, ship owners and publishers, the figure is about 650, according to the *Belfast Directory* of 1858. It seems unlikely that a sector this size could alone have sustained the large number of sales that took place. It is therefore possible that buyers came from elsewhere, perhaps dealers from other parts of Ireland or from Britain.

Whatever the quality and genuineness of the works on offer, it is apparent from the above-mentioned Cramsie/Everard sale of

September 1859, and from the many other auctions advertised, that Belfast had become a lively trading centre for art by the 1850s. Such was the town's reputation that the well-known London dealer Henry Wallis sent two collections of modern British paintings to Belfast for display in the early years of the decade.[98] His first exhibition, which he hoped would become an annual event, was held in the Commercial Buildings during February and March 1850 and contained 120 paintings.[99] Amongst artists represented were major names such as Augustus Egg, William Etty and John Martin. In the spirit of the times and in response to an art trade damaged by doubtful Old Masters, Wallis guaranteed the authenticity of every work. Though the exhibition was well attended, with sometimes about 200 visitors a day, sales were apparently not as good as expected.[100] Unfortunately, the number of paintings sold remains unknown.

Undaunted, Wallis sent a second collection to the same venue the following year. The exhibition, which ran from mid-December 1851 to early January 1852, comprised fifty-nine paintings, including works by Sir Augustus Wall Calcott, William Powell Frith and Clarkson Stanfield.[101] Again, there is no information regarding purchases. However, sales appear to have been slow; on 27 December, the *Northern Whig* commented dryly that 'If the Belfast amateurs [connoisseurs] can resist such temptations, they are something more that Stoics'.[102] Perhaps because of the situation, Wallis closed the exhibition early and instructed Hyndman to auction the unsold works.[103] This was the last time he was to send a collection to the town. Though the failure of this venture does not square with Belfast's development as a lively art market, one of the reasons behind it may have been a surfeit of art – a glut of paintings for sale in a small trading centre within a relatively short space of time. Between 1850 and early 1852, the time frame of Wallis's sales, there were ample opportunities to purchase art besides at his exhibitions, namely, at the aforementioned *Exhibition of Modern Works of Painting and Sculpture* of 1850–51 and through at least twelve fine art auctions at the various auction houses noted above.[104] Overall, therefore, there was a large number of works of art before the Belfast public during this short space of two years or so – perhaps too much for the town to sustain at this particular point.

## LOCAL COLLECTORS

Although there were probably several collectors in Belfast by the 1850s, only three are known of in any detail: John Clarke, Samuel Greame Fenton and Francis McCracken. Clarke (1793–1863), mayor in 1844 and a leading public figure in the town, had been involved in the local art world for several years, having been on the committees

of the Northern Irish Art Union, the Belfast Fine Arts Society and the School of Design.[105] Unfortunately, there is little information available regarding his collection and his obituary in the local press is tantalisingly vague: 'His liberal patronage of the fine arts, his great discrimination, and his exquisite taste are well known; and he has left behind him collections which include several rare and beautiful specimens of the best masters.'[106] Amongst the works he is known to have owned were three by the history painter John Rogers Herbert – one of which, *Sir Thomas More and his Daughter*, he purchased from Francis McCracken by 1850 – and a landscape by Thomas Creswick.[107] He is also recorded as having been a buyer at Wallis's second exhibition and sale of 1851–52, although there are no details of his acquisitions.[108]

Samuel Greame Fenton (1795–1863) also took part in the local art world as well as being a keen collector.[109] A committee member of the Northern Irish Art Union, the *Exhibition of Modern Works of Painting and Sculpture* of 1850–51 and of the Belfast Fine Arts Society in 1854, he was also, like Clarke, mayor for a time, namely, in 1852.[110] That he owned a sizeable collection by the early 1850s is clear from a *Belfast News-Letter* advertisement of 1853, in which a local picture restorer, T. Yorke, stated that he had cleaned and restored fifty paintings for him.[111] By 1861 he had left Belfast and was living at Castlerigg, Cumberland. He died at Upper Norwood, near London, on 29 November 1863.[112] His collection of Old Masters, engravings and modern paintings – 179 pictures in all – was auctioned by Christie's in London on 13 and 20 February 1864.[113] It is not known if he had acquired the works whilst living in Belfast, with the possible exception of one piece – *Christ stilling the Storm*, by John Martin (1789–1854), which he had almost certainly purchased at Wallis's Belfast sale of 1850.[114] A small version of the picture, which was apparently of a substantial size and is now lost, is in York City Art Gallery (Plate 17). Amongst his Old Masters were Canaletto, Nicholas Poussin and Salvator Rosa, whilst his modern masters included Thomas Clater, Francis Danby and George Morland. Overall, his collection appears to have been extremely impressive, judging by the names represented.

The best-known and most interesting collector of the three, however, was the cotton mill manager Francis McCracken (1802–63).[115] Like Clarke and Fenton, he too was involved in the various local art societies of the 1840s and 1850s and was a committee member of the School of Design.[116] A collector from the mid-1830s, his importance lies in the small group of Pre-Raphaelite paintings he began to acquire in November 1851 and which he was forced to sell for financial reasons in 1854 and 1855.[117] His 'conversion' to the Pre-Raphaelites came after reading John Ruskin's *Modern Painters* (1843–46).[118] Writing in 1853

to Ford Maddox Brown, artist and friend of the Pre-Raphaelites, he described his change of heart thus: 'It was the writing of Ruskin which first opened my eyes to the subject of art, which led me to kick over the whole tribe of my bedaubed, bedevilled and be[damne]d old rubbish and replace them with works by Brown, Hunt & Co.'[119] Amongst the paintings which he purchased were *Wycliffe reading his Translation*, by the said Brown; *Ophelia*, by Arthur Hughes; *Valentine rescuing Sylvia from Proteus*, by the above-mentioned Hunt (that is, William Holman), and *Ecce Ancilla Domini! (The Annunciation)*, by Dante Gabriel Rossetti (1828–82) (Fig. 49).[120] He also took on approval, in early 1853, Brown's now famous *Pretty Baa Lambs* but eventually returned it, disliking the colouring.[121] Had he decided to buy, this would have been the most prestigious Pre-Raphaelite work in his collection.

In his acquisition of Pre-Raphaelite paintings, McCracken dealt directly with the artists. However, his constant haggling over prices, general waywardness in paying and habit of offering works from his collection in part-exchange for payment, made him the subject of much mirth and ridicule within the Pre-Raphaelite circle, to the extent that Rossetti – with whom he corresponded frequently – was moved to lampoon him in a sonnet of 1853 entitled 'McCracken'.[122] A parody of Tennyson's poem 'The Kraken' (which described a monstrous creature of the ocean), the piece poked fun at McCracken's methods of collecting and depicted him as a one-eyed picture-acquiring monster. Ironically, the last line of the sonnet, which declared jokingly that McCracken would end up insolvent, proved to be fatefully accurate, for in 1854 he was forced to sell part of the collection, as mentioned above. From the early 1850s, he had been beset with financial difficulties as the Belfast cotton industry, which had been declining since the 1820s, moved finally towards collapse.[123] In 1855 he was obliged to sell a further number of paintings, including the *Ecce Ancilla Domini!* above.[124] This

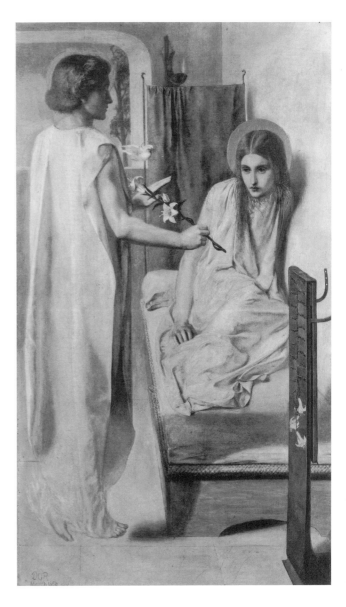

49 Dante Gabriel Rossetti *Ecce Ancilla Domini! (The Annunciation)* (1849–50) This was one of a number of Pre-Raphaelite paintings owned by the Belfast collector Francis McCracken.

**50** William Mulready
*Giving a Bite* (1834)
This, or a version of it, was
exhibited by the Belfast
printseller E.H. Lamont in
June 1849.

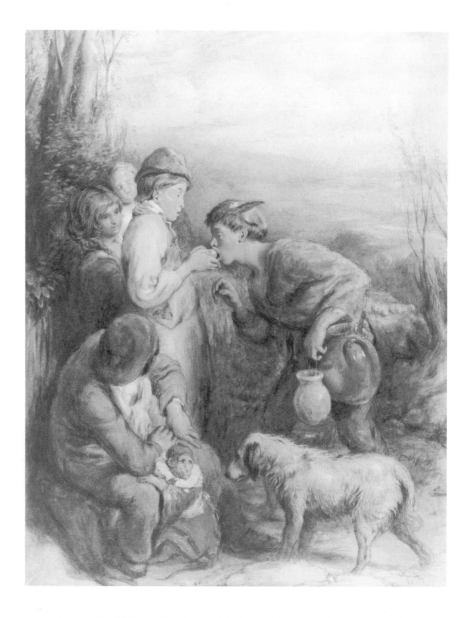

saw the end of his collection of beloved Pre-Raphaelite works. For-
tunately, a number can be traced and are now to be found in public
collections in Birmingham, London, Manchester and Oxford.[125]

By 1860, McCracken was in a severe financial crisis, owing almost
£1,300 to the leaseholder of the mill.[126] In June of that year he lost
possession of it. His only remaining assets, besides his household
furniture, were twenty-one oil paintings – presumably his 'bedaubed,
bedevilled and be[damne]d old rubbish' of former times and earlier
tastes – which he auctioned at Christie's on 16 and 17 August 1860.[127]
The pictures, which included works by Hugh Frazer, Niemann and

David Roberts, appear to have fetched low prices, fifty-five guineas for a landscape by the Belgian artist Kindermans being recorded as the highest figure in the local press. Thus did Belfast's most interesting and forward-looking collector of the nineteenth century end his career as a patron of the fine arts on a low note. Had Belfast's cotton industry not failed and brought McCracken down with it, his passion for the Pre-Raphaelites would doubtless have continued. However, whether he would have kept the collection is another matter; apparently a creature of whim, with a fondness for wheeling and dealing, he seems to have enjoyed the latter pursuits as much as the owning of works of art. Nevertheless, whatever his constancy as a collector, his name now ranks amongst the small band of patrons – several of whom were northern English merchants and manufacturers like James Leathart and Thomas Plint – to purchase works by the Pre-Raphaelites, often in the face of critical opinion.[128] As such, he remains an intriguing figure on Belfast's artistic and cultural scene in the nineteenth century.

## LOCAL PRINTSELLERS' EXHIBITIONS

The practice by local printsellers of displaying popular paintings as one-picture exhibitions continued steadily during these years. The firms of John and Robert Hodgson and E.H. Lamont remained in operation until the early 1850s, although both were considerably less energetic in this line than during the previous decade. Lamont was the first to close, in 1852, although the print publishing side of the firm had already been sold the previous year.[129] He ended his displays for the print trade on a high note, showing four works by a few of the most distinguished artists of the day in a group exhibition in June 1849: *The Combat*, by William Etty; *The Battle of Waterloo*, by George Jones; *The Loan of a Bite*, by William Mulready; and *John proclaiming the Messiah*, by Thomas Unwins.[130] The pictures, lauded by the *Belfast News-Letter* as a treat worth seeing, were large-sized oil paintings, with the exception of that by Mulready, which was a medium-scale watercolour.[131] A watercolour by the artist in the collection of the Ulster Museum, entitled *Giving a Bite* (1834) (Fig. 50) may perhaps be the work shown by Lamont.[132] Mulready is known to have also painted two oils of the subject.[133]

The Hodgsons exhibited only three paintings before their closure in the spring of 1853: *The Trial of the Seven Bishops*, by John Rogers Herbert, in 1849, and two works by Sir Edwin Landseer in 1852: *The Forester's Family* and *The Monarch of the Glen* (by 1851).[134] The latter (Plate 18), the last the firm showed for the print trade, has since become one of the best known of all Victorian paintings. On display for a week in late August, the picture had previously been exhibited in

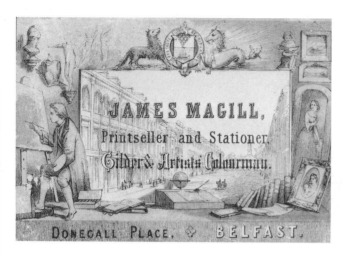

**51** Trade label of James Magill. The firm was one of the leading printsellers and fine art suppliers in Belfast from *c.* 1848 until the end of the century.

Cork and was the property of the 1st Lord Londesborough.[135] Orders for its engraving by Landseer's brother Thomas were being taken by the firm. In the image of the stag surveying the world, majestic before the wild and solitary scene, Landseer evocatively captures the essence of the Highlands, of the grandeur of nature at its most sublime.[136] The exhibition of this work, described as 'noble' and 'magnificent' by the *Northern Whig*, was an appropriate finale by the Hodgsons, who had brought so many fine paintings to Belfast since 1836.[137]

After these closures, exhibitions in this line were undertaken by a newcomer on the scene, printseller and publisher James Magill (Fig. 51), who had commenced in business about 1848 and continued to operate for the next fifty years or so.[138] During the 1850s he showed several British paintings of repute, a number of which were of historical subjects.[139] Two of the most topical were exhibited in the early years of the decade: *Queen Victoria's Departure from Ireland, 10 August 1849*, by Matthew Kendrick (c.1797–1874) and *The Opening of the Great Exhibition by Queen Victoria on 1st May 1851* (1851–52), by Henry Courtnay Selous (1803–90). *Queen Victoria's Departure from Ireland, 10 August 1849* (Fig. 52), the first major work to be shown by the firm, was on display during late May and early June 1850.[140] The painting depicted the queen's embarkation on the royal yacht at Kingstown (Dun Laoghaire) on the evening of 10 August 1849, a scene described thus in her journal: 'We stood on the paddle box, as we slowly & majestically steamed out of Kingstown amidst the cheers of thousands and thousands, & salutes, I, waving my handkerchief as a parting acknowledgement of the loyalty shown me.'[141] At the time of its Belfast showing, the queen was already the owner of the picture, having purchased it from Mr Cranfield of Dublin on 2 March or 8 April 1850. Thereafter, Cranfield exhibited it in Dublin, then at Magill's, to promote its forthcoming engraving by Charles Mottram (published by Cranfield on 1 June 1852).[142] The painting has hung in Buckingham Palace since shortly after its acquisition.

*The Opening of the Great Exhibition by Queen Victoria on 1st May 1851* (Fig. 53) was displayed during late August and early September 1852 and had previously been shown in Cork.[143] The picture illustrated the moment in the opening ceremony of the exhibition when the Archbishop of Canterbury offered up a benedictory prayer.[144] Many of the persons in the work, including the various members of the royal

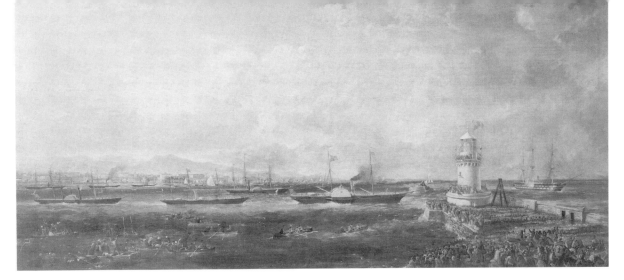

**52** Matthew Kendrick
*Queen Victoria's Departure from Ireland, 10 August 1849*
The first major work to be exhibited by Magill, the painting was on display between late May and early June 1850.

53 Henry Courtnay Selous
*The Opening of the Great Exhibition by Queen Victoria on 1ˢᵗ May 1851* (1851–52)
This interesting record of the Great Exhibition was shown at Magill's between late August and early September 1852.

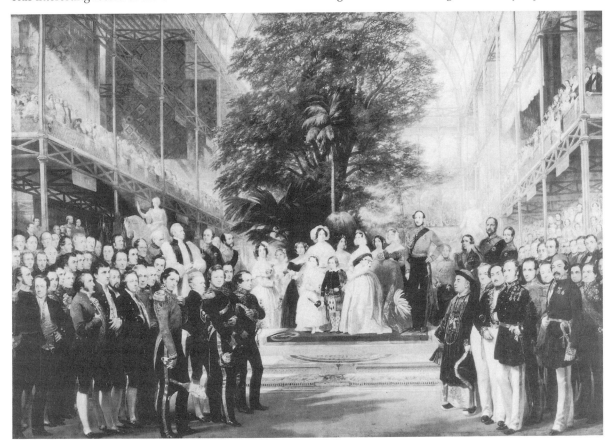

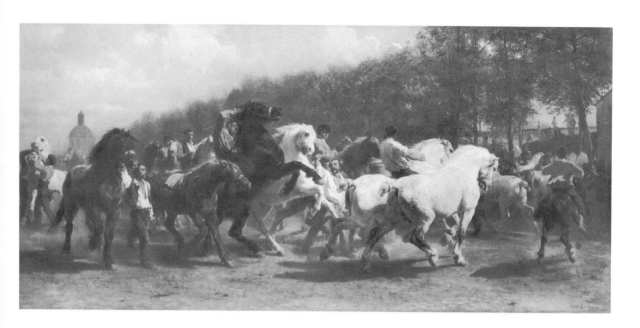

**54** Rosa Bonheur
*The Horse Fair*
One of the first works by
Bonheur to have been
seen in Belfast, the picture
was on display at Magill's
between late May and early
June 1859.

family, sat to Selous, who completed the painting during the first half
of 1852. Sir Francis Graham Moon, a partner in the print publishing
firm of Moon, Boys and Graves, appears to have been the first owner
of the picture (it was his at the time of its Belfast showing) and may
have bought or commissioned it in order to have it engraved. The
engraving, by Samuel Bellin, was published by Boys in 1856. The
*Belfast News-Letter*, in its covering of the exhibition, urged all persons
of taste to 'obtain a copy of this interesting authentic memorial of one
of the greatest events in the history of our social progress'.[145]

Aside from topical and historical works like these, Magill also
showed paintings of a more imaginative nature. *Scene from 'A Mid-
summer Night's Dream': Titania and Bottom* (1848–51) by Landseer and
*The Horse Fair* by Rosa Bonheur (1822–99) were amongst the most
interesting and attractive of the various other genres on display.
*Titania and Bottom* (Plate 19), Landseer's only illustration of Shake-
speare, had been commissioned by the engineer Isambard Kingdom
Brunel and was exhibited in December 1856.[146] The picture, engraved
by Samuel Cousins in 1857, was in Belfast to help promote sales of the
forthcoming print.[147]

A particularly prestigious exhibition for Magill was the display,
in late May and early June 1859, of *The Horse Fair* (Fig. 54), one of
the most famous paintings of the day and one of the first works by
Rosa Bonheur to have been seen in Belfast.[148] The picture shown at
Magill's was not the large original (which is in the Metropolitan
Museum of Art, New York) but a smaller version, that in the National
Gallery in London.[149] The original had been purchased in 1855 by the

dealer Ernest Gambart, who planned to have it engraved by Thomas Landseer.[150] To facilitate the engraving, Bonheur gave Gambart a second, reduced version (the National Gallery picture). By August 1855, Gambart had sold the reduced version to Jacob Bell, who, in 1859, lent it to Gambart for five years, for exhibition in any part of the United Kingdom.[151] Belfast was thus one of the many centres in which it was displayed.[152] In addition to prestigious works like those detailed above, Magill also exhibited and dealt in paintings by local artists, particularly Burgess, Hooke and Nicholl, and by well-known Irish painters such as Martin Cregan and Richard Rothwell.[153]

Local printsellers, nevertheless, did not have the monopoly on exhibitions for the print trade; occasionally, publishers from elsewhere also sent works to Belfast for the purpose. One such was John Finlay of Glasgow, who despatched an important piece by the history painter Thomas Jones Barker in the spring of 1854 – *The Meeting of Wellington and Blücher at La Belle Alliance on the Evening of the Glorious Victory of Waterloo*.[154] The work, thirteen feet by nine, was displayed in the Commercial Buildings, in order to enlist subscribers for its engraving by C.G. Lewis. Described as a 'Grand National Picture' by the *Belfast News-Letter*, the paper was high in its praise, with a minor reservation: 'The *only apparent* fault is the unanimated countenance of the victor at a scene where he and Blücher are said to have hung on one another's necks; but then it must be remembered that Wellington presented an impassive aspect, even in his moments of excitement.'[155] The painting was the first of a number by Barker to be exhibited in town.

## POPULAR ART AND PUBLIC SCULPTURE

Those ever popular theatrical experiences, panoramas and more sophisticated versions like cosmoramas and dioramas, with moving pictures and clever lighting, became regular occurrences during the 1850s; indeed, no fewer than sixteen were exhibited in town during this time, a four-fold increase on the previous decade.[156] Their content, as ever, varied between scenes of faraway places and events from recent history. During 1850–51, three panoramas of the Mississippi were to be seen: that of 'Professor' Risley and J.R. Smith, at the Theatre Royal during December 1849; Barnum's, in the Commercial Buildings between February and April 1851; and John Banvard's, the original Mississippi 'experience', at the same venue during the following July.[157] This latter work had been on tour around Britain since December 1848. Of historical events, the Crimean war seems to have struck a particular chord, with no less than four productions in Belfast between 1855 and 1857: Hampton's diorama, at the Music Hall (Fig. 55) between September and October 1855; Lancaster's *Seat of War*

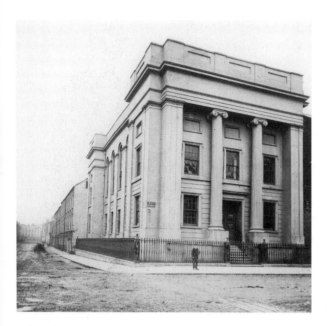

panorama, at the same place during February and March 1856; Gompertz's *Panorama of the War*, in the same location the following May and June and Plimmer's diorama, in Victoria Street during June 1857.[158] Advertisements for such productions invariably extolled the accompanying attractions, which ranged from an orchestra or brass band to a narrator providing an educational talk as the scenes unfolded.

Besides these 'spectaculars', there were a few other exhibitions that would also have attracted a wide cross-section of the public. One which certainly gripped the imagination was an exhibition of photographs relating to the Crimean war by the noted photographer Roger Fenton, at Magill's during April 1856.[159] Comprising 350 images of private soldiers going about their duties and portraits of British and French commanders – there were no scenes of the actual fighting or suffering – copies of the photographs were on sale at the gallery. Admission, initially one shilling, was eventually reduced to six pence for evening viewers.[160] Though no visitor numbers are recorded, the show was reported as being highly successful.[161] Doubtless many who seldom patronised exhibitions also attended, drawn out of curiosity to this on-the-spot reporting of a recent event. Another undoubted crowd-puller was *The Last Judgement*, after Michelangelo, on show in the Music Hall over Christmas 1859.[162] Billed, obviously incorrectly, as 'the great original [and] something to speak of in future years', it probably appealed to other sectors of the community besides those interested in art.[163] With displays like these and the multitude of works at auction rooms, printsellers' shops and exhibitions, the artistic tastes of Belfast's inhabitants were well catered for.

For those with an appreciation of sculpture, the erection of the statue to the Earl of Belfast in 1855 must have been particularly gratifying, as, indeed, to the many who held the memory of the young man dear. The idea for the sculpture (Fig. 56) – Belfast's first public memorial – originated at a meeting in the Linen Hall Library on 2 September 1853, some eight months after the earl's death.[164] By the following December, it had been agreed to award the commission to the locally-born sculptor Patrick MacDowell (1799–1870), a decision which would certainly have pleased the earl, given his deep attachment to the town.[165] As a gesture of thanks to subscribers to the project, the earl's mother, the Marchioness of Donegall, presented each with a

**55** The Music Hall, also known as the Victoria Hall and Victoria Music Hall. Built for the Anacreontic Society (a music society) and opened in 1840, it was used for concerts and a variety of art-related events: panoramas, dioramas, auctions, exhibitions and *conversazioni*. Demolished in 1983.

copy of Charles Baugniet's lithographic portrait of her son (Fig. 45) and also gave copies to the Working Classes' Association, to be sold in aid of the organisation.[166]

The site eventually selected was the road in front of the Academical Institution.[167] The unveiling ceremony on 1 November 1855 was attended by large numbers, with the Lord Lieutenant, the Earl of Carlisle, delivering the opening address.[168] Appropriately, the first speech after the unveiling was given by the local poet Francis Davis, who spoke on behalf of the Working Classes' Association. Describing the earl's short but fruitful relationship with the organisation, he summed up the young man's endeavours for the cultural improvement of the town's less privileged inhabitants with a touching tribute: 'Publicly and privately, he was the people's pioneer in every field that promised knowledge to the seeker, and on every path that presented even the possibility of their moral elevation.'[169]

With a poetical yet commanding appearance, the sculpture shows the earl standing with book in one hand, coat tails in the other, the voluminous swathes of material gathered about him like a classical robe. The work exudes the timeless aura of antiquity. In the erection of the piece, Belfast was following a trend prevalent in Britain since the 1820s, namely, the commemorating of individuals other than the monarch by public memorials. Such an addition to the townscape probably helped lend an air of dignity, of culture and refinement, to the somewhat drab surroundings of the town.

By the late 1850s, Belfast's art lovers, those who established art societies and organised exhibitions only to see them falter time after time, must surely have felt that they were promoting a lost cause. This seems obvious, as a further twenty years were to pass before another art society was set up, the Belfast Ramblers' Sketching Club, referred to earlier in this chapter. An idealistic belief that a love of art, energy and effort could effect change in the local art world, was clearly not a strong enough force. When progress was finally made in the early 1860s, when a corner was turned as regards annual exhibitions, it was not as a result of the work of local patrons but through the enterprise of a commercial dealer, Marcus Ward.

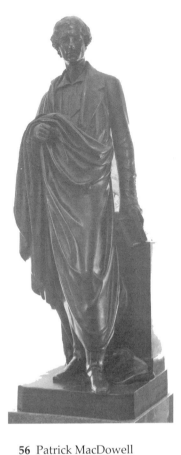

**56** Patrick MacDowell
*Frederick Richard Chichester, Earl of Belfast (1827–53)* (1855)
The statue, Belfast's first public memorial, was erected by the earl's many friends and admirers in 1855. Originally situated in front of the Royal Belfast Academical Institution, it is now in Belfast City Hall.

## ~ 6 ~

# A transformation in the arts

## The opening of Belfast's first commercial art gallery and the advent of regular exhibitions

## 1860–69

*'The success of an exhibition of works of art in this town is no longer a matter of dubiety; it is an accomplished fact'*[1]

### MARCUS WARD'S GALLERY AND THE ART UNION OF BELFAST 1866–68

The 1860s was an important decade for the fine arts in Belfast. In 1862, the town acquired a new exhibition space – the Ulster Hall (Fig. 57). The idea of a new concert hall for Belfast had first been raised in February 1857 by a number of local gentlemen including William Dunville, Charles Lanyon and Dr James Moore, committee members of the School of Design and active participants on the local art scene.[2] At Dunville's suggestion, it was proposed to include a display area for art exhibitions within the building. The scheme, which materialised as the Ulster Hall Company Ltd by February 1859, embraced 'a spacious Hall, with the necessary minor apartments, affording accommodation for between 2,000 and 3,000 persons, and suitable for Concerts, Lectures, Exhibitions of Art, Balls, Dinners and all other public purposes'.[3] The building's minor hall was to become a popular venue for art events such as auctions, panoramas and one-picture exhibitions. Of much greater significance, however, were the endeavours of the printing and publishing firm of Marcus Ward

and Company to place the fine arts on a firmer footing in the locality by opening an art gallery and establishing regular exhibitions. This new venture was to have important consequences for the local art world, as subsequent chapters will reveal.

An important backdrop to these artistic events was the state of the town itself. Although the foundations of Belfast's industrial might were already established, it was during 1860–70 that the massive expansion of the town actually began.[4] The scarcity of cotton caused by the American Civil War of 1861–65 led to a

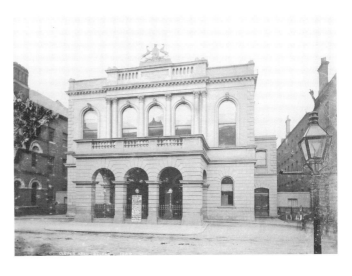

57 The Ulster Hall, Bedford Street, regarded at the time as 'one of the largest and most splendid public edifices in Belfast', was opened in 1862. One of its rooms, the 'minor hall', became a popular venue for art auctions, panoramas and one-picture exhibitions.

huge demand in home and overseas markets for its closest substitute – linen – to which the Belfast industrialists responded with vigour.[5] In the boom which followed, vast profits were made by Belfast's linen lords in 'Linenopolis', as the town came to be called.[6] So great was this growth that by the early 1870s, Belfast had become the largest linen-producing centre in the world. Shipbuilding and engineering were also vital forces in the economic success of the 1860s.[7] The extent of Harland and Wolff's enterprising drive can be seen in the fact that in 1870, the company began building Atlantic liners for the White Star Line, an alliance which was to bring about a new era in ocean travel. By this point, there were twenty iron foundries in the town, supplying the engineering needs of the linen and shipbuilding industries. In such go-ahead and prosperous times, the amount of wealth in the locality may have been a factor in Marcus Ward's decision to open their gallery.

Though Marcus Ward and Company had been in business since about 1833 (Marcus himself had died in 1847), the impact of the firm on the fine arts in Belfast was negligible until the early 1860s.[8] Then, in January 1864, the company took what was to be a new departure for them and opened a showroom on the first floor of their premises at 13, Donegall Place (Fig. 58).[9] By the following March, they had developed the space into an art gallery and had added photography to their line of business.[10] In this fine art undertaking, they, in fact, plugged a gap in the cultural fabric of the town. Whilst there were already places where art could be viewed in a gallery-like setting, notably the gallery in Cramsie's auction house and in print shops like that of James Magill, these exhibiting spaces were not commercial art galleries as such but were adjuncts of other businesses. Ward's was thus the first commercial art gallery in Belfast. Although there

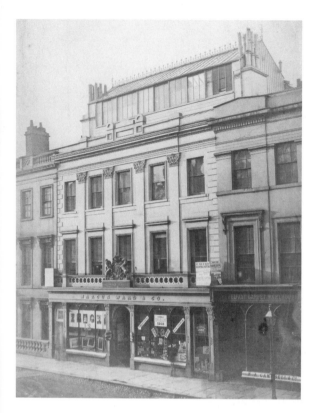

**58** Marcus Ward's premises in Donegall Place in late 1867, showing an advertisement for the Art Union of Belfast exhibition. The structure on the roof is the photographic studio. The royal warrant above the door refers to the firm's appointment as bookbinders to the Prince of Wales, which they had received in July of that year.

are no details of its dimensions or standards of comfort, the premises overall appear to have been of a reasonable size, with an attractive façade of pilasters with richly-decorated capitals uniting the first and second floors of the three-storey building.

It seems unlikely that the Ward brothers – Marcus's sons Francis Davis, John and William – would have embarked upon such a venture without assessing the market for it, given the long-established indifference of Belfast's middling ranks towards art-centred projects such as exhibiting societies and annual exhibitions. Francis and John had been partners in the company since the 1840s and had considerable experience in the fine art printing and publishing trade.[11] William, who was much younger than his brothers, did not enter the firm until 1864, when he turned twenty-one.[12] Whilst the motive behind the diversification into the art gallery line is unclear – the prosperity of the town has already been suggested – it seems reasonable to speculate that it may have been this youthful 'new blood' – William – who was behind the idea and the main promoter of the undertaking. The inspiration for the venture may have been the example of Thomas Agnew, proprietor of a successful gallery in Manchester from 1817 (known as the 'Repository of Arts' in its early days) and in London from 1860.[13] Agnew, with his commercial galleries, is regarded as having established in Britain the system whereby picture and print dealers owned their own premises and held regular exhibitions. The Ward brothers may have speculated on the fact that Belfast's middling classes would have found the gallery, modelled perhaps on Agnew's well-known London premises, appealing to their social aspirations.

The first exhibition, a small selection of watercolours by artists such as David Hardy, James Hardy and Edwin Hayes, was held in June 1864.[14] So successful was it that a second and much larger display of watercolours was held a few weeks later.[15] That the venture was regarded as something new in the locality seems clear from the *Belfast News-Letter*'s comment in its review of this second exhibition: 'The enterprize of Messrs Ward & Co. is well worthy of the support of the nobility, gentry and merchants of this neighbourhood.'[16] The setting up of the gallery was also considered noteworthy and was still being applauded in the local press the following October:

Messrs. Ward & Co. … who have already done so much to raise the repute of Belfast in art-manufacture, have made a creditable effort to introduce high-class works by opening a permanent saleroom … There is a considerable venture in this attempt to establish here a permanent sale of such first-class pictures – but the Messrs. Ward deserve credit for their enterprise, and have even already succeeded in placing on the walls of some of our local connoisseurs works of a class and price hitherto unknown in Belfast.[17]

The gallery continued to flourish over the next five years by picture dealing and exhibitions of various types, as detailed below.

In November 1866 the firm embarked upon an undertaking which was to have considerable ramifications for the progress of the fine arts in Belfast: the mounting of a large-scale exhibition on the lines of those organised by the various exhibiting societies which had failed in the past.[18] In their advertisements for the event, Ward stressed their intention as being 'to promote the interests of Art in Belfast' and appended to the notices a lengthy list of distinguished patrons.[19] Heading the names were the Marquesses of Abercorn, Donegall and Downshire, the Earls of Enniskillen and Roden and Lords Dufferin and Lurgan. These were followed by gentry such as Sir Thomas Bateson, Sir Edward Coey, Sir William G. Johnston and several worthies who had served as deputy lieutenants. This string of important names was unquestionably an attempt to lend social prestige to the venture. In a further appeal to the vanity of the upper and middling classes, the firm invited other gentlemen to permit their names to be added to the list.[20] The response to this was extremely enthusiastic, with fifty-nine persons coming forward within the space of a week.[21] Amongst these were the mayor William Mullan, a few eminent clergy, academics from Queen's College and a wide range of merchants and manufacturers, most of whom were either deputy lieutenants or justices of the peace. As a group, they symbolised wealth and status, factors that made them not only perfect patrons of the exhibition, but possible purchasers of the works in it. With support like this, the gallery – obviously well-appointed and part of an already prestigious concern – became the 'fashionable resort' which the Belfast art world had needed for so long.

The exhibition met with much enthusiasm in the local press. Nevertheless, the *Northern Whig* remained somewhat sceptical of the town's appreciation of cultural pursuits, despite the large number of distinguished patrons who had lent their names to the undertaking:

The amount of wealth that has been realised in this town during the past few years is very great, and there are more ways of

expending money than on upholstery, equipage and luxurious living. It has been said that Glasgow people have riches, but no taste; that Edinburgh people have taste, but no riches; that Manchester has both; and that Dublin has neither. In this, as in other generalisations, there is no small amount of error; but it is to be feared that, if Belfast had to be classed with any of the centres of population, in the category we would needs be coupled with Glasgow.[22]

The paper, however, continued hopeful that better days lay ahead for Belfast and that the lack of such as annual exhibitions and a free public library would eventually be remedied.

The show contained about 550 works, of which almost 300 were watercolours.[23] The entire display took up three of the largest rooms in the building. Considering the premises' size and the extremely large number of exhibits on show, works were presumably hung tightly-packed and up to ceiling height. Whilst a number of local collectors lent works, by far the greater proportion of exhibits were submitted by artists, for sale. Inviting local owners to display their treasures was perhaps a shrewd ploy by Ward in this, their first large-scale venture; by involving local collectors in this way, their aim was probably to gain greater commitment from them, rather than to add variety to an already varied exhibition. Amongst the oils for sale were examples by Abraham Cooper, Frederick Goodall and Alfred W. Williams, whilst the watercolourists included Antony Vandyke Copley Fielding, Myles Birket Foster and Samuel Prout.[24] Alongside established names like these were many works by young and rising artists.

A week after the exhibition's opening on 21 November, the *Northern Whig* made a suggestion which was to be of considerable importance to the success of the event: that there should be an art union set up in connection with the show, with shares at five shillings each.[25] The idea was sound, as such societies were a useful means of increasing the number of patrons at exhibitions and promoting sales, as already discussed in Chapter Three. Several art unions had been established in Britain since 1837 and at least seven in Ireland since 1839. Whilst visitor numbers to the event had apparently been high during the first week, the *Northern Whig* saw its recommendation as a useful way of increasing sales. The proposal was entirely in keeping with the ethos of the paper, which had been a constant promoter of the fine arts in Belfast since 1826. Ward's accepted the idea immediately and outlined a scheme in the paper on the day following publication of the suggestion. According to their advertisement:

The whole of the money subscribed, without any deduction

whatever [by this, they presumably meant expenses incurred] shall be divided into different sums by a committee of subscribers chosen from the list of patrons of the Exhibition, and apportioned by lot, as prizes, before the close of the Exhibition. Each Prizeholder shall have the right to select … One work of the value of his Prize.[26]

In line with the *Whig*'s proposal, shares were to be five shillings each, with five for a guinea. The price of the shares – a quarter of the cost of those of the ill-fated Northern Irish Art Union of 1842 – was presumably set at this reasonably modest rate to widen the appeal of the show and bring in a greater number of patrons. At the end of December, the Art Union was officially sanctioned by the Privy Council.[27] Thereafter styled 'The Art Union of Belfast', its mission was to 'afford the public an opportunity of giving *bona fide* support to the effort to establish periodical Exhibitions in Belfast.'[28] Ward's remained honorary managers and agents of the enterprise.

Sales at the exhibition were high, doubtless as a result of the Art Union scheme; the *Art-Journal*, in its review of the event shortly after its closure, claimed that almost half of the works had been sold.[29] The draw took place in the Music Hall on 24 January 1867, under the management of a committee of subscribers and chaired by the mayor, David Taylor.[30] The amount subscribed came to £871 10s, divided amongst 133 prize winners, with prizes ranging from £50 to £3.[31] The number of shareholders was 949. A large proportion of the winners apparently added to the amount of their prizes, in order to obtain works of their choice.[32] However, no details have been found regarding the paintings disposed of. How Ward's actually financed the exhibition is unclear; the shilling admission charged for those who were not Art Union shareholders would probably not have raised all that much.[33] Expense for transportation of paintings must have been considerable and this cost, as stated in their advertisement, was not met by the amount raised in Art Union shares. They may have taken commission from the artists for each work sold, to help cover costs. Concerning sales, the fact that the exhibition had been opened before the Art Union was set up meant that works could be purchased independently of it.[34] This had been the case with the Northern Irish Art Union. Generally, however, art unions did not operate a system of private sales, as that would have defeated their purpose.[35]

Within a few months of the closing of the exhibition in early February 1867 and obviously impressed by its success, Ward's decided to hold another, in the following winter.[36] As with the first exhibition, this second show also opened in November.[37] By this point, the firm had modified the approach to costs somewhat, as 'The whole of the

money subscribed, less actual expenses, will be divided and drawn for as Prizes.'[38] Presumably these costs meant heating and lighting of the premises and transportation of paintings. The exhibition was considerably larger than the first. In the absence of a catalogue but as recorded in the *Northern Whig*, there were 732 works on display, of which 368 were watercolours.[39] Amongst the artists were Copley Fielding, Birket Foster, William Hunt and John Sherrin.[40] In its advertisement for the event, Ward's stated that all the pictures in the show were available as Art Union prizes, which would lead one to suppose that there were no private sales or at least not until after the Art Union draw.[41] As with the first exhibition, a few local persons lent works.[42] According to the *Whig*, the event had been oversubscribed and numerous artists in various parts of the kingdom had had their paintings returned to them, because of lack of space in the gallery.[43] In the same issue, the paper lauded the social implications of the Art Union scheme, as it rendered 'the placing of the pictures all the more general – the horny handed mechanic whose taste, speculation, and finance reach the length of 5s … having as good a chance of becoming the retainer of a Birket Foster, a Danby or a Copley Fielding, as the wealthy merchant and millowner'. Unfortunately, there is no information as to the social rank of those who purchased shares.

The draw, held on 13 February 1868, again took place in the Music Hall, under the direction of a committee.[44] The amount subscribed this time was almost £1,000, divided amongst 170 winners, with prizes ranging from £40 to £2. In order to give 'perfect satisfaction' to winners of smaller amounts, winners of £5 or less could select their prizes from a collection of framed engravings, chromolithographs and photographs, items which would have been cheaper than original works of art.[45] By widening the scope thus, Ward's increased the selection of works for the less affluent prize winners, those who could not afford to top up their winning amounts. In this way, the benefits of the Art Union were able to permeate down through the poorer classes.

A third exhibition was held during the winter of 1868–69.[46] Unfortunately, this was to be the last. Some months before, in June 1868, Ward's had announced their intention of retiring from the retail fancy goods trade, which embraced the art gallery and photographic studio side, to concentrate on the manufacturing aspect of their operations.[47] Whilst the reason for the ending of what was obviously a highly successful sideline is somewhat puzzling, it may have been related to the opening of a London office and showroom in 1867, an undertaking which had perhaps proved to be more costly that had been anticipated.[48] Closing the retail fancy goods side was perhaps a money-saving exercise. Coincidentally, William Ward had been sent

to London in the same year (1867), to run the operation. If he was the brain behind the art gallery, as speculated, his departure may possibly have helped hasten its closure.

Although retiring from the management of the exhibition, Ward's were hopeful that it would continue on an annual basis and, in a newspaper advertisement in September 1868, declared that they had taken steps to ensure that this would be the case.[49] Whatever measures were taken remain unknown; what is certain is that they were unable to find an alternative organiser of the event, the exhibition ended and with it, the Art Union of Belfast. The only other art establishment in town remotely comparable to Ward's was the fine arts repository of James Magill. This, however, could probably not have handled such an extensive operation as the winter exhibition. Only Ward's had the financial strength and capacity for such a large undertaking. When they withdrew, the ending of the exhibition was inevitable. Of the rest of the business, the stationery and printing operations were transferred from the Donegall Place office to new premises, the Ulster Works in Fountain Street. The Donegall Place building, including the art gallery, was taken over by Francis Davis Ward by December 1868 and the photographic side of the concern sold.[50] The premises were subsequently let to the furniture maker and auctioneer N.A. Campbell in February 1869, after the exhibition closed.[51]

The show comprised 545 works, the value of which was reported to be over £15,000.[52] Both the *Belfast News-Letter* and *Northern Whig* considered the exhibition to be the best of the three, because of the large number of good quality works.[53] The usual panoply of renowned contemporary artists was represented: Copley Fielding, Birket Foster, Heywood Hardy, Samuel Prout, Alfred Vickers and Edward Matthew Ward. Unlike the previous exhibition, private sales appear to have been permitted from the start.[54] As with earlier years, admission for those not shareholders in the Art Union was a shilling. To enable the working classes to attend, the show was opened on Saturday evenings from early December at a charge of three pence, a price 'corresponding with the means of every grade of the artisan class'.[55] These reduced rate openings met with great success, as large numbers of tradesmen and their families apparently flocked to the exhibition.

The Music Hall was once again the setting for the draw, which was held on 1 February 1869.[56] The sum raised was £700, divided amongst 113 winners, with prizes of between £50 and £2. From the size of the subscription – considerably less than the amounts raised by the two previous exhibitions – it would seem as if enthusiasm for the event was on the wane. However, a more likely explanation was the general depression of 1868, caused by a loss of economic

**59** Sir John Everett Millais
*My Second Sermon* (1864)
This image of an obviously
bored Effie was shown
at Ward's between
mid-October and early
November 1865.

confidence in the aftermath of the failure of Overend and Gurney, one of Britain's leading bill brokers, in 1866.[57] Another factor, of particular relevance to Belfast, was a decline in the demand for linen, as cotton supplies returned to normal with the ending of the American Civil War. In 1868 there were some 60,000 spindles and 4,000 power looms idle in the town. Given this overall slump, there was probably less money around for the acquisition of luxury items such as paintings. Nevertheless, there is no indication of a recession in the art market in the local press. The only comment concerning the drop in subscriptions was made by the *Northern Whig* of 27 January (1869), which reminded its readers that a well-filled subscription list for the Art Union was necessary to ensure its continuance.

Like the three other printselling concerns already noted – the Hodgsons, E.H. Lamont and James Magill – Ward's also held one-picture exhibitions in connection with the print trade. This side of their operation began in 1865, with the showing of a prestigious painting by Sir John Everett Millais (1829–96), *My First Sermon* (1863) (Plate 20) during April and early May.[58] The picture, the first by Millais to show a sentimental treatment of childhood, depicted his eldest daughter Effie paying rapt attention in church.[59] The work proved to be so popular that he painted a companion to it, *My Second Sermon* (1864) (Fig. 59), which showed an obviously bored Effie asleep in the pew. This was exhibited at Ward's some six months after *My First Sermon*, that is, from mid-October to early November 1865.[60] Both paintings, for which subscriptions for engravings were being taken, drew large crowds.[61] Though examples and engravings of Millais' work had been passing through the Belfast auction rooms since 1858, these exhibitions brought his paintings before a much wider local public than hitherto.[62]

In all, Ward's held six one-picture exhibitions between 1865 and 1868, inclusive of the three mentioned here.[63] Whilst this was a much smaller number than those mounted by the Hodgsons and Magill, Ward's had probably less time to devote to undertakings of this kind because of the work involved with the winter exhibitions and the Art Union. The last painting to be shown – *The Marriage of the Prince of*

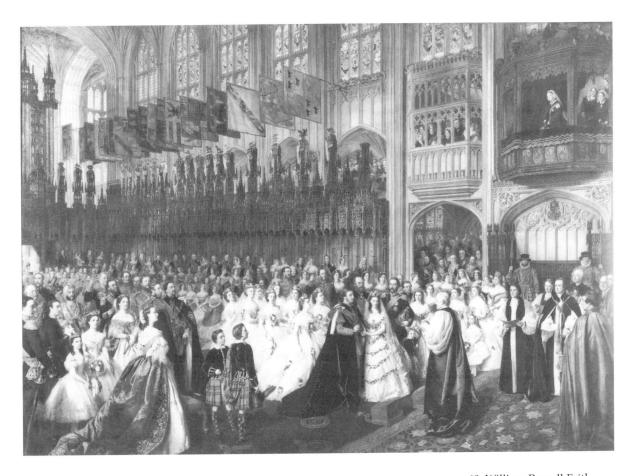

60  William Powell Frith
*The Marriage of the Prince of Wales, 10 March 1863*
(1863–65)
A smaller version of this, perhaps the picture in the Walker Art Gallery, Liverpool, was on display at Ward's between late April and late May 1868.

*Wales, 10 March 1863* (1863–65) by William Powell Frith (1819–1909) (Fig. 60) – was particularly topical, as the Prince and Princess of Wales had ended a visit to Dublin a few days before the work went on display at Ward's. Exhibited between late April and late May 1868, the picture seen was almost certainly not the original work painted for Queen Victoria, but was probably the reduced version which Frith executed for the art dealer Louis Victor Flatow.[64] Whoever the owner, Ward's advertised the painting as belonging to the queen.[65] By mid-May, the exhibition's admission charge had been reduced from a shilling to six pence, 'to enable all Classes of the Public' to attend.[66] Considering that the cost to the working classes for the forthcoming winter exhibition was to be three pence, Ward's seem to have been somewhat unrealistic in their assessment that 'all Classes' could afford such a charge. Whilst there are no details in the press as to how well the picture was received in Belfast, it seems likely that it attracted large crowds, curious to see an accurate representation

of a royal event. The display was a fitting end to Ward's one-picture exhibitions, as the firm had been appointed bookbinders to the Prince of Wales the year before.[67]

## HEALTHY COMPETITION: THE CONTINUING SUCCESS OF MAGILL'S FINE ARTS REPOSITORY

Whilst Magill's was a much smaller business than Ward's, it nevertheless led the field in the mounting of one-picture exhibitions. Between 1860 and 1869 the firm held twenty-three such displays, with works ranging from historical and narrative paintings and religious allegories to a major Pre-Raphaelite piece.[68] This sizeable number is probably explained by the fact that Magill did not hold large-scale mixed exhibitions like Ward, undertakings which would have been extremely time-consuming to organise. With no such commitments, the firm was able to concentrate more on displays for the print trade. That an element of rivalry existed between Magill and Ward seems inevitable, given that they were the only firms in Belfast operating in the field. A slight but tangible sign of this competition can be glimpsed in the local press of the mid-1860s, when the advertisements of each became bigger and bolder and were always positioned close together, as if vying with each other.[69]

Of the numerous works which Magill was responsible for showing in Belfast, the most famous was undoubtedly *The Derby Day* (1856–58) by William Powell Frith (Plate 21), exhibited in the Ulster Hall during May 1863.[70] This was the first time the building was to be used for a one-picture exhibition, a decision which may have been reached because of the large crowds expected to attend. The history of the picture sheds an interesting light on the type of transaction which could be made between artist and dealer. Apparently, the painting had been commissioned by the well-known collector Jacob Bell in 1856 for £1,500.[71] However, by mutual consent, delivery of the work was postponed for some years. Meanwhile, Frith sold the right to engrave the picture to the dealer Ernest Gambart for £1,500; also, the right to exhibit it for a further £750. All told, therefore, Frith received £3,750, one of the highest amounts paid to a British artist for a single work by that time. In 1859 Bell bequeathed the painting to the nation.[72] Prior to this, in September 1858, Gambart sent it to Paris to be engraved, a project which was completed by April 1862, when the picture was exhibited at the Upper Gallery in London's Pall Mall. It remained there until July, at which point Gambart despatched it on a tour of the British Isles, before showing it in America and Australia. Its display in Belfast was thus part of its British tour of 1862–63. As a result of these various peregrinations, the painting did not enter the

132

National Gallery's collection until 1865. It was later transferred to the Tate Gallery.

As its title suggests, *The Derby Day* shows a scene at the famous race at Epsom – not, however, the race itself or the pre-race parade but a cross-section of the large crowd at the course. Frith apparently set out to portray images of almost one hundred distinct social types, from plain countryfolk to city gentlemen, from high-class prostitutes to swindlers and beggars.[73] The painting is therefore a microcosm of Victorian society. So great was the picture's impact that on its exhibition at the Royal Academy in 1858, it had had to be guarded by a policeman. This, however, failed to stop viewers from pressing too closely. Jacob Bell, the painting's owner, wrote to Frith that he had visited the Academy and 'found the people smelling the picture like bloodhounds'.[74] A barrier was eventually erected as protection. By a happy coincidence, the picture was in Belfast during Derby week, although whether such measures as the above were required for its safety are unknown. Unfortunately, there is no indication of visitor numbers in the local press; nevertheless, it seems reasonable to assume that the work attracted large crowds.

A few other pictures also stand out amongst the many at Magill's. An historical work that drew many visitors was *The Secret of England's Greatness (Queen Victoria presenting a Bible in the Audience Chamber at Windsor)* (c.1863) by Thomas Jones Barker (1815–82) (Plate 22). The painting, exhibited not at Magill's own premises but at 2, Donegall Place Buildings from late April until mid-May 1864, had already been displayed in Dublin some weeks previously.[75] In fact, this was the eighth of thirteen pictures by Barker to be shown in one-picture exhibitions in Belfast over the years, a figure which made his works the most frequently seen in town in this particular display format. The painting apparently attracted such large crowds that it was retained for longer than originally planned.[76] The scene shows the queen presenting a Bible to an African potentate at Windsor Castle, an event said to have taken place in 1846, when an African prince was presented to the queen and received from her a Bible with the words, 'This is the secret of England's greatness.'[77] An engraving of the work, by W.H. Simmons, was published some six months after the picture's Belfast showing, in November 1864.[78] Of this forthcoming print, the local press reported during the exhibition, 'It is a picture that will engrave beautifully, and many a home in the North of Ireland … will be decorated with this … representation of an incident in the life of the Queen, which at once illustrates the virtues of the Court, the religious tone of her Majesty's mind, and, in a certain sense, the very spirit of the age.'[79] As usual, there is no indication of the volume of sales of the engraving. Nevertheless, it seems likely that print orders

were high, given the subject matter of the work: benign imperialism and the supremacy of the reformed faith. That the painting became something of a Protestant icon can be seen in the fact that it has been reproduced on banners of the Orange Order, as a symbol of the Order's allegiance to the Crown and the Reformation.

One of the most famous of all Pre-Raphaelite works was also exhibited during these years, namely, *The Finding of the Saviour in the Temple* (1854–55, 1856–60) by William Holman Hunt (1827–1910). Paintings by followers of the Pre-Raphaelites, such as Robert Braithwaite Martineau, William Bell Scott and Henry Wallis, had already been seen in town, in the Belfast Fine Arts Society exhibition of 1854. In addition, local collector Francis McCracken had owned a number of pictures by Brown, Hunt, Millais and Rossetti in the early 1850s. These, however, had probably been known only to his friends and associates. *The Finding of the Saviour in the Temple* (Plate 23) was therefore the first major Pre-Raphaelite painting to have been seen by the wider Belfast public. The picture, on display during June and early July 1865, was exhibited for longer than intended due to public interest.[80]

*The Finding of the Saviour in the Temple* was the first important work which Hunt painted in the Middle East, a setting he had chosen in order to apply the Pre-Raphaelite principles of truth to nature to subjects from the scriptures.[81] Completed by April 1860, the painting was an immediate success when exhibited in the German Gallery in London. Shortly thereafter, it was acquired by Gambart for an initial payment of £3,000 and £2,500 payable in instalments within eighteen months. The final figure of £5,500, an extremely high price at the time, was soon recouped through an extensive tour of the British Isles – with Belfast being one of the venues – and sales of engravings of the work. The extent of the picture's appeal is shown by the fact that two and a half years before publication of the engraving was announced in April 1863, Gambart had already taken orders for it worth 10,000 guineas. In all, he made a profit of £5,000 from the engraving, which was issued in November 1867 in a huge edition – 13,000 prints in various stages and at various prices. Of the painting itself, it was apparently as popular in Belfast as elsewhere, as Magill was obliged to extend the duration of its exhibition.

The gallery also saw the display of a second major picture by Frith during this period, *The Railway Station* (1862) (Plate 24), on show during June 1866.[82] The painting showed the platform at Paddington, with a multitude of people engaged in various activities: parents saying farewell to their school-bound sons, a bride and groom taking leave of their bridal party, a foreign-looking gentleman arguing with a cabby.[83] Begun in 1860 as a commission for the dealer Louis Victor

Flatow at another enormously high price – £4,500 – and completed by early 1862, the work was a sensation when exhibited in London later that year.[84] Amongst the many favourable comments, the *Illustrated London News* was loud in its praise:

> If subjects of a religious, poetical, or historical character demand higher powers of imagination, the illustration of contemporary life is nevertheless one of the most valuable functions of art. As a painter of his own time Mr Frith is only equalled by Hogarth … The conception of this remarkable picture is throughout admirable … A more characteristic illustration of the age could not have been selected.[85]

After its London showing, the picture toured the provinces for a number of years, with Belfast included on the itinerary. Its exhibition in town was described by the *Belfast News-Letter* as 'a signal success'.[86]

Besides one-picture exhibitions, Magill continued to hold displays devoted to local artists, notably Richard Hooke and Elish Lamont, and also group shows comprising a variety of painters, mostly British.[87] However, these were not the firm's only activities. Amongst other ventures was the restoration of oil paintings and the manufacture and regilding of picture frames; also, the occasional foray into publishing.[88] Photography, above all, became a particularly successful sideline after Magill purchased the stock of the well-known photographer Oliver Sarony in 1861 and branched out on his own.[89] The studio soon became the most fashionable in town and was to remain in business for over thirty years. Overall, therefore, the firm played a considerable role in the Belfast art world, despite being a small-scale concern.

## MORE FROM THE AUCTION FLOOR

Nine new firms opened during these years – the most important being Hugh Hamilton in 1863 – an indication that the art market was continuing to flourish.[90] That this was so seems clear from the fact that the town already supported six other auction houses by the beginning of the 1860s, those of Hugh C. Clarke, John Cramsie, John Devlin, George C. Hyndman, John H. Gowan and Patrick McShane. Though a number were to close during the decade – Devlin's last auction was in 1865 and Hyndman's the following year – the closures were from death, retirement or smallness of scale and not through lack of business.[91] A number of the above continued to follow the pattern of trading which had begun to emerge in the early 1840s, namely, the selling of collections for dealers elsewhere.[92] (Dealers had commenced making visits to Belfast in the mid-1820s to sell their own collections but this personal involvement appears to have tailed

off by the mid-1840s, by which point they tended to employ local auctioneers for the task.)[93]

The leading auctioneer of fine art was Cramsie, who held well over 100 sales during this period, several for British and foreign dealers.[94] Amongst the former were B. Benjamin and E.W. Radclyffe, both of London, and John Paterson of Newcastle-upon-Tyne.[95] Foreign dealers included Henri and Leopold Everard of Brussels.[96] Sometimes Cramsie and other local auctioneers used the Ulster Hall instead of their own premises, a location which had the advantage of being roomy and central. In 1865 Cramsie adopted a new approach to advertising by occasionally spotlighting a particularly meritorious work from the collection about to be sold and publicising it almost in the manner of a one-picture exhibition.[97] This was doubtless an additional attempt to attract prospective purchasers, over and above his usual lengthy advertisements. It is perhaps not too far-fetched to see this as a shrewd move in a town that was hosting an increasing number of one-picture exhibitions.

Of Cramsie's competitors, Hugh Hamilton was the most active.[98] Whilst most of his auctions during these years were derived from house clearances, a number were devoted exclusively to fine art. Amongst the latter were sales for print publishers and dealers such as the London Print Publishing Co. Ltd and Kelly and Co. of Newcastle-upon-Tyne.[99] Fellow auctioneer John H. Gowan also acted for Kelly and Co., though the bulk of his sales was likewise from house clearances.[100] Business was certainly booming by 1866, as he advertised that he had added a new saleroom to his premises 'at the request of several leading gentry and merchants of Belfast and neighbourhood'.[101] Its dimensions were ninety-six feet by twenty-five, with a lofty ceiling. By doing this, he hoped 'the Public will have every comfort and ample space to attend his Sales. The New Hall will now save his Friends the additional expence to which they have hitherto been put by engaging Public Buildings for large Sales.'[102] Probably his most significant fine art auction for a local owner was in May 1869, when he sold about forty marine and other oil paintings and engravings for the estate of auctioneer George C. Hyndman, who had died in 1867.[103]

Though Hugh C. Clarke held only four specifically fine art sales during these years, two – those for London dealer Thomas Gilbert – were noteworthy because of the apparent quality of their contents.[104] Gilbert's first sale was held in the Ulster Hall in mid-November 1868.[105] Said to be worth £12,000, many works in the collection had allegedly been shown in the Leeds Exhibition of 1868 before being sent to Belfast.[106] Numerous well-known British artists were represented, including Francis Danby, John Linnell, Daniel Maclise and Turner.

Bidding seems to have been brisk as the first day's sales realised over £1,000.[107] The few recorded prices were in the £20–£30 bracket, with sixty guineas being the highest figure and ten the lowest. The final result must have been satisfactory to Gilbert for he sent another 100 works a few weeks later, for auction in early December.[108] Perhaps to help boost the proceedings, he attended this second sale in person. Unusually for the local art market of the time, a number of buyers at the first sale were recorded in the press. Those named, all of whom were from the professional and merchant classes, included James Alexander Henderson, proprietor of the *Belfast News-Letter*, and John Preston, a merchant and future mayor of Belfast.[109]

George C. Hyndman, the oldest-established auctioneering concern in town, held only twenty sales during the first half of the 1860s. However, over half of his transactions were strictly fine art, a figure which made the firm the busiest in this line after Cramsie.[110] Though Hyndman's closure in 1866 signalled the end of an era in the local art market – its first sale had been held as far back as 1807, when Belfast was still in its infancy – its shutting probably made little impact on the local art trade, kept flourishing by the many sales of Cramsie in particular. The healthy state of the fine art market by the end of the decade was commented upon by the *Northern Whig* in the summer of 1870:

> In the private houses of the nobility and gentry of the North of Ireland there are many good pictures, and a still larger number of indifferent and inferior products of the easel. Numerically speaking, the various branches of pictorial art are fairly represented in the community. Nearly everyone who has a house of any pretensions possesses either oil or watercolour paintings … or engravings and chromos [chromolithographs]. There has of late years been a decided increase in popular feeling in this direction; and periodical sales of works of art have been so frequent as to warrant the conclusion that a taste for at least the possession of pictures is pretty general.[111]

Whether these works were acquired through the auction rooms or through the various other outlets discussed, the fact that the collecting of art had become commonplace was certainly a sign of changed times in Belfast.

## THE OTHER ART SCENE

As always, there was a wide selection of art on display at venues other than commercial centres. What was certainly the largest collection of works exhibited in town was that lent to a *conversazione* in the

Music Hall on 4 January 1860. This prestigious occasion, organised by a committee of thirty-two leading citizens, including art lovers like John Clarke, William Dunville, Samuel Greame Fenton and Francis McCracken, was modelled on the *conversaziones* of the British Institution in London.[112] This was the first *conversazione* of the type to be held in Belfast, those of the School of Design during the 1850s being merely social and prize-giving occasions.[113] The aim of the event, to quote the committee, was 'the Exhibition of Objects of Art, Sculptures, Paintings, Sketches, Engravings, Drawings, Photographs, etc., of Antiquities, and of objects Illustrating the Manners of Foreign Countries, of Articles of Vertu, of Natural Productions, and of Novelties in Science'.[114] With single tickets at two shillings and six pence each and the wearing of evening dress a stipulation, the *conversazione* was clearly geared towards the middle and upper ranks.

On the natural history and scientific side, the visitor could see collections of shells, insects and birds' eggs, as well as watch interesting experiments with electrical machines, magnets and air pumps.[115] However, the art works – over 200 of them – seem to have been the most impressive part of the event. Amongst the lenders were John Cramsie, William Dunville, who contributed Italian paintings and a bust of Napoleon by Antonio Canova, Francis Dalzell Finlay, who lent seven watercolours of Ceylon by Andrew Nicholl and Charles Lanyon, whose contribution comprised paintings by Samuel Prout. Artist-lenders were also to the fore: Dr James Moore, with about forty sketches of local scenery, Surgeon-Major Pilleau, an amateur painter, with works executed on various postings abroad and in Britain and Anthony Carey Stannus, whose watercolour landscapes were considered by the *Northern Whig* as amongst the best on show. Considering that the Belfast Fine Arts Society had folded the previous summer (1859), such a large-scale display of art must have been welcomed by many. The occasion in all its aspects – artistic and scientific – was reported as being a success, a triumph it was felt augured well for even better *conversaziones* in the future.

Other art events, however, were on a much smaller scale than this. Of particular interest during the early years of the decade were two displays of work by local artist J.H. Connop, in 1861 and 1863. An obscure figure, Connop worked as an architectural draughtsman, lithographer and landscape photographer between 1861 and 1867. He also painted scenery for panoramas on occasion, of which more later. In July 1861, an extremely large picture by him, a view of Sydenham and neighbourhood, executed for Thomas McClure of Belmont, was on display in the news-room of the Commercial Buildings.[116] McClure's reason for the commission was to advertise land he owned in the Sydenham area for property development.[117] Though untitled

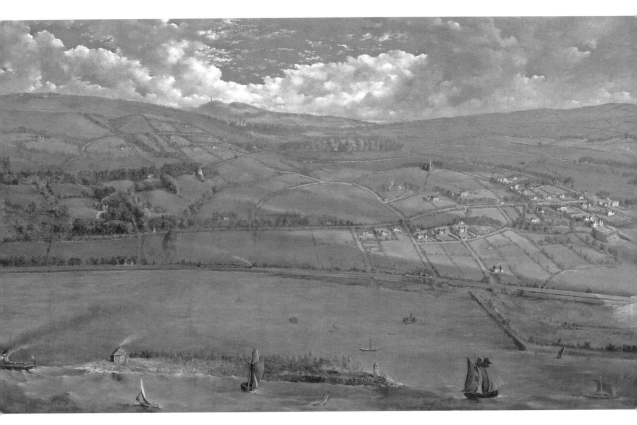

**61** J.H. Connop
*View of Sydenham, Belmont and Glenmachan* (*c.* 1861)
This was painted for Thomas McClure of Belmont, to advertise land he owned and wished to sell for property development. The view was displayed in the Commercial Buildings in July 1861, to help promote sales.

in the newspaper report of its exhibition, the painting was almost certainly the work owned by the Belfast Harbour Commissioners: *View of Sydenham, Belmont and Glenmachan* (Fig. 61).[118] With its sense of atmosphere and play of light on hills and lough, the picture shows Connop to have been a highly talented landscape painter.

The second Connop to be exhibited in town, a *View of Londonderry*, was of similar dimensions to the Harbour Commissioners' painting, that is, four feet by eight. Completed by September 1863, the picture was displayed in rooms in Donegall Place during late October and early November.[119] By this point, the work had been purchased by Dr T.C. Corry of Belfast, who charged six pence admission to its exhibition. The painting appears to have been as impressive as the Commissioners' landscape, as no less a publication than the *Illustrated London News* described it as 'a noble picture' and reproduced a lithograph of it drawn by Connop himself.[120] The whereabouts of the painting is unknown as, indeed, are the originals of other scenes lithographed by him, namely, *View of Sydenham New Park from Belfast Lough* (1861), *Bird's Eye View of Belfast* (1863) and *Belfast from St John's Church* (undated).[121] The wealth of information in these works and

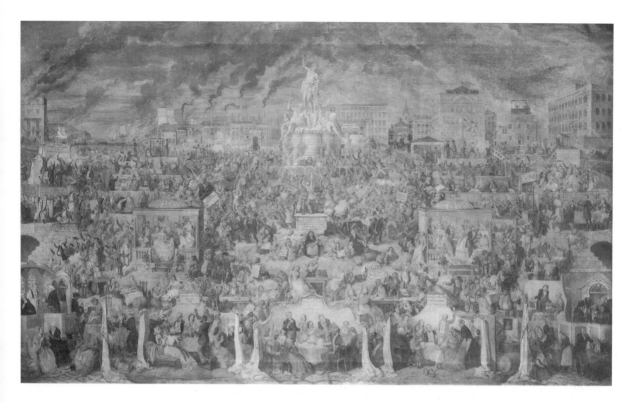

**62** George Cruikshank
*The Worship of Bacchus*
(1860–62).
Cruikshank, a reformed
alcoholic, painted this
as a teaching aid for his
temperance lectures. A
massive work (some 7½ feet
× 13), it was exhibited in
the Ulster Hall on 13 and 14
December 1866, at a bazaar
organised by the Irish
Temperance League.

also in the Commissioners' painting, is of enormous value to those interested in the growth of the town.

Whilst the majority of the 'other art scene' exhibitions during these years were held to help promote artists' works or for social occasions such as *conversaziones*, a few events were organised for moral or charitable purposes. One such was the display in September 1860 of a painting obviously intended to shock and highlight the evils of drink: *Delirium Tremens* by J. Mackenzie, a committee member of the Belfast Total Abstinence Association.[122] Exhibited in Bridge Street at a charge of one shilling and raffled in aid of the Association's funds, the painting showed a 'poor inebriate' in a paroxysm of delirium tremens, cradled in his wife's arms as his terrified children flee the scene. Though Mackenzie is unknown and the standard of the work may therefore have been poor, the events depicted were said to have been rendered 'with the utmost fidelity'. A more imposing picture, the display of which must have been something of a coup for local temperance campaigners, was George Cruikshank's well-known work, *The Worship of Bacchus* (1860–62) (Fig. 62), exhibited in the Ulster Hall on 13 and 14 December 1866, at a bazaar organised by the Irish Temperance League.[123] A reformed alcoholic, Cruikshank (1792–1878) used the painting as a kind of studio prop on a lecture tour he made around England in the early 1860s to promote teetotalism.[124] More a

series of vignettes showing the consequences of drink than a pictorial narrative – Cruikshank himself said, 'I have not the vanity of calling it a picture, it being merely the mapping out of certain ideas for an especial purpose' – the work is said to have left its English audiences cold by the bluntness of its message.[125] How well it was received in Belfast in unknown. Unfortunately for local audiences, Cruikshank did not accompany the picture in person but entrusted the reading of his copious lecture notes to another.[126]

A second cause to benefit from an art-related event was the Ragged School in Barrack Street, to aid which a bazaar and sale of work was held in the Ulster Hall on 22 December 1865.[127] In addition, there was also a 'Gallery of Paintings' lent by local collectors, possibly to help draw in the crowds. Although the number of works exhibited is unknown and few were detailed in the press – Thomas Sidney Cooper, Sir Daniel Macnee with his portrait of Rev. Dr Henry Cooke from Assembly's College, Salvator Rosa and Sir David Wilkie were the only artists' names given – the fact that the show was promoted as an obvious attraction is revealing of the popularity of art exhibitions in Belfast in the 1860s.[128]

As usual, there were a number of panoramas in town: sixteen, in fact, during the decade. Their subjects ranged widely: Continental scenery, the Holy Land, Canada and the West, Ireland, the war in America, Scotland and life and scenes in America.[129] A few, indeed, came more than once, for example, Hamilton's diorama of Continental scenery was in town in 1860 and 1867 and Dr T.C. Corry's panorama of Ireland in 1864, 1865 and 1867. This latter work, the scenery of which was painted firstly by the above-mentioned Connop, appears to have been particularly popular, possibly from patriotic reasons.[130] Its first appearance at Christmas 1864, under the title *Ireland, its Scenery, Music and Antiquities*, seems to have created quite a stir, despite the fact that a panorama of Irish scenery had already been seen in town the previous year. The *Northern Whig* waxed loud in praise of the theme:

> It is surprising that, while scenic artists go all over the world to find subjects for their canvas, no one has before thought of Ireland, a country so rich in magnificent scenery, so replete in legendary lore … Few countries have more interesting antiquities, and none more grand old national airs illustrating some phase of the national character, manners, or incident in history.[131]

The popularity of the theme was such that the work was repainted by a Glaswegian painter, Mr Dudgeon, and re-vamped for its showing at Christmas 1865, under a new title, the *Diorama of Ireland*.[132] A further re-vamping was carried out for its display at Christmas 1867.[133] In

December 1869 it opened as an entirely new production, poetically entitled *Ireland in Shade and Sunshine*.[134] It was to become the most frequently exhibited panorama in town over the next ten years or so.

The numerous displays detailed above, from 'high' art to art of a more popular kind, ensured that Belfast's patrons were well catered for by the late 1860s. However, in addition to such a large and varied number of exhibitions, the decade also saw an increased awareness and appreciation of the fine arts, brought about mainly as a result of the opening of Ward's gallery. Despite its unfortunate closing, all was not lost, as a worthy successor to its enterprising leadership was waiting in the wings, in the person of William Rodman. An erstwhile employee of Ward's, he was more than ready to take over from where his old firm had left off.

# ~ 7 ~

# Annual exhibitions and a new art society

## 1870–88

*'the public cannot but feel grateful to the enterprising art house [Rodman] which has at last succeeded in making an exhibition of pictures an established occurrence of the winter in Belfast'*[1]

### WILLIAM RODMAN AND ANNUAL EXHIBITIONS

William Rodman (Fig. 63), the founder of annual exhibitions in Belfast, settled in town in 1865 when he took up a managerial position at Marcus Ward's.[2] A native of Ayrshire, he was, according to his obituary, 'capable and shrewd in business affairs', with 'a sound and appreciative judgement in artistic affairs'.[3] In 1870, in partnership with James Adrian, he acquired Ward's retail stationery and artists' supplies business and opened a fine arts repository at 41, Donegall Place.[4] Within a few years, the premises had become an important centre for the exhibition and purchase of works of art. Amongst the displays held during these early days was a selection of sculpture by Shakespere Wood in 1870 and group exhibitions of watercolours by well-known British artists, in 1872 and 1874.[5] These were followed, in 1875 and 1876, by small one-man shows devoted to the local painters Samuel McCloy and Anthony Carey Stannus.[6] Another local artist promoted by the firm was the portrait painter Richard Hooke, who maintained a studio on the premises from 1871 and continued his links with the company until 1890.[7] Exhibitions of Hooke's completed portraits were normally organised by Rodman during the former's visits to Belfast in January and February of each year.

143

**63** William Rodman (d. 1922), a former employee of Marcus Ward's, opened a fine arts repository in Belfast in 1870 and an art gallery in 1877. A shrewd and energetic businessman, he was the originator of successful annual exhibitions in Belfast.

In keeping with the practice of the day, Rodman also held a number of one-picture exhibitions during these early years in business.[8] Of particular interest were two works by J. van Lerius, president of the Antwerp Academy of Fine Arts: *Lady Godiva* and *Ondine*. The former, on display during the spring of 1872, drew large crowds, not surprising, perhaps, given the subject matter.[9] The painting, considered striking in its naturalness and chasteness, showed Lady Godiva still clothed and about to embark upon her famous ride.[10] Its companion, *Ondine*, which also dealt with the subject of womanhood and the female form, in this case a pubescent water nymph sitting daydreaming under an oak tree, was exhibited in the spring of 1874.[11] These one-picture exhibitions, together with the above-mentioned group shows and the variety of local art, enabled Rodman to cater for a wide range of tastes, as Ward's had done.

In late 1876 Rodman bought out Adrian and commenced in business on his own account, with Ward's being one of three guarantors for the balance of the purchase money.[12] Although now on his own, the influence of his former employer seems to have been a positive force in his business strategy for, thereafter, he appears to have modelled his operations on those of Ward during the late 1860s, with the exception of the Art Union. That Ward's were willing to back Rodman in the enterprise indicates that they had every confidence in his business plan, which was on similar lines to their pioneering venture of the previous decade.

Amongst early changes was the erection of a proper art gallery.[13] Situated at the rear of the Donegall Place premises, the building was forty feet long by about twenty-five feet wide, with a glass roof to aid light levels and facilitate viewing. The exhibition area comprised two floors, the top one being a mezzanine. Though little is known of the gallery's decor save that 'nothing [was] omitted that [could] conduce to the comfort of visitors' or whether the premises were luxuriously appointed, in the manner of leading commercial galleries in London, the interior seems to have been impressive, being of 'polished pitch pine, elaborately worked into various graceful and ornamental patterns'.[14] Its opening in mid-October 1877 was hailed as an important local event, a 'well-timed effort … to place fine art on a footing equal, at least, to what it has heretofore occupied'.[15] (This latter comment probably referred to Ward's efforts of the previous decade.) The inauguration was marked by an exhibition of some 200 oil paintings and watercolours, with pride of place being given to a large history painting by William Frederick Yeames, *The Dawn of the Reformation*.[16] Other British artists represented included Myles Birket Foster, Marcus Stone and Edgar West, whilst amongst the Irish contingent were Samuel McCloy, Dr James Moore and Anthony

Carey Stannus. Unfortunately, there is no record of the number of works sold although several were reported to have been purchased within a short time of the opening. The show closed immediately after Christmas 1877.[17]

With this first large-scale exhibition, Rodman announced that henceforth he intended to hold one or two such events each year. True to his word and possibly to keep impetus alive and patrons keen, he opened his next exhibition in late February 1878.[18] With this display, however, he aimed his market at a less affluent clientele for the 200 works on show were either engravings, etchings, photoengravings or chromolithographs; there were no oil paintings or watercolours included. All the exhibits were after masters of the British and Continental schools. Although Magill and Ward had occasionally shown engravings of local subjects or of well-known works in one-picture exhibitions and both firms had also held small displays of various types of reproductions of famous paintings in the 1860s, this exhibition was the first of its kind in Belfast to give prominence to engravings and etchings, to treat this type of event as importantly as an exhibition of original paintings.[19] A notable feature of the show was the fact that the price was marked on each exhibit, possibly a shrewd marketing ploy to assist the less confident purchaser.[20] This must have been a considerable morale booster to those unused to such events. In mounting an exhibition of this kind, Rodman was responding to the enormous popularity of engravings and etchings which had arisen since the 1830s and which saw, by mid-century, the work of many modern painters being reproduced on an immense scale.[21] Whilst catering for the less affluent ranks, the show probably also attracted *bona fide* print collectors. The fact that the prices were low, as reported in the *Belfast News-Letter*, was possibly an encouragement to the former type of purchaser, the less well-off, whose introduction to art collecting may have been through the Art Union of Belfast of the 1860s.[22]

With these two exhibitions, Rodman set the pattern for the future. Each spring thereafter, with the exception of 1880, he held a large-scale display of etchings, engravings and chromolithographs.[23] These he called 'black and white exhibitions', a term he first used in 1879.[24] The originator of this type of event was the Dudley Gallery in London, which began holding such displays in 1872.[25] Shows of this kind subsequently became a regular feature of the art world. Rodman, it would seem, took the idea and popularised it in his own gallery. By the mid-1880s, his black and white exhibitions had become 'one of the events of the year in local art circles'.[26] A particular attraction was the fact that the majority of the etchings on display were recent and thus were fresh and clear; they had not yet become popular and had

therefore retained the sharpness which could be diminished by large print runs.[27] A further advantage was that many of the latest works of the foremost etchers of the day could be seen some time before they were actually published, as many were artists' proofs.[28] The number of works in the various exhibitions ranged from 100 to 400, with both British and Continental engravers represented.

The second major annual event in Rodman's calendar was the yearly winter show, which he designated 'the annual exhibition of original modern paintings'. Similar to his first, that held in mid-October 1877 to inaugurate the gallery, the exhibitions almost always opened in October and generally contained between 300 and 450 oil paintings and watercolours.[29] Whilst not as extensive as Ward's winter exhibitions of 1866–68, Rodman appears to have modelled his displays on his erstwhile employer's and included works by established British and local artists, as well as by rising youthful talent. Continental artists were also represented from 1881 onwards.[30] That his efforts for the cause of art were well appreciated is evident from the *Belfast News-Letter*'s comment regarding the winter show of 1881:

> It is not often that a private firm in any town has succeeded so well as Messrs Rodman in so arduous an undertaking as the establishment of an Art Gallery, which, for its size, has become within a few years quite equal to any of the annual English provincial exhibitions; and the public are certainly indebted to the originators of what is justly regarded as a great treat by all lovers of pictorial art.[31]

Though the number of works sold in the various exhibitions is not recorded in the local press, sales must have been healthy, otherwise the event would probably have been discontinued.[32] Likewise, there is no information in the press concerning the price of the pictures, with the exception of the 1883 exhibition, where they are recorded as ranging from a guinea to £175.[33] Such was the quality of the shows by this point that the *Belfast News-Letter* claimed in its exhibition review that Rodman had made a rod for his own back in setting such a high standard. He had, the paper stated, 'succeeded in educating the taste of the people to such a point that they have now become fastidious in the matter of pictures'.[34] Whilst this latter claim is a sweeping generalisation, the standard of the exhibitions appear to have remained high, an indication that patrons' expectations were of the same level. Both annual events – the black and white exhibition and the exhibition of original modern paintings – were to continue for many years.[35]

In addition to these annual exhibitions, the new gallery continued to devote space to the display of portraits of local worthies, notably

to those by Hooke during January and February of each year. The availability of a studio in the building for Hooke's use was undoubtedly a clever strategy on Rodman's part as it probably helped draw in leading members of the community and their friends. This, in turn, may have led to further sales. A second portrait painter, Sir Thomas Alfred Jones, president of the Royal Hibernian Academy, was given the same facility in 1886.[36] Again, this was a shrewd move by Rodman. Jones was the premier figure in the art establishment in Ireland and his association with the gallery undoubtedly conferred prestige upon it. Although he was based in Dublin, Jones had become increasingly popular with Belfast patrons from the mid-1870s and, by early in the following decade, had begun to eclipse Hooke in the latter's home territory.[37] Jones and his family spent part of the summers of 1886 and 1887 in Belfast.[38] The extent of his integration into the local art world is shown by the fact that the Belfast Ramblers' Sketching Club, dealt with later in this chapter, elected him an honorary member in 1886.[39]

Besides this encouragement of local portraiture, the gallery occasionally held small-scale exhibitions of art from further afield. Amongst these was a selection of etchings after British and Continental masters in the summer of 1879, a collection of fifty modern watercolours, mainly of the Dutch and Italian schools, in 1881 and a small group of watercolours by Edgar West in 1887.[40] In what was a new departure for the firm, the gallery also mounted a substantial exhibition of oriental art in 1885.[41] Included were carved ivories from India, embroideries from Japan and Persia and pottery from Afghanistan. Prices were reported as comparing 'favourably with the normal charges in the usual Japanese houses in London'.[42] (This, however, was not Belfast's first display of *japonisme* and oriental ware. In 1882 the furniture maker and auctioneer N.A. Campbell of Donegall Place had held an exhibition on similar lines and had brought over the distinguished London designer Christopher Dresser to deliver a lecture on the subject.)[43]

Notwithstanding such a busy round of events, the gallery maintained its programme of one-picture exhibitions, to the number of thirteen between the opening of the new premises in October 1877 and 1888.[44] Their content ranged from narrative themes and religious allegories to subjects from nineteenth-century military history. Amongst the narrative and religious works, two stand out: *An Egyptian Feast*, by Edwin Long (1829–91) and *The Man of Sorrows* (1875), by Sir Joseph Noël Paton (1821–1901). *An Egyptian Feast* (Fig. 64) was at the gallery from late March until mid-April 1878.[45] The subject depicted the ancient Egyptian custom of conveying a model of an embalmed corpse upon a funeral car before the guests at a feast, to remind them

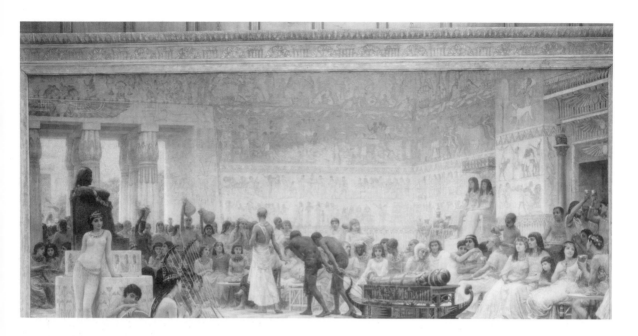

**64** Edwin Long
*An Egyptian Feast*
Exhibited at Rodman's
between late March and
mid-April 1878, the painting
made a considerable impact
on the Belfast public,
being described as 'one of
those works which appear
perhaps only once in a
decade'.

of the reality of death in the midst of gaiety.[46] The picture appears to have made a considerable impact on the local press. The *Belfast News-Letter* regarded it as the finest modern work ever exhibited in town, whilst the *Northern Whig* was almost equally enthusiastic, describing it as 'one of those works which appear perhaps only once in a decade, and irresistibly arrest attention by the rare combination of originality of conception and power of execution'.[47] Though there are no records regarding the level of attendance at the exhibition, the painting was probably as popular with the public as it was with the press.

*The Man of Sorrows* (Fig. 65) – which received similar eulogies in the press – was exhibited from early February to early March 1882.[48] This was the seventh major work by Paton to have been displayed in Belfast in one-picture exhibitions since 1864.[49] There were to be three more by 1888.[50] That his paintings featured in so many of these shows would seem to indicate that his works appealed to art lovers across the town's religious divide. The picture, based on the text, 'Surely he hath borne our griefs, and carried our sorrows' was essentially a sermon in paint, as was generally the case with Paton's religious works. Christ, alone in the desert, is shown seated on a rock, eyes raised heavenwards in an expression of intensity, his left fist clenched against the agonies of temptation. The painting was apparently the inspiration for at least one sermon in Belfast.[51]

Whilst Paton's religious works were obviously highly popular, historical subjects seem to have been even more so, judging by the frequency of their appearance over the years. Two of the most famous

pictures of events in Britain's military past were displayed at the gallery during February 1880: *The 28th Regiment at Quatre Bras* (1875) and *The Remnants of an Army: Jellalabad, January 13th, 1842* (1879), both by the renowned battle painter Elizabeth Thompson, later Lady Butler (1846–1933).[52] *Quatre Bras* (Plate 25) showed the 28th (North Gloucestershire) regiment at the battle of Quatre Bras on 16 June 1815, as it formed a square to meet the last charge of Marshal Ney's cuirassiers and Polish Lancers.[53] Thompson's aim was to depict the square 'quite close at the end of two hours' action, when about to receive a last charge. A cool speech, seeing I have never seen the thing! And yet I seem to have seen it – the hot, blackened faces … the bloodshot eyes … the unimpressionable, dogged stare!'[54] In an effort to achieve authenticity, Thompson purchased part of a field of rye grass and trampled it with the help of local children, for the actual charge had taken place in a rye field. The painting had been one of the highlights at the Royal Academy exhibition of 1875.

*The Remnants of an Army* (Plate 26) likewise created a sensation at the Academy when exhibited in 1879. Reports claimed that men were seen in tears before it.[55] The picture commemorated one of the worst disasters in British military history, when the army in Kabul was forced to retreat to the fort at Jellalabad, all the while being harried by the Afghans. The scene shows the first survivor of the force of some 16,000 men arriving at the gates of the fort, exhausted and on a dying horse. The work was one of the most poignant in Thompson's output.[56] Both paintings drew large crowds to Rodman's, doubtless on account of their subject matter but also probably because of the sex of the painter. The issue of women artists and their struggle for election to the Royal Academy had been before the public for several years, especially since the enormous success of Thompson's first major battle scene, *The Roll Call*, at the Academy in 1874.[57] In showing Thompson's pictures, Rodman enabled the Belfast public to view the work of the leading battle painter of the day but an artist nonetheless denied the official status of her peers solely for reasons of gender.

Though the one-picture exhibitions seem to have tailed off by the late 1890s, the gallery maintained its programme of black and

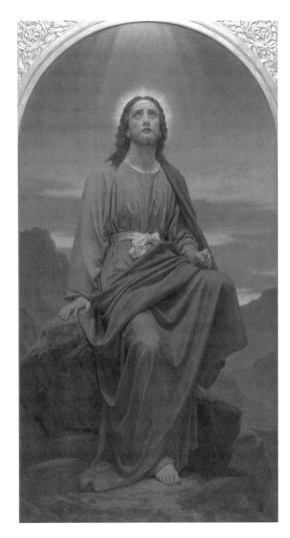

**65** Sir Joseph Noël Paton *The Man of Sorrows* (1875) This picture, the inspiration for at least one sermon in Belfast, was on display at Rodman's between early February and early March 1882.

white shows and the displays of original modern paintings until at least 1907 and probably far beyond.[58] After Rodman's death in 1922, the firm remained in business as artists' suppliers, printsellers and framers until around 1975.[59]

## MORE OF MAGILL

Like Rodman, Magill also continued to hold one-picture exhibitions, though considerably fewer than during the 1860s: only eleven between 1870 and 1888, as compared with twenty-three between 1860 and 1869. The reason for this falling-off is unclear; however, the cause may perhaps stem from the smaller firm's inability to compete after the opening of Rodman's new gallery in 1877. Amongst the eleven were two religious works by that firm favourite with Belfast's art lovers, Sir Joseph Noël Paton – *Mors Janua Vitae* and *Vigilate et Orate* – and two historical subjects by another favourite, Thomas Jones Barker: *Sedan* and *The Death of the Princess Elizabeth*.[60] The most important painting by far, though, was *The Shadow of Death* (1870–73, retouched 1886) (Plate 27), by William Holman Hunt. The second work by Hunt to be shown by Magill, the picture was on display from the end of June until late July 1875.[61]

As with *The Derby Day*, the exhibition venue was the Ulster Hall and not Magill's own premises, doubtless because of the numbers expected. Of the two versions of the painting – a large one in Manchester and a smaller example in Leeds – it was almost certainly the large work which came to Belfast, as it is known to have been exhibited in a number of other centres in Britain and Ireland.[62] Both versions had been purchased by the dealer Thomas Agnew for a down payment of 5,500 guineas, to be followed by a similar sum at a later date, derived from exhibition fees and sales of the engraving of the work.[63] The British and Irish tour of the large picture commenced in November 1873. As with Hunt's other religious works, the painting is a *tour de force* in its close attention to detail and emphasis on historical accuracy. Its subject, a presentiment of Christ's future death upon the cross, is strikingly immediate and profoundly poignant.

Apart from these one-picture events, there were a number of other exhibitions at the gallery, though generally low-key in tone: oil portraits by the firm's principal painter, Mr Mackie, presentation portraits of local worthies by unnamed artists and engravings from various periods and schools.[64] Possibly as a result of being overshadowed by Rodman, the firm, from 1880, began to focus more upon the applied arts – something Rodman had seldom concerned himself with – and also upon a female clientele, affluent women with time on their hands for artistic pursuits. The first female-centred

show, of porcelain painting by lady amateurs and enamel painting by professionals employed in the Dublin studio of decorative artist Herbert Cooper, was held in February 1880.[65] A second exhibition, solely of porcelain painting and again by amateurs and professionals, took place during April and May of the following year.[66] Perhaps to encourage interested parties, the gallery also organised classes for painting on porcelain, terracotta and wood, in 1880 and 1881.[67] Further classes in porcelain painting were held in 1884.[68] The response to these was obviously positive as other events of the kind were held in later years: an exhibition of embroidery by students of the Dublin-based Royal Irish School of Art Needlework in 1887 and classes in wood carving and repoussé brasswork, in connection with the same establishment, in 1888.[69]

By the mid-1890s, the direction of the business changed somewhat, perhaps from financial necessity. A number of sidelines were dropped, namely, the photographic studio, the restoration of oil paintings and the manufacture and re-gilding of picture frames.[70] Instead, the firm appears to have concentrated entirely upon the selling of stationery and prints. These apparent cutbacks were accompanied by a change of premises, from Donegall Place to the more prosaic location of Corn Market. The business continued in existence for another few years and closed around 1899.[71] Whether this came about because of Magill's death or problems with the firm, remains unknown.

## A NEW ART SOCIETY: THE BELFAST RAMBLERS' SKETCHING CLUB

This exhibiting society, the first to be established in Belfast since the Belfast Fine Arts Society of 1843–59, was also the first such body to actually flourish in town.[72] Part of its success lay in its timing. By the early 1880s, when it first came to prominence, a considerable amount of art was to be seen in the locality, through establishments like Rodman's and Magill's and auction houses such as Clarke's, Cramsie's and Hamilton's. The artistic climate was now very different to that of the 1840s and 1850s; picture buying had become commonplace and attending exhibitions a popular pastime. This increased appreciation of the fine arts was largely attributable to the Art Union of Belfast shows of the late 1860s and, in particular, to Rodman's ongoing exhibitions.

The Ramblers' Sketching Club had its origins in the Royal Ulster Works, the premises of Marcus Ward's printing and publishing company. In the autumn of 1879, the illuminator and amateur artist John Vinycomb, head of the firm's art department, and sixteen members of his staff decided to form a society to promote the fine arts

and encourage sketching from nature. Thus were the Ramblers born. This, in fact, was the second such society to emanate from Ward's, the first, the Belfast Sketching Club, having been founded in 1864 and lasting only two years.[73] The Ramblers' first exhibition was held in November 1881, in the lecture room of a church in Botanic Avenue, which the group used for its meetings.[74] By this stage there were about twenty-four members. One or perhaps two further exhibitions were held there before Ward's gave up the premises in 1884.[75] Thereafter, the Ramblers found themselves homeless. In January 1885 they combined with the School of Art Sketching Club (discussed in Chapter Eight) and showed in the club's exhibition in the school.[76]

Within the next few months, however, they resolved to forge their own identity and widen their membership. New officers were elected, namely, Anthony Carey Stannus, a commanding and confident figure, as president and Vinycomb as vice-president. Of this period in the club's history, Vinycomb is recorded as saying that 'Belfast was then ripe for a public art club, and the Ramblers opened their doors at precisely the right moment, students from the School of Art, members of art firms, and many others eagerly joining'.[77] Through Stannus's influence and efforts, the club obtained a suite of rooms at 55, Donegall Place, which was not only spacious but in a central location. By the time the reorganised club held its first exhibition in the new rooms, in November 1885, its membership had risen to almost fifty.[78] The show was hailed as a triumph by the *Belfast News-Letter*, which commented that 'The crude and amateurish productions of three years ago have altogether disappeared, and their place has been taken by a large number of highly finished works displaying not merely promise but genuine power … There is also a certain amount of healthy rivalry in such a club that cannot but tend to the advantage of the community in general.'[79] Admission to the exhibition and, thereafter, to others organised by the club, was free. This, combined with evening viewing hours, would have enabled the lower ranks to attend. Whether they did so remains unknown.

In the summer of 1886, the club received a considerable boost when Sir Thomas Alfred Jones, president of the Royal Hibernian Academy, graced it with a visit and was duly elected its first honorary member.[80] By this time, Jones had become a regular visitor to Belfast and was undoubtedly aware of the tardiness of the town council in the ongoing matter of a free public library, art gallery and museum for the town (as discussed in subsequent chapters). In his address to the club, he complimented it 'on the excellence of some of its work considering the members labour at a disadvantage to that of other towns, having as yet no public art gallery'.[81] Though Jones had received a few prestigious commissions from the town council by this point, his comment was

almost certainly an indirect criticism of it. Notwithstanding his status and high position, he was to continue a friend and supporter of the club over the next few years. His involvement with it probably added to its reputation within the community.

In August 1888 the club experienced a disappointment when the town council declined to allocate it 'permanent accommodation' in the Free Public Library due to be opened shortly – a hope which the club had entertained for some months.[82] Nevertheless, the council agreed to permit the group to hold exhibitions in the building, an offer which was accepted immediately. However, as the Donegall Place rooms had been given up in the expectation of space within the library, new premises had to be found. These were acquired in Royal Avenue, in a building conveniently close to the library. By this point, the club had become an increasingly important part of the local art world, through its role as a focus for local artists and by its displays of good quality art at reasonably low cost. It was to remain in existence until 1890, when it was reconstituted as the Belfast Art Society.[83] This latter operated until 1930, when it became the Ulster Academy of Arts. In 1950 the Academy was accorded royal status and was permitted to add the relevant prefix to its name. As such, the Royal Ulster Academy continues to flourish as the premier exhibiting society in the north of Ireland.

## THE NICHOLL RETROSPECTIVE, *CONVERSAZIONES*, PANORAMAS AND PUBLIC SCULPTURE

The primary concern of the Ramblers' Sketching Club was the art produced by its own members. However, in 1886, in a gesture of timely magnanimity and at short notice, it permitted its rooms to be used for a major exhibition of the work of Andrew Nicholl. This was the first large-scale one-man show and retrospective to be held in town since the James Atkins exhibition of 1834. A memorial tribute to Nicholl, who had died in London on 16 April 1886, the event was organised by the artist's Belfast-based nephew, William Nicholl. The proposal to have an exhibition had been made by an 'R.T.' in a letter to the *Northern Whig*, a week after Nicholl's death.[84] Rodman's premises, the author suggested, would be a suitable venue. A second letter, from a different author, likewise supportive of the idea and requesting Rodman's assistance, was published in the same newspaper a few days later.[85] Rodman's response was prompt and positive: he would give the use of his gallery and help in any way he could.[86] His assistance, however, was not to be required as William Nicholl assumed charge of the event the day after his offer.[87]

By early May the club had agreed to lend its rooms and a committee

had been set up to organise the exhibition, which was to be composed entirely of loans.[88] Nicholl was secretary of the fifteen-strong group, which included two members of the club – Stannus and William Gray – possibly to ensure the smooth running of the undertaking.[89] Opened on 26 May, the exhibition contained 260 watercolours by Andrew Nicholl and 16 by his brother William, a talented amateur.[90] A photograph of the display (Fig. 66) reveals that the works were densely hung, floor to ceiling, in typical nineteenth-century fashion. Chief amongst the lenders were Nicholl's daughter, Mary Anne, his nephews Andrew and William and local

**66** The Andrew Nicholl memorial exhibition, held in the Belfast Ramblers' Sketching Club rooms at 55, Donegall Place in May 1886. The hanging seems to be unfinished, as there are gaps on the walls and pictures on the floor.

collectors such as James Thompson of Macedon and the architect and amateur artist Robert Young. The show closed around the end of May.[91] The event was highly praised by the *Belfast News-Letter* and the *Northern Whig*, the former marvelling that 'in the course of a few days so many fine examples of [Nicholl's] work should be forthcoming from this locality alone'.[92] Though no details of visitor numbers were given, the exhibition almost certainly drew large crowds, considering the artist's popularity and reputation. The show was a highly fitting tribute to Nicholl, the best-known painter to have emerged from Belfast by that point.

Besides one-man retrospectives, another type of relatively new event was the *conversazione*, a multi-discipline occasion featuring displays of antiquarian, ethnographical and natural science objects, together with works of art. The only other *conversazione* of the type to have been held so far had been that of 1860, discussed in the previous chapter. Between 1871 and 1881, however, another eight were held, mainly under the auspices of the Belfast Naturalists' Field Club and the Belfast Natural History and Philosophical Society.[93] Both clubs' *conversaziones*, held in the museum in College Square North (Fig. 11) in October or November, were one-night-only gatherings, open to members and their families and friends. Attendance would therefore have been from the middle classes. Art works lent over the years ranged from paintings by James Howard Burgess, David Cox, Dr James Moore and Anthony Carey Stannus to watercolours from the Ladies' Sketching Club attached to the School of Art (of which more in the following chapter).[94] A *conversazione* with a difference was that which took place in the Working Men's Institute on 3, 4 and 5 March 1881, in aid of the establishment.[95] Not only longer in duration than

usual, it was also open to a wider public than was the norm, namely, to the working classes as well as to the more affluent. Amongst the works of art were watercolours by Dr James Moore, lent by himself and a large collection of etchings, courtesy of William Rodman. Also on show were the usual antiquarian, ethnographical and geological specimens. In general, therefore, *conversaziones* had something of interest for almost everyone and were a useful means of bringing scientists, antiquarians and art lovers together.

Panoramas, those long-established attractions, continued to be extremely popular. Between 1870 and 1888, there were thirty-three in town, some staged more than once, as had been the case during the 1860s.[96] Their subjects, as usual, were varied: life and scenery in America, Canada and New Zealand, the landscape of Scotland, tours around the world and the Franco-Prussian war of 1870. Most popular of all was Ireland, which local surgeon Dr T.C. Corry had made the subject of a well-known panorama in 1864: *Ireland, its Scenery, Music and Antiquities*. Corry, indeed, seems to have owned more than one panorama of the country, as two belonging to him, with other titles, were at different venues in Belfast in January 1872. His best-known example, that of 1864 referred to above, mutated into *Ireland in Shade and Sunshine* in 1869 but seems to have reverted to its former title by the mid-1870s. In all, his various Irish panoramas were in town seven times between 1870 and 1888. The inclusion of northern scenes and topical songs written by Corry himself, doubtless made them particularly appealing to local audiences.[97]

**67** Samuel Ferres Lynn
*Rev. Dr Henry Cooke*
*(1788–1868)*
(1875)
The idea for the statue of Cooke, a Presbyterian minister well known for his political Protestantism and anti-Catholic stance, originated in 1868. Despite considerable opposition from those opposed to his hard-line beliefs, the statue was erected in front of the Royal Belfast Academical Institution in 1876, replacing that of the Earl of Belfast, which had been removed two years before.

Compared to the crowds at the unveiling of Belfast's first public memorial, that of the Earl of Belfast outside the Academical Institution in 1855 (see Chapter Five), few members of the public were present at the erection of the town's second free-standing public statue – that of Rev. Dr Henry Cooke (1788–1868) in 1876 (Fig. 67).[98] Instead, the sculpture was taken 'In the darkness of the early March morning [24th] … to Wellington Place and with the combined efforts of a great many workmen, who had only been told that morning what they were to do, lowered into its place'.[99] The only persons present were three or four members of the statue committee, including Cooke's son-in-law, Rev. Professor J.L. Porter. Behind such secrecy lay the town council's fear of a massive Orange Order demonstration planned to be held at the statue's inauguration.[100] By erecting the sculpture surreptitiously and without any kind of official ceremony, the council hoped to prevent counter-demonstrations by nationalists and probable sectarian clashes. Not to be outdone, however, some 80,000–100,000 Orangemen held an inaugural ceremony of their own six weeks later, on 11 May, an event which passed off peacefully, to the relief of the authorities.[101]

Perhaps not surprisingly, given the tension surrounding the occasion, members of the town council were nowhere to be seen, as likewise the statue committee, with the exception of the above-mentioned Rev. Porter, who watched from a window at a safe distance. The Orange leader and member of parliament William Johnston of Ballykilbeg was the chief speaker at the proceedings.

The idea for the statue had originated with a group of Cooke's friends and supporters in December 1868, some two weeks after his death.[102] Minister of May Street Presbyterian Church in Belfast, Cooke was well known for his identification with political Protestantism and for his anti-Catholic stance.[103] As such, therefore, he was honoured by many and vilified by countless others. Inevitably, given Belfast's mixed community, the erection of the sculpture was to be surrounded by controversy – mainly, it must be said, because of the site chosen rather than the fact that the person commemorated was Cooke. By early 1874 a number of locations had been considered: at the front of the White Linen Hall, or Great Victoria Street, Upper and Lower Crescents, Queen's College or Assembly's College (now Union Theological College).[104] Assembly's College remained the statue committee's choice, though a number of Cooke's supporters complained that it was too out of the way and that Cooke belonged to Ulster and not simply to Presbyterians.[105] Despite these objections, however, the committee continued to favour this location until April 1874, it being the best available.[106]

What happened next was to be the spark that ignited the controversy. At some point around this time, councillor Thomas Gaffikin, chairman of the town improvement committee, worried about the state of neglect into which the Earl of Belfast's statue had fallen and, feeling that it needed to be under cover, voiced his concerns to Lord Donegall's agent.[107] Why he raised the issue at this particular point is unclear – perhaps the unresolved matter of the Cooke statue focused his attention upon the sorry state of the earl's. By early May, Lord Donegall had agreed to the relocation of his son's memorial to the Town Hall and 'had signified his willingness to pay any expenses in connection with the removal, and of improving the statue'.[108] (Presumably 'improving' meant cleaning.) At this point, the council had no plans to hand over the soon-to-be-vacated site to the Cooke statue committee – nor, indeed, had Gaffikin intended this to happen when he set the process in motion in April.[109] However, once word went around of the impending removal (which event took place on 17 June 1874), Cooke's supporters mounted a vigorous campaign to secure the site.[110] There followed a number of letters of protest in the press but to no avail – at the council's meeting on 1 August, it agreed to the Cooke statue committee's request.[111]

Inevitably, this decision met with disapproval in numerous quarters. Amidst the subsequent letters of complaint in the *Northern Whig*, the following poem, of which two verses are appended, was particularly scathing of the council's action:[112]

> O, Site well chosen! – station meet
> Our Cooke's grim visage to evoke!
> The centre of a crowded street,
> 'Mid atmosphere of dust and smoke;
> Sidewinds up metal nose to blow
> The Blackstaff's incense as they pass,
> And anthems drummed in Sandy Row
> Oft echoing in those ears of brass!
>
> O, ediles! sound in faith and taste,
> Remonstrant proclamations spurn;
> Here, for young Poet's form displaced,
> Exalt Polemic's image stern,
> Thus, too, shall all beholders guess,
> As her new monument they scan,
> How much Belfast doth honour less
> Philanthropist than partisan![113]

A year and a half later – on 10 March 1876 – the statue arrived in Belfast from London via the Fleetwood steamer.[114] 'It was long looked for, but it has come at last', commented the *Northern Whig*, 'and now that it has reached us, the difficulty seems to be what to do with it'.[115] The solution, as detailed above, was the furtive erection on the 24th of the month.

Of the statue itself, its creator was the young Wexford-born sculptor Samuel Ferres Lynn (1836–76), who had already undertaken a number of commissions for Belfast, most notably the statue of the Prince Consort on the Albert Memorial Clock.[116] He received the commission for Cooke in 1870 and submitted two designs: a single figure on a pedestal and a group comprising the figures of Religion and Oratory seated beneath the main subject.[117] The single figure design was chosen because of cost constraints and the sculpture executed in 1875.[118] Regarded by Cooke's friends as an admirable likeness, the statue cuts a commanding presence in College Square East, the doctoral robes and gown lending an air of classical dignity to the figure. During the next forty years or so, other sculptures were to be added to the townscape – merchant princes like Sir Edward Harland and Sir James Haslett, public figures such as the 1st Marquess of Dufferin and Ava

and Lord Kelvin – even another hard-line Presbyterian cleric, Rev. Dr Hugh Hanna.[119] Whilst a history of their commissioning and erection is yet to be written, it seems unlikely that any aroused such public feelings as that of the memorial to Cooke.

## AUCTIONEERS AND AUCTIONS

The period between 1870 and 1888 was one of expansion followed by contraction in the local auctioneering world, as several new firms opened, only for a number of them to close within a year or so. In 1870 there were seven auctioneers active in town: N.A. Campbell, Hugh C. Clarke, John Cramsie, John H. Gowan, Hugh Hamilton, Patrick McShane and William Montgomery.[120] Between then and 1887, twenty-seven new firms emerged, fifteen of which, however, remained in existence for about a year or less.[121] Though the art market continued buoyant, judging by the enormous amount of auctions advertised, the sizeable number of short-lived concerns suggests that the establishment of new businesses had reached saturation point. By the mid-1880s, the flurry of activity had subsided, with only twelve firms competing for business.[122] This figure was reduced to nine in 1888.[123] Amongst these were long-established auctioneers like Clarke and Cramsie and newer concerns such as those of James Morton and Walter Watson. Throughout the various changes, Cramsie remained in the premier position, holding more auctions than anyone else.[124] After his death in 1882, the business passed to his son John, who ran it equally successfully.[125]

Amidst the vast number of sales advertised, some stand out as being of particular interest. One such was held by James Morton, one of the busiest firms since its establishment in 1877.[126] In October 1878 the company auctioned an extremely large collection of oils and watercolours, to the number of 1,400 works.[127] According to the press, the items had been destined for the Glasgow auction houses by a London dealer. However, owing to the depressed state of trade in the former city, in consequence of the collapse of the City of Glasgow Bank in that year, the collection had been sent to Belfast instead.[128] This change of plan would seem to indicate that the town was regarded as a good place to sell by those in the trade. Morton's advertisement for the second part of the collection, comprising 750 works, would seem to bear this out. According to his notice, 650 paintings had already been disposed of during the first part of the sale (the collection was auctioned in two groups).[129] How successful he was in disposing of this second part remains unknown.

A number of Hugh C. Clarke's auctions were also noteworthy, on account of the apparent quality of their contents.[130] His most valuable

contact during these years was George Wilson, a dealer from Southport, who brought four important large collections to Belfast between 1881 and 1886. The first sale, held in May (1881), comprised 249 modern British and Continental oils and watercolours by artists who included Sir John Gilbert and Sir Edwin Landseer.[131] The auction was apparently well patronised, with the majority of paintings sold by the third and final day.[132] Its success – Wilson claimed that only six works had been left unsold – encouraged him to send a further 350 pictures or so to Clarke the following month.[133] The highlight of this second group, as indicated by the prominence given to them in advertisements, was a pair of well-provenanced paintings by William Hogarth: *The Death of the Righteous* and *The Death of the Sinner*.[134] Also of interest was a picture by James McNeill Whistler: *A Symphony in Blue and White*. This was the first time that a painting by this founding father of Modernism had been seen in town. The *Belfast News-Letter* urged its readers 'who admire the peculiarities of the American painter … not [to] lose the opportunity of purchasing a work which will be found a capital example of his style'.[135] The location of the painting is unknown.[136] (As a point of interest, Whistler's work was not seen in Dublin until three years later, when he exhibited with the Dublin Sketching Club in December 1884.)[137] There were no press reports concerning the outcome of this second sale and no details of purchasers. That Clarke desired to make an impact by both sales was apparent from the extremely large size of his newspaper advertisements, which extended to double column width and varied between sixteen and eighteen inches in length.[138] Wilson was present for the duration of both auctions.[139]

Clarke's third sale for Wilson was held during mid-June 1883.[140] The collection, which contained almost 800 oils and watercolours, was hung under Wilson's supervision.[141] (As with all four auctions for Wilson, Clarke virtually transformed his premises into an art gallery for the pre-sale viewing days.) Amongst the more interesting works was *The Flaying of St Bartholomew* by Spagnoletto and the two pictures by Hogarth already seen in the June 1881 auction. Included in the wide range of paintings were many meritorious examples by British and Continental masters, mainly modern. Wilson's reason for returning to Belfast, it was reported, was his conviction 'of the growing desire amongst the people for works of a high class'.[142] Clarke's advertisement for this sale was particularly striking, being almost two feet long and, again, double columned in width.[143] Whilst there are few details regarding the auction's success, almost 400 works were reported to have been sold halfway through the eight day event.[144]

The final sale, which comprised 668 works by British and Continental

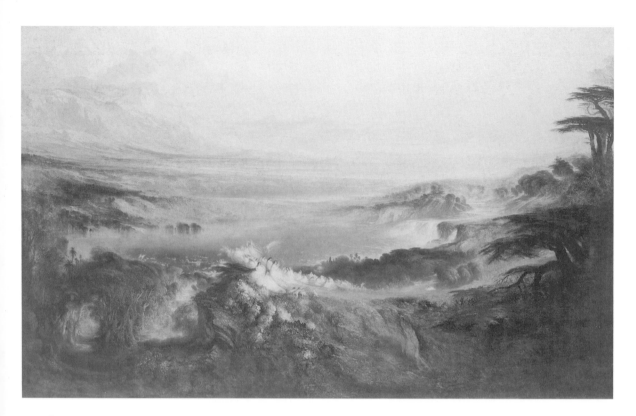

**68** John Martin
*The Plains of Heaven*
(1851–53)

artists, took place during the last week of September 1886.[145] By this point Wilson had moved to London and was planning to retire after the disposal of this particular collection. Unlike the earlier sales, he appears not to have attended the event in person. The most important pieces on display were three famous apocalyptic paintings by John Martin: *The Great Day of his Wrath* (1851–53) (Plate 28), *The Plains of Heaven* (1851–53) (Fig. 68) and *The Last Judgement* (1853) (Fig. 69).[146] The results of the sale – the advertisement for which was only half the size of that of the 1883 auction – are unknown. Also unknown is the fate of the Martin paintings – were they purchased whilst in Belfast or did they fail to sell and were returned to Wilson in London?[147] They are now in the Tate Gallery, which, unfortunately, has no details of their Belfast showing.[148] Their inclusion in the sale was probably the high point of Clarke's auctions for Wilson.

As has been shown in this and preceding chapters, there was an enormous quantity of art to be seen in Belfast through the years, in one-picture exhibitions which brought top-ranking paintings by major figures to the town and also through auction houses. Whilst the quality of the many Old Masters is impossible to substantiate, the bulk of the eighteenth- and nineteenth-century pictures were by accredited

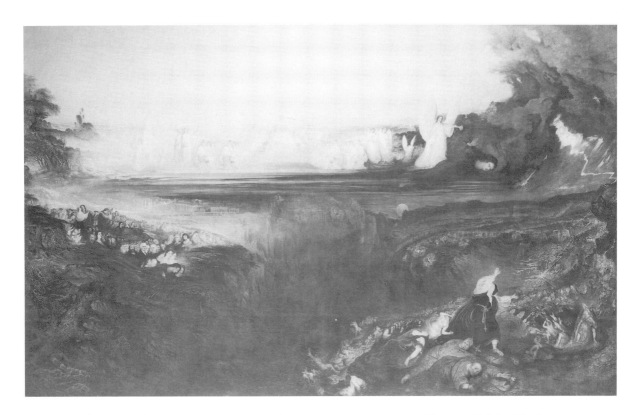

**69** John Martin
*The Last Judgement*
(1853)

names and many of the contemporary paintings were guaranteed by the dealer concerned. Though there may have been some dross, there is no reason to believe that most of the eighteenth- and nineteenth-century works in the auction rooms were not of good quality. It was through these commercially-driven ventures – auction houses, print shops, Ward's, Rodman's – that Belfast's citizens were enabled to see and appreciate high quality art. This, in turn, helped raise awareness of the fine arts in general and guaranteed the success of Rodman's annual exhibitions and the future of the Ramblers' Sketching Club. As regards the town council's concern to improve the standing of the fine arts within the community, this was sadly lacking until 1882, when the ratepayers forced it to decide to provide amenities such as a free public library, art gallery and museum. Efforts by supporters of the arts to bring these changes about will be discussed in later chapters. Meanwhile, their work in establishing a School of Art in 1870 to replace the failed School of Design of the 1850s was to meet with considerable success, as Chapter Eight will reveal.

# ⌣ 8 ⌣

# The establishment of a new School of Art in 1870

*'Though ... our School is regarded as a resuscitation of a former institution, virtually it must be regarded ... as a new school, for it has no principles of the elder establishment to guide its management, and, happily, no traditions of obsolete practice to fetter it'*[1]

The call for a replacement to the School of Design was first made in 1868 by William Gray (1830–1917) (Fig. 70), an energetic advocate of education for the working classes and the future leader of the free public library movement of the 1880s.[2] In a lengthy letter to the *Northern Whig*, he stressed that despite Belfast's progress and increasing wealth, there was scarcely a town in the kingdom where so little was done for the advancement of science and art or for the provision of intellectual recreation 'for the toiling multitude, on whose toil and energy and skill [Belfast's] success so much depends'.[3] As an example of his disillusionment with the existing associations for intellectual pursuits, he cited the Belfast Natural History and Philosophical Society and claimed that it was both ineffective and inactive. Furthermore, its museum in College Square North (Fig. 11) was useless as an educational resource, because of the poor quality of its displays. The Belfast Library (by which he meant the Linen Hall Library) was beyond the reach of the poorer classes, as it was not free.

One of his strongest criticisms was the lack of provision for art education in the town, a situation he considered shameful given

that Dublin, Cork and Waterford – as well as the small country town of Clonmel – were able to maintain flourishing Schools of Art. From a utilitarian standpoint, the fact that Belfast could not afford to provide the most elementary art education was a considerable loss to the community, considering that the School of Design had been of benefit to the locality and had produced a number of artists of worth such as Samuel Ferres Lynn and Anthony Carey Stannus. He suggested that the town's various intellectual societies unite and be run from a central institution, under a single committee and recommended that this idea be put before the locality's wealthy inhabitants. Whether his plan got further than the newspaper column is unknown. However, like similar proposals to Belfast's wealthy citizens in the past – for example, Hugh Frazer's plan for an Institute of Fine Arts of 1833 – the suggestion was probably greeted with indifference by the majority of the town's affluent merchants and businessmen. The letter, interesting and useful in itself, is also perhaps reflective of the rising profile of the fine arts in the town during the later 1860s, a situation brought about by the opening of Ward's gallery and its highly successful Art Union of Belfast exhibitions, discussed in Chapter Six.

**70** William Gray (1830– 1917) was an energetic advocate of education for the working classes and leader of the free public library movement in Belfast during the 1880s.

The impetus to establish the school seems to have originated with Francis Davis Ward of Marcus Ward's and a group of unnamed local gentlemen, who broached the subject with Professor Wyville Thomson of Queen's College in early 1870.[4] The ensuing discussion led to the sending out of a circular, which called attention to 'the want in Belfast of systematic art instruction, available for the working classes, which has been long felt'.[5] The circular also publicised a meeting in the Academical Institution on 15 March 1870, to consider the matter further. Amongst those who attended were Dr Samuel Browne (mayor), the educationalist Vere Foster, William Gray, Dr James Moore, Francis Davis Ward and John Vinycomb.[6] Art and educational interests were thus well represented. Resolutions were passed in favour of the project and a provisional committee was set up.[7] At a public meeting in the Academical Institution a week later, the decision was taken to establish a school.[8] A sub-committee was appointed to pursue the matter and after careful consideration, including visits to, and communication with, schools of art elsewhere, the project was deemed viable for Belfast. At a meeting on 6 June, the provisional committee accepted the sub-committee's recommendations and work towards the school entered its final stages.

By the end of June, by which point news of the impending opening had appeared in the press, the Academical Institution had agreed to let the north wing again (Fig. 37) at the same rate as before, that is, £100 per annum.[9] Amongst press comments, that by the *Belfast News-Letter* was particularly appropriate and echoed claims of former days. 'It is out of the question', it maintained, 'that we should any longer continue to resort to foreign sources for our designs, not by reason of any narrow national prejudice ... but because the means of supplying the demand exist at our very doors, and merely await equipment'.[10] In the midst of these positive steps, however, a proposal for gentlemen supportive of the aims of the school to band together into an Ulster Art Association to raise funds for the establishment did not materialise.[11]

The organisation of the school was to be very different from the establishment of the 1850s.[12] Gone was the hated centralisation by London and Henry Cole. Instead, a board of managers was to have complete control over the running of the school and was to be free to make its own decisions, including setting salaries and hiring and firing of staff. The Department of Science and Art would award grants on results of examinations – payment by results was the key factor – and students would compete in annual national competitions and local examinations. The headmaster and assistant master were to be paid out of money raised by pupils' fees and could receive bonuses from the Department. The latter would give up to £500 for alterations to school buildings (Belfast was granted £300) and would supply casts and copies of sculpture at a quarter of the price.[13] Whilst the school was to be largely self-supporting – a situation which the earlier establishment had found anathema – the fact that the heavy hand of London had gone made its self-reliant status a challenge rather than an impossible burden.

Methods to help raise funds were tightly structured and were built into the rules of the establishment. The school was to be partially financed on a tiered system, by donors, who gave £10 a year or more, and by subscribers, who gave £1 or more annually.[14] The institution was to be run by a board of managers, consisting of thirty members, ten of whom retired annually but were eligible for re-election. Donors and subscribers voted in the election of managers to the board and were themselves entitled to be elected as managers. The fact that subscribers of only £1 a year had an opportunity to become involved in the school's operations, through their vote and perhaps through a seat on the board, was probably an important element in the school's subsequent success and its continued existence for the next thirty years. Furthermore, the small sum of £1 not only conferred power upon subscribers – it also gave dignity and status to supporters with

limited financial means. The property of the school was vested in two trustees, members of the wealthier ranks within the community.[15] The first chairman of the board was Professor Wyville Thomson, whilst Vere Foster was vice-chair.[16] The headmaster was Thomas Mitchener Lindsay.

The school opened on 17 October 1870 with considerably less fuss than that which had been accorded to the School of Design.[17] Two of the most immediate concerns, the rent and the headmaster's salary, had already been taken care of. Wealthy merchant William Dunville paid the former with a subscription of £100.[18] This munificence was not an isolated gesture on his part but was given annually from 1870 and, after his death in 1874, was continued on the same basis by his executors until 1900, when the thirty year lease on the building expired. The headmaster's salary was guaranteed by Vere Foster for the first two years, a vital safety net in this formative period.[19] Whether he had to pay it is unclear; nevertheless, that the offer had been made must have been a considerable relief to the board.[20]

## DONORS, SUBSCRIBERS AND OTHER PATRONS

The school got off to an extremely positive start, especially as regards donations, which amounted to over £700 in the first year.[21] This was to be the highest figure ever for a single year. A few individuals were particularly generous, notably John Charters, a patron of the *Belfast and North of Ireland Workmen's Exhibition* of 1870 (see next chapter), who gave £100, and John Ward, a director of Marcus Ward's, who gave the same amount. Other donors included Vere Foster, Sir James Musgrave and Professor Wyville Thomson, of whom the former contributed £20 and the others £10 each. The bulk of the £700, however, came from businesses with an interest in the school, such as the Clonard Bleaching Company, which donated £25; Harland and Wolff, £25; the Northern Spinning Company Ltd, £25; Richardson, Sons and Owden, £50, and William Spotten and Company, £50. Other firms gave amounts of £1, £5 and £10.

After the euphoria surrounding the opening of the school, donations dropped considerably. In 1872 the figure stood at £168.[22] By 1875 it had shrunk to £53. Five years later, it rose to £84. Unfortunately, this upward trend did not last and in 1885 the sum was a paltry £3. This sharp decline may have been related to the depression of the mid-1880s, which had been precipitated by the collapse of the major spinning firm of John Hind and Company.[23] Donations improved somewhat in the 1890s but only to a maximum of £62 in 1899.[24] In general, gifts from businesses declined after 1880. One of the most

loyal firms, as regards financial support, was the York Street Flax Spinning Company, which gave a total of £170 in donations of £10 up to 1900, after which the school was reconstituted as part of the Municipal Technical Institute (see below). Harland and Wolff, on the other hand, contributed nothing further after the £25 donated in 1870, a somewhat surprising situation for such a large and successful enterprise. Appeals for financial support to the wealthy and to gentry outside Belfast were made repeatedly in the *Annual Reports* but had comparatively little success. The poor response to these entreaties was partly alleviated in 1891 when the city council gave a grant for the first time, to the amount of £100, under the Technical Instruction Act of 1889.[25] By 1900, the school had received £2,375 from this source.

Annual subscriptions, though generally for smaller amounts than single donations, were by their constancy a vital source of income generation. In 1871 they totalled £208 and were to remain in that region for the duration of the school's existence.[26] A few donors were also subscribers, as for example, the York Street Flax Spinning Company, which subscribed £55 over the years.[27] Of the three main firms involved in the promotion of fine art, whose support might have been expected – Magill, Ward and Rodman – only Ward was in any way generous, contributing £134 in subscriptions.[28] By contrast, Magill gave only five guineas and Rodman £1.[29] (The latter, however, also gave £1 to the debt extinction fund in 1899.) None of the auctioneering firms involved in the art trade appear to have given at all, either as subscribers or donors. With individuals, prominence and wealth were no guarantee of generosity – local magnates Sir Edward Harland and Sir James Musgrave subscribed only £24 and £59 respectively.[30] On the other hand, the well-known art collector Sir Richard Wallace, member of parliament for Lisburn 1873–85, and Lady Wallace – merely occasional visitors to Belfast and Lisburn – were rather more generous, subscribing a total of £80.[31] Sir Richard also made a donation of £25 in 1880.[32]

An unheralded and somewhat low-key form of patronage was the local prize scheme, a fund quite separate from the general monies of the school, for the awarding of cash prizes in the school's own examination system.[33] Names of donors and individual amounts towards this scheme were seldom noted in the *Annual Reports*; however, amongst firms known to contribute were David Allen and Sons, designers and producers of theatrical posters, the York Street Flax Spinning Company and Marcus Ward.[34] The amount awarded in local prizes varied considerably from year to year, from £86 in 1871, £37 in 1880, £27 in 1890 to £74 in 1900.[35] The scheme, specifically devoted to the fostering of local talent, was an extra incentive to students and an important part of the school year.

Nevertheless, despite the various monies received, the funding of the school was indifferent. Compared with the School of Design, the financial situation was reasonably sound – annual subscribers remained loyal and the £200 or so raised yearly in this way was a vital asset. However, considering that the town had an upper echelon of extremely wealthy industrialists and merchants, donations should have been much higher than they were. This group, who probably stood to gain the most from a well-trained work force, gave the least. Their indifference was detrimental to the actual state of the school. Had they been more generous, problems with lack of space and poor amenities might have been readily overcome. In reality, it was to the middling ranks and professionals and not to the 'merchant princes', that the school owed its existence.

## FROM MERE MECHANICS INTO ART WORKMEN: ARTISAN STUDENTS

Though the school planned to reach all classes of society, as the School of Design had done, its primary aim was the education of artisans. Working men of all trades would be welcome, the headmaster Thomas Lindsay stressed in his inaugural lecture, delivered to the artisans' evening class on the opening day:

> We especially invite the cunning artificer in brass and iron. We shall be disappointed if we do not meet the young mason, cabinet-maker, upholsterer, joiner, carver and gilder, house painter and decorator in our classes. We have no hesitation in saying that we can impart instruction of practical value to the operative, no matter what the craft by which he earns his daily bread.[36]

The advantage of training to working men was an acknowledged fact, a point Lindsay was to emphasise numerous times over the years, but perhaps never more eloquently than in the *Annual Report* of 1871:

> Without joining in any of the alarmist cries about foreign competition, we have ample evidence of the great advantages possessed by artisans of whom the majority have a specific training in drawing, and other kinds of knowledge applicable to their several crafts. Indeed, it is only by such that the *mere mechanic* is raised to the position of an *art workman*.[37]

Classes for artisans and other members of the public were held in the evenings, with fees per term costing six shillings and six pence for elementary classes and ten shillings and six pence for advanced tuition.

To help stimulate the number of artisan students, donors of £25 or more were granted the privilege, for life, of nominating one free student to the artisan classes for every £25 given.[38] Annual subscribers of £5 or more were entitled to nominate, for each £5 given, one free pupil to similar classes for the year in which the subscription was paid. However, the extent to which donors and subscribers availed themselves of these privileges is not noted in the *Annual Reports*. Also uncertain is the number of artisan students on the register during the first few years. Notwithstanding this lack of concrete information, artisan pupils appear to have acquitted themselves ably by 1872. In that year the board reported that considerable progress had been made in the production of designs suitable for several local manufactures and that a number had already been adopted.[39]

In 1873, by which time the school was ranked eleventh of the 131 art schools in Britain and Ireland in terms of results, a positive move was made to increase attendance, especially of artisans, by a forceful appeal to employers. This took the form of a circular, endorsed by a large number of leading local firms, which was distributed to businesses not yet supportive of the aims of the school. Simple and direct, it is an interesting example of positive discrimination:

> The undersigned manufacturers and merchants desire to express their opinion that a knowledge of drawing is desirable in all who have to do with the manufacture, as well as with the buying and selling, of goods of an ornamental character. For this reason, where persons who, in other respects, are equally suitable, apply to us for employment, with a view of becoming designers, heads of departments, drawing clerks, travellers, foreign agents, salesmen, buyers, etc., we will give a preference to those who have a knowledge of drawing.[40]

Details of those who endorsed the circular were not included in the *Annual Report*. However, the tactic was apparently successful as an increase in attendance at all classes was recorded.

In 1874, when student statistics were included in the *Annual Report* for the first time, there were 416 pupils on the register, of whom 184 attended the artisan and evening classes.[41] A useful breakdown of the trades of the students at these classes was appended.[42] Occupations ranged from situations directly relevant to the school, such as architects' pupils (eight), designers (two), designers' apprentices (six), linen trade (six) and lithographers (six) to trades less so, such as clerks (twenty-three), ministers (four), publicans (three) and a solitary sexton. About 100 of the 184 students were artisans, that is, skilled craftsmen or apprentices in training. The following year, 1875, saw a slight increase in these classes, to a figure of 206, with

the number of artisans being about 126.[43] Overall, however, artisan figures were regarded as less than satisfactory, with the result that the board invited manufacturers and employers to visit the classes and see for themselves the training available.

Unfortunately, the breakdown of trades in these particular classes was published only in the *Annual Reports* of 1874 and 1875. Thereafter, information was confined to the yearly number in the classes; there were no details of trades included. Numbers during the remainder of the decade tended to fluctuate somewhat. In 1876 they rose to 253, then dropped substantially the following year before climbing to 266 in 1878. In 1879 they fell again.[44] By this point the school was playing an active role in the labour market by supplying to local firms designers, draughtsmen, apprentices and assistants of various kinds and workers for the construction industry, notably foremen and clerks of works.[45] Indeed, in 1879 the headmaster described the school as 'a sort of "Registry Office" for Art workmen'.[46]

In an effort to increase artisan numbers in the early 1880s, an assertive marketing exercise was undertaken in 1882.[47] This took the form of a specially prepared brochure detailing the classes for artisans, copies of which were sent to factories and workshops for distribution amongst the workforce. As a result of this strategy, numbers rose by twenty-four on the 1881 figure, an increase which the board hoped resulted 'not so much from external influence upon the Artisans of the town, as from the realisation … that the acquisition of technical Art knowledge is a decided advantage to themselves, and that in consequence there is a growing desire on their part to obtain it'.[48] Substantial dips in 1885 and 1886 were caused by a trade recession in the former year and serious religious riots in the latter, the result of the defeat of Gladstone's Home Rule Bill of 1886.[49] Nevertheless, despite these setbacks, numbers finally exceeded the 300 mark in 1888.[50] For the remainder of the school's existence, they varied between 278 and 390, with peaks of over 400 in 1890 and 1896.[51]

## CLUBS AND LADY STUDENTS

Amongst the school's more interesting features were the various clubs formed by the students themselves. These probably helped create a kind of campus atmosphere and led to cohesion within the student body as a whole. Of these societies, the Ladies' Sketching Club was the first to be established and the best known. Its members, who came from the wealthier ranks, attended private classes in the mornings, unlike the 'female students' from the working population, whose classes were held in the evenings, obviously to suit their hours of employment. Established in 1872 for the study of landscape and

figure subjects from nature, the club's progress was recorded in the *Annual Reports*, whilst its exhibitions, held in the school, were generally covered by the local press.[52] A second club, that for evening students, was founded by 1875 on the lines of the ladies' society.[53] Both clubs amalgamated in 1882 as the Sketching Club.[54] Other groups less prominent within the school were the Monthly Illustration Club, also formed by lady students, and the Morning Students' Sketching Club.[55] Like the local prize scheme, these various clubs gave considerable encouragement to students by acting as exhibiting platforms and as social groups where young artists could meet and exchange ideas.

The role played by young middle-class women was one of the most distinctive features of the school. Although their numbers are known only for the years 1874–76, when the figures stood at sixty-two, sixty-four and seventy-nine, they appear to have been a considerable force within the establishment.[56] *Annual Reports* regularly referred to them in glowing terms, in sentiments such as 'the ladies as usual occupy a very distinguished position'.[57] Their presence is in marked contrast to the situation at the School of Design in the 1850s, when lack of female students led Lord Dufferin to make his impassioned plea to the town's young ladies to take up the mantle of art.

This emergence in the 1870s of female students from the wealthier ranks was almost certainly allied to the movement for the higher education of women in Britain and Ireland. In Belfast, this was seen in the founding of the Belfast Ladies' Institute in 1867, under the energetic secretaryship of Isabella Tod, the leading pioneer in the women's movement in Belfast in the last quarter of the century.[58] The Institute, with classes in a wide range of academic subjects, was an immediate success. In 1869 it petitioned successfully for the opening, to young women, of the examinations of the Queen's University of Ireland (of which Queen's College, Belfast formed a part). This increased appreciation and availability of higher education for women in the locality was almost certainly a factor in attracting middle-class female students to the school. The burgeoning feminist movement of the time and the opening up of new possibilities for women may also have played a part.[59]

## SUCCESSES AND HIGHLIGHTS

The extent of the school's success was measured in results achieved in the Department's examinations and by the number of students on the register.[60] The first factor was the more important of the two. By 1873, as mentioned above, the school was eleventh in the league of schools, through the winning of thirteen national awards including a gold medal, the highest distinction possible.[61] This compared favourably

170

with Glasgow and Birmingham, each of which gained five awards, Dublin, which achieved nine and Edinburgh and Manchester, both of which received eleven. The winning of prizes fluctuated from year to year. The late 1880s, for example, saw none won by the school, as by this time cramped conditions and inadequate equipment were having an impact; also, because competition from new schools in Britain was starting to tell.[62] Alterations to the premises in 1890 helped ease the overcrowding and the results in the London examinations improved somewhat.[63] However, three more years were to pass before medals began to be won again, although another gold was not achieved until 1900.[64] In the case of national scholarships, nineteen were gained between 1873 and 1899.[65]

Notable highlights of the years between 1870 and 1888 included exhibitions sent by the Department in 1881 and 1882. The 1881 event, held between March and June, comprised a collection of over 100 examples of Indian textiles.[66] This was considered of practical benefit to the students, many of whom had never seen such materials before, and also proved of interest to the general public. Unfortunately, lack of a proper exhibition space meant that the collection had to be displayed in a classroom, a location less than ideal. The exhibition of 1882 was probably more popular than the 1881 show, being a selection of the prize-winning drawings from the national competition of that year.[67] In 1880 the Department had started sending displays of this kind to provincial schools for brief periods, to help stimulate artistic taste. Manchester, Glasgow and Belfast, in that order, had the works for a week each in 1882.[68] Belfast was the first centre in Ireland to host the event.

Such was the size of the show – about 350 drawings from 182 schools in Britain and Ireland – that it could not be accommodated within the school and, instead, had to be hung in the new gymnasium of the Academical Institution. The works were displayed in two sections, one containing the entries from Belfast and the other the pictures from elsewhere. Belfast's contribution held up well by comparison, with works by a number of lady students singled out by the *Belfast News-Letter* as being particularly meritorious.[69] The event was opened by a *conversazione* attended by members of the board, prominent businessmen and professionals.[70] In its *Annual Report*, the board expressed the opinion that the exhibition would 'undoubtedly have a beneficial effect, as it brought the Belfast School of Art more prominently before the public, and made known the scheme of Art instruction which the Science and Art Department has so successfully carried on throughout the country'.[71] In fact, artisan and evening classes were to experience a healthy increase in numbers over the next few years, rising by thirty-seven in 1883 and twenty-three in

1884.[72] Whether this was due to the exhibition remains uncertain. Irrespective of the show's effect, the fact that it had to be held in premises other than the school underlined, yet again, the need for a proper display area within the building.

Whilst these exhibitions were undoubtedly interesting and beneficial, two major local shows, in 1876 and 1888, were also important milestones in the school's calendar, as they enabled students to display their works before a wider audience than usual. The 1876 event, an industrial exhibition held in the Ulster Hall, contained a section submitted by the school. Works from a wide cross-section of the student body included landscapes and still-life, machine and architectural drawings.[73] The show of 1888, the largest art exhibition mounted in Belfast by that point, was a particularly prestigious platform for would-be designers and artists. Organised to mark the opening of the free public library and held in the new library building, the school's contribution comprised models, casts from nature, designs for textiles and ironwork and paintings in oil and watercolour.[74] The collection was arranged specifically to illustrate the course of teaching in the school, particularly with regard to industrial art. These exhibitions, both of which are discussed in subsequent chapters, were probably a considerable incentive to the school and to the students involved.

## THE PROMOTION OF AN ART MUSEUM AND ART GALLERY

A theme stressed repeatedly by headmaster Thomas Lindsay during the 1870s, at public meetings and through the *Annual Reports*, was the need for an art museum and picture gallery in the town. The subject was first raised in his report of 1871, when he recommended the establishment of a museum for the display of various kinds of art productions, especially those with relevance to local manufactures.[75] In 1873 he spelt out in greater detail what he hoped to see:

> What we need most is a local Art Museum and Art Library, to which our students could have free and easy access. Liverpool, Nottingham and Salford already possess institutions of this kind; other towns are exerting themselves in a similar direction, and it is to be hoped that ere long every town of importance will boast its Art Museum, including, also, a Picture Gallery and Art Library.[76]

In a return to the topic a few years later, he also alluded to the fact that the government was contemplating setting up a national art museum in Dublin.[77] Whilst such an institution might be of benefit

to Belfast in terms of loans, he believed nevertheless that the town needed an art museum of its own. In his opinion, if Belfast was given a grant to establish its *own* museum, it would be of greater benefit to the country overall than the projected single institution in Dublin. (This latter eventually opened in 1890 as the National Museum of Ireland.)

By the late 1870s, the art museum idea had become part of a larger project current by that time: the establishment of an art gallery within a free public library, as discussed in subsequent chapters.[78] The school's voice was one of several in the surge of public support for this venture, which was to materialise in 1888. The involvement of the school in this undertaking was undoubtedly a contributing factor to the project's success. Alongside this broader scenario, the board also stressed the need for an art museum and exhibiting space within the school itself.[79] However, this shortcoming was never rectified, partly through lack of funds.

## THE COMPOSITION OF THE BOARD

The make-up of the board remained remarkably consistent for the duration of the school, with several names recurring frequently over the years. A wide spread of occupations was represented, including merchants and manufacturers, artists, architects and professions related to the arts, educationalists and academics. There were no nobility involved. Of the numerous persons who served, many for lengthy spells, William Gray, the industrialist Sir James Musgrave, John Vinycomb and Robert Young were members for the thirty odd years of the school's existence. The architect William Henry Lynn served for twenty-nine years. Gray, as was to be expected, was a particularly assiduous attender at board meetings, whilst Lynn and Musgrave usually managed only one or two meetings a year.[80]

Besides Musgrave, the various industrialists involved included the building contractor and timber merchant Sir James Porter Corry, shipbuilder Sir Edward Harland, newspaper proprietor James Alexander Henderson and his son James, and John Workman, who was likewise in shipbuilding. Overall, they tended to give little, either in money or time (when known). Corry, a member from 1882 to 1891, attended no meetings whatsoever and donated only £10.[81] Harland, probably the best known 'merchant prince' on the board, served between 1870 and 1888, attended no meetings after 1882 (it is not recorded if he did so before) and gave a mere £24 in all, as stated above.[82] The Hendersons, members from 1870 to 1902, with James succeeding his father in 1884, donated £43 in total – a somewhat meagre sum for the owners of the *Belfast News-Letter*.[83] The attendance

pattern of Henderson senior is unknown; however, his son is recorded as having been present at twenty-two meetings between 1885 and 1892. John Workman, whose service extended from 1879 until 1902, attended nineteen meetings between 1882 and 1892 and donated £6.[84] (However, his family firm of J. and R. Workman gave £25.)[85] Membership of businessmen like these, whilst it may have seemed to promise much, appears to have delivered relatively little for the benefit of the school, certainly in financial terms.

The real backbone of the establishment was the professionals like William Gray, who not only devoted considerable time to the school but contributed generously in relation to their circumstances. Gray, for example, gave £24, a sum which compared favourably with amounts donated by much wealthier individuals.[86] Others included the architect Sir Charles Lanyon, chairman of the board from 1871 to 1888, who attended forty-seven meetings between 1882 and 1892 and gave £132, part of which was bequeathed as a memorial trust; Robert Young, who went to sixty-two meetings during the same period and donated £44; and John Vinycomb, in attendance for 122 meetings.[87] Vinycomb, like Gray, was deeply involved in the school. His financial contribution, however, was small – a mere £4. Another keen supporter, not a professional but a member of the gentry, was James Thompson of Macedon, Whitehouse. A trustee from 1870 to 1897 and a board member for many years, he attended 127 meetings between 1882 and 1892 and donated £35.[88] The enthusiasm and commitment of individuals like these must have been a considerable asset to the school.

A few well-known local artists also served on the board, namely, Dr James Moore from 1870 to 1883, Anthony Carey Stannus between 1889 and 1894 and Ernest E. Taylor from 1896 to 1901.[89] The last years of the century – and of the school – saw the addition of a number of female members: Sarah Blackwood and Sydney Mary Thompson, later Madame Christen, in 1899, Emma Shaw Boyd in 1900 and Mrs C.E. Allan in 1901.[90] Blackwood, Boyd and Thompson were all former pupils of the establishment. This mixture of professional and amateur painters was probably useful for a variety of reasons, not least because of their experience and knowledge of art education. Their financial contributions were generally small.[91]

## FINALE

The end of the school as a self-supporting institution came in 1901, when the city council assumed responsibility for it. The origins of this change of status went back to 1889 and the passing of the Technical Instruction Act. Under this, the city council was empowered to strike

174

a special rate of a penny in the pound for the promotion of technical education – in which category the School of Art was included.[92] This, however, it declined to do. Instead, in 1891 it allocated to the school and to two other technical establishments in the city the meagre sum of £300 in all.[93] The following year this annual figure was increased to £700. This, too, proved to be insufficient and in 1898, after pressure from various bodies, the decision was finally made to strike the rate and consider the establishment of a municipal technical institute.[94]

Following this long-awaited declaration, the school requested to be incorporated within the proposed institute. However, no decision was reached as the council did little further during 1899 to advance its scheme. The passing of the Agriculture and Technical Instruction Act in 1900 brought matters to a head. With the prospect of an annual grant of £10,000 or more now available from the Department of Agriculture and Technical Instruction, the council could no longer prevaricate on the issue. Plans to erect the new institute in the grounds of the Academical Institution were soon underway. In 1901 the council agreed to take over the school. As the lease of the north wing of the Academical Institute had expired, the school was moved into temporary accommodation in North Street in September 1901. It was relocated on the top two floors of the Municipal College of Technology (as the institute was styled) on its completion in 1907. Thus dawned a new era of art education in Belfast, in spacious quarters that contained top-lit studios, workshops, a lecture hall and sculpture gallery. The College of Art, as it came to be called, was to be an important part of the city's artistic and cultural life for the next sixty years or so.[95] The 1960s saw it transformed into the Ulster College of Art and Design, with impressive new premises in York Street. Reconstituted as the School of Art and Design of the University of Ulster in the early 1980s, it remains the centre of the creative arts in the city, the nurturing ground for aspiring artists in numerous media.

Though only twelve years elapsed between the final closing of the School of Design and the opening of the School of Art, the time span seems much longer; a gap of decades seems to separate the first establishment, inward-looking and somewhat negative in attitude, from its more pragmatic and positive successor. Undoubtedly, a considerable amount of civic pride was bound up with making the School of Art a success. The fact that flourishing art schools could be maintained in other Irish cities and towns – even in a small country town like Clonmel – probably helped give the issue a competitive edge. From the start, the promoters of the school appear to have been reconciled to the ethos of self-sufficiency, as no approaches seem to have been made to the town council for financial help. Self-reliance and acceptance of what the Department had to offer was the order of

the day – there was no looking back to the early 1850s, when schools were given generous grants. Those who ran the school, especially the professionals and lesser middling ranks who did the bulk of the work, were pragmatic in approach and determined to succeed.

The energy of these two particular groups was one of the reasons for the school's success. Other factors included a broad base of support and a businesslike approach. Patrons with limited financial means were enabled to play a *real* part in the school's proceedings for £1 per annum, a relatively modest amount which allowed many supporters to become involved. William Gray, for example, belonged in this category. These small subscribers had their names published in the *Annual Reports* alongside those who gave larger sums. This equity of treatment was a clever tactic which probably helped retain patrons' support and interest. In the same businesslike vein, the publishing of board members' attendance at meetings from 1882 onwards may have been intended as something of a shaming exercise. In the case of industrialists like Harland, however, the ploy was to no avail as he seldom, if ever, attended.

An examination of the board members, as shown in a previous section, indicates a strong level of commitment from those from the lower middling ranks. This was a considerable improvement on the situation at the School of Design, which failed because of lack of support from this sector of society in general. In the case of the very wealthy, the position remained unchanged – they had given little to the first school and, with the exception of individuals like John Charters, William Dunville and John Ward, gave little money or time to the second. That they were included on the board primarily to lend it status and influence seems highly likely.

In addition to individual effort, the improved artistic climate in Belfast almost certainly played a part in the school's success; the greater appreciation of the fine arts created by Marcus Ward's exhibitions of the second half of the 1860s cannot be overlooked. By the time the school opened in 1870, supporting the arts and visiting exhibitions had become a fashionable pastime. That the school flourished and endured was in part a by-product of these changed times.

As regards the benefits of the school to the community, these were considerable both for artisans and the middling ranks. For the former, the school not only provided a sound training at various levels, but also acted as an employment registry on occasion. With its regular appeals to employers, it tended to stand between master and workforce and was almost, in a way, the caretaker of the latter's productions and creative welfare. In addition, its part in the free public library movement, particularly in relation to the inclusion of an art gallery, was bound up with its overall promotion of the education

of the lower classes. For the middling ranks, it encouraged both sexes to the pursuit of art as a profession and as a pastime. In the spirit of the times, when the higher education of women was becoming an accepted fact, it treated female students on a par with their male counterparts; there was no repeat of the patriarchal and patronising bluster delivered by Lord Dufferin in late 1855.

Finally, it made an important contribution to local art by enabling aspiring young artists to pursue art at home rather than elsewhere. This, in turn, was of benefit to the artistic milieu of Belfast, as many remained and forged careers in the city. Several thereafter became leading figures in the local art world of the 1920s, 1930s and 1940s. Probably the best known of its many students were William Conor (1881–1968), who made his reputation as a painter of the Belfast urban scene, and Paul Henry (1877–1958), who left his native city and found his particular niche in the landscape of the west of Ireland. These and many others owed their artistic training to the school.[96] Works by almost all of them are to be found in the premier public art collection in Northern Ireland, that in the Ulster Museum. Their contribution to Ulster art is probably the school's greatest legacy.

# ～ 9 ～

# Industrial exhibitions and the free public library movement

## 1870–80

*'It is now generally recognised that something ought to be done in the way of providing facilities for those who have the desire, but perhaps few opportunities, of advancing themselves'*[1]

### RATIONAL RECREATION: IMPROVEMENT FOR BODY AND MIND

In 1871 the population of Belfast was 174,412, of which about a third was employed in the town's various industries.[2] Despite the existence of this large work force, few measures had been taken to provide for its educational and social needs until the second half of the 1860s. The urge to improve the lot of Belfast's toiling masses, voiced in the above quotation from the catalogue of the Belfast Working Men's Institute and Temperance Hall exhibition of 1871–72, sprang not simply from humanitarian sympathy but was reflective of a broader picture, the concept of 'rational recreation'.[3] Promoted by clergy, social reformers and well-meaning individuals in Britain since the 1830s, rational recreation was basically an idealistic crusade to reform the leisure habits of the working classes. The practical results of the movement were shown in a variety of ways: in the establishment

of coffee houses, public parks and organised athletic sports and in the opening of free public libraries, museums and working men's institutes, all safe havens from the snares of the public house. A number of voluntary efforts in this line had been made in Belfast during the 1840s and 1850s, ranging from the formation of bodies like the Society for the Amelioration of the Working Classes of Belfast in 1845 and the Belfast Working Classes' Association for the Promotion of General Improvement in 1847 to the development of the Queen's Island as a resort for the working classes in the early 1850s.[4] This latter, though not planned as such, became the closest approximation to a park for the industrious population, where healthful recreation could be enjoyed at a very low cost. A common feature of the above-mentioned bodies and others of the type was the fostering of literary and scientific knowledge amongst the working classes. In Britain, the founders of such associations and institutes for working men were generally members of the middle ranks. This was also the case with Belfast.

In 1866 the most ambitious attempt thus far to rectify the lack of educational and recreational facilities for the town's labouring men – the establishment of a Working Men's Institute and Temperance Hall – was made by a number of leading local merchants and professionals.[5] The project's prospectus is worth quoting from at some length, for the light it throws on the ethos of rational recreation:

> Hitherto Belfast … with its teeming population of the Working-classes, has had no Working Men's Institute; no public place where the Artisan and Mechanic may meet with his friends; and secure from the counter-attractions of the 700 public houses that stud our streets, can have a cup of coffee, spend an hour or two in social intercourse, read the papers of the day, or periodicals bearing on his own trade, and where he might hear lectures, scientific and useful, at a moderate charge; while towns much smaller in England and Scotland – even in Ireland – can boast of one or more. In a town where the working classes form so large and important an element, it is most desirable that there should be some place of resort free from the drinking customs, and where they would have opportunities for mental improvement … Knowledge derived from intercourse and reading developes [sic] the understanding; habits of temperance benefit body and mind; and both prepare for increased utility, making the working man not only of more value to his employer, but developing in him those higher principles of his nature, which cause him to understand his true position, and his relation to society.[6]

The project met with considerable success from the start, £2,000

being raised by public subscriptions in 1866 alone.[7] This enabled the committee, in the same year, to purchase a site for the Institute at the corner of Queen Street and Castle Street, a location described as 'the very centre of our growing town, and within reach of thousands of the working classes, who pass and repass it to their places of employment every day'.[8] However, another four years were to go by before the foundation stone was laid, as funds had to be raised towards the building. The laying of the stone took place on 14 May 1870, the ceremony being carried out by Miss Charters, daughter of John Charters, one of the largest employers of labour in town.[9] The Institute was officially opened on 15 November 1871.[10] Two of the three industrial exhibitions dealt with below, those of 1871–72 and 1876, were held to help clear debts on the building. Besides displays of machinery and commercially-produced goods, the shows also contained sections devoted to the fine arts.

### BELFAST AND NORTH OF IRELAND WORKMEN'S EXHIBITION OF 1870

Though only a few days separated the laying of the Institute's foundation stone and the opening of the Workmen's exhibition on 17 May, there was no direct link between the two projects. Both, however, shared the common goal of the moral and educational improvement of the working classes. The exhibition, the first of its kind in Ireland, was held in the Ulster Hall and continued until 4 June.[11] The idea for the show came about in 1869 as part of the preliminary planning for the Workmen's International Exhibition, due to be held in London in 1870.[12] As a prelude to this event, towns were encouraged to hold displays of goods produced by local workmen before the items were forwarded to the London show. The idea met with enthusiasm in Belfast, a committee of working men set the project in motion and an executive committee of local gentlemen was established to propel the undertaking along. Included on the latter were the mayor (Dr Samuel Browne), businessmen and professionals like James Porter Corry and Dr William MacCormac and those stalwarts in the cause of art education, William Gray and Dr James Moore.[13] Amongst the event's several patrons were John Charters and William Dunville, both of whose generosity has already been alluded to, George Horner of the Clonard Foundry and bakery owner Bernard Hughes.[14] A wide range of manufacturing interests was therefore represented in the venture.

The exhibition, intended to serve 'as far as possible, the purpose of a School of Technical Education', was divided into various sections: machinery, tools, textiles, furniture, ceramics and stationery; also fine art, archaeology and natural history.[15] The rationale behind

the inclusion of this latter section was explained by William Kirkpatrick, honorary secretary of the executive committee, at the opening ceremony: 'It was felt ... that in this (our first) industrial experiment we should be obliged to supplement our Exhibition from other departments than the workshop, and that the beauties and instruction of antiquity, science and art, might not inappropriately be blended with the produce of our more humble labours'.[16] Medals and certificates of merit were awarded for the best products by working men, a selection process which obviously ensured a high standard for the London show.[17]

Each section was organised by a sub-committee, with Gray and Moore amongst those responsible for fine art. Indeed, Moore's artistic judgement was so highly regarded by the executive committee that they entrusted him with a special mission to Dublin, to inform the Lord Lieutenant, Earl Spencer, about the event.[18] Moore was accompanied to the vice-regal lodge by Thomas Alfred Jones, president of the Royal Hibernian Academy. As a result of the meeting, Moore was invited by the earl to select works from the lodge for inclusion in the show. The choice he made possibly reflected his gratitude to the earl for his interest in the undertaking, for he selected a bronze equestrian sculpture of Countess Spencer by Sir Joseph Edgar Boehm, *Salmon Fishing in the River Awe* by Frederick Richard Lee (which contained a portrait of the earl) and a portrait of the earl and countess by Henry Tanworth Wells.[19] His selection also included a number of unspecified paintings and two other bronzes by Boehm.

Other lenders to the exhibition included the Duke of Manchester, with a few family portraits; the Earl of Charlemont, who contributed unspecified paintings from his gallery at Roxburgh Castle, Moy; Lord Dufferin, who lent a marble sculpture of a sea-king by Patrick MacDowell and other items not detailed; and Sir Thomas Bateson, whose loan included a picture already noted in Chapter Two: *The Patron, or the Festival of St Kevin at the Seven Churches, Glendalough* (1813) by Joseph Peacock (Plate 12).[20] Amongst others who lent were John Cramsie, James Alexander Henderson, Moore himself and Francis Davis Ward. The variety of work on show seems to have been considerable, with local artists such as James Howard Burgess, Moore and Anthony Carey Stannus being represented, as well as painters like Erskine Nicol, George Petrie and Richard Rothwell. There were also sculptures by Shakespere Wood and Samuel Ferres Lynn. Probably the most interesting example of these was Lynn's presentation bust of Rev. Dr Pooley Shuldham Henry, president of Queen's College (Fig. 71), lent by the college.[21] Paintings by amateurs and artisans were also included. The total number of exhibits was over two hundred.

**71** Samuel Ferres Lynn
*Rev. Dr Pooley Shuldham
Henry (1801–81)* (1867)
This bust of the first
president of Queen's
College (now Queen's
University) was lent by the
college to the industrial
exhibitions of 1870 and 1871.

As was perhaps to be expected with an event of this kind – the like of which had never been seen in Ireland before – there was a certain amount of criticism from various quarters. The hanging of the pictures, for example, elicited complaints that insufficient care had been taken with their display, as works by artisans had been placed close to those by professionals and therefore suffered in comparison.[22] The inclusion of the art loans was also criticised, as the exhibition had been intended as a vehicle for the operative classes. The actual aim and content of the show was also questioned. Deeming it necessary to respond to these charges, Kirkpatrick replied in a letter to the *Northern Whig*.[23] The exhibition's object, to show the talent and skill of working men in Belfast and Ulster, had been carried out in the main, he explained. Whilst it was true that many of the exhibitors were not artisans, over half of those taking part were indeed *bona fide* working men. Furthermore, in the machinery, architectural and textile sections, almost all of the participants were from the artisan class. As for the fine art loans, he emphasised their educational value and stressed the elevating influence of art on human nature. He concluded by pointing out the uniqueness of the exhibition and called upon the support and co-operation of those interested in the advancement of the working classes.

The fine art section, displayed in the minor hall and thus in a kind of art gallery by itself, was reported to have attracted the greatest number of visitors, although no figures were given in the press.[24] Whilst the admission charge for the working population was not particularly cheap – six pence in the evening, reduced to three pence on the last two nights – the cost does not appear to have been a deterrent as the show was apparently well attended by all ranks – about 70,000 persons in all.[25] The fact that mill owners and other employers could treat their workforces at a reduced rate may have helped swell the number of artisan visitors. The amount of money raised by the event was about £700.[26] On the closing of the show, Kirkpatrick was given an honorarium of £200 out of the proceeds for his work as honorary secretary and £150 was donated to the General Hospital.

Unfortunately, an undignified row thereupon broke out between William Gray and others regarding the remainder of the profits.[27] Gray argued that all or most should be given to the School of Art then being established. This was in line with the thinking of the committee of the London exhibition, which had recommended, amongst other proposals, that proceeds from the local exhibitions be used to establish or support such schools. Gray, however, was motivated by a more locally-based consideration than the London committee's thinking. In his view, the promoters of the Belfast show:

should be the foremost advocates of a School of Art, for the friends of art were their chief supporters at the recent Exhibition, and it would be a graceful return to the art patrons who lent their treasures ... if the committee devoted to the purposes of art no small portion of the funds the art department was mainly instrumental in accumulating.[28]

Others wished the money to go to the soon-to-be-opened Working Men's Institute or to be used to send a number of 'intelligent workmen' to the London exhibition, to assess the foreign competition – a solution which would also have been of benefit to the School of Art.[29] In the end, the school received £50.[30] Whether donations were made to other bodies is unclear, as is also whether workmen were actually sent to the London show, which opened on 16 July in the Agricultural Hall in Islington.[31]

   Irrespective of this petty bickering, one of the most positive results to emerge from the exhibition was the good will evident between the various classes. The fact that the upper and middling ranks had happily lent their treasures was proof of this harmony. Although the wealthier classes had lent to the occasional exhibition in the past – for example, to the Belfast Association of Artists show of 1837, to the *Exhibition of Modern Works of Painting and Sculpture* of 1850–51 and to Ward's winter exhibitions of 1866 and 1867 – they had done so in the cause of art. Lending to an industrial exhibition and for educational reasons was something of a new departure for those with art collections. Another positive outcome was the evident appreciation of the fine art section by the working population, attested by the large and interested crowds reported in the press. Whilst a love of art by the lower ranks had already been observed and commented upon in local newspapers in the past – artisans had formed enthusiastic audiences at the four major art exhibitions of the 1850s – the fact that they were well represented amongst the crowds who had flocked to the art exhibits was renewed proof that an appreciation of art belonged to no particular class.[32]

## BELFAST WORKING MEN'S INSTITUTE AND TEMPERANCE HALL EXHIBITION OF 1871–72

The opening of the Working Men's Institute and Temperance Hall on 15 November 1871 was the occasion for the town's second industrial exhibition. Contributions towards the building had been mounting steadily since 1866. By 1871, £3,000 had been raised, with £2,000 still being required to bring the project to completion.[33] It was to help raise this amount that the exhibition was held.[34] Designed by local architect

Anthony Jackson, the Institute comprised a news-room, reading room and refreshment area on the ground floor, library and lecture room on the first floor and a large public room capable of holding 1,200 people on the top floor, complete with orchestra gallery.[35] With so many functions under one roof – there was also a games room and smoking room – the building was obviously an ideal centre to serve the physical and intellectual needs of Belfast's working men. The Institute's president was the Marquess of Donegall, whilst its trustees numbered men of substance like John Lytle, Thomas McClure and John G. Richardson.[36] Lord Dufferin, Adam Duffin and Jonathan Richardson were amongst those on its governing council.[37]

The opening ceremony, described in the exhibition catalogue as 'one of the most imposing and successful demonstrations of the friends of labour and industry that has been held in this country for a long time' was a grand occasion.[38] Those present included the mayor (Philip Johnston) and town council, Lord Dufferin, a few members of parliament, the presidents of various local boards and the president and professors of Queen's College.[39] Amongst other visitors were large-scale employers like John Charters, John Hind and James Musgrave and persons involved in art such as William Gray, Francis Davis Ward and Robert Young. Overall, the audience comprised the middle ranks whose affluence and charitable impulse were a vital source of paternalism in Belfast. Following the speeches, an inauguration ode written by local poet Francis Davis was sung by a choir to a hushed and appreciative audience so enraptured with the performance that it had to be repeated.[40] Though overblown and sententious to the modern ear, the piece nonetheless evokes the optimism and high seriousness of the occasion. An extract is included:

> O Mind, Almighty Fount of Beams
> That all partake of, more or less,
> This Temple, sacred to our dreams,
> Of truth and Beauty, deign to bless!
> Till, radiant from its centre, streams
>
> A Beam of Love and Loveliness,
> Revealing to remotest lands,
> In works of holiest form and hue,
> What Irish Mind, and hearts, and hands,
> For God, for man, and Art can do!
>
> . . .

Oh! here before the Highest's throne,
Let high and low proclaim the need
Each hath of each, as brain and bone
To work for each, hath God decreed!
Who toils for self, and self alone,

Toils for a pigmy soul indeed!
But wealth, betrothed to manual skill,
Whereof this Temple is the seal,
Shall, bless'd by Heav'n! make clearer still,
God glorified, means human Weal![41]

As with the exhibition of 1870, the show comprised a number of sections (now called departments): fine art and photography, textiles, mechanical examples and models, natural history and antiquities and a musical division. As before, each department was organised by a sub-committee. Amongst the twelve on the fine art sub-committee (the largest of the groups) were William Gray, Thomas Mitchener Lindsay, Dr James Moore and Robert Young.[42] That the exhibition had caught the public imagination is evident from the fact that there were no less than ninety-six persons on its general committee, ranging from the mayor to industrialists, merchants and professionals.[43]

The show was spread throughout the entire Institute.[44] The ground floor was taken up with mechanical and architectural models, sewing machines and examples of Irish tweed and pottery, whilst the lecture room on the first floor was given over to the art gallery. A room close by, intended to serve as the library, contained specimens of natural history. The large public room on the top floor housed working models connected with the carpentry and engineering trades and was also used as a place of promenade for the duration of the exhibition. It was here that the opening ceremony took place.

The fine art display contained almost 300 oil paintings and watercolours, of which about half were loans and the rest contributions from amateur painters. As with the 1870 exhibition and as was to be the case in 1876, the purpose of this department was to instruct and elevate, to encourage 'the culture of the Fine Arts amongst working men'.[45] Earl Spencer, the Lord Lieutenant, lent works yet again, in this instance a portrait of himself by Thomas Alfred Jones, one of Countess Spencer by Henry Weigall and one of Richard Burke by Sir Joshua Reynolds. Lord Dufferin lent eleven paintings, six of which were copies after the Old Masters. However, the majority of the exhibits were by local artists such as James Howard Burgess, Andrew Nicholl and Anthony Carey Stannus. There were also a few well-known British names like George Armfield, William Etty and

George Morland. Of the few sculptors represented, Samuel Ferres Lynn was the most distinguished. Examples by him included a model for his statue of Rev. Dr Henry Cooke (Fig. 67), destined for College Square in 1876, as discussed in Chapter Seven, and the bust of Rev. Dr Pooley Shuldham Henry of Queen's College, lent yet again by that establishment.

Strangely, in view of the coverage accorded to the 1870 event, there are few details in the press regarding the success of the exhibition and only a few references to visitor numbers. Apparently, over 4,000 persons attended during the first few days; also, 1,520 were recorded during the week ending 28 November.[46] If weekly attendance was around 1,500, the final figure may have been over 18,000 by the time the show closed on 17 January 1872.[47] Given that entrance charges were similar to those of 1870, that is, one shilling for daytime admission and sixpence for evening, a substantial sum was probably raised for the Institute. However, the actual amount collected remains unknown. That aside, probably the most positive result of the exhibition was the continuing concern by the middle and upper ranks for the intellectual welfare of the working population.

## THE INDUSTRIAL EXHIBITION OF 1876

Like the exhibition of 1871–72, that of 1876 was held to help clear the Institute's debts.[48] Although the establishment had become financially self-supporting by 1875, it was still burdened with a £3,800 deficit.[49] At a public meeting in the Institute in August of that year, the decision was taken to tackle this through the organising of yet another industrial exhibition, combined with a bazaar.[50] Within a week, the format of the show had been determined.[51] There were to be a number of sections, as with the previous exhibitions: fine art, scientific and mechanical appliances, textiles, products of various kinds and natural history and antiquities; also a bazaar for the sale of fancy goods. As had become standard practice with such events, sub-committees were then set up to organise the various sections. Sir Charles Lanyon was subsequently elected chairman of the fine art committee.[52] Others on it included William Gray, Dr James Moore (vice-chair) and John Vinycomb.[53]

The exhibition was to be the most prestigious yet held in Belfast, especially as regards the social standing of those involved. Numerous members of the nobility, gentry and middle ranks either lent their names to the proceedings or took active roles. Heading the list of twenty-eight patrons was the Lord Lieutenant, the Duke of Abercorn.[54] The Marquess of Donegall, Viscount Bangor, Sir Thomas Bateson, Sir Thomas McClure and Sir Richard Wallace were also

of the number. James Alexander Henderson was exhibition president. The general committee, an extremely large group, comprised 135 members ranging from professionals to businessmen and manufacturers.[55] Overall, the list of those involved reads like a *Who's Who* of the nobility, gentry and commercial interests of the north of Ireland. Equally impressive were the 'patronesses' and ladies of the bazaar, many of whom were the wives or daughters of those involved with the exhibition.[56]

From the beginning, the show was given considerable coverage in the local press, with committee meetings recorded in detail. Indeed, once the undertaking had begun to be publicised, donations came flooding in; five weeks after the August meeting in the Institute, £650 had been raised towards the elimination of the debt.[57] Already by this point, a prominent local collector had offered to lend fourteen or fifteen oil paintings to the event.[58] This spurred others on to do likewise. By the time the exhibition opened in May 1876, sixty-four local persons had lent works. However, not all the lenders were from Belfast or the north. In September 1875 a deputation had called upon Sir Richard Wallace (Fig. 72) at his Lisburn residence, to request the loan of works from his fabled art collection, housed in his London home, Hertford House.[59] He agreed and, accordingly, lent fifty-one watercolours and an oil painting.[60] The South Kensington Museum (later to become the Victoria and Albert) also lent watercolours and oils, together with cartoons for mosaics, wood-carvings and works in enamel, glass and ivory.[61] The premier contributor, however, was the queen, whose decision to lend was taken a few weeks before the exhibition opened.[62] Her loan comprised applied art items such as a framed mosaic of Flora, bronze plaques of *The Seasons* by Soldani and a few vases; also a selection of weapons including a sword and dagger of Philip II of Spain.[63]

The exhibition, described as 'one of the largest collections of articles of utility and vertu ever displayed in the North of Ireland', opened in the Ulster Hall on 23 May.[64] Amongst those present were the town council, the presidents of Queen's College and Methodist College, patrons and members of the exhibition's various committees, manufacturers, professionals and clergy. Wallace, being one of the chief lenders, was also there. Guest of honour was the Duke of Abercorn, who performed the inaugural ceremony.[65] After his replies to addresses from the president and committee of the exhibition and

**72** ? R.W. Benyon, Jr (fl. 1870s)
*Sir Richard Wallace, Bt, MP (1818–90)* (c. 1873)
Wallace, one of the most famous art collectors of the day and MP for Lisburn 1873–85, lent over fifty works to the Industrial Exhibition of 1876, held in the Ulster Hall. His fabled art collection at Hertford House, London (the Wallace Collection) was bequeathed to the nation by his widow in 1897.

from the president of the Working Men's Institute, a 150-strong choir sang an 'Ode to Industry' specially written for the occasion.[66] This was followed by a chorus by Haydn, 'Achieved is the glorious work' and, bringing the musical part of the festivities to a close, Handel's inspiring 'Halleluiah' chorus from the *Messiah*. With such music, fashionably-dressed crowds and be-robed town councillors, the ceremony was indeed as splendid as the exhibition it celebrated. It was also the most impressive event of the kind yet seen in Belfast.

The art collection was equally impressive. Displayed in the minor hall, as had been the case with the exhibition of 1870, it comprised over 350 oil paintings and watercolours, a small number of sculptures, mainly by the eminent Irish sculptor Albert Bruce-Joy, and designs by members of the Belfast Architectural Association and students of the School of Art. There were also photographs by local photographers and examples of needlework by local women. Wallace's pictures, a representative cross-section of the best of British watercolour painting of the nineteenth century, stood out as being especially noteworthy. Included were ten landscapes and subject pictures by Richard Parkes Bonington (1802–28), amongst which was *Sunset in the Pays de Caux* (1828) (Plate 29), five landscapes by Antony Vandyke Copley Fielding, six by David Roberts and four by Turner (1775–1851), one of which was *Scarborough Castle: Boys Crab-Fishing* (1809) (Plate 30).[67] Continental artists such as Leon Cogniet, Paul Delaroche and Horace Vernet were also represented.

South Kensington's contribution was a useful foil to Wallace's, as amongst the thirteen oils lent were seven by Dutch, Flemish and Italian Old Masters.[68] These must have been an asset as the exhibition contained few other Old Masters. The six remaining works were by nineteenth-century British and Continental artists such as William Mulready and Georg Emil Libert.[69] Of the watercolours, of which there were also thirteen, there were examples by Peter de Wint, Nicholas Pocock and Paul Sandby, amongst others.[70] These, together with Wallace's pictures, formed an impressive array of British watercolours of the eighteenth and nineteenth centuries. Amongst local lenders were prominent businessmen like Edward Harland, James Alexander Henderson and James Musgrave and persons involved in the arts such as William Rodman and Francis Davis Ward. Local artists James Howard Burgess, Samuel McCloy, Dr James Moore, Felice Piccioni and Anthony Carey Stannus also lent examples of their work. A wide selection of art was therefore on display.

Admission charges were one guinea for a gentleman's season ticket, ten shillings and six pence for a lady's and two shillings daily at the turnstile.[71] As had become standard practice, the working population was admitted at a reduced rate on certain days, at the usual cost of

six pence each.[72] The success of the exhibition can be judged by visitor numbers. By the time the show closed on 12 August, over 72,000 persons had passed through the doors, together with another 30,000 people (including children) at a reduced rate.[73] This was much greater than the number of visitors to the 1871–72 event, which had lasted about two months and had attracted possibly around 13,000 people. The fact that there were about eight times the number in attendance at this third exhibition indicates that such shows, with their wide variety of exhibits – antiquities, art, natural sciences and industrial objects – had become extremely popular in Belfast. Though the figure of 102,000 included holders of season tickets and the organisers had no idea how often such persons had attended, they nevertheless professed themselves pleased with the public's response. The event had also been a financial success as the exhibition had raised £2,000 and the bazaar £755.[74] This amount went a long way towards clearing the Institute's debt. (The outstanding balance of £1,000 was to be tackled in a fourth industrial exhibition, held in the Ulster Hall in 1895.)[75]

The above statistics were conveyed at the closing ceremony on 14 August, as were also reports from the chairmen of the various sections.[76] That for fine art was delivered by Dr James Moore, the section's vice-chair. Expressing thanks to the lenders in order of status – the queen, Wallace, South Kensington and 'the gentry, merchant princes and artists' – he then made an interesting suggestion: that Belfast have an annual exhibition of South Kensington's paintings. They were, after all, public property and the town had a right to them. Possibly to underline Belfast's suitability for such shows, he went on to emphasise that not a single picture had been damaged in any way – a remark perhaps also designed to remind his middle-class audience that the working classes could behave with propriety. The ceremony ended with yet more discussion on art matters when committee member Professor Thomas Andrews – perhaps influenced by Moore's proposal regarding South Kensington – suggested the establishment of a 'permanent picture gallery in Belfast'. In his view, the town 'required some such institution to encourage the cultivation of the fine arts, which was perhaps at present more imperatively required than anything else … The advantage of cultivating the fine arts could scarcely be over-rated in a town like Belfast'.[77]

Though a dedicated art space in town was several years off, these three industrial exhibitions made an important contribution to the local art scene by placing before the general public a wide variety of art, much of it of good quality. Furthermore, their timing was fortuitous as Ward's winter exhibitions had ended in 1869 and Rodman's series of annual exhibitions of original modern paintings had yet to begin.

(It is tempting to speculate that the success of the shows possibly influenced Rodman in the subsequent mounting of his own large-scale events.) In reality, therefore, the industrial exhibitions were a useful substitute for commercial gallery displays in the cultural fabric of the town. Also, for the working population in particular, the six pence admission charge meant that many could afford to attend and see displays of art again. Entrance to Ward's winter exhibitions of 1866–67 and 1867–68 had been one shilling, a prohibitively high cost for many of the working classes. An experiment by the firm with their last show in 1868–69, a three pence charge for the labouring population on Saturday evenings, had been an enormous success.[78] This had been the only large-scale art exhibition in the 1860s which many of the working classes had been enabled to see. These industrial exhibitions were therefore of considerable value to those interested in art but with limited financial means to enjoy such occasions. Whilst visitor numbers of the working population to the exhibitions are unknown, it seems likely that about one third of the final figures were from the artisan classes: roughly about 23,000 in 1870, perhaps around 6,000 in 1871–72 and close to 30,000 in 1876. This, however, is speculative and there may well have been many more. Though there was a considerable difference between the overall attendance figures for the 1871–72 show and the other two events, this may have been because of the venue – the Working Men's Institute being a good deal less fashionable than the Ulster Hall. Finally, as Andrews' remark revealed, the shows highlighted once again the strong need for an exhibiting space in the town – an art gallery for the permanent display of works of art and for the holding of temporary exhibitions.

## TOWARDS A FREE PUBLIC LIBRARY, ART GALLERY AND MUSEUM

Moves to establish a free public library in Belfast accelerated from the early 1870s, partly perhaps in consequence of the industrial exhibitions and their emphasis on the importance of education for artisans. The subject had first been discussed by the town council in 1855 but the idea had been abandoned almost immediately, as detailed in Chapter Four. The issue was raised again in 1865 in a lengthy editorial in the *Belfast News-Letter*, which opened by claiming that 'Few towns in the United Kingdom of the same extent as Belfast are so destitute … of means of enjoyment for the masses'.[79] The piece then extolled the value of education for working men, which helped turn them into better husbands, fathers and citizens, and deplored the lack of library facilities and reading rooms for the working classes. The editorial ended by calling upon benevolent individuals or, failing that, the

ratepayers to rectify the situation. However, nothing came of this attempt to stir the public conscience.

In Britain, such libraries had been part of the cultural landscape since the late 1840s, when three had been established in Canterbury, Warrington and Salford in 1847, 1848 and 1850.[80] These pioneering institutions had been founded through William Ewart's Museums Act of 1845, which was sufficiently flexible to permit the formation of free public libraries, financed, like museums, by a maximum rate of a halfpenny in the pound in boroughs with populations over 10,000.[81] Between 1851 and 1862 a further twenty-three were established in various parts of Britain, namely, twenty-one in England, one in Scotland and one in Wales.[82] These were funded through Ewart's Public Libraries Acts of 1850 and 1855, the latter of which reduced the population requirement to 5,000 and raised the rate to a maximum of one penny in the pound. Two thirds of the ratepayers had to be in agreement, either through a poll or by public meeting.[83] In total, 125 libraries were established in Britain between 1847 and 1886.[84]

In Ireland, whilst the 1855 Act was greeted with considerable enthusiasm, progress was much slower.[85] Only one library was opened before 1880, that in Dundalk in 1858. Effective support in Ireland for the free public library movement did not begin until 1877. In March of that year, the citizens of Dublin called on their corporation to adopt the 1855 Act. They also requested the government to grant additional powers to the Act. This was subsequently approved and agreed under the Public Libraries (Ireland) Amendment Act of 1877. In Belfast, the library issue came before the town council in April of the same year, as detailed below. The project, however, took several years to come to fruition, as discussed in this and the following chapter. In 1880, a second library was opened, this time in Sligo. Others were established within the decade, notably two in Dublin in 1884 and, eventually, one in Belfast in 1888. Tardy by British standards, Belfast was also slow to found a library when considered within an Irish context.

Between 1871 and 1875, a number of letters appeared in the Belfast press, urging the foundation of such a library. One of the most earnest proponents was William Shepherd, secretary of the School of Art. In January 1871 he issued an impassioned plea on the subject in a letter to the *Belfast News-Letter*. His argument was eloquent:

> It is time that Belfast should awake to the necessity of providing more intellectual food for the *people*. We have but two public libraries … the Linen Hall and the People's Institute; but none *free* to all … To expect men to be wise, good and intelligent citizens without books, is to repeat the Egyptian tyranny, and expect them to make bricks out of straw.[86]

The 'People's Institute' of his letter was presumably the Belfast People's Library Institute, formed about 1865 through the amalgamation of the Belfast Mechanics' Institute and the Belfast People's Reading Room.[87] Whether the contents of its library were of good quality remains unknown; however, it seems reasonable to assume that they were less than so. Either way, neither it nor the Linen Hall Library was accessible to all, as neither was free.

Shepherd returned to the subject in November 1871, a few days before the opening of the Working Men's Institute and Temperance Hall. In a second letter to the *Belfast News-Letter*, he suggested that the Institute be handed over to the town for use as a free public library.[88] In his opinion, if this were done, subscriptions could be raised to clear the debt on the building and 'float the library into existence'. The library could thereafter be maintained through the penny rate available under the Public Libraries Act. He also envisaged the formation of a popular museum in connection with the Institute. If the idea was adopted, he believed that working men could only stand to gain by it. A similar scheme was broached by the *Northern Whig* in the autumn of 1875, namely, that a free public library be established within the Institute and form part of it.[89] The size and central location of the Institute were obviously determinants in these proposals. That they got no further than the newspaper columns perhaps indicates that they were unacceptable to the Institute's committee.

The movement to establish a free public library gained momentum in 1877, with the installation of John Preston as mayor. In his inaugural speech to the town council on 1 January, he urged his fellow members to give the establishment of such an amenity serious thought, stating 'This matter I believe to be one of the greatest importance to the inhabitants of our town – morally and socially – and for my own part I should be glad to see the ratepayers join heartily and cordially with this Council in adopting this act [the Public Libraries Act of 1855] in Belfast.'[90] The issue went before the town council on 2 April following, when it was decided to explore in greater depth the expenditure involved before taking steps to call a public meeting on the subject.[91] After further deliberations, the council, at its quarterly meeting on 1 May, resolved:

> That considering the rates at present levied on the borough, the state of trade, and all the branches of industry, and that amendments of the law relating to the establishment of such libraries are at present under consideration [the Amendment Act of 1877, as mentioned above], we recommend that the further consideration of the matter be deferred.[92]

Preston regretted this decision and maintained that it was the duty of

the council to put the matter before the ratepayers. As evidence of his support for a library, he offered to give £100 towards its establishment, if ten others would join him. However, nothing came of this. The issue remained before the public during 1877 through letters to the press, a number of which were critical of the council's stance.[93]

The idea of combining an art gallery with the hoped-for library – which is what eventually came about – appears to have originated with Robert Young, a vice-chairman of the board of the School of Art. Young first made the suggestion at a meeting of the school's donors and subscribers on 15 February 1878.[94] The idea was wholly new although that of the establishment of an art gallery as a solo institution was not, having been promoted constantly since 1871 by Thomas Mitchener Lindsay, the school's headmaster, as discussed in Chapter Eight. Young may have made the suggestion out of expedience, in the belief that a free public library would happen at some point and that an art gallery might come about more quickly if attached to it. He may also have been influenced by the success of the art displays in the industrial exhibitions referred to above and the need they had shown for a dedicated art space in town. This lack had been highlighted periodically in the press since 1826, when Francis Dalzell Finlay and Hugh Frazer first drew attention to the necessity for an art gallery in Belfast. By the 1870s, however, the provision of art galleries – and also free public libraries – had come to be seen as municipal responsibilities.

The School of Art was not alone in promoting the art gallery idea; a number of individuals supportive of the project also made their voices heard, by means of the press. The issue intensified in September 1879, when letters from William Gray and one J.R. Hall appeared in the *Belfast News-Letter*, urging the establishment of an art gallery – together with an art museum – for the benefit of students of art.[95] Their correspondence drew an enthusiastic response from a designer and an art student in the same newspaper in early October. The designer, a former pupil at the School of Art, concurred heartily with the necessity of an art museum, maintaining that 'The want of one has long been felt by pupils who, like myself, were studying design, and the benefits which would result from having such a museum would not be confined to pupils alone, but would serve to train the public (manufacturers included) in the principles of good taste'.[96] For the student's part, he or she urged local merchants – and Sir Richard Wallace – to assist in the art museum idea.[97]

The *Belfast News-Letter* itself took up the cudgel a few weeks later, in a lengthy editorial of mid-October. Stressing the educational and social value of such an amenity, it envisaged the museum as being composed mainly of loans from local collectors and from South

Kensington. The link between industry and the School of Art was underlined: 'The necessity for inculcating and training taste in a manufacturing centre has long since become widely recognised. Indeed, experience proves that the only way a manufacture can be sustained with rigour is by cultivating its alliance with art.'[98] Following this, a number of letters appeared in the paper over the next few months on a common theme: the value of an alliance between art and industry and the necessity for art students and designers to see fine and applied art collections in their home town.[99] A particularly stirring letter in the issue of 4 November posed the question – would Ulster's fine linen have been such a commercial success if it had not been packaged in well-designed and beautifully-ornamented linen bands and wrappings? 'Where', the writer continued, 'are our young and rising artist designers to learn and cultivate their taste for the production of these works of art – and many of these deserve this name – without an art school accessible to all?' (By this, he appears to have meant an art museum.) He called on the town's merchant princes to follow the example of the 'right-minded, princely men' of Leeds, Liverpool, Manchester and Sheffield and erect 'a temple of art', namely, an art gallery combined with a museum and also a free public library.

The *Belfast News-Letter* fired a second salvo on the subject at the beginning of January 1880, in a lengthy editorial on the progress of science and art in Belfast. In essence a criticism of the lack of advance in these areas, the piece provides a valuable insight into the depth of feeling raised by the free public library and art gallery issue:

> We are justly proud of the progress of Belfast and also to speak of the rapid increase of the wealth and commercial importance of the town … Yet what have we done for science and art? Where is our free public library? our town museum, with its art and economic branches? Where is our art gallery or our public lecture hall? Simply nowhere … If we had a Town Art Gallery we might … have an annual exhibition of drawings and designs, from the Belfast and other Schools of Art, with loans from private art collectors, supplemented by the rich contributions … from South Kensington Museum. In the same building there should be a permanent art museum of examples for the study of designs … This can and should be speedily accomplished in Belfast … Such a scheme should be considered in connection with the establishment of a free public library, and could be respectably maintained by a local tax of one penny in the pound, which on our present valuation would realise an income of £2,200 a year.[100]

William Gray echoed these sentiments the following November in an address to the Belfast Naturalists' Field Club, of which he was president. In the matter of an art gallery, he regarded its lack as something of an anomaly, 'all the more strange when we remember that we have the foremost of art patrons in this kingdom in our immediate locality'.[101] By this he meant Sir Richard Wallace, who resided periodically in Lisburn. It is worth speculating that had Wallace taken the lead with any of these hoped-for and much needed institutions and given financial assistance, Belfast's merchant princes might have followed his example.[102]

Gray's address elicited appreciative and supportive letters in the *Belfast News-Letter*, from such as 'A Lover of Pictures' and 'An Athenian'.[103] Indeed, the topic was aired even further afield – perhaps as a result of the publicity it had generated – with no less a magazine than the *Art-Journal* devoting space to it in a winter issue of 1880.[104] In its comments, the journal noted how the rapid growth of Belfast during the past fifty years had left its busy citizens little time for the cultivation of the fine arts. Strangers might admire its warehouses and docks but, when they inquired after those public art institutions such as were possessed by many lesser towns, there were none to be found. No public effort had been made to provide an art gallery and art museum. 'Beyond the establishment of a school of Art … private enterprize has done everything [here they were referring to the art productions of Marcus Ward and the exhibitions held by Rodman]; the town, as a town, nothing.'

Such then was the extent of public feeling on the subject of a library, art gallery and art museum by the close of 1880. Beginning with a few letters in the press in 1871, the issue gathered momentum after 1877 until, by late 1880, it had become a topic of discussion not only in Belfast but also in London, through the columns of the leading art periodical of the day. The value of such publicity was not lost upon William Gray, the most energetic crusader for art causes since Hugh Frazer in the 1820s and 1830s. Like Frazer, Gray used the power of the press to put his message across. However, there the similarity ended for Frazer had little influence and was scarcely heeded. Gray, on the other hand, was to bring an increasingly large body of the middle classes with him during the 1880s, in the drive to see the free public library finally opened. He, more than anyone else, was to provide the vital force necessary to propel an almost immovable object – the town council – towards a library, art gallery and museum.

# ～ 10 ～

# The erection and opening of the Free Public Library

## 1881–88

*'Today we boast a seat of literature, a fountain from which, all may freely drink, presented to us by the energy of a few'*[1]

### CIVIC PORTRAITURE AND CITY STATUS

By the early 1880s, Belfast was not only the largest linen-producing centre in the world, it was also experiencing a massive expansion in shipbuilding and engineering. Such industrial success inevitably engendered considerable civic pride, a sentiment almost certainly reflected in the demand by the town council from the mid-1870s for portraits of council members. By 1882 there were seven such paintings in the council chamber of the Town Hall, of which five were by Richard Hooke, who had had the monopoly with this kind of commission thus far.[2] The other two were by Sir Thomas Alfred Jones, soon to take Hooke's place in the council's favour.[3]

Jones's artistic ascendancy began in 1883, when he was asked to paint a portrait of Queen Victoria. Events behind the commission shed an interesting light on the council's aspirations to dignity and importance and are also revealing of the fact that business dealings – then as now – could be 'back room' and clannish. The idea for the painting originated with James Alexander Henderson, who made the suggestion at a council meeting in March 1883.[4] The portrait was to be procured by a committee comprising himself and a few others.[5] Unfortunately, by the following May, when the council officially approved

196

the proposal, Henderson was dead. Nevertheless, the project went ahead and, by early June 1883, Jones was given the commission.

Thereafter, what should have been a straightforward matter of council business became instead a subject for acrimony and ridicule. According to a letter from Hooke in the *Northern Whig* of 15 June 1883, Henderson had promised the commission to *him* in June of the previous year. Briefly, events as related by Hooke were as follow. In May 1882, he had chanced to meet Henderson in London, had thought he looked ill and had invited him to spend a week at a Lancashire resort. To repay Hooke for his kindness, Henderson subsequently divulged to him 'a little scheme' he had in mind for a portrait of the queen and indicated that Hooke would be the ideal person to carry it out. If Hooke felt able for the task, Henderson pledged to put the idea before the council at the first opportunity. Hooke, however, urged caution 'as familiarity is said to breed contempt, and as my name is rather common in Belfast, he [Henderson] had better keep it out of sight for the time being'. The two men had discussed the matter further during Hooke's annual visit to Belfast in February 1883 and had set a price. However, on Henderson's death the following April, Sir John Preston, one of the portrait committee, persuaded the council to give the commission to Jones, on the grounds that the latter's title and rank in society would ensure access to the queen, whilst Hooke's lesser social standing would not. As it transpired, however, Jones was not granted a sitting either, despite his status, and was forced to work from existing portraits and photographs.[6] The episode, exposed and ridiculed by the *Northern Whig*, cast the council in a very poor light.

Despite this embarrassment for the council, it continued to favour Jones and, during 1886 and 1887, added another four works by him to the 'municipal picture gallery', as the council chamber was occasionally referred to during these years.[7] The first of the group, a portrait of mill owner William Ewart, was placed in the chamber at the end of October 1886.[8] By the beginning of the following December, the decision was taken to also acquire portraits of Sir Edward Harland and Sir John Preston.[9] Later in the month, the fourth work was decided upon, a portrait of merchant and manufacturer John Lytle, who had died in 1871.[10] The portrait of Preston was unveiled in April 1887, that of Lytle the following September.[11] Harland's portrait had a more varied history. Completed by April 1887, it was displayed temporarily in the Town Hall but was moved to a permanent location within the Free Public Library in October 1888, shortly before the opening.[12] The choice of site seems to have been made out of respect for Harland's distinguished position within the community. In being placed thus, it became the first municipal portrait to be seen by the general public, including the working population. Whilst such

paintings had occasionally been exhibited at Magill's and Rodman's, audiences there did not embrace such a wide social spectrum as those at the library.

Although Hooke appears to have been embittered by the council's treatment of him, as can be detected in his above-mentioned letter of 15 June 1883, in which he described Jones as '[an] artist quite unconnected with Belfast', he maintained a deep pride in his portraits in the council chamber. Twice in 1887 he sent lengthy letters to the press, complaining about the unsympathetic hanging of his works in the chamber.[13] In both communications, he urged the council to alter the lighting in the room from a side to a top light, the ideal means for a picture gallery, and maintained that this could be achieved at low cost.[14] If this was done, it would give 'favourable and equal light to every picture, [leave] wall space for as many more when required, and [form] a handsome gallery and commodious council-room'.[15] Poor lighting was not the only problem; the handling and conservation of his portraits was also a matter of concern to him. He explained:

> At the time these pictures were painted I was permitted, or rather instructed, to have them placed in the more favourable side lights, where they long gave general satisfaction; but latterly they have every one been removed; and hung as above described [opposite the windows], to give place to others of later production [those by Jones], and besides, they have in these repeated shiftings received considerable damage. Straining wedges have been loosened or lost, allowing the canvas to warp and wrinkle; and the worst is, all these seeming defects are most unjustly charged to me.[16]

Such a situation obviously weighed heavily upon him. Whether the council took heed of his complaint in its push to acquire additional portraits of those who had helped make Belfast the industrial capital of Ireland, is unclear.

The movement to have Belfast elevated to the status of a city was initiated by Francis Davis Ward, during his presidency of Belfast Chamber of Commerce in 1887.[17] Ward first raised the subject at a meeting of the Chamber on 12 May of that year. By this point he had already obtained legal advice in London favourable to his enquiry: the Crown could confer the dignity of a city upon Belfast 'without altering any of the existing statutory arrangements of the borough, without being made a county of a city, and without any but a very nominal cost'.[18] He subsequently called a conference at the Chamber a few days later, attended by the mayor (Sir James Haslett) and representatives of the Harbour Commissioners, the Board of Poor Law Guardians and the Water Board.[19] At the meeting Sir Edward

Harland (Harbour Commissioners) suggested that the opinion of the best Irish counsel should also be sought before taking further action. Obviously determined to push the matter ahead, Ward then obtained this additional advice at his own expense. This concurred with the opinion given in London. At a further meeting in the Chamber on 25 May, at which the various boards were again represented, the group resolved to memorialise the Crown on the subject. At this point Ward passed the project to the town council, as the memorial had to come from the council rather than from the boards.

Perhaps in the hope of a speedy resolution, it being the queen's Golden Jubilee year, the council responded with uncharacteristic promptness. By 16 June the memorial had been despatched to the Lord Lieutenant, requesting that a royal charter be granted creating Belfast a city.[20] To justify the application, the piece contained illuminating details of Belfast's expansion. At this point – 1887 – the population stood at over 230,000, an increase of about 160,000 since the queen's accession in 1837. Even more remarkable, in terms of growth, was the Customs' revenue of the town. 'In the year 1855 this … was £363,175, whereas in the year ending 31 December, 1886, it reached the sum of £1,635,669, and is still steadily increasing. Belfast is now, therefore, as regards Customs' revenue, the third port in the United Kingdom, being exceeded only by London and Liverpool.'[21] Statistics like these were proof of the town's right to city status.

If the council had hoped that the application would be granted within the Jubilee year, it was to be disappointed for the matter was to drag on for another year. Not until July 1888 was word received that the government had resolved to grant the charter. The news was received somewhat lukewarmly by the *Northern Whig* – 'Whether we shall be any better for the title we do not know: but at all events we shall not be worse', whilst the *Belfast News-Letter* was much more positive: 'Belfast has had an honourable and a distinguished history, and, now that it is to be created a city, we trust a new era will open before it, while we are certain it will fully justify the action of Ministers in giving an honour that must be acknowledged to be exceedingly well merited.'[22] Both newspapers paid tribute to Ward for his exertions on the matter. The honour was conferred by Lord Londonderry, the Lord Lieutenant during an official visit the following October, as detailed below.

## THE ERECTION OF THE FREE PUBLIC LIBRARY

As discussed in Chapter Nine, the free public library movement accelerated from 1877 under the mayoralty of John Preston, a keen supporter of the venture. Despite Preston's wishes, however, the town

council refused to put the matter before the ratepayers. The issue came before the public again in January 1881 when a new mayor, Edward Porter Cowan, a keen art collector, likewise took up the cause and, in his installation address, spoke of his hopes that the town would soon have a free public library and art gallery, valuable assets to the social and intellectual improvement of the working population.[23] His comments were warmly welcomed by the editor of the *Northern Whig* and by William Gray, who, in a letter in the same, maintained that 'The time for action has at length arrived … The ball has started and will be kept moving.'[24] A lengthy editorial in the same newspaper in the following March reiterated that Belfast badly needed such public institutions and claimed that Irish towns were far behind those on the Continent in the provision of such amenities.[25]

This seems to have prompted supporters of the project into action. At a meeting in the museum in College Square North on 20 April, a petition was drawn up, requesting that the town council ascertain the opinion of the ratepayers on the matter.[26] A number of leading figures signed in support, notably the presidents of the Chamber of Commerce and Queen's College and those involved in art such as James Musgrave and Francis Davis Ward. To give the petition as much weight as possible, copies were left for ratepayers' signatures in local banks, the Chamber of Commerce and with firms involved in art such as Magill and Rodman and the furniture maker and auctioneer N.A. Campbell.[27] By this point Gray was acting as honorary secretary of the proceedings.

The petition, signed by over 500 ratepayers, was presented to the town council by a six-man deputation on 2 May (1881).[28] Gray was of the party, in his capacity as secretary of what had become, in fact, a library pressure group. In an address to the council, he requested it to call a public meeting at an early date or ascertain the opinion of the ratepayers by some other means. He also emphasised the strength of support for the petition, which he stated had been signed 'by three members of Parliament, by the heads of the various educational institutions … a good many of the learned professions; but the great bulk of the signatures were of those whose intelligent labour was the mainstay of this community'.[29] The matter was discussed by the council at the beginning of July, when it was resolved to set the issue aside to a later date, on the grounds that 'the time was not very opportune … They all believed it was a very desirable institution to have in a town like Belfast; but they had so much on hand at present that they did not think it would be wise to further tax the inhabitants.'[30] Cowan did not concur with this and felt that the issue should have been put before the ratepayers; unfortunately, as with Preston in 1877, his voice was in the minority on the council.

If the council had hoped that the subject would now be dropped, it was greatly mistaken. In April of the following year (1882), Gray raised the matter again through a letter to the *Northern Whig*, addressed to supporters of the movement.[31] In it he recapped events to date and repeated the supporters' determination to place the issue before the council during the year. The following week the newspaper stated, yet again, its support for the undertaking and stressed the 'advantages of an institution of the kind … where there is a large and intelligent artisan class such as … in Belfast'.[32] Criticism was levelled at the council, which, in the paper's view, had 'shown no little apathy, not to say hostility, towards the project, though [it has] nothing to do with the matter further than to approve of the question being put to the vote of the ratepayers'. Always supportive of the arts, the paper had become an important voice of the free public library movement by this time. (The *Belfast News-Letter*, on the other hand, though also sympathetic, was much more restrained in its comments throughout the course of the campaign.)

Obviously encouraged by this latest spate of publicity, the supporters held a meeting on 18 May, again in the museum in College Square North – a little over a year from their first.[33] Amongst the large and representative audience, composed mainly of the middle ranks, were delegates from the United Trades' Council in Belfast, one of whom spoke on behalf of the working men of the town. The object of the meeting was to reappoint the deputation of the previous year and present another petition to the town council, requesting it to seek the ratepayers' opinion on the adoption of the Public Libraries Act (Ireland) of 1855 and the Amendment Act of 1877. Gray, who as secretary had been in contact with councils of numerous towns and cities in England on the subject, reported that 'the whole of the United Kingdom is at present looking forward to Belfast with jealous eyes' – Belfast which could now benefit from the experience of other town councils, some of which had 'rushed at the Act' and had suffered considerable difficulties as a result.[34] Gray did not elaborate on these problems. However, they perhaps occurred in towns with populations barely over the 5,000 minimum permitted for the adoption of the Act. This may have made the financing of such schemes difficult, if the libraries concerned were overly ambitious in scale.

The deputation this time was much larger than the previous year and comprised about fifty people, amongst whom were John Shaw Brown, William Gray, James Musgrave and Francis Davis Ward.[35] The petition, signed by 130 householders, was presented to the council on 1 June. Gray, in his address as secretary, stressed upon the council the importance of the deputation:

It ... properly represented the ratepayers of Belfast. It was not drawn from any particular class; it was not sent forward by any social grade or particular school of thought; but was an exact exponent of the great composite body of the ratepayers of Belfast, who yearned to emulate the example of the other towns which have adopted the Free Libraries Act.[36]

The mayor, Cowan yet again, promised to call a council meeting at the earliest possible moment, to consider putting the matter before the ratepayers. Finally, on 12 June (1882) came the decision which the supporters of the movement had been hoping for since 1877: a poll was to be taken to ascertain the ratepayers' views.[37] The *Northern Whig* made much of the long-awaited announcement: 'We confess we cannot understand the hesitation which has been manifested in the matter. The question is one of the few which the ratepayers have the right to determine directly for themselves ... We are glad, however, that the Corporation [council] [has] at last decided to do what [it] might have done with a better grace long ago.'[38]

By September the ratepayers had still not been polled. At a council meeting at the beginning of the month, Cowan, in response to growing public impatience, requested the council to clarify the steps it had taken thus far.[39] The town clerk, in his reply, pleaded pressure of business for the delay and indicated that the voting papers would be sent out in October. This proved to be the case and the papers were despatched to the ratepayers on the 30th of the month.[40] Unfortunately, this stage of the proceedings – like so much else in the history of the library – also attracted criticism. In the council's advance notification of the poll, published in the local press on 25 October, it had declared that the 'adoption of the Act will necessarily involve the imposition of an additional tax, which at present is limited to 1d in the £ on the valuation'.[41] Gray immediately went on the offensive over the wording of this and, in a letter in the *Belfast News-Letter*, commented: 'Now this at present is misleading, and may be mischievous, because it implies that the 1d might be increased, whereas the amount of the rate cannot possibly be increased ... it cannot be altered by the will of the Town Council. It is fixed by the act.'[42] Whether the statement was intended to mislead was ultimately irrelevant for the vote was carried by 5,238 in favour and 1,425 against.[43] The way was finally clear for the establishment of the library. By the time the result was announced – on 8 November – a site for the building had been reserved in the rapidly developing Royal Avenue.[44] At the beginning of December the council formed a library committee, to liaise with other centres which had adopted the act regarding the size of building likely to be needed.[45]

By the beginning of February 1883 the library committee had taken on board the wish of various interested parties that an art gallery and museum be included within the overall library scheme.[46] The cost of such additions, however, was beyond the funds available to the council. As a result, the committee appealed to 'any gentleman of large heart and purse' to come forward and pay for an extra wing or gallery.[47] No one responded, despite the committee's offer to name the additional building after the donor. In the absence of a benefactor, therefore, the possibility that the scheme would be confined solely to a library became a distinct reality. Concerned about the committee's indecision on this point, Gray, at the end of April, reminded it through a letter to the press that the deputations of 1881 and 1882 had requested an art gallery and museum in their petitions, as well as the library. In his opinion, 'A scheme … that is limited to a mere library would sadly disappoint the reasonable expectations of the ratepayers, and would not be in accordance with the spirit of the act itself. An art gallery would be aided by the Government, and the public would no doubt support the museum.'[48] In a subsequent letter, he also maintained that a building to accommodate all three uses – library, art gallery and museum – could be erected for the £15,000 which the council had allocated for the project.[49]

By early June the committee had resolved to hold an architectural competition for the building and, in its brief to architects, stipulated that two picture galleries be included – a decision which enraged Gray as there was no mention of space for a museum.[50] The inclusion of the galleries appears to have been a compromise designed to meet part of the deputations' wishes. Sceptical as ever, Gray also maintained that the actual site was too small and that a number of architects were unhappy about its restrictions. Whatever the architectural problems of the project, applicants were undeterred for the competition attracted fifty-six entries, which the committee began assessing in early August.[51]

The winning entry, announced in early September, was by the local architect William Henry Lynn, whose buildings in the town included Belfast Castle and the library of Queen's College.[52] The method of selection did not please everyone; the *Northern Whig*, for example, felt that the ratepayers should have had an input into the choosing of the winner.[53] In a somewhat dry editorial, it commented that 'To afford the people an opportunity of examining a collection of drawings after a selection has been made in their name [the entries were on display in the Town Hall] is a very questionable compliment to their intelligence, and is not a very valuable privilege.'[54] Lynn's plan was estimated to cost £16,000. The second floor, as described in the above

newspaper, was of particular interest to those concerned with an art gallery and museum :

> To the left side [of the main staircase] there is an ante-room (thirty feet by twenty feet) and opening from it a picture gallery, or lecture-room (thirty feet by forty-four feet) and there is also on the left a large room suitable for an art museum. These rooms are lighted from the roof ... the internal arrangements are likely to afford convenience in every department.[55]

Although somewhat altered, these rooms – Belfast's first municipal art gallery and museum – are still in use as part of Belfast Central Library. Despite the allocation of the space, Gray was unhappy with it – and with the building as a whole – and was also unconvinced of the committee's ability to bring the project to a completion.[56] Probably to offset the latter, he began promoting the idea of a composite library committee, that is, one which would include persons not on the council, outsiders with energy and enthusiasm to get things done. It seems likely that he envisaged himself as belonging to it; however, the idea had still not materialised by the time the library opened in 1888.

Perhaps influenced by Gray's reservations about the site, the council decided by the winter of 1883 to acquire more land at the back of the building.[57] The idea of an enlargement to the scheme was quickly seized upon by interested parties dissatisfied with the allotted art gallery and museum space (the extent of which Gray regarded as almost worthless). Accordingly, a deputation of various groups called on the library committee in early December.[58] The aim of the group concerned with art, which included Vere Foster, Gray and Sir Charles Lanyon, chairman of the School of Art, was to impress upon the committee the need for a proper art gallery and museum, something better than the rooms on the top floor. Lanyon, who spoke at length, stressed the utility of an art gallery 'to the people of Belfast, in improving their minds and developing a taste for the fine arts'.[59] The committee responded by declaring that the upper floor, intended for picture galleries, might also be used as an art gallery (that is, a space for the display of sculpture and the applied arts).[60] This satisfied the representatives of the School of Art (though not Gray). Other groups in the deputation were not so easily accommodated. Representatives from the Belfast Naturalists' Field Club made the case for a good general museum and lecture hall, whilst working men from the Belfast United Trades' Council highlighted the need for a news-room for the labouring population. To these various claims the committee promised to give careful consideration.

However, by April 1884, the committee had still not responded to

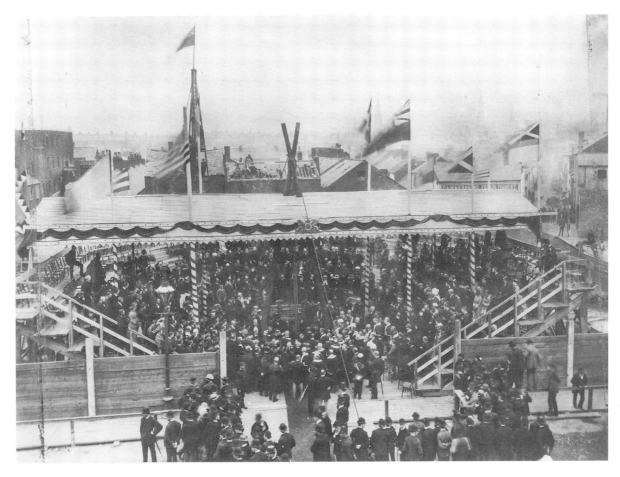

**73** The laying of the
foundation stone of the
Free Public Library by Earl
Spencer, Lord Lieutenant of
Ireland, on 18 June 1884.

the deputation, a silence which caused Gray to send an irate letter to
the *Northern Whig*, complaining that the ratepayers were not being
kept informed of developments; had the design been enlarged to
include a more extensive art gallery and museum and was a news-
room to be included?[61] The committee's report, presented to the
council at the beginning of May, contained disappointing news – there
was to be no grander scheme, no larger art gallery and museum.[62]
Nevertheless, the council had placed a bill before parliament seeking
approval to acquire the extra land at the back of the building – which,
however, was to be reserved for future use and not for the current
project. The library's art amenities, therefore, were to remain as in
Lynn's design. Gray regarded the committee's failure to adopt a more
comprehensive plan as a betrayal of the movement. In his account
of the development of science and art in Belfast, published in 1904,
he recalled how the library committee had received the deputation
of December 1883 'with their usual official courtesy, and with cool

dignified deliberation pursued the even tenor of their way, as the witches with Macbeth –

> To keep the word of promise to our ear
> And break it to our hope.'[63]

Though written almost twenty years after the event, the note of bitterness evident in these recollections would seem to indicate that the committee's decision, a disappointing blow, still rankled with him.

The foundation stone was laid on 18 June 1884 by the Lord Lieutenant, Earl Spencer, amidst considerable ceremony (Fig. 73).[64] Amongst the 300 guests or so, many of whom were involved in art and education and in the library movement, were representatives from various local trades such as lithographic printers, engineers, mechanics and linen finishers.[65] Sir Edward Porter Cowan, whose enthusiasm for a library had galvanised the movement into action in 1881, made the opening speech as chairman of the library committee. A bottle containing details of the project, a list of council members and examples of coinage of the day, was placed in the stone before the earl completed his part of the ceremony and wished success to the undertaking.

Unfortunately – and perhaps not surprisingly, given the history of the project – the erection of the building proved to be anything but straightforward. The next four years, until the opening of the library in October 1888, were notable for a series of blunders and inefficiency by both Lynn and the library committee, but especially the latter. In December 1884, for example, a major quarrel erupted regarding the plastering of the building, which Lynn insisted upon being carried out by Scottish craftsmen, as he considered the quality of local labour to be inferior.[66] Such was the strength of public feeling on the issue that the committee was forced to withdraw from its contract with Lynn's preferred firm in February 1885. There were also problems with the stonework of the base of the building, which the committee had stipulated should be Scottish granite, as part of the order was lost at sea and a further quantity arrived from Scotland wrongly cut.[67] The full amount was not received until December 1885.[68] The committee's preference for Scottish stone, when Lynn had recommended Castlewellan or Newry granite, was roundly condemned by the *Northern Whig* as an 'expensive prank'.[69]

Throughout 1886, numerous letters from Gray and others appeared in the local press, deploring the committee's handling of the business and the snail-like pace of progress with the project.[70] By this point, cynicism and ridicule for the committee had replaced enthusiasm for the undertaking in the newspaper columns. In January 1887 – at

which time the building was not even halfway completed – there were calls in the press for a 'public indignation meeting' of ratepayers to be held, to compel the council to speed up the work.[71] However, no meeting took place. Construction accelerated from August 1887 and, in January 1888, the protective hoarding was finally removed from around the building, some three and a half years after it had first been erected.[72] The final upset in the long-running saga concerned the post of librarian, which went to a 'stranger', namely one G.H. Elliott of Gateshead.[73] The fact that the appointment had not

been given to a local man caused considerable resentment amongst large numbers of ratepayers, to the extent that a well-attended protest meeting was held at the end of February 1888, under the auspices of the Belfast United Trades' Council. The library committee, wisely, refused to be swayed by such rampant xenophobia and Elliott remained in post.

The library (Fig. 74) was opened by the Lord Lieutenant, Lord Londonderry, on 13 October 1888 in the presence of a large and brilliant assembly.[74] The *Northern Whig* described the event as 'an epoch in the history of Belfast and of literature' but could not resist the opportunity to cast a swipe at the library committee – 'It is said that nothing is ever well done which is hurriedly done. On that basis of reckoning the constitution of our new Library should be one of the best local ventures ever made, for assuredly its inception was by no means a hurried one.'[75] Despite the ill-feeling which had besmirched the entire building project, the opening itself was a glittering success. After the event, at a lunch in the Town Hall, the Lord Lieutenant performed yet another important function, namely, to announce that the queen had been pleased to confer upon Belfast the dignity and title of city. This was the first official notification of the honour, although the charter granting it had actually been signed by the queen on 9 October.[76] The notification of city status on the same day as the opening of the library seems particularly appropriate as both were new beginnings in the history of Belfast.

**74** Belfast Free Public Library, Art Gallery and Museum, photographed by R.J. Welch c. 1891. The arched windows on the top floor are those of the art gallery and museum.

Almost as noteworthy as the actual opening was the exhibition organised around it. The idea for the show appears to have originated with William Gray, who, in a letter in the *Northern Whig* of 1 June, suggested a loan exhibition of paintings to fill the picture galleries. By August the library committee had taken up the suggestion and had resolved to ask local owners to lend works for the opening ceremony and for about a month thereafter.[77] A composite selection committee (which included Gray) was appointed to wait on the gentry and local clubs, in order to procure exhibits. So generous was the response that the committee was forced to decline many offers due to lack of space.[78] That the reaction took it by surprise is evident from the exhibition catalogue, which declared that 'It has become evident that the stores of Art Treasures in the neighbourhood have only been touched upon … It would be very desirable that the present effort might lead not only to more exhibitions of the kind but aid the formation of a Permanent Art Gallery.'[79] The exhibition opened to the public on 17 October – four days after the official opening of the library – and was divided into three categories: ancient and modern works of art, including sculptures and bronzes; contributions from local institutions and societies like the Belfast Harbour Commissioners, the Ramblers' Sketching Club and the School of Art; and an historical collection of local portraits and antiquities.[80] Admission was free, with evening opening three times per week, for the benefit of the labouring population.

The display comprised almost 800 works, mainly paintings, together with an assortment of local antiquities, old manuscripts and silver. Of the 108 private individuals who lent, a few were from the upper echelons, namely, Lord Deramore, the Marquess of Downshire, the Earl of Kilmorey, the Duke of Manchester, Lord O'Neill, the Countess of Shaftesbury and Viscount Templetown. Missing from the group was Lord Dufferin, who, as Viceroy of India between 1884 and 1888, had presumably not been approached. Most of the lenders, however, were from the professional and merchant classes. Notable amongst these were Lavens M. Ewart, Sir Charles Lanyon, William H. Patterson, James Thompson of Macedon and Gustav Wilhelm Wolff. Others included those well-known figures in the art world – John Vinycomb, Francis Davis Ward and Robert Young.

Of the paintings, there was a wide selection by masters of the British school such as Constable, Gainsborough and Sir Thomas Lawrence and also by illustrious Continental painters like Pompeo Batoni, Caravaggio and Rubens (although whether these latter works were genuine is unknown). Local artists were also prominent – figures

from the past such as Samuel Hawksett, Thomas Robinson and Joseph Wilson – and more recent painters like James Howard Burgess, Andrew Nicholl and Dr James Moore. Enlivening the local aspect of the exhibition was a large collection of paintings by members of the Ramblers' Sketching Club, comprising 197 works by well-known and not so well-known figures, mainly amateurs, in the local art world. Overall, there was probably something to please everyone, from the connoisseur of high art to the visitor more interested in scenes of local places, the productions of the students of the School of Art or local history and antiquities.

The show, in fact, was the largest and most successful art exhibition held in Belfast by that point. Five days after the event opened to the public, over 32,000 visitors had attended.[81] Such was the exhibition's popularity that by the beginning of November, the library committee requested the owners' permission to keep the works until the end of the month.[82] This was agreed. However, an attempt to retain the exhibition until after the Christmas holidays, as 'an intellectual and aesthetic feast' for the working population, failed to come about, as a number of owners were unwilling to extend the period of their loans.[83] By 29 November – two days before the closing date – 99,067 persons had visited the show, an extremely impressive figure for Belfast even by today's standards.[84] Only the 1876 Industrial Exhibition had exceeded this, with 102,000 visitors, including children, within the space of two and a half months. That event, however, had not been dedicated solely to art but had contained a multiplicity of other attractions. Whilst the figure of some 99,000 within a period of one and a half months is noteworthy in itself, it is even more so given the fact that the population of the city in 1891 was 256,000.[85] If the population was about 235,000 in 1888, such visitor numbers indicate a very high turnout indeed, even allowing for return trips by season ticket holders and visitors from out of town. These attendance figures were regarded by the *Northern Whig* as 'good encouragement for the project of establishing a permanent collection, without which Belfast's newly-acquired title is incomplete'.[86]

Exceptionally, the newspaper was somewhat out of touch on this point, as six works towards a permanent collection had already been acquired by donation since the summer of 1886, beginning with a portrait of *Gordon Augustus Thomson* by Thomas Flintoff, received by the mayor for the free public library, art gallery and museum in the summer of that year.[87] Amongst the five other pieces were sculptures of *Commerce* and *Agriculture* by Emma Stebbins, presented by R.G. Dunville by July 1887 and retained by the library, where they can still be seen.[88] Perhaps encouraged by the success of the exhibition, a few other local people donated works by early December, bringing

the total number of acquisitions to ten by the end of 1888 – a small beginning to the city's municipal collection.[89]

Besides underlining how popular art exhibitions had become in Belfast, the show also revealed the identity of a number of local collectors, a particularly useful piece of information as few buyers' names were ever recorded in press reports of local auctions. From the exhibition catalogue it is possible to pinpoint several owners of sizeable holdings, such as Lavens M. Ewart, who lent fifty-five paintings and engravings; Sir Charles Lanyon, who lent sixteen works; William H. Patterson, twenty-seven; James Thompson of Macedon, thirty-five and Gustav Wilhelm Wolff, fifteen. These owners and, indeed, almost all of the 108 persons who lent, were from the professional and merchant classes. Of the almost 800 exhibits on display, about 500 were owned by these individuals. Whilst a number of their works were family portraits and Old Masters, many were by contemporary artists. Considering the lively nature of the Belfast art trade, it seems probable that numbers of these contemporary paintings had been purchased locally. Although mystery, therefore, still surrounds the buyers at the town's numerous art sales down the years, it nevertheless seems reasonable to assume that the lenders to the exhibition – and many more from the same sector of Belfast society – were amongst the nameless patrons of the fine arts in town.

The ending of the exhibition was greeted with regret in many quarters, according to the *Northern Whig*, which itself expressed 'a feeling akin to sorrow' in one of its editorials and maintained that 'the closing … will leave a melancholy blank in the building itself and in our far-too-limited list of local places of intellectual entertainment'.[90] The same newspaper also concluded 'it [was] certainly a pity to have a large portion of the building unoccupied', a sentiment shared by William Gray, who had already begun calling for a loan of applied art from South Kensington.[91] The process of obtaining this and the ramification of the transaction was to lead to official recognition of the space as the Belfast Art Gallery and Museum in 1890. Gray, assiduous as ever in the cause of art, was to be one of the loudest voices in the period leading up to the institution's establishment.

# ～ 11 ～

# The establishment of the Belfast Art Gallery and Museum

## 1889–90

*'We may congratulate ourselves … that we have at last what must be a permanent public museum, and let us hope that the wealthy citizens will make it worthy of the city; and the collection now on view … is a promising earnest of future success'*[1]

As to filling the empty art galleries with a loan from South Kensington, the city council evinced a marked lack of urgency over the next eighteen months or so, much to William Gray's disgust. It was, indeed, Gray who had first suggested the loan when serving on the exhibition's selection committee in September 1888 – furthermore, he had even obtained a loan application form for the mayor.[2] Though dismissive of Gray's proposal, the library committee paid greater heed when George Trobridge, headmaster of the School of Art, made a similar suggestion a few months later.[3] This change in the committee's attitude is easily explained: Trobridge was a figure of considerable standing within the community, a person to be listened to, whilst Gray, with his constant haranguing on the subject of the library, art gallery and museum, was an irritating nuisance. The committee thereupon requested some of its members, in company with the mayor and Trobridge, to pursue the matter further.

To help fill the galleries, the committee permitted the holding of two events during the first few months of 1889: a display of photographs by the Ulster Amateur Photographic Society and an exhibition

of paintings and drawings by students of the School of Art.[4] Such piecemeal solutions infuriated Gray, who fired off angry letters to the *Northern Whig* during the shows, complaining about the committee's lack of progress with the loan.[5] 'I cannot understand', he grumbled in late March, 'why the Town Council will not procure for us the collection of art objects South Kensington is willing to send and fill the rooms we have procured at such cost and that have been vacant for months'.[6] His criticism may have helped spur the committee into action for, on 24 April (1889), it finally submitted the loan application.[7] The lending body, the Department of Science and Art, responded on 8 June, stating that it had placed the library, art gallery and museum on its list of provincial museums entitled to annual loans from its holdings, 'provided that further efforts are made to increase the Corporation's [council's] own collection … one of the conditions under which objects are lent … is that they are supplemental to other contributions'.[8]

Thus obligated, the committee embarked upon a policy of purchasing works for the collection, by means of a grant of £500 from the council and a similar amount from the Department.[9] This was a new area for the committee and one for which it was little qualified. Fortunately, one of the conditions of the Department's funding was that a South Kensington curator advise on the selection of the acquisitions.[10] Accordingly, the mayor and town clerk, together with the curator, paid a visit to Paris in November and chose a number of copies of nineteenth-century French bronzes.[11] The latter official also assisted with the purchase of a few copies of Antique Greek bronzes from a dealer in Naples the following month.[12] In addition to these, four more paintings were donated between August 1889 and March 1890, one of which was the portrait of Robert Langtry by Samuel Hawksett (Fig. 18), discussed in Chapter Two.[13] By the spring of 1890, therefore, the collection comprised a few portraits of local worthies, two Belfast scenes, a seascape and a variety of sculpture, including a bust of the queen by Sir Joseph Edgar Boehm.

Despite this progress made between April 1889 and April 1890 – the application for the loan and the first steps towards a municipal collection – the committee felt little compunction to keep the public informed of what it was doing, so much so that Gray, during the same period, was compelled to send a number of letters to the *Northern Whig*, demanding to know what was happening and asking when the art gallery and museum was expected to open.[14] Behind his continued letter writing lay deep frustration at the committee's somewhat cavalier attitude towards the supporters of the library, art gallery and museum movement, who had striven so long for the completion of the project.

Events took a more positive turn at the beginning of May 1890, when it was announced in the press that a curator, James F. Johnson, had been appointed to take charge of the future art gallery and museum.[15] (This news appears to have mollified Gray as he ceased sending angry letters to the *Whig*.) At the beginning of July the loan finally arrived and on the sixteenth of the month, the Belfast Art Gallery and Museum was officially opened. Unlike the fanfare that had attended the inauguration of the library in October 1888, there was little formal celebration on this occasion. Indeed, so low-key was the opening that the *Belfast News-Letter* and *Northern Whig* seemed not to appreciate the true significance of the day, with the former referring to it simply as an exhibition of works of art and the latter merely as the opening of the South Kensington loan collection.[16] Only the *Belfast Evening Telegraph* seemed to grasp the real meaning of the occasion, with a headline which proclaimed the new art gallery and an opening paragraph which highlighted the importance of the event.[17]

The inaugural ceremony was brief and to the point, with one of the high spots of the proceedings being the donation by local solicitor and art patron Edward Allworthy of a painting to add to the collection, namely, *The Slave* by Robert Parker.[18] The speeches appear to have been kept to a minimum, according to press reports. Allworthy spoke concerning his donation, then Sir David Taylor, presiding for the mayor, responded with a short statement, expressing the committee's thanks for the gift and declaring the exhibition open.[19] The town clerk thereupon supplied details of the institution's opening hours and Gray, fittingly, brought the occasion to a close by congratulating the committee on the success of its labours and the mounting of the exhibition. He also expressed hope that Allworthy's donation would be the precursor of many more from the citizens of Belfast and that they and the committee would work together, to ensure that the full benefit of the Public Libraries (Ireland) Act of 1855 might be reaped. This comment on working together was almost certainly an allusion to a composite committee, that is, one comprising council and non-council members, the necessity of which he had been advocating for years. (Ironically, when co-opted members were admitted, he failed to be elected.)[20]

Of the contents of the new institution, the central of the three galleries was given over to the sculptures that the committee had purchased with South Kensington's help. In addition to these, the gallery contained the contemporary works by Albert Bruce-Joy and Samuel Ferres Lynn which had been acquired by donation.[21] The second, smaller room also comprised items bought by the committee, namely, copies of Antique sculptures and reproductions of Dutch, German and Italian metalwork, armour and coins. The third and

largest gallery held the South Kensington loan, which consisted of cases of specimens of the applied arts of Britain, Europe and the Orient. Included were examples of goldsmiths' work, embroidered fabrics, enamelware, porcelain, pottery and glass. Around the walls were a large number of oil paintings lent by the Earl of Kilmorey, including the thirty-six already seen in the opening art exhibition of 1888. These latter included family portraits by Gainsborough and Hyacinthe Rigaud, portraits of unknown sitters by Sir Godfrey Kneller and Sir Peter Lely, and landscapes by Nicolaes Berchem and Richard Wilson. Overall, therefore, the fledgling art gallery and museum contained a fair range of paintings and applied art and a useful collection of sculptures, albeit mainly reproductions.

The day after the inauguration and obviously annoyed by the lack of ceremonial, Gray fired off yet another letter to the *Northern Whig*, clarifying the true significance of the occasion: 'The very unpretending ceremony … was but an extremely feeble recognition of the important event – namely, the opening of our permanent art gallery and museum.'[22] The loan from South Kensington was only in Belfast, he explained, because the municipal authorities had resolved to have an art gallery and museum and only because of this could it be retained for a year and renewed. In stating thus, he placed the importance of the occasion back where it belonged – on the provision of the art gallery and museum and not on the exhibition itself, as the committee had done. Nevertheless, despite his rancour, he ended his letter on an optimistic note: 'let us hope that the wealthy citizens will make it [the art gallery and museum] worthy of the city; and the collection now on view … is a promising earnest of future success'.[23]

The art gallery and museum remained on the top floor of the library and also utilised space at the rear of the building and in the old College Square North museum until 1929, when a purpose-built museum and art gallery was opened on the Stranmillis Road.[24] By this stage the collections had grown enormously, both with works of fine and applied art and also with specimens of archaeology, local history and natural history. The institution continued as the Belfast Museum and Art Gallery until 1962, when it was removed from the care of Belfast Corporation and became a national museum, with government funding and the new title of Ulster Museum. A large, modern extension was subsequently added to the building and was officially opened on 30 October 1972. Since then, the Ulster Museum has expanded on the role of its predecessor and become an even more important part of the community, through its ever increasing collections, lively exhibition programme and educational services. In 1998 it was amalgamated with the Ulster Folk and Transport Museum

and the Ulster American Folk Park as the National Museums and Galleries of Northern Ireland. As such, the new institution heads into this new century a worthy successor to that which went before, having more than fulfilled Gray's hopes of future success.

# Afterword

The over-arching conclusion to be drawn from this study of the art world of Belfast between 1760 and 1888 is the symbiosis between socio-economic developments and art developments. The small mercantile town of the late eighteenth century had supported only three resident artists, whose patrons demanded little else but portraiture, either purely for posterity or partly for political reasons, as with the Volunteer images produced. By the mid-1830s, by which point the population reached over 50,000, the expansion of the middle ranks, together with a period of remarkable industrial and commercial growth, led to the acquisition of art as luxury by those with money to spend. It is no mere coincidence that the first thirty years of the nineteenth century saw the development of landscape painting in the town, in the careers of Hugh Frazer and Andrew Nicholl. Both produced pleasing views of local scenery, the ideal decoration for middle-class homes.

Concurrent with this production of landscape art by resident artists, the town saw the beginning of a commercial art market. Here again, the middle ranks' growing desire for refinement and culture was behind the demand which led to this supply. Visits by dealers from elsewhere, with large collections of paintings and engravings, became a common occurrence by the mid-1830s, as did also the holding of art auctions by Hyndman, the main auctioneer in town. This trend became an established pattern by the early 1850s, by which stage a number of other auctioneers were competing with Hyndman and each other in the sale of art. By this point the population stood at over 87,000 and the foundations of future industrial might had been laid by the establishment of iron shipbuilding on the Queen's Island.

Parallel with this thriving art trade of the 1830s to the 1850s was the failure by locally organised exhibiting societies and exhibitions to reach the level of patronage accorded to the commercial art sector. Part of the reason for this appears to have lain in the lack of a well-appointed art gallery, where not only art collectors, but also those with social aspirations, could meet. Such a centre did not materialise until the 1860s with the opening of Marcus Ward's gallery, a prestigious venue where connoisseur and social climber could gather in a pursuit

that was regarded as cultured and refined. The fact that numbers of the town's wealthier middle ranks flocked to support Ward's first large exhibition in 1866, when the firm began publishing the names of the show's patrons in its advertisements, bears out this point. It is worthy of note that this decade saw the beginning of Belfast's massive expansion, particularly with linen. Thus, there was much money around in the 1860s and a growing middle class anxious to acquire the trappings of refinement. The purchase of art and the appearance of connoisseurship partly answered this urge. Thereafter, from this seminal decade, the middle ranks played a greater role in the art world of the town, through patronage of exhibitions (albeit in the commercial sector) and by involvement in movements designed to improve the lot of the labouring population.

In the field of art education, the growth of industrialisation was a major factor in the establishment of the School of Design of 1849–58 and thereafter with the School of Art of 1870. Both institutions were founded primarily for the training of skilled designers for the linen industry and both were set up by professionals, academics and persons involved in the trade. That the first one failed and the second survived was partly the result of changed attitudes by the middle ranks to the worth of art, which had arisen during the second half of the 1860s. It also stemmed partly from growing middle-class realisation of the moral value of education, including art training, for the working population. The lack of art education facilities, together with a dearth of amenities for the mental stimulation of the labouring classes, were to be highly important factors in developments in art and education from 1870.

The influence of industry was also behind the three major art exhibitions of the 1870s, namely, the art sections of the industrial exhibitions of 1870, 1871–72 and 1876. Organised by the middle ranks to display the town's industrial prowess, stimulate local industry and raise funds for the Working Men's Institute and Temperance Hall, the art sections were included to add interest and an educational content to the displays. Whilst the exhibitions themselves may have helped promote local industry and the industrial exhibits may have been of interest to many, particularly the labouring population – it was the art sections which proved to be the most popular of all. This convinced the organisers of the 1876 event and probably many others, of the necessity for a municipal art gallery. The knowledge of this may have helped to reinforce the subsequent call for a gallery within the free public library scheme.

By 1881 the labouring population stood at about 75,000 people. It was for their needs that the free public library movement had come about and it was for their benefit that an art gallery and museum

thereafter also became part of the overall library project. All three concepts – library, art gallery and museum – were promoted in the spirit of rational recreation by the town's middle ranks, to help educate and morally improve this large sector of Belfast society. The opening of the library in 1888 and, two years later, the art gallery and museum, stemmed largely from this philanthropic impulse. The establishment of these amenities and the various other instances cited above, are indications that socio-economic developments and art developments in Belfast were closely interlinked and strongly dependent upon each other.

Of actual artistic activity, the most important conclusion is the fact that although the town supported only a small number of resident artists – eight major figures in all between 1760 and 1888, namely, Strickland Lowry, Joseph Wilson, Thomas Robinson, Hugh Frazer, Andrew Nicholl, Samuel Hawksett, Richard Hooke and James Howard Burgess – it was nevertheless not a cultural desert. On the contrary, it was home to an increasingly large amount of good quality art, through a flourishing trade in the sale of art. The extent of the art market through auctions has been alluded to above, in relation to the period before the 1850s. During the next forty years this market expanded considerably, as the number of auctions increased and more auctioneering firms were established. Old Masters, many of them perhaps doubtful, contemporary British and Continental paintings and watercolours and engravings from many periods and schools – passed through the salerooms in massive quantities. Many were exhibited in pre-sale previews, a situation which may have gone some way towards alleviating the lack of a municipal art gallery. Meritorious art *could* therefore be seen in Belfast, albeit not in a town-supported art space.

Aside from auction houses, the main agents in the placing of high quality art before the Belfast public were the printsellers' shops of John and Robert Hodgson and James Magill and the commercial galleries of Marcus Ward and William Rodman. The one-picture exhibitions which these businesses mounted to help promote engravings of the originals, brought many famous paintings to the town, a number of which have since become icons of Victorian art – works such as *The Derby Day* and *The Monarch of the Glen*. That art lovers were enabled to see works like these, many known from the pages of the *Art-Union* and *Art-Journal*, must surely have been a considerable stimulant. It may also have fuelled their desire to add to their own collections, perhaps through the town's numerous auctions. The large exhibitions at Ward's from 1866 and at Rodman's from 1877 also enabled the Belfast public to see a wide range of good quality works by reputable artists. Thus, from moderate beginnings in the 1760s, Belfast had

established itself firmly over the years as a lively and flourishing centre of art.

Of the various other themes contained within this study, the establishment of the School of Design of 1849–58, the School of Art of 1870, the Free Public Library and the Belfast Art Gallery and Museum have played a large part. The most notable feature of their foundation is not that they came about, but that they were initiated by leaders *other* than the town's elected leaders. It was persons outside the hallowed walls of the council chamber who caused them to be – figures such as Lord Dufferin in the 1850s and William Gray, Francis Davis Ward and Robert Young in the 1870s and 1880s. These latter three and many others working towards the same end were from the middle ranks. Thus this grouping within Belfast society contributed much to the community, in the foundation of these amenities.

With the wealthier end of the same sector, it was a different story. Those who could be termed 'merchant princes', figures in the business community such as Sir Edward Harland, James Alexander Henderson and Sir James Musgrave did little to forward the cause of art. Whilst they were involved in the School of Art, they contributed little to it in time or money, as discussed in Chapter Eight. Although they certainly possessed generous impulses – Henderson, for example, was a firm supporter of the Working Men's Institute and Temperance Hall and Musgrave was a benefactor of Queen's College – they stopped short when it came to serious commitment to art institutions. No gentleman 'of large heart and purse' to quote the *Belfast News-Letter* of 2 February 1883 – and there were many with the latter – ever came forward with offers of financial assistance towards the erection of an art gallery or museum. Had someone taken the lead, others might have followed. That this did not happen is a sad reflection of Belfast's wealthier ranks.

# Notes

## CHAPTER ONE

1. Martha McTier's comments on Belfast to Dr William Drennan, 1784; see Jean Agnew (ed.), *The Drennan-McTier Letters 1776–1793* (Dublin: The Women's History Project/Irish Manuscripts Commission, 1998), p.179.
2. For a history of the fine arts in Ireland, see Anne Crookshank and The Knight of Glin, *The Painters of Ireland c. 1660–1920* (London: Barrie & Jenkins, 1978).
3. Jane Fenlon, 'The Painter Stainers Companies of Dublin and London, Craftsmen and Artists 1670–1740', in Jane Fenlon, Nicola Figgis and Catherine Marshall (eds), *New Perspectives: Studies in Art History in Honour of Anne Crookshank* (Dublin: Irish Academic Press, 1987), p.101.
4. James Meenan and Desmond Clarke (eds), *The Royal Dublin Society 1731–1981* (Dublin: Gill & Macmillan, 1981), p.1.
5. John Turpin, *A School of Art in Dublin since the Eighteenth Century* (Dublin: Gill & Macmillan, 1995), pp.7–8, 43, 55.
6. See George Breeze, *Society of Artists in Ireland: Index of Exhibits, 1765–80* (Dublin: National Gallery of Ireland, 1985).
7. For the development of art in Ulster, see John Hewitt and Theo Snoddy, *Art in Ulster: 1* (Belfast: Blackstaff Press, 1977).
8. For a useful history of Belfast from its earliest times to the early 1980s, see Jonathan Bardon, *Belfast: An Illustrated History* (Belfast: The Blackstaff Press, 1982). Also W.A. Maguire, *Belfast* (Keele: Ryburn Publishing, Keele University Press, 1993), which covers the period 1603–1993.
9. J.C. Beckett, 'Belfast to the End of the Eighteenth Century', in J.C. Beckett *et al.*, *Belfast: The Making of the City* (Belfast: Appletree Press, 1983), pp.21–4.
10. Ibid., p.14; also Bardon, *Belfast: An Illustrated History*, pp.47–65.
11. W.H. Crawford, 'Economy and Society in Eighteenth-Century Ulster' (unpublished Ph.D. dissertation, The Queen's University of Belfast, 1982), p.162.
12. Beckett, 'Belfast to the End of the Eighteenth Century', pp.24–5.
13. Emily Boyle, 'Linenopolis: The Rise of the Textile Industry', in J.C. Beckett *et al.*, *Belfast: The Making of the City* (Belfast: Appletree Press, 1983), pp. 41–2.
14. W.P. Carey, *Some Memoirs of the Patronage and Progress of the Fine Arts in England and Ireland … with Anecdotes of Lord de Tabley* (London: Saunders and Ottley, 1826), p.179.
15. Fisher appears to have visited Belfast during his travels round the Carlingford area in the early 1770s, for an unpublished engraving by him, *View of Belfast from Cromac Wood*, is in the Ulster Museum. This seems to have been the only time he travelled round the north. For the other visiting artists mentioned, see *BNL*, 1–5 Sept. 1775, 3 Sept. 1802, 20 July 1804, 28 Feb. 1806, 18 Nov. 1808. See also Hewitt and Snoddy, *Art in Ulster: 1*, pp.178, 185–6. Nixon is known to have paid regular visits to Ireland, including the north, between 1782 and 1798. In 1786 he painted a view of High Street, Belfast; see W.A. Maguire, 'High Street, 1786, by John Nixon', text accompanying a Linen Hall Library reproduction, 1984.
16. *BNL*, 2–6 Oct. 1778, 12–16 Feb. 1790.
17. Eileen Black, *A Catalogue of the Permanent Collection: 3: Irish Oil Paintings, 1572–c. 1830* (Ulster Museum, 1991), pp.42–8.
18. For information on the Belfast Volunteers and radicals, see Bardon, *Belfast: An Illustrated History*, pp.47–65 and Jonathan Bardon, *A History of Ulster* (Belfast: The Blackstaff Press, 1992), pp.210–39. For a more in-depth account of events between 1782 and 1810, see R.B. McDowell, 'Parliamentary Independence, 1782–9'; also, 'The Age of the United Irishmen, Reform and Reaction, 1789–94' and 'The Age of the United Irishmen: Revolution and the Union, 1794–1800', all in T.W. Moody and W.E. Vaughan (eds), *A New History of Ireland: IV: Eighteenth-Century Ireland 1691–1800* (Oxford: Clarendon Press, 1986), pp.265–88, 289–338, 339–73.
19. Black, *A Catalogue of the Permanent Collection: 3*,

pp.99–105; Hewitt and Snoddy, *Art in Ulster: 1*, pp.7–9, 190–1.

20. See George Benn, *History of Belfast* (London: Marcus Ward & Co., 1877), p.755.

21. S. Shannon Millin, *Sidelights on Belfast History* (Belfast and London: W. & G. Baird, Ltd., 1932), p.171.

22. Wilson drew Amyas Griffith and published the drawing as an engraving in 1786. The latter was used as a frontispiece to Griffith's *Miscellaneous Tracts* (Dublin: W. Corbet, B. Dornin and J. Mehain, 1789). For information on Griffith and the lodge, see Aiken McClelland, 'Amyas Griffith', *Irish Booklore*, 2, 1 (Spring 1972), pp.6–21.

23. The miniaturists were Gustavus Hamilton in 1775, a few anonymous gentlemen in 1777, Mrs John Collins in 1781, Mr Williams in 1783 and George Madden in 1792 (*BNL*, 1–5 Sept. 1775, 10–14 Oct. 1777, 18–22 May 1781, 17–20 June 1783, 20–24 Jan. 1792).

24. His death notice in the *BNL* of 12–15 March 1793 describes him as a portrait and landscape painter.

25. Ibid.

26. Black, *A Catalogue of the Permanent Collection: 3*, pp.59–64; Hewitt and Snoddy, *Art in Ulster: 1*, pp.12–15, 181–2.

27. See E.R.R. Green, 'Thomas Percy in Ireland', *Ulster Folklife*, 15–16 (1970), pp.224–32 for Percy's life in Ireland.

28. Robinson's reference to his youthful poetic ambitions appears in the Percy-Robinson papers, Houghton Library, MS. Eng. 734.3 (1). One of his poems, verses to a young lady, was published in the *Belfast Monthly Magazine*, vol. 1, part 1 (1808), pp.373–4.

29. For example, he alluded to and praised two works by Robinson, namely, *The Battle of Ballynahinch* (1798) and *The Giant's Causeway from the West* (1801) in a letter he published on the Causeway, under the initials 'A.B.', in the *Belfast News-Letter* of 23 March 1802. The letter and accompanying comments on the Causeway by naturalists appeared in *The Gentleman's Magazine*, May 1802, pp.387–8.

30. The aim of the book was to preserve the 13-year-old Thomas Romney Robinson's writings for posterity and to use the money from the book's subscriptions and sales to help educate the young poet at Trinity College, Dublin. See a letter from Dr William Bruce to Dr William Drennan, PRONI D456/17.

31. Drawings by Robinson, of features in the garden at Dromore, are in the History department of the Ulster Museum. In 1799, Robinson's wife presented Percy and his wife with a wooden obelisk and urns, painted in *trompe l'œil* by Robinson, and also a wooden bust of Mrs Percy. See Bertram H. Davis, *Thomas Percy: A Scholar-Cleric in the Age of Johnson* (Pennsylvania: University of Pennsylvania Press, 1989), p.310.

32. *BNL*, 6, 13 Nov. 1798. Art sales and art auctions were also held in the Assembly Rooms. The earliest sale noted by the author was held on 22 Jan. 1813 (*BNL*, 22 Jan. 1813).

33. For useful details on the painting, see W.A. Maguire, *Up in Arms: The 1798 Rebellion in Ireland: A Bicentenary Exhibition*, Ulster Museum, 1998, pp.245–9.

34. The two other portraits are head-and-shoulders size. One is in the Ulster Museum, the other in Belfast Harbour Office.

35. The poem was included in Thomas Romney Robinson, *Juvenile Poems* (Belfast: J. Smyth & D. Lyons, 1806), p.10.

36. A.P.W. Malcomson (ed.), *The Extraordinary Career of The 2nd Earl of Massereene, 1743–1805* (Belfast: HMSO, 1972), p.114.

37. Percy-Robinson papers, Houghton Library, MS. Eng. 734.3 (13). Robinson, writing to Bishop Percy, stated that he had painted two 'fine pictures' for the earl, for which he had received eighty-two guineas.

38. Ibid., MS. Eng. 734.3 (14). Tom, the elder of Robinson's two sons and the centre of his father's existence, appears to have been cherished and respected by all three of Robinson's major patrons, namely, Bishop Percy, William Ritchie and the Earl of Massereene. Robinson seems to have treated him as an adult, rather than as a child.

39. Vol. LXXV (1805), part i; Malcomson, *The Extraordinary Career of The 2nd Earl of Massereene, 1743–1805*, pp.111–14.

40. His drawing school opened on 1 Aug. 1804 (Percy-Robinson papers, Houghton Library, MS. Eng. 734.3 (14) and remained in operation during 1805 (*BNL*, 1 Jan. 1805). There is no further information concerning it.

41. Eileen Black, *Paintings, Sculptures and Bronzes in the Collection of The Belfast Harbour Commissioners*, Ulster Museum, 1983 (Belfast Harbour Commissioners, 1983), pp.37–8, 97.

42. Percy-Robinson papers, Houghton Library, MS. Eng. 734. 3 (15).

43. A key to the painting is reproduced in Black, *Paintings, Sculptures and Bronzes in the Collection of The Belfast Harbour Commissioners*, p.97. Of the forty-four main figures, seven remain unidenti-

fied. Dr William Drennan's portrait was originally included and was said in the *BNL* of 31 July 1807 to be positioned in the group comprising Dr and Mrs William Bruce, Mrs Narcissus Batt, Miss Lyle and John Sinclaire. According to the Drennan letters, PRONI T765/1/1311, Martha McTier, on her visit to Robinson in February 1807, agreed to lend Robert Home's portrait of Drennan to the artist, to enable him to take a likeness. Robinson promised to remove the image if Drennan did not approve. This appears to have happened for Drennan's portrait is no longer there. It was perhaps deleted in 1809 when the picture was exhibited in Dublin. In the Drennan letter referred to above, Martha McTier hinted that Drennan would have felt unease at being included in a painting which depicted Yeomanry.

44. D.A. Chart (ed.), *The Drennan Letters* (Belfast: HMSO, 1931), p.375.
45. W.A. Maguire, *Living like a Lord: The Second Marquis of Donegall 1769–1844* (Belfast: Appletree Press, 1984), p.32.
46. *BNL*, 24 Feb. 1807.
47. Ibid., 31 July, 14 Aug., 28 Aug. 1807.
48. Chart, *The Drennan Letters*, p.375.
49. *BNL*, 25–28 June, 6–10 Sept. 1782.
50. Ibid., 30 Nov. 1804.
51. Ibid., 18 Oct. 1805, 18 Nov. 1808.
52. Ibid., 19–22 Sept. 1786.
53. Ibid., 21–25 Sept. 1787.
54. Ibid., 15 July 1766.
55. Ibid., 6 Nov. 1807, 25 March 1808, 10 March 1809.
56. Ralph Hyde, *Panoramania!* (London: Trefoil Publications Ltd., 1988), pp.13, 208.
57. Ibid., p.21.
58. Ibid., pp.36–42.
59. Panoramas, as dioramas (moving panoramas with sophisticated lighting effects) remained a popular form of entertainment in Belfast as late as 1886. *Zealandia*, a diorama of New Zealand, was in the Victoria Hall from 24 Dec. 1885 until after 27 Jan. 1886 (*NW*, 19 Dec. 1885; *BNL*, 27 Jan. 1886). For information on dioramas, see Hyde, *Panoramania!*, pp.109–24.
60. *BNL*, 16 Feb., 16 March 1798.
61. Ibid., 11 May 1798.
62. Ibid., 7 May 1802.
63. See Hyde, *Panoramania!*, p.65 for fuller details.
64. *BNL*, 13 Aug. 1802.
65. There were only five paintings in the drawing room of Donegall House in 1803 and six prints in one of its small rooms. There are, however, no details given of the works (Donegall papers, PRONI D509/1517).

CHAPTER TWO

1. Jonathan Bardon, *Belfast: An Illustrated History* (Belfast: The Blackstaff Press, 1982), pp.66–70; W.A. Maguire, *Belfast* (Keele: Ryburn Publishing, Keele University Press, 1993), pp.34–41.
2. Bardon, *Belfast: An Illustrated History*, pp.83–4; John Jamieson, *The History of the Royal Belfast Academical Institution 1810–1960* (Belfast: William Mullan and Son, 1959), pp.1–2.
3. Maguire, *Belfast*, p.55.
4. Jamieson, *The History of the Royal Belfast Academical Institution*, pp.83–5.
5. It closed in 1870, when the School of Art was established in the north wing of the Institution. Pupils at the Institution who wished to have art instruction thereafter obtained it at the School of Art (ibid., p.103).
6. *BNL*, 25 Oct. 1811; Royal Belfast Academical Institution papers (RBAI), PRONI SCH 524/7B/70/1, 11.
7. See also John Hewitt and Theo Snoddy, *Art in Ulster: 1* (Belfast: Blackstaff Press, 1977), pp.157–8 for biographical details of Fabbrini.
8. RBAI papers, PRONI SCH 524/7B/9/18.
9. Ibid., SCH 524/7B/70/19.
10. *An Account of the System of Education in the Belfast Academical Institution* (Belfast: Joseph Smyth, 1818), Hyndman archive, History department, Ulster Museum.
11. RBAI papers, PRONI SCH 524/7B/70/29, 31; Jamieson, *The History of the Royal Belfast Academical Institution*, p.84.
12. Amongst his accusations, he claimed that Dr Henry Montgomery had flogged two boys, one of them severely. He also stated that a young woman had been smuggled in, to teach the boarders dancing (RBAI papers, PRONI SCH 524/7B/70/38).
13. RBAI papers, PRONI SCH 524/7B/14/19; SCH 524/7B/70/48.
14. Ibid., PRONI SCH 524/7B/14/43.
15. Ibid., PRONI SCH 524/7B/14/24, 28.
16. *BNL*, 2 Feb. 1821, 28 March 1826.
17. John Ford, *Ackermann 1783–1983: The Business of Art* (London: Ackermann, 1983), pp.61–4.
18. RBAI papers, PRONI SCH 524/7B/24/28.
19. Ibid. Molloy was appointed on 22 June.
20. *BCC*, 27 Dec. 1843.
21. *The Irishman*, 2 Feb. 1821.
22. *NW*, 21 May 1832.
23. Ibid., 1 Aug. 1836.
24. *NW*, 7 March 1839; see also Quentin Bell, *The Schools of Design* (London: Routledge and Kegan Paul, 1963).

25. Quotation from a handbill issued by Fabbrini, dated 5 Sept. 1847, History department, Ulster Museum. For the School of Design, see Chapter Four.
26. *BCC*, 4 Dec. 1848; *NW*, 26 July 1849.
27. *BNL*, 15 Dec. 1820.
28. Ibid., 5 Sept. 1820.
29. Ibid., 3 April 1821.
30. *BNL*, 14 April 1826; also *NW*, 9 Feb. 1832.
31. Robert Young, 'Recollections of a Monogenerean', unpublished MS., c. 1906–07, Linen Hall Library, p.68. Young stated that Giles' Academy was in Fountain Street in 1832, p.65; however, in that year it was at 6, Castle Place. It was located at 38, Fountain Street in 1835 (*NW*, 19 Nov. 1835).
32. Young, 'Recollections of a Monogenerean', p.69.
33. *NW*, 3, 6 Nov. 1834.
34. Ibid., 13 Nov. 1834. Campbell planned to repeat the lecture but no record of his having done so has been found in the press.
35. *BNL*, 6 March 1835. As an example of his writing, a letter to his pupils in Dunfermline, on the principles of drawing and painting, was published in Belfast as a pamphlet in December 1834. Part of it appeared in the *BNL* of 26 Dec. 1834.
36. *NW*, 9 March 1835.
37. The mummy is in the Antiquities department of the Ulster Museum.
38. For details of the lectures, see W.P. Carey. *Observations on the Primary Object of the British Institution and of the Provincial Institutions for the Promotion of the Fine Arts* (Newcastle: T. & J. Hodgson, 1829).
39. The Dublin lectures were held 4–14 June (1828). Carey gave the same lecture series in Leeds, November–December 1827; Glasgow, November 1828; Edinburgh, February 1829; Dundee and Aberdeen, April 1829; Perth, July 1829; Newcastle-upon-Tyne, August–September 1829; Sunderland, October–November 1829.
40. Carey, *Observations on the Primary Object of the British Institution*; *BNL*, 9 Sept. 1828. Carey had been invited by the Dublin Society in January 1828 to give his lecture series but the matter had then been dropped, presumably because of his engagement with the Royal Irish Institution (Carey, *Observations*; also *Royal Dublin Society Proceedings*, vol.64–5, pp.73–4, 89).
41. *BNL*, 9 Sept. 1828.
42. Ibid.
43. Tennent papers, PRONI D1748/B/1/47/1-3. This source reveals that Carey was in Belfast by 4 August.
44. W.A. Maguire, 'Banker and Absentee Landowner:

William Tennent in County Fermanagh, 1813–32', *Clogher Record*, XIV, 3 (1993), pp.8–11.
45. Tennent papers, PRONI D1748/B/47/2.
46. See PRONI D1748/B/3/4/1–8 for details of the contents of Tennent's library.
47. See Eileen Black, *A Catalogue of the Permanent Collection: 3: Irish Oil Paintings, 1572–c. 1830* (Ulster Museum, 1991), pp.6–10.
48. *BNL*, 3 July 1818.
49. Ibid., 12 Feb. 1819.
50. The Downshire's subscriptions of £22.15.0 each were the highest, as far as is known. Batt gave £11.7.6, Tennent £5 (*BNL*, 12 Feb. 1819).
51. In a letter of 11 February 1819 to the Marquess of Downshire, Batt spoke of his enquiries regarding Atkins' travelling expenses to Italy and of his intention of calling a meeting of subscribers to finalise plans for the journey (Downshire papers, PRONI D671/C/38/26).
52. *NW*, 13 Jan. 1834.
53. Ibid., 25, 29 Dec. 1834. The exhibition was in a house at 8, Donegall Place.
54. Ibid., 25 Dec. 1834.
55. Henry Ley, 'Copy of Titian's Altarpiece at Queen's University', *The Queen's University Association Annual Record*, 1970–71, pp.56–7. The picture was presented to the college by Charles Davis, nephew of Atkins' brother-in-law, Hugh Davis (*NW*, 23 Aug. 1849; also Art department records, Ulster Museum).
56. *NW*, 30 March, 2 April 1835.
57. *NW*, 4 Nov. 1824; also Eileen Black, *Paintings, Sculptures and Bronzes in the Collection of The Belfast Harbour Commissioners*, Ulster Museum, 1983 (Belfast Harbour Commissioners, 1983), pp.20–1.
58. Eileen Black, *A Catalogue of the Permanent Collection: 4: Irish Oil Paintings, 1831–1900* (Ulster Museum, 1997), pp.27–30.
59. *BNL*, 13, 27 Jan. 1824.
60. *BNL*, 5 Nov. 1824; also Hewitt and Snoddy, *Art in Ulster: 1*, p.161.
61. Black, *Paintings, Sculptures and Bronzes in the Collection of The Belfast Harbour Commissioners*, pp.20–1; RBAI papers, PRONI SCH 524/3A/1/ 4-5, SCH 524/7B/73/1-4, SCH 524/7B/34/21.
62. *BNL*, 10 Nov. 1835.
63. He exhibited locally during 1842 and 1843. An engraving of his portrait of Rev. Hugh McNeill, Dean of Ripon, by Thomas Lupton, was exhibited at Lamont's, Donegall Place in June 1845 (*BCC*, 23 June 1845). The work had apparently been painted in 1844 (*BCC*, 2 July 1845).
64. Black, *A Catalogue of the Permanent Collection: 3*,

pp.26–8; Hewitt and Snoddy, *Art in Ulster: 1*, p.159.

65. *BNL*, 4 Oct. 1825. Copies of the essay are in the Art department of the Ulster Museum and in the National Library of Ireland.

66. Quotation from Hugh Frazer, *Essay on Painting* (Belfast: M. Jellett and Dublin: James Burnside, 1825), p.23.

67. *NW*, 13 Sept. 1827.

68. RBAI papers, PRONI SCH 524/7B/24/13.

69. The Institution's drawing school already owned a few works of art prior to Frazer's suggestion of May 1830. Two busts of Antonio and Sappho had been acquired by July 1817 (RBAI papers, PRONI SCH 524/7B/15/7/b-c). In April 1830 Besaucele offered the school two busts of Venus and Paris, after Canova, which were probably accepted (ibid., SCH 524/7B/24/12). All told, by July 1830 the school had seven busts and five figures, one oil painting and three copies (ibid., SCH 524/7B/24/27).

70. Ibid., SCH 524/7B/24/13.

71. *NW*, 15 May 1834.

72. Ibid., 9 June 1834.

73. Ibid., 23 June 1834.

74. See Martyn Anglesea, *Andrew Nicholl 1804–1886*, Ulster Museum, 1973 and 'Andrew Nicholl and his Patrons in Ireland and Ceylon', *Studies*, (Summer 1982), pp.130–51; Ronald Adams, 'Andrew Nicholl', *Irish Arts Review*, 1, 4 (Winter 1984), pp.29–34; Anne Crookshank and The Knight of Glin, *The Watercolours of Ireland: Works on Paper in Pencil, Pastel and Paint c. 1600–1914* (London: Barrie & Jenkins, 1994), pp.166–9.

75. A small selection of the views is included in *Andrew Nicholl's Paintings of the Antrim Coast in 1828*, Glens of Antrim Historical Society (Belfast: The Universities Press Ltd., 1982) (introduction by Martyn Anglesea).

76. Adams, 'Andrew Nicholl', p.29.

77. Martyn Anglesea, *Portraits and Prospects: British and Irish Drawings and Watercolours from the Collection of the Ulster Museum* (Ulster Museum, 1989), p.78.

78. Crookshank and Glin, *The Watercolours of Ireland*, p.169.

79. *NW*, 24 June 1830.

80. *NW*, 11 July, 20 Sept., 7 Nov. 1831, 17 Sept. 1832, 19 Aug., 12 Sept. 1833, 16 June 1834, 28 Sept. 1835; *BNL*, 14 July 1864.

81. Anglesea, 'Andrew Nicholl and his Patrons in Ireland and Ceylon', pp.135–6; Adams, 'Andrew Nicholl', pp.31–2.

82. Hewitt and Snoddy, *Art in Ulster: 1*, p.176.

83. *BNL*, 28 Dec. 1827.

84. Black, *A Catalogue of the Permanent Collection: 4*, pp.54–5.

85. The volume was reprinted by the Linen Hall Library in 1983, with a modern commentary by Fred Heatley and Hugh Dixon.

86. Twenty-three of Molloy's watercolours for Proctor are in the History department of the Ulster Museum.

87. *BNL*, 18 July 1828.

88. Young, 'Recollections of a Monogenerean', pp.69–70.

89. The proposed building probably materialised as the Music Hall, built for the Anacreontic Society in 1839. Prior to that, the Society paid for and maintained a large upstairs room in the Belfast Savings Bank in King Street, completed in 1826. See C.E.B. Brett, *Buildings of Belfast 1700–1914* (revised ed., Belfast: The Friar's Bush Press, 1985), pp.21, 27.

90. One of the earliest galleries in Britain was the Dulwich Picture Gallery, a semi-private gallery erected between 1811 and 1813 to house the collection of art bequeathed to Dulwich College in the former year. National galleries and public picture galleries were not established until the 1820s, with the founding of the National Gallery in London in 1824 and the Royal Manchester Institution (later Manchester City Art gallery) in 1823. See Giles Waterfield (ed.), *Palaces of Art: Art Galleries in Britain 1790–1990*, Dulwich Picture Gallery and National Gallery of Scotland, 1991–92, *passim*.

91. The reason for this seemingly sensible suggestion not coming about remains unknown. However, given the failure of the Belfast Art Society in 1838 and the apparent disinterest by the community to support any kind of art venture, it is perhaps not surprising that the Anacreontic Society declined to take Finlay's idea further.

92. The new buildings the author referred to probably included the Commercial Buildings, erected in Waring Street in 1822 and the Georgian terraces in the area around Great George's Street. See Brett, *Buildings of Belfast 1700–1914*, pp.21, 27.

93. In Dublin, the Royal Hibernian Academy was established in 1823 and held its first exhibition three years later. Cork, however, was far in advance of the capital. There, in 1815, a number of artists and amateurs, encouraged by the success of the Royal Irish Institution in Dublin, held the first exhibition of the work of Munster artists. In February 1816 they set up the Cork Society for Promoting the Fine Arts. Three years later the

Prince Regent, patron of the society, presented it with a series of 115 casts of famous statues in Rome, which had been given to George III by the Pope – see W.G. Strickland, *A Dictionary of Irish Artists* (Dublin and London: Maunsel & Co., Ltd., 1913), vol.2, p.655. In Liverpool, the Academy, which held exhibitions of contemporary work, was re-established in 1810 and flourished for many years – see C.P. Darcy, *The Encouragement of the Fine Arts in Lancashire 1760–1860* (Manchester: The Chetham Society, 1976), pp.33–52. As regards Glasgow, the Glasgow Institution for Promoting and Encouraging the Fine Arts in the West of Scotland was set up in 1821 but expired after two or three exhibitions. The Dilettanti Society of Glasgow, established in 1825, held its first show in 1828 – see David and Francina Irwin, *Scottish Painters at Home and Abroad 1700–1900* (London: Faber and Faber, 1975), p.222.

94. *NW*, 23 Sept. 1833.
95. Frazer obviously gave much thought to the layout of the institute, judging by the detailed nature of his plan. There were to be three rooms, namely, a large room to house a drawing school, a smaller room designated as a sculpture gallery and modelling area and a room for the teaching of oil painting. Regarding materials, he undertook to provide oil paintings for the use of students in that particular department and also elementary instruction books, written by himself, for junior pupils.
96. Strickland, *A Dictionary of Irish Artists*, vol.2, p.606; S.B. Kennedy, 'Introduction', in Ann M. Stewart, *Irish Art Loan Exhibitions 1810–1960* (Dublin: Manton Publishing, 1990), pp.viii, xiii.
97. Besides the exhibitions of Old Masters, the Institution awarded prizes for paintings by artists resident in Ireland: £100 for the best historical or poetical composition, £50 for second best, £50 for the best landscape or sea piece and £50 for any other subject except portraiture (*Royal Irish Institution Catalogue*, 1814). This patronage came from money donated by subscribers to the Institution. In addition, the Institution gave timely practical help to the RHA by paying the £300 required to complete the process for its Deed of Charter in 1823 (Catherine de Courcy, 'The History of the Royal Hibernian Academy of Arts' in Ann M. Stewart, *Royal Hibernian Academy of Arts: Index of Exhibitors 1826–1979* (Dublin: Manton Publishing, 1985), p.xii.
98. See note 93 above.
99. De Courcy, 'The History of the Royal Hibernian Academy of Arts', p.xii.
100. Crookshank and Glin, *The Painters of Ireland*, p.173.
101. De Courcy, 'The History of the Royal Hibernian Academy of Arts', p.xii.
102. *NW*, 26 May, 5, 26 June, 16 Oct. 1834. A fifth essay, supposed to deal with the art of William Cumming, has not been located. It is not known if there were others.
103. Downshire papers, PRONI D671/A38/IB. The contents comprised twenty-eight portraits, a landscape, a religious subject, five bird pictures and an interior showing five persons dining. Hillsborough Castle is ten miles from Belfast.
104. Londonderry papers, PRONI D654/SI/I. Mountstewart is roughly twelve miles from Belfast.
105. There is no information available on Mariette. His French-sounding name may have been a pseudonym, as he declared in one of his articles that he was Irish.
106. *BNL*, 9, 15, 22 Aug., 5 Sept. 1828.
107. Ibid., 26 Aug., 14 Oct., 7, 25 Nov., 9 Dec. 1828.
108. Ibid., 7 Nov. 1828.
109. Apart from Mariette's details, the earliest known record of the contents of Belvoir is a *Catalogue of Paintings at Belvoir Park*, published in 1865.
110. *BNL*, 9 Dec. 1828.
111. Ibid., 14 Oct., 9 Dec. 1828.
112. *BNL*, 19 Sept., 14 Oct., 9 Dec. 1828; also Black, *A Catalogue of the Permanent Collection: 3*, pp.55–7.
113. See C.M. Kauffmann, *Catalogue of Paintings in the Wellington Museum* (London, 1982), pp.85–6 for details of the painting.
114. *BNL*, 24, 27 Sept., 8, 25 Oct. 1816.
115. Newspaper accounts of the exhibition give only a brief description of the picture. However, a young visitor to the event, Robert James Tennent, stated in his diary that the painting 'represented [Napoleon] in the gallery of statues in the palace of the Tuilleries' (Tennent papers, PRONI D1748/G/750/1). This particular version by Lefèvre was engraved by Thomas Lupton, repr. J.T. Herbert Baily, *Napoleon* (London: Connoisseur Magazine, 1908), p.113. The whereabouts of the painting is unknown.
116. J.R.R. Adams, 'Popular Art in Belfast 1824–1836', *Ulster Folklife*, 29 (1983), pp.43–6.
117. *BNL*, 1 Oct. 1824. The Commercial Buildings in Waring Street were erected 1819–20 and took over the function of the old Assembly Rooms, which stood opposite. The building contained a commercial hotel, shops, offices, news-room and coffee room – see Paul Larmour, *Belfast: An Illustrated Architectural Guide* (Belfast: Friar's

Bush Press, 1987), pp.4–5. Several art exhibitions were held in it over the years.

118. *BNL*, 26 Nov. 1824, 23 Oct. 1835.

119. There were no panoramas between 1811 and 1824. Those which came between 1824 and 1835 were *Waterloo*, owned by Messrs Marshall, in 1824 (*BNL*, 21 Sept. 1824); *Waterloo*, owned by Barker, Sinclair and Co., also in 1824 (*BNL*, 21 Sept. 1824); *The Bombardment of Algiers* and *The Frozen Regions lately visited by Captain Parry*, owned by Messrs Marshall, both likewise in 1824 (*BNL*, 26 Nov. 1824); *Niagara Falls*, owned by Messrs Marshall, in 1835 (*BNL*, 8 Sept. 1835); *The Battle of Navarino* and *The City of Constantinople*, owned by Messrs Marshall, both in 1835 (*BNL*, 23 Oct. 1835).

120. See Chapter One, note 59.

121. *BNL*, 29 April 1831; *NW*, 26 May 1831.

122. *NW*, 26 May 1831; J. McBain, 'James Thom, Sculptor', *Burns Chronicle and Club Directory*, 1916, p.62.

123. *BNL*, 29 April 1831; *NW*, 26 May 1831.

124. By the early nineteenth century, Burns' poems had had over a dozen Belfast reprints, a reflection of the popularity of his work; see John Hewitt, 'The Northern Athens and After' in J.C. Beckett *et al.*, *Belfast: The Making of the City* (Belfast: Appletree Press, 1983), p.71.

125. W.S. Lanham, *The History of James Thom The Ayrshire Sculptor* (publication details unavailable), unpaginated.

126. Only four advertisements were found in the local press, namely, in the *BNL* of 15 July 1766, 6 Nov. 1807, 25 March 1808, 10 March 1809.

127. Ibid., 10 May 1825, 3 Jan. 1826, 5 Feb. 1828.

128. Ibid., 23 July 1811, 22 Jan. 1813, 7 April 1815, 29 Aug. 1823 (James Dowling Herbert); *NW*, 11 Aug. 1825 (L. Witte); *BNL*, 22 July 1831 (C. Fleming).

129. The firm had been in existence since 1807, when it advertised a sale of prints in the *BNL* of 17 Nov. Subsequent advertisements in the *BNL* include 9 July 1813, 22 March 1814, 20 Feb. 1827, 18 Sept. 1829, 11 May 1830, 21 Nov. 1833, 13 March 1835.

130. Ibid., 27 Feb. 1835. In 1818 the Hodgson family opened a new circulating library of over 6,000 volumes at their High Street premises, a catalogue of which is in Belfast Central Library, Bigger collection, A70. There is no information on the firm in the National Archives, National Register of Archives or PRONI.

131. *NW*, 29 Oct. 1835. According to an advertisement in the *BNL* of 7 June 1879, the firm had

been established in 1832 at 7, Arthur Square. The first advertisement located by the author was in the *NW* of 27 Nov. 1834.

CHAPTER THREE

1. Hugh Frazer to the committee of the Royal Irish Art Union (RIAU), June 1839 (*BNL*, 18 June 1839). See also 'The Belfast Association of Artists 1836–38' section in main text.

2. Trevor Fawcett, *The Rise of English Provincial Art: Artists, Patrons and Institutions outside London, 1800–1830* (Oxford: Clarendon Press, 1974), p.1.

3. See Chapter Two, note 93.

4. Fawcett, *The Rise of English Provincial Art*, p.178.

5. Ibid., pp.173, 176.

6. Ibid., pp.1, 186.

7. Ibid., p.1; also Chapter Two, note 93.

8. Fawcett, *The Rise of English Provincial Art*, p.1.

9. Ibid., pp.2–3.

10. Ibid., p.3.

11. Ibid., p.2.

12. Ibid, pp.3–9.

13. *NW*, 28 April 1836.

14. Ibid.

15. *BCC*, 4 May 1836.

16. *NW*, 16 May 1836. The Belfast Natural History Society museum, opened on 1 November 1831 as the Belfast Museum of Natural History, was the first provincial museum in Ireland. The society became the Belfast Natural History and Philosophical Society in 1842. See Arthur Deane (ed.), *The Belfast Natural History and Philosophical Society Centenary Volume 1821–1921* (Belfast: W. Erskine Mayne, 1924) and Noel Nesbitt, *A Museum in Belfast* (Belfast: Ulster Museum, 1979).

17. Belfast Association of Artists (BAA) catalogue, 1836, pp.6–7.

18. Ibid., p.6.

19. *NW*, 5 Sept., 8 Oct. 1836. The catalogue lists 217 exhibits but two paintings shared the same number, 138.

20. BAA catalogue, 1836 (185), p.15.

21. There is no trace of them in the Irish Architectural Archive, Dublin or in the British Architectural Library, Royal Institute of British Architects.

22. *NW*, 29 Sept. 1836.

23. Ibid., 1 Oct. 1836.

24. *BNL*, 7 Oct. 1836.

25. No catalogue of the 1837 exhibition has been found and details have therefore been abstracted from the local press.

26. *NW*, 7 Sept. 1837.

27. Ibid.; also *BCC*, 21 Oct. 1837.
28. *NW*, 17 Oct. 1837.
29. Ibid., 7 Sept. 1837.
30. *BCC*, 11 Sept. 1837.
31. Ibid., 25 Oct. 1837.
32. Ibid., 11, 14, 21 Oct., 1 Nov. 1837.
33. *NW*, 30 Sept. 1837. A break-down of the lottery is as follows: Nicholas Joseph Crowley (2), Mrs John Emmerson (2), Hugh Frazer (2), W. Gillard (1), Master John Hawksett (1), Arthur Joy (1), Henry Maguire (1), James W. Millar (1), Joseph Molloy (2), George Francis Mulvany (1), Andrew Nicholl (6), William Nicholl (2), Hugh Talbot (1).
34. *BCC*, 1 Nov. 1837.
35. *NW*, 20 Sept., 18 Oct. 1838; BAA catalogue, 1838.
36. *BCC*, 22 Sept. 1838; *NW*, 27 Sept. 1838; *BNL*, 28 Sept. 1838.
37. *NW*, 18, 25 Oct. 1838.
38. *BNL*, 18 June 1839.
39. *BCC*, 1 March 1837.
40. The Music Hall, designed by Thomas Jackson, was opened on 26 March 1840. The idea of new premises for the Anacreontic Society had first been raised in 1826. See Chapter Two, main text and note 89.
41. PRONI D297/1, Minute Book of the Anacreontic Society, 1838–63.
42. *NW*, 12 April 1838.
43. *NW*, 1, 29 Sept. 1842.
44. The others were the Marquesses of Downshire and Hertford, the Earls of Charlemont and Clanwilliam, Viscounts Castlereagh and O'Neill, the Bishop of Down and Connor, the Deans of Connor and Ross, General D'Aguilar, John Cunningham of Macedon, William Sharman Crawford, David R. Ross (*NW*, 3 Sept. 1842).
45. The remaining twenty-four committee members were W.J.C. Allen, Drummond Anderson, Henry Bell, William Bottomley, John Clarke, Richard Davison, Samuel Greame Fenton, William Garner, Edmund Getty, John Godwin, John Grattan, Thomas Greg, A.H. Haliday, John Hind, Jr, John Hodgson, Charles Lanyon, Francis McCracken, William McGee, S.K. Mulholland, Rev. A. Oulton, John R. Shannon, George Smith, James Thompson, S.S. Thompson (Northern Irish Art Union (NIAU) Prospectus, author's records).
46. See Eileen Black, 'Practical Patriots and True Irishmen: the Royal Irish Art Union 1839–59', *Irish Arts Review*, 14, Yearbook (1998), pp.140–6, for information on the RIAU.
47. Lyndel Saunders King, *The Industrialization of Taste: Victorian England and the Art Union of London* (Ann Arbor: UMI Research Press, 1985), p.5.
48. Anthony King, 'George Godwin and the Art Union of London 1837–1911', *Victorian Studies*, 8, 2 (Dec. 1964), p.102.
49. Saunders King, *The Industrialization of Taste*, p.5.
50. Ibid., pp.115–16.
51. *NW*, 3 Sept. 1842.
52. *NW*, 29 Sept. 1842.
53. *NW*, 22 Oct. 1842; also *BCC*, 5 Dec. 1842.
54. *NW*, 3 Sept., 25 Oct., 29 Nov. 1842.
55. Details of the exhibition have been compiled from newspapers.
56. *BCC*, 5 Nov. 1842; *BNL*, 8, 15 Nov. 1842; *NW*, 8 Nov. 1842.
57. *NW*, 1, 5, 8 Nov. 1842.
58. *BCC*, 22 Oct. 1842. The painting's exhibition number is unknown.
59. *NW*, 27 Dec. 1842.
60. The artists were as follows: J. Bateman, T. Clater, J. Dujardin, J.T. Gilbert, C. Hancock, H. Jutsum, H. McCullough, T.F. Marshall, J. Tennant, A. Vickers.
61. *NW*, 20 Dec. 1842. Prizes were as follows: £20 (1), £10 (1), £5 (6), £4 (1), £3 (2).
62. Ibid., 27 Dec. 1842. The prize pictures were: J.W. Allen, *Landscape*; J. Cook, *The Trumpet*; W. Cranbrook, *Landscape*; J. Fussell, *Repose*; J. Hawksett, *Moonlight*; W.H. Maguire, *Composition*; A. Nicholl, *Meeting of the Waters*; C.D. Smith, *View on the Thames*; J. Tennant, *Landscape*; G.A. Tripp, *Glen Scene*; S. Walter, *Prussian Brig*.
63. *Art-Union*, Feb. 1843, p.43.
64. The number of members may have been less than 242, as subscribers could take out more than one subscription. This entitled them to another chance in the lottery and free admission to the exhibition for their families.
65. The RIAU had an agent in Belfast for a number of years, namely, John Hodgson of High Street (*NW*, 27 July 1839; *BCC*, 25 Sept. 1844).
66. *NW*, 24 Aug. 1843.
67. The others were Henry Bell, William Garner, John Godwin, John Grattan, John Hind, Jr, Dr J.D. Marshall, Dr William McGee, George Smith, James Thompson.
68. *NW*, 31 Aug. 1843; *BNL*, 17 Oct. 1843. No catalogue of the exhibition has been found and details have therefore been compiled from the following : *BCC*, 4, 9, 20 Sept. 1843; *BNL*, 12, 19 Sept. 1843; *Ulster General Advertiser*, 16 Sept. 1843.
69. *NW*, 31 Aug. 1843.
70. Eileen Black, *Paintings, Sculptures and Bronzes in the Collection of The Belfast Harbour Commissioners*,

Ulster Museum, 1983 (Belfast Harbour Commissioners, 1983), pp.20–1; also Chapter Two, note 63.

71. *NW*, 26 Nov. 1840, 26 April 1842, 16 Sept. 1848.

72. According to an advertisement in the *NW* of 21 July 1842, Frazer planned to open elementary drawing classes in early August at his studio in Chichester Street.

73. Petrie papers, NLI, MSS. 791, nos. 290, 291. Frazer had been a member of the Royal Hibernian Academy (RHA) since 1837.

74. Ibid., no. 298.

75. Eileen Black (ed.), *Celebrating Ulster Art: 10 Years of the W. and G. Baird Calendar* (Belfast: W. & G. Baird Ltd., 1996), pp.38–9.

76. *NW*, 12 April 1838. The contents of his studio were advertised to be sold on 19 May (ibid., 10 May 1838).

77. Ibid., 9 June 1838.

78. Ibid.

79. Ibid., 3 Oct. 1839, 5 Aug., 16 Nov. 1843, 1 Oct. 1844.

80. *BCC*, 17 June 1846; Martyn Anglesea, 'Andrew Nicholl and his Patrons in Ireland and Ceylon', *Studies*, (Summer 1982), pp.139–46.

81. On 6 Aug. 1846 (*BCC*, 10 Aug. 1846).

82. Ibid., 10 Aug. 1846.

83. *NW*, 8 Sept. 1849.

84. *NW*, 10 Nov. 1840; Black, *Paintings, Sculptures and Bronzes in the Collection of The Belfast Harbour Commissioners*, p.13; [Eileen] Black, *A Catalogue of the Permanent Collection: 4: Irish Oil Paintings, 1831–1900* (Ulster Museum, 1997), pp.14–15.

85. Illustrations by Burgess can be found in *Views, Illustrative of the North of Ireland* (Belfast: Marcus Ward, 1842); Mr and Mrs S.C. Hall, *Ireland: its Scenery, Character, etc.* (London: Virtue and Co., 1841–3), 3 vols; *Illustrations of the North of Ireland and Guide to the Giant's Causeway* and *Ward's Drawing-Book of Irish Scenery, In Six Parts* (both Belfast: Marcus Ward, 1848) (*NW*, 1 July 1848); John Hewitt and Theo Snoddy, *Art in Ulster: 1* (Belfast: Blackstaff Press, 1977), pp.152–3.

86. *BCC*, 27 Dec. 1843.

87. *BCC*, 22 June 1844; also Black, *Paintings, Sculptures and Bronzes in the Collection of The Belfast Harbour Commissioners*, pp.23–4; Black, *A Catalogue of the Permanent Collection: 4*, pp.34–5.

88. Eileen Black, *A Sesquicentennial Celebration: Art from The Queen's University Collection*, Ulster Museum, 1995 (Queen's University of Belfast, 1995), pp.36–7.

89. For the period 1811–35, the author found advertisements for ten different Hyndman auctions in the local press. For the years 1836–48, twenty-seven were located. Besides Hyndman, there was an obscure auctioneer, William Rodgers, who conducted a sale on 1 May 1841 (*BNL*, 30 April 1841).

90. *BNL*, 3 Jan. 1840, 2 April 1842.

91. Three sales, in October 1839, May 1841 and Dec. 1846 dealt with furniture and house contents as well as paintings (*NW*, 3 Oct. 1839; *BNL*, 30 April 1841; *BCC*, 7 Dec. 1846).

92. *NW*, 14 Jan. 1836 (Burroughs), 3 Oct. 1839 (Nicholl).

93. *BNL*, 7 Aug., 14 Dec. 1838, 3 Oct. 1843; *BCC*, 15 May 1843, 13 Oct. 1845, 4 May 1846.

94. *BNL*, 14 Dec. 1838; *NW*, 7 Feb. 1843.

95. *BNL*, 12 Oct. 1838, 3 Oct. 1843; *BCC*, 18 Oct. 1848.

96. For details of his auctions, see *BNL*, 1 Feb. 1839; *BCC*, 31 Jan. 1842, 6 Nov. 1844.

97. Fawcett, *The Rise of English Provincial Art*, pp.70–1; John Brewer, *The Pleasures of the Imagination: English Culture in the Eighteenth Century* (London: Harper Collins, 1997), p.204.

98. Fawcett, *The Rise of English Provincial Art*, p.70.

99. Ibid.

100. Jeremy Maas, *Gambart: Prince of the Victorian Art World* (London: Barrie & Jenkins, 1975), pp.41–2.

101. Dianne Sachko Macleod, *Art and the Victorian Middle Class: Money and the Making of Cultural Identity* (Cambridge, New York, Melbourne: Cambridge University Press, 1996), p.48.

102. Anthony Dyson, *Pictures to Print: The Nineteenth-century Engraving Trade* (London: Farraud Press, 1984), p.4.

103. Ibid., p.3.

104. As yet, little research has been carried out on this aspect of the print trade. Its influence on Belfast was unknown, prior to the author's research.

105. In 1818, the Hodgson family opened a new circulating library of over 6,000 volumes at their High Street premises, a catalogue of which is in Belfast Central Library, Bigger collection, A70. There is no information on the firm (which also sold books) in the National Archives, National Register of Archives or PRONI.

106. Graves papers, BL, Add. MSS. 46140, p.317; *Art-Union*, June 1841, p.107.

107. There is no correspondence in the Graves papers (BL, Add. MSS. 46140, above) between the firm of Hodgson and Graves and that of John and Robert Hodgson of Belfast. I am grateful to Dr Anne Summers of the British Library for checking this for me (letter of 10 Dec. 1991).

108. The other works exhibited between 1836 and 1848

were Stephen Poyntz Denning, *The Greenwich Pensioners commemorating Trafalgar*, in 1836 (*BCC*, 26 March 1836); Thomas Duncan, *Prince Charles Edward and the Highlanders*, in 1845 (*NW*, 3 July 1845) and *Prince Charles Edward asleep*, in 1846 (*NW*, 9 July 1846); Daniel Maclise, *The Actor's Reception of the Author*, in 1845 (*NW*, 18 Sept. 1845); John Frederick Herring, Snr., *Feeding the Horse*, in 1846 (*NW*, 17, 19 Nov. 1846).

109. *NW*, 14 May 1839.

110. The Wallace Collection is unable to substantiate the picture's Belfast showing as they have no details of provenance before 1855 (letter of 19 Aug. 1991). See John Ingamells, *The Wallace Collection Catalogue of Pictures: British, German, Italian, Spanish* (London, 1985), p.181. The Wagstaff engraving, not published officially until 1840, was in fact published by April 1839 (*Art-Union*, April 1839, p.52). Engravings were sometimes issued before the declared date of publication, possibly to prepare the way for sales. I am grateful to Dr Anthony Dyson, University of London, for this information (letter of 2 Oct. 1991). See also Carrie Rebora Barratt, *Queen Victoria and Thomas Sully* (Princeton, NJ: Princeton University Press/Metropolitan Museum of Art, 2000), pp.164, 170.

111. Ingamells, *The Wallace Collection Catalogue of Pictures*, pp.179–81; Barratt, *Queen Victoria and Thomas Sully*, p.3.

112. *NW*, 6 June 1840.

113. *Art-Union*, Feb. 1840, p.23.

114. *NW*, 2 April 1840.

115. The Wagstaff engraving of Prince Albert was published by Hodgson and Graves on 24 May 1840; see Adrian le Harivel (ed.), *National Gallery of Ireland: Illustrated Summary Catalogue of Prints and Sculpture* (Dublin, 1988), p.391.

116. *Art-Union*, April 1842, p.69; *NW*, 23, 27 May 1843. Both *The Waterloo Heroes ...* and *The Heroes of the Peninsula* were shown in Exeter in January 1844 (Samuel A. Smiles, 'Plymouth and Exeter as Centres of Art 1820–1865' [unpublished Ph.D. dissertation, University of Cambridge, 1982], p.215); also in Cheltenham in 1845 (David Addison, 'Picture Collecting in Bristol and Gloucestershire c. 1800–c. 1860' [unpublished M.Litt. dissertation, Bristol University, 1993], p.104).

117. *Art-Union*, April 1842, p.69; *NW*, 27 May 1843.

118. *Art-Union*, Feb. 1839, p.16. According to the *Art-Union* of Aug. 1839, p.115, the picture was painted for the express purpose of being engraved. *The Waterloo Heroes ...* and *The Heroes of the Peninsula* are owned by the Marquess of Londonderry.

119. *BCC*, 29 May 1843.

120. *NW*, 7, 18, 25 May 1844.

121. Both paintings were exhibited at Graves' Pall Mall gallery in March 1844 (*Art-Union*, March 1844, pp.69–70).

122. *NW*, 23, 28 Oct. 1845; *BCC*, 29 Oct., 1 Nov. 1845.

123. Robin Hamlyn, curator of *Shoeing* at the Tate Gallery, has no information on the painting having visited Dublin and Belfast (communication of 8 Nov. 1991). See also Richard Ormond, *Sir Edwin Landseer*, Philadelphia Museum of Art and Tate Gallery, 1981–2, p.183.

124. *BCC*, 1 Nov. 1845.

125. Ibid., 29 Oct. 1845.

126. Ormond, *Sir Edwin Landseer*, p.184.

127. *BCC*, 3 Nov. 1845. The painting, bequeathed by Bell to the National Gallery in 1859, was transferred to the Tate Gallery in 1912 (Ormond, *Sir Edwin Landseer*, p.183).

128. Ormond, *Sir Edwin Landseer*, p.183. The Lewis engraving was published by F. Moon on 1 June 1848.

129. The Hodgsons' other displays were as follows: *Rev. Dr Henry Montgomery* and *William Sharman Crawford*, by John Prescott Knight, in 1846 (*NW*, 3 Jan. 1846); *General Sir Robert Sale*, by Henry Moseley, in 1844–45 (*BCC*, 21, 25, 28 Dec. 1844); *General Sir Henry Pottinger, Bart.*, by Sir Francis Grant, in 1846 (*NW*, 21 March 1846); twenty-six watercolours by Louis Haghe, from his second series of *Picturesque Sketches in Belgium and Germany*, in 1844–45 (*NW*, 28 Dec. 1844, 4 Jan. 1845); Royal Irish Art Union prize-winning paintings as follows – Corbould, *The Travellers*, Francis Danby, *The Tempest*, William Fisher, *The Greek Refugees*, in 1846 (*BCC*, 14, 31 Oct. 1846); F.W. Topham, *The Sisters at the Holy Well*, in 1848 (*BCC*, 29 April, 6 May 1848).

130. The first reference to McComb found by the author is in the *BCC* of 10 Feb. 1836. In 1837 he published an engraving of the Rev. James Morgan, engraved by W. Carlos after Samuel Hawksett (*BCC*, 25 March 1837).

131. He exhibited a portrait of Rev. Dr Edgar, by Samuel Hawksett, in 1840 and one of John Campbell, 2nd Marquess of Breadalbane, by John McLaren Barclay, in 1844 (*BNL*, 7 July 1840; *BCC*, 27 July 1844). He also sold a number of works by Andrew Nicholl in 1842 (*NW*, 17, 20 Sept. 1842).

132. The first reference to Lamont found by the author is in the *NW* of 9 Dec. 1843.

133. He published an engraving of Rev. Dr Henry Montgomery, after a drawing by Elish Lamont, in 1843 (*NW*, 9 Dec. 1843); also advertised the publication of an engraving of Rev. Dr Henry

Cooke, after Richard Hooke, in 1848 (*BCC*, 10 April 1848). Amongst paintings exhibited and sold were works by Andrew Nicholl, in 1844 and 1846 and by Hugh Frazer, in 1848 (*NW*, 19 Oct. 1844, 21 Feb. 1846, 16 Sept. 1848).

134. Lamont's other exhibitions for the print trade were *The First Reformers presenting their famous Protest at the Diet of Spires*, by George Cattermole, in 1844–45 (*NW*, 31 Dec. 1844); twelve watercolours by J.D. Harding, Joseph Nash, David Roberts and others for the first two parts of *Scotland Delineated* (London: Joseph Hogarth, 1847), shown in 1847 (*Art-Union*, Feb. 1847, p.76; April 1847, p.145; *BCC*, 20 March 1847).

135. *BCC*, 20 Dec. 1847. There are two sets of watercolours of *Views of Windsor Castle*: one at Anglesey Abbey and the other in the royal collection, Windsor Castle. It is not known which of the sets was shown at Lamont's. However, the Anglesey set is more closely associated with the published plates than the Windsor Castle set. This is therefore probably the one that came to Belfast. Information from the Hon. Mrs Roberts, curator, Windsor Castle (letter of 21 Nov. 1991).

136. *BCC*, 20 Dec. 1847.
137. *NW*, 4 Nov. 1847.
138. See note 108.
139. The sole exhibition at McComb's confined to ticket holders only was the display of the portrait of the Marquess of Breadalbane, in 1844 (see note 131).
140. *NW*, 31 March 1840.
141. Ibid., 26 Nov. 1840, 9 Nov. 1843.
142. Ibid., 9 Nov. 1843.
143. *NW*, 3 Aug. 1839, 14 Sept. 1841; *BCC*, 16 May, 6 June 1846.
144. *BNL*, 10 Sept. 1839. The figure quoted was 8,531 persons and the display lasted five weeks.
145. *NW*, 2 June 1846.
146. Quotation from Kendall B. Taft, 'Adam and Eve in America', *The Art Quarterly*, XXIII, 3 (Summer 1960), p.173.
147. *NW*, 3 Aug. 1839, 14 Sept. 1841, 26 May 1846.
148. *BNL*, 10 Sept. 1839; *NW*, 14 Sept. 1841; *BCC*, 16 May 1846.
149. See Taft, 'Adam and Eve in America', for details.
150. For example, the pictures were displayed in Cheltenham in 1842 and 1860 (Addison, 'Picture Collecting in Bristol and Gloucestershire c. 1800–c. 1860', pp.104–5); also in Exeter in 1860 and in Plymouth in 1858 and 1860 (Smiles, 'Plymouth and Exeter as Centres of Art 1820–1865', pp.217, 220). Details of other centres are unknown to the

author, as little has been published on art in the provinces.

151. Quotations from Taft, 'Adam and Eve in America', pp.174–5.
152. The 'Belfast press', in this instance, is the three main newspapers: the *BCC*, *BNL* and *NW*.
153. Creighton cited this figure in an advertisement in the *NW* of 26 May 1846.
154. *NW*, 8 Sept. 1846. The number of figures is uncertain – according to the same newspaper of 1 Sept. (1846), there were thirteen statues.
155. *NW*, 8 Sept. 1846; *BCC*, 9 Sept. 1846.
156. *BCC*, 9 Sept. 1846.
157. *NW*, 1 Sept. 1846.
158. *BCC*, 9, 28 Sept. 1846.
159. *BCC*, 9, 23, 28 Sept., 7 Oct. 1846.
160. *BNL*, 17 Aug., 3 Dec. 1841; *BCC*, 5, 10 June 1848. The other two were *The City of Jerusalem*, owned by Messrs Marshall, exhibited between Feb. and May 1838 (*BNL*, 20 Feb., 29 May 1838); also *The War in China and Syria and Views in the Holy Land*, proprietor Mr Holburne, on display during April 1841 (*BNL*, 16 April 1841).
161. *BNL*, 5 Oct. 1841.
162. Ibid., 22 Oct., 17 Dec. 1841.
163. *BCC*, 5 June 1848.

CHAPTER FOUR

1. Quotation from the Earl of Belfast's address at the annual *conversazione* and prize distribution, 18 March 1851 (*NW*, 20 March 1851).
2. Jonathan Bardon, *Belfast: An Illustrated History* (Belfast: The Blackstaff Press, 1982), p.90.
3. The report appeared in the *NW* of 28 November 1848, in an account of a meeting on 27 November, to discuss the establishment of a School of Design.
4. W.A. Munford, *William Ewart MP: Portrait of a Radical* (London: Grafton and Co., 1960), p.78. The Select Committee also examined the workings of the Royal Academy and its influence. Ewart's inquiry into the academy arose not only from an interest in art, but was one of a number of attacks he launched upon the privileges of powerful corporations. Other institutions targeted by him included the Bank of England and the East India Company.
5. Quentin Bell, *The Schools of Design* (London: Routledge and Kegan Paul, 1963), p.48.
6. See John Turpin, *A School of Art in Dublin since the Eighteenth Century* (Dublin: Gill & Macmillan, 1995) for a survey of the Royal Dublin Society school of art.
7. Bell, *The Schools of Design*, pp.48–9.

231

8. Ibid., pp.45–8.
9. Munford, *William Ewart MP: Portrait of a Radical*, p.80.
10. Bell, *The Schools of Design*, p.52.
11. Bell, *The Schools of Design*, pp.53–5; also Munford, *William Ewart MP: Portrait of a Radical*, pp.77–85.
12. Bell, *The Schools of Design*, p.57.
13. Ibid., p.85.
14. Bell, *The Schools of Design*, p.58.
15. Ibid., p.59.
16. Ibid., pp.60, 67–8.
17. Ibid., p.72.
18. Ibid., p.67.
19. Ibid., p.75.
20. Ibid., p.85.
21. Ibid., pp.101–2. Bell incorrectly gives Belfast's year of opening as 1850.
22. The idea was current in Belfast by September 1844, when Gaetano Fabbrini petitioned the board of managers of the Royal Belfast Academical Institution to appoint him headmaster of the School of Design about to be established in connection with the Institution (RBAI papers, PRONI SCH 524/7B/70/69b). If the board agreed to this, Fabbrini promised to relinquish his long-standing claim to the position of master in the Institution's drawing school (he had always maintained that his dismissal from the Institution in 1820 had been illegal; see Chapter Two). His case against the Institution had gone to arbitration in 1843, when it was found that there was no proof to substantiate any legal cause to justify his dismissal (ibid., PRONI SCH 524/7B/70/68).
23. John Turpin, 'The School of Design in Victorian Dublin', *Journal of Design History*, 2, 4 (1989), p.248.
24. This visit is referred to in the *NW* of 28 Nov. 1848.
25. Cork's school was situated in the old Custom House, home of the Royal Cork Institution since 1832. The Institution, a literary society, owned the plaster casts of the Vatican marbles, which the Prince Regent had presented to the Cork Society for Promoting the Fine Arts in 1819. See John Turpin, 'Irish Art and Design Education from the Eighteenth Century to the Present' (unpublished MS., 1991), pp.11–12 and W.G. Strickland, *A Dictionary of Irish Artists* (Dublin and London: Maunsel & Co., Ltd., 1913), vol. 2, p.655.
26. For details of the transition of the Royal Dublin Society schools into the Dublin School of Design, see Turpin, 'The School of Design in Victorian Dublin'.
27. A detailed report of the meeting is in the *NW* of 28 Nov. 1848.
28. The grant had been approved by 24 August 1848 (*NW*, 28 Nov. 1848).
29. *NW*, 18 Jan. 1849. He delivered his paper on 15 January (1849).
30. He cited Norwich and Nottingham.
31. Thomas Kelly, *A History of Public Libraries in Great Britain 1845–1975* (London: Library Association, 1977), p.10; Munford, *William Ewart MP: Portrait of a Radical*, p.117.
32. As at Canterbury (1847), Warrington (1848) and Salford (1849) (Kelly, *A History of Public Libraries in Great Britain 1845–1975*, p.10).
33. *NW*, 2 Dec. 1848. The decision to seek legal advice was taken on 27 November, the same day as the meeting in the Town Hall.
34. The committee comprised William Bottomley, woollen manufacturer; Francis Coates; William Dunville, iron founder and art patron; Counsellor Gibson; Hugh Harrison; John Herdman, flax merchant; John Holden, sewed muslin manufacturer; James MacAdam, Jr; R.S. McAdam, muslin manufacturer; Francis McCracken, cotton mill manager and art collector; Dr William McGee, art patron; Alexander Moore, decorator and house painter; S. K. Mulholland, mill owner; J.R. Neill, jeweller; Robert Roddy, linen and damask manufacturer and bleacher; John Simms; Moses Staunton, room paper warehouse owner; William Thompson, president of the Belfast Fine Arts Society (*BCC*, 29 Nov. 1848).
35. According to a copy book of letters of the School of Design, 15 Sept. 1848–11 March 1851 (no pagination), Belfast College of Technology papers, PRONI, uncatalogued, the committee received a reply from the town council on 1 January 1849. Of their reply, committee member James MacAdam, Jr, reported in the copy book:

    We have this day received a communication from them [the council] in which they state that having taken legal opinion as to their power to appropriate a sum from the Borough rates for this purpose they find they are unable to do so as the only act under which money could be granted for any similar purpose 8 and 9 Victoria c. 43 [that is, the Museums Act of 1845] would interfere with the form of management specified by the Board of Trade as the only one applicable to Schools of Design. The Belfast Council does not possess corporation property and therefore could not as in the case of Cork contribute any amount.

(Cork's school was in a municipal building, the city's old Custom House.) This inability by the council to provide funding was to be the case for the duration of the school's existence, despite the fact that a rate could have been raised in 1855, by the Public Libraries Act (Ireland) of that year. Schools which received annual municipal grants, according to details supplied by Robert McAdam of the Soho Foundry at the meeting on 27 November 1848 were Newcastle-upon-Tyne (£50), Norwich (£75) and Nottingham (£50).

36. *NW*, 6, 27 Feb., 31 May 1849.
37. Ibid., 29 May 1849.
38. Ibid., 31 May 1849.
39. The committee comprised the following: A.S. Adair MP; Dr Thomas Andrews; W.J. Anketell; Samuel Archer; William Bottomley; James Brown of Donaghcloney; Francis Coates; Robert Corry; William Dunville; William Ewart; Samuel Greame Fenton; J.F. Ferguson; James Gibson; John Godwin; Hugh Harrison; John Henning of Waringstown; John Herdman; John Holden; David Lindsay of Ashfield; Rowley Miller; Alexander Moore; S.K. Mulholland; Robert McAdam; Francis McCracken; Dr William McGee; John McMaster; J.R. Neill; John Owden; Robert Roddy; John Simms; Moses Staunton; R.J. Tennent MP; William Valentine.
40. Copy book of letters of the School of Design, 15 Sept. 1848 – 11 March 1851 (no pagination), Belfast College of Technology papers, PRONI, uncatalogued. The decision was made on 17 September 1849.
41. Joint board minute book 1843–64, RBAI papers, PRONI SCH 524/3A/1/6, p.188.
42. Ibid., p.189.
43. *NW*, 5 July 1849.
44. John Jamieson, *The History of the Royal Belfast Academical Institution 1810–1960* (Belfast: William Mullan and Son, 1959), pp.63, 205.
45. Joint board minute book 1843–64, RBAI papers, PRONI SCH 524/3A/1/6, pp.224–5. The correspondence is dated 1 November.
46. *NW*, 4 Dec. 1849, 8 Jan. 1850.
47. The £50 was divided thus: £25 for the best design for a damask tablecloth; £10 for the best design for a muslin robe; £5 for the best design for a muslin chemisette; £3 for the best design for a lady's cambric or lawn dress; £3 for the best design for a linen band; £2 each for the best design for a cambric or lawn handkerchief border and for the ornaments for a box for cambrics (*NW*, 28 Feb. 1850).
48. Ibid., 4 Dec. 1849, 31 Jan. 1850.
49. The proceedings were reported in the *NW* of 31 Jan. 1850.
50. By 25 January 1850, the total receipts were £435 12s 4d, whilst total disbursements amounted to £427 14s 4d, leaving a balance of £7 18s 0d.
51. *NW*, 11 April 1850; *BNL*, 12 April 1850.
52. Quotations from *NW*, 11 April 1850.
53. Ibid., 1 Nov. 1849, 4 April 1850.
54. Ibid., 4 April 1850.
55. See note 47.
56. *NW*, 28 Sept., 16 Nov., 12 Dec. 1850.
57. Ibid., 26 Oct. 1850.
58. The identity of this stationer is unknown. It may perhaps have been Marcus Ward, the leading firm in this line in Belfast, or possibly Thomas McCracken, not a stationer but a manufacturer of linen bands.
59. *NW*, 26 Oct. 1850.
60. Copy book of letters of the School of Design, 15 Sept. 1848 – 11 March 1851 (no pagination), Belfast College of Technology papers, PRONI, uncatalogued. Communication dated 8 Jan. 1850.
61. Joint board minute book 1843–64, RBAI papers, PRONI SCH 524/3A/1/6, p.238.
62. Ibid.
63. Ibid., pp.255–7.
64. Copy book of letters of the School of Design, 15 Sept. 1848 – 11 March 1851 (no pagination), Belfast College of Technology papers, PRONI, uncatalogued. Communication dated 12 Dec. 1850.
65. *NW*, 8 March 1851.
66. Ibid.
67. Ibid., 20 March 1851.
68. John Turpin, 'The Royal Dublin Society and its School of Art, 1849–1877', *Dublin Historical Record*, XXXVI (Dec. 1982), p.7.
69. *NW*, 13 March 1851. Charges were four shillings for ladies, five for gentlemen, fifteen for a family ticket for four persons and one pound for a family of six.
70. Ibid., 20 March 1851.
71. Ibid., 15 May 1851.
72. Ibid., 14 June 1851.
73. Dufferin papers, PRONI D1071/H/T/3.
74. *NW*, 16 Oct. 1851.
75. Ibid., 20 Dec. 1851.
76. Ibid., 11 Nov. 1851. The prizes were for sums of three guineas and two guineas.
77. Ibid., 30 March 1852.
78. The sum of £400 does not appear in the treasurer's report of 1 Jan. 1851 to 1 April 1852, Cole papers, NALVA Box VII 97E – there, local sub-

scriptions are given as £193 13s 8d. The *Annual Report* presented in March 1851, to be found only in local press reports, does not contain any reference to donations received. Dufferin apparently derived the amount of £400 from an official return.

79. *NW*, 30 March 1852.

80. Bell, *The Schools of Design*, p.250.

81. Cole papers, NALVA Box 55 AA 51, p.11. Regrettably, there is no index of the Cole papers in NALVA.

82. Dufferin papers, PRONI D1071/H/T/2, 19 April 1852.

83. *NW*, 30 March 1852.

84. Ibid., 10 Aug. 1852.

85. Ibid., 21 Oct. 1852.

86. Ibid., 23 Oct. 1852.

87. Ibid., 30 March 1852. Lanyon's design for the sculpture gallery cannot be traced (letter from Dr Paul Larmour, an authority on Lanyon, 12 Feb. 1993).

88. Dufferin papers, PRONI D1071/H/T/2, 1 April 1852.

89. The lectures were reported in the *NW* of 11, 18, 25 March and 1 April 1852. The Earl of Belfast, who was raised in England, paid his first visit to the town in June 1848 and came regularly thereafter (*BCC*, 17 June 1848).

90. *NW*, 24 April 1852. The meeting was held on 22 April in the reading room of the Working Classes' Association.

91. Ibid., 20 April 1852.

92. Ibid., 24 April 1852.

93. Ibid.

94. Ibid. Though the Earl of Belfast's proposed Athenaeum never came about, a 'mini-Athenaeum' was opened at 22, Castle Street in 1867. Owned by W.H. Greer and run as a commercial operation, it offered young men intellectual recreation and refreshment 'without being dependent upon the Public Houses or Hotels' (*NW*, 29 April 1867). The first public lecture was held on 31 March 1868 (*BNL*, 12 March 1868).

95. The Earl of Belfast died in Naples on 11 February 1853 (*NW*, 24 Feb. 1853). The *DNB* mistakenly records his death as 15 February. Quotation from *NW*, 14 April 1853.

96. *NW*, 16 April 1853. The meeting was held on 15 April (1853).

97. The *Annual Report* is published in the *NW* of 16 April (1853).

98. *NW*, 1 Feb. 1851, 16 April 1853; Cole papers, NALVA Box VII 97E, treasurer's report of 1 April 1852 to 1 April 1853, *Annual Report*, 1853.

99. Details of the Board Minute and its implications appear in the Dufferin papers, PRONI D1071/H/T/3, letter of 18 May 1853 from James MacAdam, Jr, to Henry Cole, Department of Practical Art. The author has found no such stipulation regarding the grant in any of the material checked.

100. Ibid.

101. Ibid.

102. *NW*, 18 June 1853.

103. Dufferin papers, PRONI D1071/H/T/2, copy of a letter from Henry Cole to James MacAdam, Jr, undated but certainly written in December 1853. Though the letter was signed by Norman McLeod of the Board of Trade, MacAdam or Dufferin (it is unclear which of them) was convinced that it was from Cole himself. MacLeod was registrar of the Department of Science and Art in 1856 (*Art-Journal*, July 1856, p.228).

104. Dufferin papers, ibid.

105. *BDM*, 30 Dec. 1854. This is a report of a meeting of friends and subscribers of the school, held in the Chamber of Commerce on 29 December to examine the reasons for its closure.

106. Ibid.

107. *BNL*, 7 April 1854.

108. *BCC*, 8 June 1854; *BNL*, 12 June 1854.

109. *BCC*, 8 June 1854.

110. *BCC*, 10 June 1854; *BNL*, 12 June 1854; Cole papers, NALVA Box VII 97E, *Annual Report*, 1852, 1853.

111. *BDM*, 30 Dec. 1854. This report stated that Nursey and the second master received a similar salary in Norwich to that which they had obtained in Belfast. However, this may have been given in order to 'encourage' them to leave Belfast.

112. Dufferin papers, PRONI D1071/H/T/3, address drafted by Lord Dufferin, undated but written in 1855.

113. *Second Report of the Department of Science and Art* (London, 1855), p.xxi.

114. *BNL*, 20 Dec. 1854.

115. *First Report of the Department of Science and Art* (London, 1854), pp.136–7. The figure of £370 for the masters' salaries was possibly the amount paid before a share of the pupils' fees was included. This point is unclear.

116. *Third Report of the Department of Science and Art* (London, 1856), p.206.

117. *BDM*, 30 Dec. 1854.

118. Turpin, *A School of Art in Dublin since the Eighteenth Century*, pp.152–4.

119. Peter Murray, *Catalogue of the Crawford Municipal Art Gallery, Cork* (unpublished MS.), unpaginated.

120. Munford, *William Ewart MP: Portrait of a Radical*, p.140.

121. Strickland, *A Dictionary of Irish Artists*, vol.2, p.655; Peter Murray, compiler, *Illustrated Summary Catalogue of the Crawford Municipal Art Gallery* (Cork, 1991), p.5.

122. Ian Budge and Cornelius O'Leary, *Belfast: Approach to Crisis: A Study of Belfast Politics, 1613–1970* (London and Basingstoke: The Macmillan Press Ltd., 1973), pp.60–1.

123. The case was heard 11–19 June.

124. *NW*, 2 Aug. 1855. The author has found no record of this offer in Belfast City Council records, which, however, are neither fully catalogued nor easily accessible. According to a report of the audit committee to council, 1 October 1855, the council agreed to pass the volumes to the Working Classes' Association.

125. *NW*, 2 Aug. 1855.

126. *NW*, 15 Sept. 1855; also Dufferin papers, PRONI D1071/H/T/3.

127. *BNL*, 26 Sept. 1855.

128. Ibid., 13 Nov. 1855. The finance committee comprised Michael Andrews, William Coates, William Dunville, John Herdman and William Tracy.

129. *NW*, 29 Dec. 1855; *BNL*, 31 Dec. 1855.

130. *NW*, 29 Dec. 1855. All the quotations in this address to the young ladies of Belfast are from this source.

131. *BDM*, 31 Dec. 1855.

132. *NW*, 3 Jan. 1856.

133. Ibid.

134. *BDM*, 5 Jan. 1856. Angelica Kauffmann (1741–1807), a Swiss-born historical and portrait painter, worked in England from 1766 to 1781. She became one of the original Royal Academicians, on the Academy's foundation in 1769.

135. *BDM*, 8 Jan. 1856.

136. *NW*, 15 Jan. 1856.

137. Ibid., 24 Jan. 1856.

138. *Fourth Report of the Department of Science and Art* (London, 1857), pp.212–15. This figure is the number of female students who had attended in the year ending 30 June 1856.

139. *BNL*, 28 Jan. 1856.

140. Ibid., 12 Jan. 1856.

141. The exhibition was held on 22, 23, 24 and 25 Jan. (*BNL*, 12, 25 Jan. 1856). There were no drawings from Belfast, Clonmel (a new school), Cork and Limerick.

142. *BNL*, 26 Jan. 1856.

143. *BDM*, 21 Feb. 1856.

144. *Art-Journal*, Feb. 1856, p.58.

145. *BNL*, 10 Sept. 1856.

146. *Fifth Report of the Department of Science and Art* (London, 1858), pp.26–7, 30–1, 32–3.

147. Ibid., pp.32–3.

148. *BNL*, 17 Oct. 1857.

149. Ibid., 15 Feb., 16, 22 March 1858; also *NW*, 20 Feb. 1858.

150. *BCC*, 27 June 1854. The exhibition was in circulation for five years and was held in twenty-six provincial towns throughout the United Kingdom. A total of 306,907 persons visited the show (*Seventh Report of the Department of Science and Art* [London, 1860], p.129).

151. *NW*, 20 Feb. 1858.

152. Ibid., 23, 25 Feb. 1858.

153. Admission was six pence daily and three pence for evening, later reduced to two pence and one penny respectively (*NW*, 20 Feb. 1858; *BNL*, 16 March 1858).

154. *Seventh Report of the Department of Science and Art* (London, 1860), p.130.

155. The duration at the other venues was as follows: Dublin, sixty-five days; Limerick, thirty-eight; Clonmel, forty-six; Waterford, thirty-nine (ibid.).

156. *BDM*, 14, 15 June 1858. William Tracy, of the finance committee, put the school's case personally to the Marquess of Salisbury, president of the Board of Trade and to Henry Cole.

157. These figures were cushioned by the benevolence of the Academical Institution, which agreed at the end of 1855 to reduce the rent to £75 per annum and wipe out arrears of £250. In 1862, the Institution accepted £65 collected by friends of the School of Design, in full settlement of rent arrears amounting to almost £300 (Jamieson, *The History of the Royal Belfast Academical Institution 1810–1960*, p.206, n.1).

158. *BNL*, 17 July 1858. This refers to testimonials paid to the masters and states that 15 July was the final evening for attendance at the school. The fact that the school had closed for good did not seem to have occurred to the paper.

159. *NW*, 15 June 1858.

160. *BNL*, 21 July 1858. The paper, in its issue of 20 July, covered a Commons speech by Mr Blake, member of parliament for Waterford, in which he discussed the financial position of the schools in Ireland and criticised the Department for starving them of funds whilst appropriating most of the parliamentary grant of £80,000 for the central school and museum at South Kensington.

161. *Art-Journal*, July 1858, p.221.

162. Ibid., September 1858, p.276.

163. A month after the school closed, a Royal

Commission was appointed to inquire into the state of the borough (Budge and O'Leary, *Belfast: Approach to Crisis*, p.62).

164. *BNL*, 11 April 1860.
165. There are none in the collections of the Ulster Museum and Ulster Folk and Transport Museum.
166. Useful sources for the history of the school are James Brenan, 'Art Instruction in Ireland', in *Ireland: Industrial and Agricultural: Handbook for The Irish Pavilion, Glasgow International Exhibition, 1901* (Dublin: Department of Agriculture and Technical Instruction, 1901); William Gray, *Science and Art in Belfast* (Belfast: reprinted from *Northern Whig*, 1904); Strickland, *A Dictionary of Irish Artists*; John Hewitt and Theo Snoddy, *Art in Ulster: 1* (Belfast: Blackstaff Press, 1977); Turpin, 'Irish Art and Design Education from the Eighteenth Century to the Present'. However, none of these accounts are accurate.
167. *NW*, 17 Oct. 1870.
168. See Martyn Anglesea, *Portraits and Prospects: British and Irish Drawings and Watercolours from the Collection of the Ulster Museum* (Ulster Museum, 1989); also Eileen Black: *James Glen Wilson R.N. (1827–1863) Landscape and Marine Painter* (Ulster Museum, 1980); *Samuel McCloy (1831–1904) Subject and Landscape Painter* (Lisburn Museum, 1981–2); *A Catalogue of the Permanent Collection: 4: Irish Oil Paintings, 1831–1900* (Ulster Museum, 1997).

CHAPTER FIVE

1. Getty scrapbooks, PRONI D3695, vol.1, p.294.
2. Ibid., vol.2, unpaginated. The committee of the 1850–51 exhibition comprised the following: Lord Dufferin (president); Sir Robert Bateson, Lord John Chichester, Richard Blakiston Houston, James Stirling, Sir James Emerson Tennent, Robert James Tennent (vice-presidents); Robert Boag, William Coffey, Richard Davison, Samuel Greame Fenton, Robert Gaffikin, John Godwin, Robert Henderson, Charles Lanyon, James McCaw, Francis McCracken, Dr William McGee, W.H. Malcolm, G.T. Mitchell (treasurer), Dr James Moore, Claude Lorraine Nursey (honorary secretary). Seven of the fifteen ordinary committee members had been involved with the Northern Irish Art Union and/or the Belfast Fine Arts Society; also three of the six vice-presidents.
3. Ibid., vol.1, p.294. There is no information about expenditure for the Belfast Fine Arts Society exhibition of 1843.

4. *NW*, 15 Oct. 1850.
5. Getty scrapbooks, PRONI D3695, vol.1, p.294.
6. *BNL*, 20 Dec. 1850.
7. Ibid; also *NW*, 24 Dec. 1850, 6 Feb. 1851.
8. *NW*, 21 Dec. 1850; *BCC*, 11 Jan. 1851.
9. *BNL*, 20 Dec. 1850.
10. *NW*, 26 Dec. 1850.
11. *NW*, 9 Jan. 1851; also *BCC*, 17 Feb. 1851.
12. *NW*, 4 March 1851.
13. *NW*, 6, 8 Feb., 4 March 1851; also *BCC*, 8 Feb. 1851.
14. *NW*, 26 Dec. 1850, 4 Jan., 8 Feb. 1851; *BCC*, 8 Feb. 1851.
15. *BCC*, 3 March 1851.
16. Money raised from the exhibition was as follows: ninety-two subscriptions of one guinea each (£96 12s 0d), £89 9s 6d day admission charges and catalogues, £35 10s 6d evening admission charges and catalogues and £49 9s 3d commission on sales (*BCC*, 5 Nov. 1851).
17. *NW*, 17 Jan., 1 April 1852.
18. *NW*, 17 Jan. 1852. William Tracy was a committee member of the School of Design.
19. *BNL*, 10 March 1852. A catalogue cannot be found.
20. *NW*, 6 March, 9 March 1852 (quotation).
21. Ibid., 11 March 1852.
22. Ibid; also C.E.B. Brett, *Buildings of Belfast 1700–1914* (revised ed., Belfast: The Friar's Bush Press, 1985) p.55, pl.54.
23. *NW*, 11, 23 March 1852; *BNL*, 28 April 1852.
24. *NW*, 19 Feb. 1852; *BNL*, 10 March, 10 May 1852.
25. *BNL*, 22 March 1852.
26. Ibid., 14 April 1852.
27. Ibid.
28. *NW*, 29 April 1852.
29. *Art-Journal*, June 1852, p.196.
30. Quotation from *BNL*, 12 April 1852.
31. The catalogue is in the Cole papers, NALVA Box VII 97E.
32. The 1854 committee was as follows: Lord Dufferin (president); Sir Robert Bateson, the Bishop of Down, Connor and Dromore, Richard Blakiston Houston, Hugh McCalmont Cairns, Richard Davison, Marquess of Downshire, F.H. Lewis, Marquess of Londonderry, Lord Lurgan, William Sharman Crawford, Sir James Emerson Tennent (vice-presidents); Joseph Bristow, George A. Carruthers, William Coffey, Samuel Greame Fenton, Robert Gaffikin, John Godwin, Robert Henderson, John Hind, Charles Lanyon, James McCaw, Francis McCracken, Robert J.T. Macrory, W.H. Malcolm, G.T. Mitchell (treasurer), Dr James Moore, Claude Lorraine Nursey

(honorary secretary), William Tracy (honorary secretary), William Young.

33. Of the eleven vice-presidents of the 1854 exhibition, three had served thus with the 1850–51 show, whilst of the fifteen ordinary committee members, ten had also been on the 1850–51 committee. Four of the 1854 members – John Godwin, John Hind, Francis McCracken and G.T. Mitchell – had been on the Belfast Fine Arts Society committee of 1843.

34. *BCC*, 17 April 1854.

35. The works were as follows: Robert Martineau, *Kit's Writing Lesson*; William Bell Scott, *Boccaccio's Visit to Dante's Daughter*; Henry Wallis, *An Inevitable Mate*. (This Wallis is not the London dealer mentioned later in note 98.)

36. Martyn Anglesea, 'Francis McCracken: Pre-Raphaelite Patron or Speculator?', (unpublished MS., 1984), p.16.

37. *BNL*, 17 April 1854; *BCC*, 20 June 1854.

38. William Holman Hunt, *The Awakening Conscience* (1853–54) and *The Scapegoat* (1854).

39. *BNL*, 12 April 1854.

40. Ibid., 17 April 1854.

41. Ibid., 22 May 1854.

42. Ibid., 31 May, 7 June 1854.

43. *BCC*, 20 June 1854.

44. *BNL*, 7 June 1854.

45. *BCC*, 20 June 1854.

46. *Art-Journal*, Sept. 1854, p.304.

47. *NW*, 14 Feb., 18 April 1859.

48. Ibid., 14 May 1859.

49. Ibid., 20 May 1859.

50. *BNL*, 14 May 1859; *NW*, 21 May 1859.

51. *NW*, 16 May 1859.

52. *BNL*, 25, 28 May 1859.

53. *NW*, 20 May 1859. For example, *Evening Studies* by Henry Johnston and *Mind your Eye*, artist's name not given.

54. *NW*, 16 May 1859; also *BNL*, 4 June, 2 July 1859.

55. *NW* 18 June, 2 July 1859.

56. *BNL*, 21 July 1859; *NW*, 22 July 1859.

57. See Chapter Seven.

58. A collection of his work was sold through three local printsellers, Robert Gaffikin, William McComb and James Magill, in July 1851 (*NW*, 3, 12 July 1851). Magill also held a subscription sale of his work in Oct. 1852 (ibid., 19, 26 Oct. 1852). Nicholl was in Belfast for these sales. He was also in the north in Oct. 1851, to paint views of the Giant's Causeway on commission (ibid., 4 Oct. 1851).

59. *BNL*, 15 Sept. 1854.

60. Ibid., 17 Nov. 1854.

61. *NW*, 26 June 1855.

62. *NW*, 3 July 1856; also *BNL*, 14 July 1864.

63. *BNL*, 22 Jan. 1856.

64. See Martyn Anglesea, *James Moore 1819–1883*, Ulster Museum, 1973.

65. *NW*, 13 Dec. 1883.

66. See Eileen Black: *James Glen Wilson R.N. (1827–1863) Landscape and Marine Painter* (Ulster Museum, 1980); 'James Glen Wilson (1827–1863): An Irish Artist in Australia', *Familia*, 2, 3 (1987), pp.37–46; 'James Glen Wilson', in Joan Kerr (ed.), *The Dictionary of Australian Artists: Painters, Sketchers, Photographers and Engravers to 1870* (Melbourne, Oxford, Auckland, New York: Oxford University Press, 1992), pp.866–7.

67. The conflict was between Orangemen and Ribbonmen. For further information on Dolly's Brae, see Jonathan Bardon, *A History of Ulster* (Belfast: The Blackstaff Press, 1992).

68. The names of many of those in the public classes at the School of Design are recorded in the press; however, details of students in the private classes are not given.

69. John Hewitt and Theo Snoddy, *Art in Ulster: 1* (Belfast: Blackstaff Press, 1977), p.28. For a light-hearted account of Piccioni and the community of Italian artists in Belfast, see Cathal O'Byrne, *As I Roved Out* (Dublin: At the Sign of the Three Candles, 1946), pp.119–20.

70. *Belfast Industrial Exhibition and Bazaar* catalogue, 1876.

71. There are five other portraits of the Nicholl family, by him, in the Ulster Museum's History department.

72. Brett, *Buildings of Belfast 1700–1914*, pp.27–8.

73. *NW*, 17 May 1849.

74. *BNL*, 25 Sept. 1849.

75. Ibid.

76. *NW*, 23 March 1850.

77. Ibid., 30 March, 6 June, 2 July 1850.

78. Ibid., 2 Oct. 1851. Quotation from *BNL*, 25 Sept. 1849.

79. See Eileen Black, *The People's Park: The Queen's Island, Belfast 1849–1879* (Belfast: Linen Hall Library, 1988) for details of the Queen's Island and its Crystal Palace, a conservatory erected in 1851.

80. Situated in the grounds of the British Telecom Training School at 46, Fortwilliam Park, the fountain, although ruinous, was still functioning in 1988.

81. *NW*, 23 March 1852.

82. *BCC*, 23 Jan. 1854.

83. *NW*, 25 Oct. 1858.

84. *NW*, 26 May 1855; also *BCC*, 30 May 1855.
85. *NW*, 17, 31 July 1855. The sculpture showed two British orphans of the Crimea.
86. *BNL*, 19 May 1854; *NW*, 5, 15 May 1855; *BNL*, 4 March 1856.
87. Population figure from W.A. Maguire, *Belfast* (Keele: Ryburn Publishing, Keele University Press, 1993), p.39.
88. Samuel A. Smiles, 'Plymouth and Exeter as Centres of Art 1820–1865' (unpublished Ph.D. dissertation, University of Cambridge, 1982), pp.134, 234.
89. According to an advertisement in the *Belfast Directory*, 1880, Cramsie's firm was established in 1848 and Clarke's in 1829. These years do not accord with newspaper sources. First advertisement found for Dale is in *NW*, 22 Dec. 1849; for McShane, *BNL*, 7 Dec. 1853; for Gowan, *NW*, 22 Oct. 1857; for Magee, ibid., 12 Nov. 1850; for Martin, *BNL*, 20 March 1858.
90. *NW*, 31 May 1855, 17 June, 3 Oct. 1859, 19 March, 11 Aug., 8 Nov. 1860; *BNL*, 24, 29 Sept., 31 Oct., 3, 5 Nov. 1859.
91. *NW*, 22 Sept. 1859; *BNL*, 12 Nov. 1859.
92. *NW*, 22, 25 Aug. 1849, 10 May 1851. Clarke also sold the contents of Cleverly's seat in Co. Cork (ibid., 3 July 1851).
93. Ibid., 28 Oct. 1851.
94. Ibid., 21, 23, 26 July 1853.
95. Ibid., 1 Sept. 1857. This is the last mention of Dale found in the press.
96. *Art-Journal*, Oct. 1859, p.365. The *Art-Union* became known as the *Art-Journal* in 1849.
97. *BNL*, 24 Sept. 1859.
98. Wallis (1804–90) began his career as an engraver but turned dealer when he was struck down by paralysis. He worked as manager of Gambart's French Gallery for a time, before he purchased the lease in 1867; see George C. Williamson (ed.), *Bryan's Dictionary of Painters and Engravers* (London: G. Bell and Sons, Ltd., 1919), vol.5, p.331; Dianne Sachko Macleod, *Art and the Victorian Middle Class: Money and the Making of Cultural Identity* (Cambridge, New York, Melbourne: Cambridge University Press, 1996) p.262.
99. *NW*, 21 Feb., 2, 5, 14, 19 March 1850. R. Winstanley of Manchester supervised the two Wallis exhibitions.
100. Ibid., 19 March 1850.
101. *BCC*, 13, 20, 27 Dec. 1851; *NW*, 23, 27 Dec. 1851, 3 Jan. 1852.
102. *NW*, 27 Dec. 1851.
103. Ibid., 3 Jan. 1852.
104. Hugh C. Clarke held three auctions, on 22–23 May, 9 July, 4 November 1851; John Devlin held one, on 21 October 1851; George C. Hyndman held eight, on 12 June, 6 August, 10 September 1850, 8 January, 17 February, 6 May (two sales), 14 October, 11 Dec. 1851 (*NW*, 11 June, 6 Aug., 7 Sept. 1850, 26 April, 10 May, 3 July, 4, 28 Oct. 1851; *BCC*, 1 Jan., 17 Feb., 20 Oct., 6 Dec. 1851).
105. *NW*, 3 Sept. 1842, 24 Aug. 1843, 25 Dec. 1851. A marble bust of Clarke, by Samuel Ferres Lynn, is in the collection of the Belfast Harbour Commissioners. See Eileen Black, *Paintings, Sculptures and Bronzes in the Collection of The Belfast Harbour Commissioners*, Ulster Museum, 1983 (Belfast Harbour Commissioners, 1983), pp.63, 126.
106. *BNL*, 23 April 1863.
107. Martyn Anglesea, 'A Series of Letters relating to John Rogers Herbert, Francis McCracken, John Clarke, Thomas Creswick and others' (unpublished MS., 1992), pp.7, 15.
108. *NW*, 25 Dec. 1851.
109. Information on Fenton first came to light in 1992, as a result of the author's researches.
110. *NW*, 3 Sept. 1842, 22 Oct. 1850; *BCC*, 20 June 1854; *BNL*, 1 Dec. 1863.
111. *BNL*, 10 Aug. 1853.
112. *Cumberland Directory*, 1861; C. Roy Hudleston and R.S. Boumphrey, *Cumberland Families and Heraldry with A Supplement to An Armorial for Westmorland and Lonsdale* (The Cumberland and Westmorland Antiquarian and Archaeological Society, 1978) p.109; *Carlisle Journal*, 4 Dec. 1863; *BNL*, 1 Dec. 1863.
113. Copies of these sale catalogues supplied by Christie's, London. The sale of 13 February comprised thirty-seven engravings and ninety-two Old Masters, that of 20 February, fifty modern pictures.
114. *Christ stilling the Storm*, by John Martin, was lot 35 in the Fenton sale of 20 February. Described as 'a grand work' and therefore of a substantial size, it had been owned previously by Richard Nicholson of York and had been lot 189 in Nicholson's sale at Christie's on 13–14 July 1849. Henry Wallis purchased it on 14 July for twenty guineas. A painting by Martin of a similar subject, *Christ stilleth the Tempest*, was in Wallis's Belfast exhibition and sale of 1850. Whilst it is not known who acquired it, it seems highly likely that it was purchased by Fenton and ended up as lot 35 in his above-mentioned sale of 20 February (*NW*, 21 Feb. 1850; *BNL*, 1 March 1850). Fenton's painting was probably the version exhibited at the Royal Academy in 1843 (541) and at the

British Institution in 1844 (192). Information on provenance provided by Richard Green, York City Art Gallery (letters of 17 Dec. 1992 and 6 Jan. 1993).

115. See Anglesea, 'Francis McCracken: Pre-Raphaelite Patron or Speculator', for an informative account of McCracken's career as a collector. Also [Martyn] Anglesea, 'A Pre-Raphaelite Enigma in Belfast', *Irish Arts Review*, 1, 2 (Summer 1984), pp.40–5, and Gail S. Weinberg, '"An Irish Maniac": Ruskin, Rossetti and Francis McCracken', *The Burlington Magazine*, (Aug. 2001), pp.491–3.

116. He was on the committees of the Northern Irish Art Union of 1842, the Belfast Fine Arts Society exhibition of 1843, the *Exhibition of Modern Works of Painting and Sculpture* of 1850–51 and the Belfast Fine Arts Society exhibition of 1854 (*NW*, 3 Sept. 1842, 24 Aug. 1843, 22 Oct. 1850; *BCC*, 20 June 1854).

117. At auction at Christie's, London, on 17 June 1854 and 31 March 1855.

118. Anglesea, 'Francis McCracken: Pre-Raphaelite Patron or Speculator?', p.16.

119. Ibid.

120. Anglesea, 'A Pre-Raphaelite Enigma in Belfast', pp.40–3; Weinberg, '"An Irish Maniac": Ruskin, Rossetti and Francis McCracken', p.493.

121. Anglesea, 'Francis McCracken: Pre-Raphaelite Patron or Speculator?', pp.26–7, 30.

122. Ibid., pp.41–2.

123. Ibid., pp.1, 3.

124. Weinberg, '"An Irish Maniac": Ruskin, Rossetti and Francis McCracken', p.493.

125. *Wycliffe reading his Translation* (Brown) is in Bradford City Art Gallery; *Ophelia* (Hughes) is in Manchester City Art Gallery; *Valentine rescuing Sylvia from Proteus* (Hunt) is in Birmingham City Museums and Art Gallery; *Dante drawing an Angel on the First Anniversary of the Death of Beatrice* (Rossetti) is in the Ashmolean Museum, Oxford; *Wandering Thoughts* and *Death of Romeo and Juliet* (Millais) are in Manchester City Art Gallery.

126. Anglesea, 'Francis McCracken: Pre-Raphaelite Patron or Speculator?', pp.56–7.

127. *NW*, 10, 16, 17 Aug. 1860.

128. Julian Treuherz, *Victorian Painting* (London: Thames and Hudson, 1993) pp.82–4.

129. *NW*, 17 April 1852. The lithographic side of the business was taken over by W. and G. Agnew in the winter of 1851 (ibid., 28 Oct. 1851).

130. *BNL*, 8 June 1849.

131. *The Combat* was engraved by G.T. Doo; *John proclaiming the Messiah* by John Outrim; *The Battle of Waterloo* by J.T. Willmore.

132. Marcia Pointon, *Mulready*, Victoria and Albert Museum, 1986, pp.117, 158; Martyn Anglesea, *Portraits and Prospects: British and Irish Drawings and Watercolours from the Collection of the Ulster Museum* (Ulster Museum, 1989), pp.62–3.

133. Pointon, *Mulready*, pp.117, 120, 122, 157–8.

134. *The Trial of the Seven Bishops* (*NW*, 18 Dec. 1849; *BNL*, 12 Feb. 1850); *The Forester's Family* (*NW*, 27 April 1852). John Hodgson retired in January 1852 and the business was carried on by his brother Robert A. Hodgson (*BNL*, 9 Jan. 1852). The firm closed in the spring of 1853, when its stock was auctioned by Hyndman (*NW*, 24 March 1853; *BNL*, 22, 25 April 1853). Robert Hodgson subsequently moved to London and commenced in the printselling business there in 1858 (*NW*, 9 Oct. 1858).

135. *NW*, 21, 24, 28 Aug. 1852; *BNL*, 25 Aug. 1852. Richard Ormond, *Sir Edwin Landseer* (Philadelphia Museum of Art and Tate Gallery, 1981–2), p.174 contains no reference to the painting having been sent on tour around the British Isles in 1852. Robin Hamlyn of the Tate Gallery has no information about such a tour (communication of 2 Oct. 1992).

136. See Ormond, *Sir Edwin Landseer*, pp.173–4 for information on the painting.

137. *NW*, 28 Aug. 1852.

138. Ibid., 17 June 1848. Magill closed at some point between 1896 and 1909.

139. Besides the four pictures discussed in the text, the other twelve were *Queen Victoria taking the Coronation Oath*, by Sir George Hayter, in 1851 (*NW*, 8 April 1851); *Sir Walter Scott and his Friends at Abbotsford*, by Thomas Faed, in 1852 (ibid., 12 June 1852); *Cromwell's last Interview with his favourite Daughter, Mrs Claypole*, by Charles Lucy, in 1853 (ibid., 16 June 1853); *Napoleon at Bassano: a Lesson in Humanity*, by Thomas Jones Barker, in 1854 (*BNL*, 5 May 1854); *Nelson praying in the Cabin of the Victory, before the Battle of Trafalgar*, *Wellington reading the Indian Despatches* and *Nelson receiving the Swords of the Spanish Officers on board the Quarter-deck of the San Josef*, by Thomas Jones Barker, in 1855 (*NW*, 12 May 1855; *BNL*, 7 Dec. 1855); *Queen Victoria*, by Stephen Catterson Smith, in 1855 (*NW*, 11 Oct. 1855); *Loch Laggan* and *The Watch Dogs*, by Sir Edwin Landseer, in 1856 (ibid., 16 Dec. 1856); *Infant Prayer*, by James Sant, in 1856 (ibid.); *Denizens of the Highlands*, by Rosa Bonheur, in 1859 (ibid., 24 May 1859).

140. *NW*, 28, 30 May, 1, 6 June 1850.

141. Oliver Millar, *The Victorian Pictures in the Collection of Her Majesty the Queen* (Cambridge, 1992), p.129.

142. There are no records in the royal collection regarding the painting having been exhibited in Belfast or Dublin. Information from Charles Noble, assistant to the surveyor of the queen's pictures (letter of 18 Feb. 1993).

143. *NW*, 24, 28 Aug., 2 Sept. 1852. The Victoria and Albert Museum has no record of the painting having been exhibited in Cork and Belfast. Information from Ronald Parkinson (letter of 23 Sept. 1992).

144. Ronald Parkinson, *Catalogue of British Oil Paintings 1820–1860*, Victoria and Albert Museum (London, 1990), pp.257–8.

145. *BNL*, 27 Aug. 1852.

146. *BNL*, 15, 16 Dec. 1856; also Ormond, *Sir Edwin Landseer*, pp.189–90.

147. There is no information in the National Gallery of Victoria's records regarding the painting having been exhibited in Belfast in 1856 (letter of 26 Nov. 1992 from Dr Emma Devapriam).

148. *BNL*, 21, 24 May 1859; *NW*, 24 May 1859. The other work by Bonheur was *Denizens of the Highlands,* on display at Magill's at the same time. These were the first works by the artist to be exhibited in Belfast, according to the author's records.

149. *BNL*, 24 May 1859; also, information from John Leighton, National Gallery (letter of 9 Feb. 1993).

150. Martin Davies, *National Gallery: Catalogue of French School, Early 19th Century, etc.* (London, 1970), pp.10–12. Gambart sold the original to William P. Wright of New Jersey in 1857; see Charles Sterling and Margaretta M. Salinger, *French Paintings: A Catalogue of the Collection of the Metropolitan Museum of Art* (New York, 1966), p.164.

151. Jeremy Maas, *Gambart: Prince of the Victorian Art World* (London: Barrie & Jenkins, 1975), p.181. Bell bequeathed *The Horse Fair* to the National Gallery in 1859.

152. There is no information in the National Gallery archives regarding the various centres in which *The Horse Fair* was exhibited (letter from John Leighton, as note 149 above).

153. *BNL*, 5 Dec. 1853, 15 Sept. 1854, 22 Jan. 1856, 22 Oct. 1858; *BCC*, 26 March 1855.

154. *BNL*, 27 Feb. 1854.

155. Ibid.

156. Besides the seven productions discussed in the text, the other nine were Mons. de la Cambe's *Great Exhibition* cosmorama, in 1852 (*BNL*, 9 April 1852); Thomas's *Panorama of Australia,* in 1853 (ibid., 29 April 1853); *Jerusalem and the Holy Land* diorama, in 1854 (ibid., 6, 27 Feb. 1854); Washington F. Friend's *Panorama of Canada*, in 1857, (*NW*, 4, 18 April 1857); Williams's diorama of Henry Smith's tour of American cities, in 1857 (*BNL*, 20 Oct., 14 Dec. 1857); Henry's diorama of the heavens, in 1857 (*NW*, 5 Nov. 1857); Forrest's *Revolt in India* panorama, in 1858 (*BNL*, 5, 31 May 1858); Hamilton's *Panorama of India*, during 1858–59 (ibid., 10 Dec. 1858, 12 Feb. 1859); panorama of *The Children of Israel,* in 1859 (*NW*, 29 Nov. 1859; *BNL*, 12 Dec. 1859).

157. Risley and Smith (*NW*, 18, 29 Dec. 1849); Barnum's (ibid., 25 Feb., 1 April 1851); Banvard's (ibid., 1, 17 July 1851). See also Ralph Hyde, *Panoramania!* (London: Trefoil Publications Ltd., 1988), pp. 132–3.

158. Hampton's (*NW*, 6 Sept., 11 Oct. 1855); Lancaster's (*NW*, 1 March 1856; *BNL*, 25 March 1856); Gompertz's (*BNL*, 13 May, 14 June 1856); Plimmer's (*NW*, 16 June 1857).

159. *BNL*, 2 April 1856; Mark Haworth-Booth, (ed.), *The Golden Age of British Photography 1839–1900,* Victoria and Albert Museum; Philadelphia Museum of Art; The Museum of Fine Arts, Houston; The Minneapolis Institute of Fine Arts; The Pierpoint Morgan Library, New York; Museum of Fine Arts, Boston, 1984–86, pp.73–4.

160. *BNL*, 21 April 1856.

161. Ibid., 14 April 1856.

162. Ibid., 22, 26 Dec. 1859.

163. Ibid., 26 Dec. 1859. *The Last Judgement*, a fresco 48 x 44 feet, was painted by Michelangelo for the Sistine Chapel 1536–41.

164. *NW*, 1 Oct. 1853.

165. Ibid., 17 Dec. 1853.

166. *BNL*, 6 Oct., 11 Dec. 1854.

167. *NW*, 4 Sept. 1855.

168. Ibid., 3 Nov. 1855.

169. Ibid. Davis, whose ballads appeared in the *Nation* newspaper, appended 'The Belfast Man' to his signature, to distinguish himself from Thomas Davis, the Young Ireland leader and one of the founders of the paper.

CHAPTER SIX
1. *BNL*, 5 Feb. 1867.
2. Ibid., 13 Feb. 1857.
3. *NW*, 8 Feb. 1859.
4. W.A. Maguire, *Belfast* (Keele: Ryburn Publishing, Keele University Press, 1993) p.59.
5. See D.L. Armstrong, 'Social and Economic Conditions in the Belfast Linen Industry 1850–

1900', *Irish Historical Studies*, VII, 28 (Sept. 1951), pp.225–69 for an account of the Belfast linen industry in the second half of the nineteenth century.

6. Emily Boyle, '"Linenopolis": The Rise of the Textile Industry' in J.C. Beckett *et al.*, *Belfast: The Making of the City* (Belfast: Appletree Press, 1983), pp.47–8.

7. Maguire, *Belfast*, pp.61–8.

8. The firm began as wholesale stationers and, in 1842, branched out into lithography and bookbinding. The business expanded considerably between the 1850s and 1870s and in 1874, opened its premier building, the Royal Ulster Works, in Belfast's Dublin Road. Its activities at this time included the manufacture of stationery, photograph albums and office equipment, lithography and bookbinding, the design and production of greetings cards and the production of volumes of illuminated manuscripts and addresses. The company was racked by a series of law suits from 1876 and gradually went into decline from the mid-1880s. It closed in 1901. See Diane Gracey, 'The Decline and Fall of Marcus Ward', *Irish Booklore*, 1, 2, (Aug. 1971), pp.186–202; Diane Gracey, 'Marcus Ward', *Irish Booklore*, 2, 1 (Spring 1972), pp.156–8; Betty Elzea, *The Wards and the Sloans*, Delaware Art Museum, Occasional Paper No.3, 1990; and Roger Dixon, '"By Appointment to Emperors": Marcus Ward and Company of Belfast', in John Gray and Wesley McCann (eds), *An Uncommon Bookman: Essays in Memory of J.R.R. Adams* (Belfast: Linen Hall Library, 1996), pp.34–46.

9. *NW*, 26 Jan. 1864.

10. Ibid., 5 March 1864. There is a brief mention of the art gallery in Elzea, *The Wards and the Sloans*, p.38 but none in the articles by Gracey or Dixon, note 8. For further details of Ward's photographic business, see W.A. Maguire, *A Century in Focus: Photography and Photographers in the North of Ireland 1839–1939* (Belfast: The Blackstaff Press / Museums and Galleries of Northern Ireland, 2000).

11. Gracey, 'The Decline and Fall of Marcus Ward', p.186.

12. Elzea, *The Wards and the Sloans*, pp.14, 44–5. The brothers' birth and death dates are as follow: Francis Davis (1828–1905), John (1832–1912) and William (1842–19?). John was a well-known amateur landscape painter. See John Hewitt and Theo Snoddy, *Art in Ulster: 1* (Belfast: Blackstaff Press, 1977), p.180.

13. Giles Waterfield (ed.), *Palaces of Art: Art Galleries*

in Britain 1790–1990 (Dulwich Picture Gallery and National Gallery of Scotland, 1991–92), pp.162–4.

14. *NW*, 25 June 1864; *BNL*, 27 June 1864.

15. *BNL*, 8, 15 July 1864.

16. Ibid., 15 July 1864.

17. *NW*, 11 Oct. 1864.

18. The exhibition opened on 21 November 1866 (*NW*, 17 Nov. 1866).

19. *NW*, 31 Oct. 1866; *BNL*, 1 Nov. 1866.

20. *NW*, 1, 2 Nov. 1866.

21. Ibid., 2, 8 Nov. 1866.

22. Ibid., 20 Nov. 1866.

23. Ibid. No catalogue of the exhibition has been found and accounts in the local press vary as to the number of exhibits. Only ninety-seven works can be identified.

24. *Art-Journal*, April 1867, p.110.

25. *NW*, 17, 26 Nov. 1866. The latter issue contained the suggestion for organising the Art Union.

26. Ibid., 27 Nov. 1866.

27. Ibid., 31 Dec. 1866.

28. Ibid.

29. *Art-Journal*, April 1867, p.110.

30. *BNL*, 25 Jan. 1867. The committee comprised Robert Boag, Dr Browne, J.M. Calder, T.J. Cantrell, Thomas Jackson, Dr Keown, R.W. Pring, Charles Reynolds, James Stelfox, John Arnott Taylor and J.W. Valentine.

31. *NW*, 31 Dec. 1867.

32. *Art-Journal*, April 1867, p.110.

33. *BNL*, 15 Nov. 1867.

34. According to the *NW* of 3 Jan. 1867, many works had been sold by that point, an indication that private sales were allowed.

35. See section 'The Northern Irish Art Union of 1842' in Chapter Three for details of the operation of art unions.

36. *NW*, 5 Feb. 1867; *Art-Journal*, April 1867, p.110.

37. *BNL*, 31 Oct. 1867. The exhibition opened on 4 November.

38. Ibid.

39. *NW*, 18 Nov. 1867.

40. Ibid., 31 Oct. 1867.

41. Ibid., 31 Dec. 1867.

42. *BNL*, 2 Dec. 1867. The lenders were the Marquess of Downshire and Vere Foster.

43. *NW*, 31 Oct. 1867.

44. *BNL*, 27 Nov. 1867. The committee this year comprised Dr Browne, J.M. Calder, Thomas Cantrell, William Hartley, Dr Keown, Thomas Jackson, Charles Reynolds, James Stelfox, David Taylor and John Arnott Taylor.

45. Ibid., 23 Jan. 1868.

46. The exhibition opened on 19 October 1868 and

closed on 6 February 1869 (*BNL*, 15 Oct. 1868; *NW*, 4 Feb. 1869).

47. *NW*, 30 June 1868. The Ulster Works were supposed to open in September 1868 but did not do so until late February 1869 (*NW*, 22 Feb. 1869).

48. Elzea, *The Wards and the Sloans*, p.17; Dixon, '"By Appointment to Emperors": Marcus Ward and Company of Belfast', p.40.

49. *BNL*, 8 Sept. 1868.

50. *NW*, 4, 5 Dec. 1868. The photographic business was sold to William Scott Parkes and Horatius Gedge. Parkes had been manager of Ward's photographic outlet for four years.

51. *BNL*, 1 March 1869.

52. A catalogue of the exhibition, Young and MacKenzie papers, PRONI D2194/70 numbers the works as 1–573; however, twenty-eight numbers are missing. The valuation is given in *NW* of 4 Dec. 1868.

53. *NW*, 19 Oct. 1868; *BNL*, 20 Oct. 1868.

54. According to the *BNL* of 9 Nov. 1868, a number of works had been sold by this point.

55. *BNL*, 5, 16 Dec. 1868.

56. Ibid., 2 Feb. 1869. The committee members were Robert Boag, William Bottomley, Dr Browne, J.M. Calder, T.J. Cantrell, J.M. Darbishire, James Hamilton, William Hartley, Thomas Jackson, Sir William G. Johnston, Dr Keown, Sir Charles Lanyon, R.W. Pring, Charles Reynolds, James Stelfox, David Taylor, John Arnott Taylor and J.W. Valentine. The Marquess of Donegall was president, Viscount Templeton and Lord Dufferin vice-presidents and Francis Davis Ward honorary secretary (Art Union of Belfast exhibition catalogue, PRONI, Young and Mackenzie papers, D2194/70).

57. Armstrong, 'Social and Economic Conditions in the Belfast Linen Industry 1850–1900', pp.238–9.

58. *BNL*, 11, 28 April 1865.

59. Mary Bennett, *Millais, PRB, PRA* (Walker Art Gallery, Liverpool, 1967), pp.46–7.

60. *BNL*, 10 Oct., 3 Nov. 1865.

61. *BNL*, 11 April 1865; also *NW*, 17 April, 20 Oct. 1865. Both paintings were engraved by T.O. Barlow in 1865. The curator of the Guildhall Art Gallery, Vivien Knight, has no information regarding the paintings having been exhibited in Belfast (letter of 25 Oct. 1993).

62. According to the author's records, the first auction of a work by Millais took place at Lennoxvale, Windsor on 21 October 1858. The auctioneer was John H. Gowan (*BNL*, 21 Oct. 1858).

63. The others were Richard Ansdell, *Rescued*, in 1865 (*NW*, 12 Aug. 1865); Charles Lucy, *Cromwell*

*and his Family at Hampton Court Palace on a Sunday Afternoon, AD 1658*, in 1866 (ibid., 19 Feb. 1866); Thomas Jones Barker, *The Carnival, Rome and Races on the Corso*, in 1866 (ibid., 18 May 1866).

64. *NW*, 27 April, 21 May 1868. Frith received payment in May 1865 and the picture then entered the royal collection. It has hung almost uninterruptedly at Buckingham Palace since its acquisition. A reduced copy, signed and dated 1866, is in the Walker Art Gallery, Liverpool; see Oliver Millar, *The Victorian Pictures in the Collection of Her Majesty the Queen* (Cambridge, 1992), p.73. This may be the replica painted for the art dealer Louis Victor Flatow, who paid Frith £5,000 for copyright and planned an engraving of the work, by W.H. Simmons. Flatow later sold his replica and the engraved plate to Henry Graves, who published the engraving in 1870 (*Art-Journal*, Aug. 1870, p.259).

65. *BNL*, 6 May 1868.

66. *NW*, 16 May 1868.

67. Ibid., 15 July 1867.

68. Other than those described in detail here, the other nineteen displays were Thomas Jones Barker, *Wellington crossing the Pyrenees*, in 1860 (*NW*, 20 March 1860); Thomas Jones Barker, *Garibaldi at Caprera*, in 1862 (ibid., 30 May 1862); John Philip, *The Marriage of the Princess Royal, 25 January 1858*, in 1862 (*BNL*, 22 July 1862); Henry Nelson O'Neil, *Home Again*, in 1863 (ibid., 4 Feb. 1863); Sir Edwin Landseer, *The Maid and the Magpie*, in 1863 (ibid., 5 Aug. 1863); James Sant and David Roberts, *The Saviour journeying to Emmaus*, in 1864 (*NW*, 26 April 1864); Sir Joseph Noël Paton, *The Pursuit of Pleasure*, in 1864 (ibid., 4 June 1864); Henry Courtnay Selous, *Jerusalem in her Grandeur* and *Jerusalem in her Fall*, in 1864 (ibid., 5 Sept. 1864); Gourley Steele, *Queen Victoria at a Cottage Bedside on the Isle of Wight*, in 1865 (*NW*, 26 Jan. 1865); Charles Baxter, portraits of the Prince and Princess of Wales, in 1865 (ibid., 26 Jan. 1865); Theodore Jensen, portraits of the Prince and Princess of Wales, in 1865 (ibid., 4 March 1865); Thomas Jones Barker, *The Intellect and Valour of Great Britain and Ireland*, in 1865 (*NW*, 29 June 1865); Henry Courtnay Selous, *The Crucifixion*, in 1865 (ibid., 12 Oct. 1865); Henry Barraud, *Hyde Park in 1864*, in 1866 (ibid., 12 Jan. 1866); Sir Joseph Noël Paton, *The Silver Cord Loosed*, in 1866 (ibid., 16 Oct. 1866); Jerry Barrett, *A Drawing Room in St James's Palace in the Reign of Queen Victoria*, in 1867 (*NW*, 27 March 1867); Thomas Jones Barker, *The Noble Army of Martyrs*, in 1868 (ibid., 16 May 1868); Henry Gales, *The*

*Derby Cabinet*, in 1869 (ibid., 2 Sept. 1869); Henry Barraud, *The Royal Visit to Punchestown Races*, in 1869 (ibid., 20 Oct. 1869).

69. As, for example, in *BNL*, 3 Oct. 1864, 16 March 1866.

70. *BNL*, 16, 18 May 1863; also *NW*, 16, 23 May 1863.

71. Paula Gillett, *The Victorian Painter's World* (Gloucester: Alan Sutton, 1990), pp.85–6.

72. Information from Robin Hamlyn, Tate Gallery (letter of 16 Sept. 1993). There are no details in the National or Tate Gallery archives concerning early tours of the picture.

73. Simon Wilson, *Tate Gallery: An Illustrated Companion* (London: Tate Gallery, 1989), p.85.

74. Gillett, *The Victorian Painter's World*, p.87.

75. *BNL*, 29 April 1864; *NW*, 26 April, 20 May 1864. The painting was at Mr Cranfield's in Dublin, c.16 March–23 April (*Dublin Evening Mail*, 16 March, 21 April 1864).

76. *BNL*, 16 May 1864. The exhibition was extended for four days and closed on 20 May (ibid., 20 May 1864).

77. *NW*, 30 April 1864. The incident is also referred to in Rev. James Hall Wilson, *The Late Prince Consort: Reminiscences of His Life and Character* (London: F.W. Partridge and Co., 1862), p.22. There is no information in the National Portrait Gallery archives regarding the picture's exhibition in Belfast or Dublin (letter of 28 March 1994 from Dr Peter Funnell, curator of the work).

78. The Printsellers' Association list (details supplied by Funnell, letter of 28 March 1994).

79. *BNL*, 30 April 1864.

80. *NW*, 6 June 1865; *BNL*, 17, 29 June, 3 July 1865.

81. Rosemary Treble, *Great Victorian Pictures: Their Paths to Fame* (Arts Council of Great Britain, 1978) p.46. See also *The Pre-Raphaelites*, Tate Gallery, 1984, pp.158–60 for a fuller discussion of the painting.

82. *NW*, 9 June 1866; *BNL*, 29 June 1866.

83. Treble, *Great Victorian Pictures: Their Paths to Fame*, pp.36–7.

84. Jeannie Chapel, *Victorian Taste: The Complete Catalogue of Paintings at the Royal Holloway College* (London, 1982), pp.87–92. The figure of £4,500 included picture and copyright. The painting was exhibited at Flatow's gallery in The Haymarket between April and September 1862 and was subsequently shown at Haywood and Leggatt's in Cornhill.

85. Treble, *Great Victorian Pictures: Their Paths to Fame*, p.37.

86. *BNL*, 22 June 1866.

87. *BNL*, 2 March 1860, 15 Sept. 1864; *NW*, 17 Jan., 19 Nov. 1863, 7 Dec. 1864, 25 Feb., 12 Oct. 1865, 5, 13 March, 17 Aug. 1866, 8 July 1867.

88. *NW*, 29 Feb., 1 Oct. 1864. The business also supplied watercolours and chromolithographs for hire to teachers, amateur artists and 'summer sketchers' and employed a 'stable' of painters to produce oil and watercolour portraits from life or cartes de visite (*NW*, 27 July 1863, 6 July 1864; *BNL*, 28 Nov. 1864).

89. Maguire, *A Century in Focus: Photography and Photographers in the North of Ireland 1839–1939*, pp.22–3. Magill purchased the contents of Sarony's studio by July 1861 (*NW*, 8 July 1861; *BNL*, 26 July 1861).

90. The nine firms were David Morton (1862), Hugh Hamilton (1863), Thomas H. Thompson (1867), John Press (1867), Michael Woods (1867), W. Cambridge (1867), Carse and Henderson (1868), N.A. Campbell (1868) and William Montgomery (1869). First advertisement found for Morton is in *BNL*, 22 Dec. 1862; for Hamilton, *NW*, 10 Nov. 1863; for Thompson, ibid., 24 April 1867; for Press, ibid., 13 Aug. 1867; for Woods, *NW*, 28 Aug. 1867; for Cambridge, ibid., 26 Oct. 1867; for Carse and Henderson, ibid., 17 April 1868; for Campbell, *NW*, 22 Dec. 1868; for Montgomery, *BNL*, 27 April 1869. Only Hamilton, Campbell and Montgomery remained in business to the 1880s. Last advertisement found for Morton is in *NW*, 5 April 1871; for Thompson, *BNL*, 5 Nov. 1873; for Press, *BNL*, 11 Oct. 1867; for Woods, *NW*, 7 Aug. 1869; for Cambridge, ibid., 27 April 1870; for Carse and Henderson, *BNL*, 29 Oct. 1868.

91. The last auction found for John Devlin is in *BNL*, 6 Dec. 1865. He was dead by May 1867, when Cramsie auctioned his stock (*NW*, 7 May 1867). Hyndman retired in July 1866, when his business was taken over by a relative, William McTear (*NW*, 16 July 1866). McTear's last auction advertisement is in *BNL*, 24 Oct. 1867. Hyndman died on 18 Dec. 1867 (*NW*, 20 Dec. 1867). Firms of little consequence were those of Morton, Thompson, Press, Woods, Cambridge and Carse and Henderson.

92. Hyndman undertook this from the early 1840s – see *BNL*, 10 Feb. 1843; *BCC*, 15 May 1843, 13 Oct. 1845, 4 May 1846.

93. Dealers' visits to Belfast became infrequent by the mid-1840s. Those known to have come between 1837 and 1846 included Bartholomew Watkins, a leading Dublin dealer, G. Watkins, also from Dublin, and John Workman of Edinburgh and Glasgow (*BCC*, 10 May 1837, 25 Feb. 1846; *NW*, 28 April 1842).

94. The total number of Cramsie's sales found for this period was 120.

95. An auction for Benjamin was held on 6 April 1869 (*BNL*, 6 April 1869), auctions for Radcliffe on 9 Nov., 20 Dec. 1864, 4 July 1865 (*NW*, 2 Nov., 14 Dec. 1864, 1 July 1865), those for Paterson on 25 March, 15 Oct. 1862, 4 Oct. 1864, 27 Nov. 1867, 10 Nov. 1868 (ibid., 26 March, 16 Oct. 1862, 4 Oct. 1864, 16 Nov. 1867; *BNL*, 4 Nov. 1868).

96. Auctions for the Everards were held on 27, 29 March, 17 Aug., 9–10 Nov. 1860, 18–19 Jan. 1867 (*NW*, 7, 19 March, 11 Aug., 8, 10 Nov. 1860, 16 Jan. 1867).

97. *NW*, 21 Oct. 1865.

98. He held fifty auctions between 1860–69, of which eight were devoted to fine art.

99. An auction for the London Print Publishing Co. Ltd was held on 17 June 1868, one for Kelly and Co. on 2 Aug. 1869 (*NW*, 13 June 1868; *BNL*, 31 July 1869).

100. Gowan held forty auctions, seven of them exclusively fine art. His sale for Kelly and Co. was held 18–20 Sept. 1865 (*NW*, 20 Sept. 1865).

101. *BNL*, 30 Oct. 1866.

102. Ibid.

103. The sale was on 11 May 1869 (*BNL*, 8 May 1869).

104. Clarke held thirty auctions in total 1860–69.

105. *BNL*, 24 Oct., 4, 10 Nov. 1868.

106. The Leeds Exhibition of 1868 was a large-scale show on the lines of the Manchester Art Treasures Exhibition of 1857.

107. *BNL*, 12 Nov. 1868.

108. Ibid., 23 Nov., 2 Dec. 1868.

109. The other buyers were Mr Finlay, Alexander Guild, Alexander Johnston, James McCaw, Thomas Meadley, Rev. T.E. Miller, John Musgrave and William Spotten (*BNL*, 12 Nov. 1868; *NW*, 12, 13 Nov. 1868).

110. Hyndman held eleven fine art auctions.

111. *NW*, 5 Aug. 1870.

112. *BNL*, 28 Nov. 1859. The committee comprised the following: Dr Thomas Andrews, Robert Batt, Rev. Robert W. Bland, Theobald Bushell, Rev. Dr Henry Cooke, James Crawford, Richard Davison, Bishop of Down, Connor and Dromore, John F. Ferguson, John Grainger, Rev. Dr P.S. Henry, George C. Hyndman, Charles Lanyon, William T.B. Lyons, Robert MacAdam, Dr William McGee, Rev. William McIlwaine, Henry H. McNeile, Dr James Moore, Robert Patterson, Surgeon-Major Pilleau, Surgeon-Major Prendergast, Dr Henry Purdon, Dr Thomas Reade, Professor Stevelly, Professor Tait, William S. Tracy, Professor Wyville Thomson.

113. According to the *NW* of 28 Nov. 1859, *conversazioni* were 'not very usual hitherto in this town'. The only *conversazioni* known to the author, prior to this one, were those held by the School of Design, as discussed in Chapter Four.

114. *BNL*, 28 Nov. 1859.

115. There is extensive coverage of the event in the *NW* of 5 Jan. 1860.

116. *BNL*, 19 July 1861; *NW*, 19 July 1861.

117. A lithograph of the work, published by James Magill, bears the inscription: 'With the villas erected and in progress, part of which is laid out for building as per map accompanying, the view situated within two miles of Belfast and commanding extensive prospects of the Lough and County Antrim mountains.'

118. See Eileen Black, *Paintings, Sculptures and Bronzes in the Collection of The Belfast Harbour Commissioners, Ulster Museum, 1983* (Belfast Harbour Commissioners, 1983), pp.15, 75.

119. *BNL*, 23 Sept. 1863; *NW*, 12, 26 Oct., 2 Nov. 1863.

120. Reproduced in *ILN*, 10 Oct. 1863 (*NW*, 12 Oct. 1863).

121. *View of Sydenham New Park from Belfast Lough* is reproduced in *McComb's Guide to Belfast* (Belfast: William McComb, 1861; republished by S.R. Publishers Ltd., East Ardsley, Wakefield, 1970). Facsimiles of the lithographs of *Bird's Eye View of Belfast* and *Belfast from St John's Church* were published by the Linen Hall Library in 1982 and 1988.

122. *BNL*, 17, 24, 26 Sept. 1860.

123. *NW*, 6, 12, 14 Dec. 1866.

124. See Andrew Graham-Dixon, 'Cruikshank and the Demon Drink', *Sunday Telegraph* magazine, 20 May 2001, pp.30–3. The painting, decayed and forgotten for many years, was restored and exhibited at Tate Britain, 24 May–2 Dec. 2001, in 'Demon Drink: George Cruikshank's "The Worship of Bacchus" in Focus'.

125. Quotation from Graham-Dixon, 'Cruikshank and the Demon Drink', p.33.

126. Cruikshank's lecture notes were read by Mr R.P. Mace (*NW*, 14 Dec. 1866).

127. *BNL*, 11 Dec. 1865; *NW*, 21 Dec. 1865.

128. *NW*, 22 Dec. 1865.

129. Hamilton, *Diorama of Continental Scenery*, in 1860 (*NW*, 14 July 1860); *Pilgrimage through the Holy Land*, in 1861 (ibid., 23 March 1861); Professor Clarke, *Panorama of the Holy Land*, in 1862 (ibid., 4 Aug. 1862); Sinclair, *Panorama of India and Italy*, in 1862 (ibid., 11 Aug. 1862); W.H. Edwards, *Canada and the Far West*, in 1862 (ibid., 25 Dec. 1862); McLeod, *Panorama of the Struggles for Liberty of*

*Sir William Wallace and King Robert Bruce*, in 1863 (*NW*, 13 March 1863); W.H. Edwards, *Two Hours in the New World*, in 1863 (ibid., 1 April 1863); *Panorama of Irish Scenery*, in 1863 (ibid., 1 April 1863); *Diorama of the Holy Land*, in 1863 (ibid., 28 July 1863); Professor F.A. Gosnold, *Optical Diorama of Ireland and America*, in 1863 (ibid., 6 Oct. 1863); W.H. Edwards, *Great Panorama of the War in America* and *Wanderings in the Far West*, in 1864 (*NW*, 12 Nov. 1864); Dr T.C. Corry. *Ireland, its Scenery, Music and Antiquities*, in 1864 (ibid., 7 Dec. 1864); Dr T.C. Corry, *Diorama of Ireland* (originally *Ireland, its Scenery, Music and Antiquities*) in 1865 (ibid., 9 Nov. 1865); Hamilton, *Diorama of Continental Scenery*, in 1867 (ibid., 4 Feb. 1867); Dr T.C. Corry, *Diorama of Ireland*, in 1867 (ibid., 19 Dec. 1867); *Royal Diorama of Scotland*, in 1868 (*NW*, 24 Oct. 1868); W.H. Edwards, *Life and Scenes in America*, in 1869 (ibid., 11 Sept. 1869); Dr T.C. Corry, *Ireland in Shade and Sunshine*, in 1869 (*BNL*, 8 Dec. 1869).

130. *NW*, 20 Dec. 1864.
131. Ibid. For a light-hearted account of Dr Corry and *Ireland, its Scenery, Music and Antiquities*, see Cathal O'Byrne, *As I Roved Out* (Dublin: At the Sign of the Three Candles, 1946), pp.23, 190–2.
132. *NW*, 9 Nov. 1865.
133. Ibid., 19 Dec. 1867.
134. *NW*, 5 Oct. 1869, 7 Jan. 1870; *BNL*, 8 Dec. 1869.

## CHAPTER SEVEN

1. *BNL*, 14 Oct. 1878.
2. For his obituary, see *BNL*, 29 Dec. 1922; *BT*, 29 Dec. 1922.
3. *BT*, 29 Dec. 1922.
4. L'Estrange and Brett papers, PRONI D1905/2/45/9 (a notice of dissolution of the partnership of Rodman and Adrian); also *BNL*, 1 June 1870.
5. *NW*, 5 Aug. 1870; *BNL*, 5 Aug. 1872; *NW*, 3 March 1874.
6. *BNL*, 23 Nov. 1875, 17 March 1876.
7. *NW*, 2 Feb. 1871, 19 Feb. 1890.
8. Excluding the works by van Lerius, Rodman's one-picture exhibitions were Sir Joseph Noël Paton, *Faith and Reason*, in 1872 (*BNL*, 5 July 1872); William Bradford, *Crushed by Icebergs* and Thomas Faed, *A Wee Bit Fractious* and *Saturday Afternoon*, in 1873 (*NW*, 5, 19 May 1873).
9. *NW*, 29 April, 23 May 1872.
10. *BNL*, 27 April 1872.
11. *NW*, 30, 31 March 1874; *BNL*, 4 April 1874.
12. L'Estrange and Brett papers, PRONI D1905/2/

45/9. It has not been possible to trace Rodman's records, despite an appeal in the *BT* of 13 Sept. 1996.
13. *BNL*, 17 Oct. 1877.
14. Ibid. (both quotations).
15. Ibid.
16. *NW*, 16 Oct. 1877; *BNL*, 17 Oct. 1877.
17. *BNL*, 17 Dec. 1877.
18. Ibid., 22 Feb., 2 March 1878.
19. See, for example, *NW*, 4 Dec. 1862, 20 Feb. 1863, 13, 25 June 1864, 15 Feb. 1866.
20. Ibid., 2 March 1878.
21. Anthony Dyson, *Pictures to Print: The Nineteenth-century Engraving Trade* (London: Farraud Press, 1984), pp.ix, 3.
22. *BNL*, 2 March 1878.
23. Although he had held black and white exhibitions in 1878 and 1879, Rodman, for reasons unknown, advertised the show of 1881 as his first such venture.
24. Rodman described his etching and engraving exhibition of 1879 as 'black and white', in an advertisement in the *BNL* of 12 May. Admission was free in 1879, then six pence between 1881 and 1883 and free again from 1884.
25. *Art-Journal*, Aug. 1872, p.212. The Dudley Gallery (1865–1918?), intended as a rival to the Royal Academy, held a spring show of watercolours, a winter oil-painting exhibition and a show devoted to prints and drawings. See Susan P. Casteras and Colleen Denney (eds), *The Grosvenor Gallery: A Palace of Art in Victorian England* (New Haven and London: Yale University Press, 1996), p.13.
26. *NW*, 5 April 1886.
27. *BNL*, 5 April 1886.
28. *NW*, 4 April 1887.
29. Between 1877 and 1888, the only exhibition not opened in October was that of 1885, which commenced in late September.
30. *BNL*, 3 Oct. 1881.
31. Ibid., 7 Oct. 1881.
32. Sales are known to have been good in 1880, 1882 and 1885 (*BNL*, 9 Nov. 1880, 19 Oct. 1885; *NW*, 22 Nov. 1882).
33. *NW*, 15 Oct. 1883.
34. *BNL*, 15 Oct. 1883.
35. Both types of exhibition continued until at least 1907 (*NW*, 11 April 1907; *BNL*, 7 Oct. 1907).
36. *BNL*, 16 April 1886.
37. In 1876 three presentation portraits by Jones were unveiled in Belfast, those of James Alexander Henderson in the Town Hall, Sir James Hamilton in Belfast Harbour Office and David Cunningham in the Samaritan Hospital (*BNL*, 11, 18 July, 28

Dec. 1876). In 1884 his portrait of Queen Victoria, for Belfast town council, was unveiled by the Lord Lieutenant, Earl Spencer (*BNL*, 19 June 1884). This latter was probably the most prestigious of his numerous local commissions during the 1880s.

38. *NW*, 10 June 1886, 4 Aug. 1887.

39. *BNL*, 5 Aug. 1886.

40. *BNL*, 17 July 1879, 1 June 1881; *NW*, 9 June 1887.

41. *BNL*, 11 July 1885.

42. Ibid.

43. Ibid., 13, 17 June 1882. The lecture was held in the Ulster Hall on 16 June.

44. Besides the four works dealt with in the text, the selection comprised Sir Joseph Noël Paton, *Life or Death* or *The Man with the Muck Rake*, in 1879 (*NW*, 25 Feb. 1879); Sir John Everett Millais, *The Princes in the Tower*, in 1880 (*BNL*, 5 Feb. 1880); Sir Joseph Noël Paton, *Satan watching the Sleep of Christ in the Wilderness*, in 1880 (*NW*, 7 Aug. 1880); Sir Joseph Noël Paton, *In Die Malo*, in 1883 (ibid., 4 June 1883); Sir Joseph Noël Paton *Lux in Tenebris*, in 1884 (*BNL*, 22 Aug. 1884); Edwin Long, *Thisbe*, in 1885 (ibid., 28 May 1885); Marcus Stone, *The Peacemaker*, in 1887 (*BNL*, 9 May 1887); Frederick Goodall, *For of Such is the Kingdom of Heaven*, in 1887 (*NW*, 23 June 1887); E. Goodwyn Lewis, *The Last Supper*, in 1888 (*BNL*, 2 Feb. 1888).

45. *BNL*, 28 March, 13 April 1878. Bradford Art Gallery has no information regarding the painting's provenance prior to 1885 (letter of 22 June 1995 from Christine Hopper).

46. *BNL*, 9 April 1878.

47. Ibid; also *NW*, 1 April 1878.

48. *NW*, 2 Feb. 1882; *BNL*, 27 Feb. 1882. The Laing Art Gallery has no details of the picture's provenance before 1914 (letter of 4 April 1997 from Sarah Richardson).

49. For ready reference, the others were: *The Pursuit of Pleasure* (Magill, 1864); *The Silver Cord Loosed* (Magill, 1866); *Mors Janua Vitae* (Magill, 1871); *Faith and Reason* (Rodman, 1872); *Life or Death* or *The Man with the Muck Rake* (Rodman, 1879); *Satan watching the Sleep of Christ in the Wilderness* (Rodman, 1880).

50. *In Die Malo* (Rodman, 1883); *Lux in Tenebris* (Rodman, 1884); *Vigilate et Orate* (Magill, 1887).

51. Preached by Rev. G.R. Maxwell in Spamount Church, North Queen Street on 12 Feb. 1882 (*BNL*, 11 Feb. 1882).

52. *BNL*, 5, 23 Feb. 1880. The paintings were accompanied by a copy of Thompson's *The Roll Call*, by M. Jazet, and *The Princes in the Tower*, by Sir John Everett Millais. The National Gallery of Victoria has no details regarding the exhibition of *Quatre Bras* in Belfast and afterwards Derry (letter of 16 June 1993 from Sonia Dean). The gallery acquired the work in 1883.

53. Paul Usherwood and Jenny Spencer-Smith, *Lady Butler: Battle Artist 1846–1933* (National Army Museum, 1987), pp.61–2.

54. Ibid., p.61.

55. Ibid., pp.77–8.

56. The Tate Gallery, which acquired the painting in 1897, has no information concerning the picture having been exhibited in Belfast and afterwards Derry (letter of 19 June 1995 from Robert Upstone).

57. Usherwood and Spencer-Smith, *Lady Butler: Battle Artist 1846–1933*, pp.37–40.

58. *NW*, 1 June 1896, 11 April, 4 Oct. 1907.

59. See *BNL*, 29 December 1922; *BT*, 29 Dec 1922 for his obituary. See also *Belfast Directories* for listings of the firm.

60. Besides William Holman Hunt's *The Shadow of Death*, the others were Sir Joseph Noël Paton, *Mors Janua Vitae*, in 1871 (*NW*, 23 May 1871); Thomas Jones Barker, *Sedan*, in 1872 (ibid., 2 March 1872); unknown artist, *The Royal Agricultural Show, Dublin, 1871*, in 1872 (ibid., 9 Aug. 1872); Henry Barraud and J. Hayter, *The Irish House of Commons, 1790*, in 1873–74 (*NW*, 12 Dec. 1873); Edwin Long, *A Question of Propriety*, in 1877 (ibid., 12 May 1877); Robert Dowling, *Moses on Mount Nebo*, in 1877 (ibid., 13 Nov. 1877); Thomas Jones Barker, *The Death of the Princess Elizabeth*, in 1879 (*NW*, 8 Oct. 1879); Charles Mercier, *The late Lord Beaconsfield and Cabinet in Council*, in 1883 (ibid., 6 July 1883); Sir Joseph Noël Paton, *Vigilate et Orate*, in 1887 (ibid., 11 June 1887); Theodore Blake Wirgman, *Peace with Honour. Her Majesty the Queen giving Audience to the Earl of Beaconsfield in 1887* (ibid., 8 July 1887).

61. *BNL*, 30 June, 20 July 1875.

62. The large painting was exhibited in London, then Oxford, Manchester, Liverpool and Dublin. It was presumably shown in Belfast after this latter venue. There is no information in Manchester City Art Galleries' archive regarding its Belfast showing (letter of 16 Dec. 1994 from Sandra Martin).

63. *The Pre-Raphaelites* (Tate Gallery, London,1984), pp.221–3.

64. *BNL*, 3 Jan. 1870, 9 June 1885; *NW*, 1 Feb. 1876.

65. *NW*, 23 Jan. 1880. For information on Cooper, see Paul Larmour, *The Arts and Crafts Movement in Ireland* (Belfast: Friar's Bush Press, 1992), pp.5–6.

66. *BNL*, 9 March 1881.

67. *NW*, 3 Feb. 1880, 20 Jan. 1881.
68. *BNL*, 7 Jan., 2 Oct. 1884.
69. Ibid., 23 Dec. 1887, 28 Feb. 1888.
70. *Belfast Directory*, 1895.
71. The firm is recorded in the *Belfast Directory* of 1899 but not in that of 1900.
72. See Martyn Anglesea, *The Royal Ulster Academy of Arts* (Belfast: The Royal Ulster Academy of Arts, 1981), pp.7–25.
73. Ibid., p.8. The author has found no details of this club in the press.
74. *NW*, 28 Nov. 1881; *BNL*, 29 Nov. 1881. The church concerned was the Secession Church.
75. Anglesea, *The Royal Ulster Academy of Arts*, p.10 states that two more exhibitions were held in the Botanic Avenue premises. However, the author has found record of only one, that in December 1882 (*BNL*, 6 Dec. 1882). This was the club's second exhibition and comprised almost 200 watercolours (*NW*, 5 Dec. 1882).
76. *BNL*, 17 Jan. 1885.
77. Anglesea, *The Royal Ulster Academy of Arts*, p.10.
78. *NW*, 11 Nov. 1885.
79. Anglesea, *The Royal Ulster Academy of Arts*, p.14.
80. *BNL*, 5 Aug. 1886.
81. Anglesea, *The Royal Ulster Academy of Arts*, p.17.
82. *NW*, 14 Feb., 13 July, 16 Aug. 1888; Anglesea, *The Royal Ulster Academy of Arts*, pp.20–1.
83. Anglesea, *The Royal Ulster Academy of Arts* is the main history of the Belfast Art Society and its successors.
84. *NW*, 22 April 1886.
85. Ibid., 26 April 1886.
86. Ibid., 29 April 1886.
87. Ibid., 28 April 1886.
88. Ibid., 10 May 1886.
89. Others on the committee were Edward Allworthy, R.J. Callwell, Dr Samuel Dickey, J.H. Haslett, James Henderson, William Henry Lynn, W.F. MacElheran, James Magill, A.W. Munster, Andrew Nicholl, R.H. Reade, Robert Young.
90. *Catalogue of Water Colour Drawings by the late Andrew Nicholl, RHA*, 55 Donegall Place, Belfast, 26 May 1886.
91. According to the *NW* of 28 May, the exhibition was to close in a few days. The exact date is unknown.
92. *BNL*, 26 May 1886 (quotation); *NW*, 26 May 1886.
93. The *conversaziones* were as follows: Belfast Naturalists' Field Club (BNFC), 3 May 1871 (*NW*, 4 May 1871); Belfast Natural History and Philosophical Society (BNHPS), 6 May 1875 (ibid., 7 May 1875); BNHPS, 26 October 1877 (*BNL*, 30 Oct. 1877); BNHPS, 1 November 1878 (ibid., 5 Nov. 1878); BNFC, 7 November 1879 (ibid., 11 Nov. 1879); BNFC, 22 October 1880 (*BNL*, 27 Oct. 1880); Working Men's Institute, 3, 4, 5 March 1881 (ibid., 4 March 1881); BNFC, 8 November 1881 (ibid., 12 Nov. 1881).
94. *NW*, 7 May 1875; *BNL*, 30 Oct. 1877, 12 Nov. 1881.
95. *BNL*, 4 March 1881.
96. Duncan McLaren, *Diorama of Scotland*, in 1870 (*NW*, 2 Aug. 1870); Poole and Young, *Panorama of the Franco-Prussian War*, in 1871 (*BNL*, 27 Feb. 1871); Birrell and Lamb, *Royal Diorama of Scotland*, in 1871 (ibid., 14 Oct. 1871); Dr T.C. Corry, *Diorama of Irish Scenery*, during 1871–72 (ibid., 11 Dec. 1871, 19 Jan. 1872); Dr T.C. Corry, *National Diorama of Ireland*, in 1872 (*BNL*, 11 Jan. 1872); J.S. Edwards, *Diorama of the Continent and America*, in 1872 (ibid., 3 Feb. 1872); Hardy Gillard, *Great American Panorama*, in 1872 (ibid., 22 July 1872); Dr T.C. Corry, *Ireland in Shade and Sunshine*, in 1872 (ibid., 25 Oct. 1872); Hamilton and Overend, *Diorama of Thanksgiving Day* and *Diorama of the Franco-Prussian War*, in 1873 (*BNL*, 29 Jan. 1873); Dr T.C. Corry, *Ireland in Shade and Sunshine*, in 1873 (ibid., 12 April 1873); Hardy Gillard, *Great American Panorama*, in 1875 (ibid., 11 Nov. 1875); J.S. Edwards, *Diorama of the Continent and America*, in 1876 (ibid., 20 March 1876); Dr T.C. Corry, *Ireland, its Scenery, Music and Antiquities*, in 1876 (*BNL*, 14 April 1876); John Banvard, *Panorama of America and Canada*, in 1876 (ibid., 25 April 1876); Dr T.C. Corry, *Ireland, its Scenery, Music and Antiquities*, in 1877 (*NW*, 13 Jan. 1877); Alexander Lamb, *Royal Diorama of Scotland*, in 1878 (ibid., 21 Nov. 1878); Dr T.C. Corry, *Ireland, its Scenery, Music and Antiquities*, during 1879–80 (ibid., 19 Dec. 1879, 22 Jan. 1880); Dr T.C. Corry, *Ireland, its Scenery, Music and Antiquities*, during 1880–81 (*BNL*, 23 Dec. 1880, 17 Jan. 1881); Hamilton, *Voyage round the World*, in 1881 (ibid., 20 Jan. 1881); *Great Zealandia Panorama of New Zealand*, in 1881 (ibid., 4 July 1881); W.H. Edwards, *Two Hours in America*, during 1881–82 (*BNL*, 19 Dec. 1881, 21 Jan. 1882); W.H. Edwards, *Life and Scenes in America*, in 1882 (ibid., 3 April 1882); Henry Howard, *London to the Battlefields of Egypt*, in 1882 (ibid., 17 Oct. 1882); *Zealandia*, during 1883–84 (*NW*, 28 Dec. 1883, 22 Jan. 1884); J.H. Drake, *Great Excursions from London to India and Back*, in 1884 (*BNL*, 7 June 1884); Henry Howard, *Round the Globe*, in 1884 (ibid., 15 Sept. 1884); Washington, *Diorama of Scotland*, during 1884–85 (ibid., 23 Dec. 1884, 5 Jan. 1885); H.A. Kennith,

*Diorama of America and Canada* during 1884–85 (*BNL*, 23 Dec. 1884); *Zealandia*, during 1885–86 (ibid., 25 Dec. 1885, 27 Jan. 1886); Henry Howard, *Liverpool to Burmah*, during 1886–87 (ibid., 22 Dec. 1886, 3 Jan. 1887); Charles W. Poole, *Picturesque Trips Abroad*, in 1887 (*BNL*, 30 July 1887); George Poole, *Picturesque Trips Abroad*, in 1888 (ibid., 7 Aug. 1888).

97. See Cathal O'Byrne, *As I Roved Out* (Dublin: At the Sign of the Three Candles, 1946), pp.190–2.

98. The town's second public statue was actually that of the Prince Consort by Samuel Ferres Lynn, erected on the front of the Albert Memorial Clock in Queen's Square. However, it was neither free-standing, like the statues of the Earl of Belfast and Cooke, nor immediately before the public, being in a niche some forty feet off the ground. The clock tower was completed in mid-1869 and the statue placed in position in Jan. 1870 (*NW*, 26 May, 2 July 1869, 15 Jan. 1870).

99. *NW*, 25 March 1876.

100. Ibid., 11 March 1876.

101. Ibid., 12 May 1876.

102. The memorial was to comprise a statue and a meeting hall for the Presbyterian General Assembly, with subscribers free to contribute to either or both projects. In Nov. 1869 the memorial committee split into two distinct groups, one to pursue the statue, the other the hall (*BNL*, 30 Dec. 1868; *NW*, 29 Jan., 30 Nov. 1869).

103. For details on Cooke, see R. Finlay Holmes, *Henry Cooke* (Belfast, Dublin, Ottawa: Christian Journals Ltd., 1981).

104. *BNL*, 25 Oct. 1870; *NW*, 18 Feb. 1874.

105. *NW*, 28 Feb., 6, 7 March 1874; *BNL*, 11 March, 16, 22 April 1874.

106. *BNL*, 12 May 1874.

107. *NW*, 3 Aug. 1874.

108. Ibid., 2 May 1874.

109. At the town council meeting on 1 May (1874), alderman Robert Boag expressed concern that 'If [the earl's statue] were being taken away to make room for another statue [namely, Cooke's], it was a grand mistake'. Councillor William Mullan of the town improvement committee reassured him that nothing of the kind was contemplated (ibid., 2 May 1874).

110. *BNL*, 18 June 1874.

111. *NW*, 25, 27, 30 June, 7 July, 3 Aug. 1874. The resolution to grant the site was carried by eighteen votes to four, with Gaffikin and Boag being amongst the opposition (ibid., 3 Aug.).

112. *NW*, 4, 10, 11 Aug. 1874.

113. Ibid., 11 Aug. 1874.

114. Ibid., 11 March 1876.

115. Ibid.

116. Lynn was the brother of the Belfast-based architect William Henry Lynn. See Martyn Anglesea, 'The Lynn Brothers, Architect and Sculptor', *Irish Arts Review*, Yearbook 1989–90, pp.254–62; Eileen Black: *Paintings, Sculptures and Bronzes in the Collection of The Belfast Harbour Commissioners*, Ulster Museum, 1983 (Belfast Harbour Commissioners, 1983), pp.63–4, 126–7; Eileen Black: *A Sesquicentennial Celebration: Art from The Queen's University Collection*, Ulster Museum, 1995 (Queen's University of Belfast, 1995), pp.52–3, 117.

117. *BNL*, 25 Oct. 1870, 25 Aug. 1871. A sketch model of the group was on view at E.T. Church's in Donegall Place in October 1870, whilst a model for the principal figure was to be seen there the following August. An engraving of the group as a unit is in J.L. Porter, *The Life and Times of Henry Cooke, D.D., LL.D.* (London: John Murray, 1871), p.1.

118. *NW*, 18 Feb. 1874, 11 March 1876.

119. Their locations are as follow: Harland, City Hall grounds, 1903; Haslett, City Hall grounds, 1909; Dufferin and Ava, City Hall grounds, 1906; Kelvin, Botanic Gardens, 1913; Hanna, Carlisle Circus, 1894. (Years given are unveilings.)

120. Clarke died on 23 September 1870, after which his son took charge (*NW*, 24 Sept. 1870), Gowan on 29 March 1872 (*BNL*, 30 March 1872), Hamilton on 29 June 1881 (ibid., 30 June 1881).

121. The twenty-seven firms were P.J. Woods, 1871 (*NW*, 5 July 1871); Adam Craig, 1872 (*BNL*, 12 July 1872); Joseph Thompson, 1872 (ibid., 21 Dec. 1872); William Hunter, 1873 (ibid., 17 June 1873); Thompson and Henderson, 1874 (*BNL*, 1 Jan. 1874); James Meharg, 1874 (ibid., 27 Aug. 1874); Samuel Anderson, 1874 (ibid., 22 Sept. 1874); William Dysart, 1874 (*BNL*, 7 Nov. 1874); William B. Caughey, 1875 (ibid., 1 Jan. 1875); Mr Parker, 1875 (*NW*, 14 May 1875); Samuel Morton, 1876 (*BNL*, 28 Sept. 1876); James Morton, 1877 (ibid., 21 March 1877); William John McCoy, 1877 (ibid., 17 July 1877); John Ward, 1879 (*BNL*, 28 Feb. 1879); Robert Stewart, 1879 (*NW*, 2 June 1879); James McCann, 1881 (*BNL*, 13 Jan. 1881); Walter Watson, 1881 (*NW*, 29 June 1881); Robert Metcalfe, 1881 (*BNL*, 13 July 1881); Samuel Murphy, 1881 (ibid., 23 Aug. 1881); Robert H. Stitt, 1881 (ibid., 20 Dec. 1881); William Johnston, 1882 (*BNL*, 12 April 1882); Thomas Somers, 1882 (ibid., 5 Dec. 1882); Metcalfe and Murphy, 1883 (ibid., 25 Jan. 1883); J.H. Mulholland, 1883 (*BNL*,

5 Feb. 1883); J.H. Smyth, 1883 (ibid., 27 Oct. 1883); J. Briggs and Co., 1887 (ibid., 10 Sept. 1887); William Barry, 1887 (*BNL*, 24 Oct. 1887). Dates in brackets refer to the first advertisements found. The fifteen short-lived firms were Woods, Craig, Thompson, Thompson and Henderson, Meharg, Caughey, Parker, McCoy, McCann, Murphy, Stitt, Johnston, Metcalfe and Murphy, Briggs and Co., Barry.

122. The twelve firms operating in 1885 were N.A. Campbell, John Cramsie, William Hunter, Patrick McShane, Robert Metcalfe, William Montgomery, James Morton, James H. Smyth, Thomas Somers, Robert Stewart, John Ward, Walter Watson.

123. The nine auction houses in 1888 were those of N.A. Campbell, John Cramsie, Patrick McShane, Robert Metcalfe, William Montgomery, James Morton, James H. Smyth, Robert Stewart, Walter Watson.

124. Cramsie held 386 auctions in all by 1888, of which eighty-six were specifically fine art sales. The remainder were combined art and furniture auctions.

125. Cramsie died on 15 September 1882 (*NW*, 16 Sept. 1882). According to the *BNL* of 10 Oct. 1882, Cramsie Jr had worked in his father's firm since 1864.

126. Morton held 292 auctions 1877–88, twenty-two of them exclusively fine art.

127. *BNL*, 2, 10, 14, 15 Oct. 1878. The London dealer is unnamed.

128. Sir Robert Ensor, *England 1870–1914* (Oxford: Clarendon Press, 1936), p.111.

129. *BNL*, 15 Oct. 1878.

130. Clarke died on 23 September 1870 and the business was carried on by his son, Mr S. Clarke (*NW*, 24 Sept. 1870). The firm held 265 auctions 1870–88, eleven of them specifically fine art.

131. *BNL*, 9, 11 May 1881.

132. *NW*, 13 May 1881.

133. *BNL*, 16 June 1881.

134. Owned by the Rev. David Hogarth, they were advertised as never having been out of the Hogarth family's possession.

135. *BNL*, 22 June 1881.

136. A painting of the same title, whereabouts unknown, is listed in the 1980 catalogue raisonné of Whistler's work; see Andrew McLaren Young, Hamish Miles, Margaret MacDonald and Robin Spencer, *The Paintings of James McNeill Whistler* (New Haven and London: Yale University Press, 1980), p.89, n.146a. There is no information regarding the picture having been purchased at the Belfast sale.

137. S.B. Kennedy, *Irish Art and Modernism 1880–1950* (Belfast: The Institute of Irish Studies, The Queen's University of Belfast, 1991), pp.4–5. Examples by Whistler may have gone through the Dublin auction rooms prior to December 1884; however, there is no information available regarding this.

138. *BNL*, 9 May, 16 June 1881.

139. Ibid., 11, 31 May 1881.

140. Ibid., 1, 20 June 1883.

141. Ibid., 7 June 1883.

142. Ibid.

143. *BNL*, 1 June 1883. This was the largest auctioneer's advertisement seen by the author.

144. Ibid., 20 June 1883.

145. Ibid., 14 Sept. 1886.

146. A few other famous works by Martin had already been seen in Belfast: *Christ stilleth the Tempest* (Plate 17) and *The Destruction of Sodom and Gomorrah*, auctioned by Cramsie for James Polak of London, 17 October 1878 (*BNL*, 15 Oct. 1878).

147. On John Martin's death in 1854, *The Last Judgement* trilogy was toured around Britain for twenty years. In 1857, it was also taken to the United States for a time. Amongst the numerous British centres in which the series was seen were Birmingham, Chester, Leicester, Manchester and Oxford (Rosemary Treble, *Great Victorian Pictures: Their Paths to Fame*, Arts Council of Great Britain, 1978, p.57). Wilson, who owned the trilogy by some point after 1872, also exhibited it and published a pamphlet aimed at reintroducing the painting to an increasingly indifferent public, with whom Martin was no longer popular; see William Feaver, *The Art of John Martin* (Oxford: Clarendon Press, 1975), pp.200, 203.

148. *The Great Day of his Wrath* was purchased by the Tate Gallery in 1945 and the other two works were bequeathed in 1974. The Tate has no information regarding the pictures having been auctioned in Belfast (letters of 28 Aug. and 16 Oct. 1996 from Robin Hamlyn).

CHAPTER EIGHT

1. *Belfast Government School of Art Annual Report*, 1871, p.6 (hereafter referred to as *Annual Report*).

2. Gray, a surveyor by profession, was a keen archaeologist and antiquarian, a member of the Belfast Ramblers' Sketching Club and president of the Belfast Art Society 1894–96. Another of his pursuits was natural history. See Eileen Black, *A Catalogue of the Permanent Collection: 4: Irish Oil*

*Paintings, 1831–1900* (Ulster Museum, 1997), pp.46–7, 116.

3. *NW*, 21 April 1868.
4. *BNL*, 16 March 1870. Francis Davis Ward was the son of Marcus Ward and a director of the firm.
5. Ibid.
6. Others known to have been present were Dr Andrews, John Brown (possibly the merchant John Shaw Brown), James Coombe, Professor Cuming, William Dobbin, local sculptor William Fitzpatrick, J.W. Forrester, J. Gamble, Dr William MacCormac, Dr Oliver Molloy, A. Moore (possibly the decorator Alexander Moore), J. Moore, William Shepherd, C. Sherrie, Robert Young.
7. There are no details of the composition of the provisional committee.
8. *NW*, 17 Oct. 1870 (retrospective account).
9. Ibid., 23 June 1870
10. *BNL*, 25 June 1870.
11. Ibid.
12. *NW*, 23 June 1870; *BNL*, 25 June 1870.
13. *Annual Report*, 1872, p.10.
14. *Annual Report*, 1871, pp.5–7.
15. In 1870 the trustees were James Coombe and William Dunville (*BNL*, 27 Sept. 1870). Sir James Musgrave and James Thompson filled the posts in 1871 and for several years thereafter (*Annual Reports*).
16. *BNL*, 27 Sept. 1870.
17. *Annual Report*, 1871, p.4.
18. Ibid., p.5; *Annual Report*, 1874, p.5. Dunville had been involved in the local art world since the 1840s, having served on the committee of the Belfast Fine Arts Society of 1843 and of the School of Design. In 1864 he established the Sorella Trust, the aims of which included the improvement of working-class housing and the creation of public parks; also the foundation of scholarships for students at intermediate and university level and for those pursuing art education. For details of the Trust, see *NW*, 21 July 1864; *BNL*, 1 Aug. 1864; also PRONI D1905/2/273B.
19. *NW*, 17 Oct. 1870; 'Special and Final Report', in *Annual Report*, 1900, p.5.
20. The headmaster's salary fluctuated from year to year, depending upon his share of the fees and examination results. In 1871 it was £332, whilst the following year it rose to £603. Generally, it appears to have been between £400 and £500.
21. *Annual Report*, 1871, p.14.
22. Ibid., 1890, pp.16–18.
23. W.A. Maguire, *Belfast* (Keele: Ryburn Publishing, Keele University Press, 1993), p.60.
24. *Annual Report*, 1894, p.16; 1899, p.22.
25. Ibid., 1891, pp.5–6.
26. Annual subscriptions, at five-yearly intervals, were as follow: 1875, £248; 1880, £209; 1885, £174; 1890, £230; 1895, £200; 1900, £198.
27. For the period 1876–99.
28. For the period 1871–98.
29. Magill's subscriptions were for 1871–75, Rodman's for 1874–75.
30. Harland's subscriptions were for 1878, 1882, 1890–95, Musgrave's for 1872–1900.
31. Sir Richard Wallace's subscriptions were for 1881–89, Lady Wallace's for 1890–96. Wallace was MP for Lisburn 1873–85.
32. *Annual Report*, 1880, p.21.
33. For details of the local prize scheme, see *Annual Report*, 1871, local prize supplement, pp.3–6.
34. See *Annual Report*, 1897, pp.12–14.
35. Ibid., 1872, p.16; 1880, p.17; 1890, p.14; 1900, unpaginated.
36. *BNL*, 19 Oct. 1870.
37. *Annual Report*, 1871, p.7.
38. Ibid., pp.11–12, 'Prospectus, Constitution and Rules'.
39. Ibid., 1872, p.4. The types of manufactures were not detailed.
40. *Annual Report*, 1873, p.4.
41. Ibid., 1874, p.3. Besides the 184 artisan and evening class students, there were 151 schoolchildren of both sexes, 62 ladies and 19 gentlemen.
42. Ibid., p.19. The other trades were: blacksmiths (one), blockprinters (one), bookkeepers (three), brassfounders (two), bricklayers (one), builders (two), carpenters and joiners (thirteen), cabinetmakers (two), commission agents (one), customs officers (one), draughtsmen (five), drapers (two), druggists (three), engineers (two), engravers (two), errand boys (three), fitters (three), flaxdressers (one), farmers (one), gardeners (two), grocers (two), hatters (two), housekeepers (two), ironmongers (one), jewellers (one), lithographic writers (five), mechanics (nine), overlookers and mill managers (seven), painters (twelve), photographers (one), plasterers (two), plumbers (one), printers (one), sub-inspectors RIC (one), statuary manufacturers (one), shipbuilders (one), shoemakers (one), shopmen (two), stonemasons (four), taxidermists (one), teachers (eleven), telephonists (one), upholsterers (one), wood carvers (one), warehousemen (three).
43. *Annual Report*, 1875, p.18.
44. Ibid., 1876, p.5; 1877, p.7 (221); 1878, p.6; 1879, p.4 (255).
45. Ibid., 1877, p.4.

46. *Annual Report*, 1879, p.7.

47. Ibid., 1882, p.5.

48. Ibid.

49. Ibid., 1885, p.5; 1886, p.8.

50. *Annual Report*, 1888, p.4.

51. Ibid., 1890, p.4 (408); 1891, p.4 (390); 1896, p.5 (411); 1900, p.7 (278).

52. Ibid., 1874, pp.6–7; *NW*, 31 Oct. 1874, 9 Feb. 1881, 21 Jan. 1882.

53. *Annual Report*, 1875, p.5.

54. Ibid., 1882, p.11.

55. Ibid., 1874, p.7; *NW*, 3 March 1880.

56. *Annual Report*, 1874, p.3; 1875, p.4; 1876, p.5. It is impossible to ascertain figures from 1877 onwards, as the only numbers recorded thereafter were the overall totals for the day classes, made up of lady students, gentlemen and school-children.

57. Ibid., 1884, p.12.

58. Eileen Black, 'Isabella Tod and the Movement for the Higher Education of Women in Belfast, 1867–82' (unpublished dissertation, Open University, 1982), pp.6–7; Alison Jordan, *Margaret Byers: Pioneer of Women's Education and Founder of Victoria College, Belfast* (Belfast: The Institute of Irish Studies, The Queen's University of Belfast, 1990), p.10; Maria Luddy, 'Isabella M.S. Tod', in Mary Cullen and Maria Luddy (eds), *Women, Power and Consciousness in 19th Century Ireland* (Dublin: Attic Press, 1995), pp.201–4.

59. For a useful account of the women's movement in Britain from the late eighteenth century until after the First World War, see Ray Strachey, *The Cause: A Short History of the Women's Movement in Great Britain* (London: Virago, 1979).

60. *Annual Report*, 1875, p.7.

61. Ibid., 1873, p.5. Besides the gold medal, the awards comprised four bronze medals and eight Queen's prizes.

62. Ibid., 1889, p.9; also *Annual Reports*, 1885–92.

63. Ibid., 1890, pp.7–8.

64. *Annual Report*, 1893, p.22; ibid., 1900, p.11. The gold medal was awarded for designs for embroidery. These were purchased by the Board of Education and reproduced in several publications.

65. Ibid., 1899, p.9.

66. Ibid., 1881, pp.6–7.

67. *Annual Report*, 1882, p.6; also *BNL*, 10 Oct. 1882.

68. Belfast's exhibition was held 9–14 Oct.

69. *BNL*, 10 Oct. 1882.

70. Amongst those who attended were William Gray, Sir Charles Lanyon, Dr James Moore and Francis Davis Ward (management committee); also Adam Duffin, Sir Thomas McClure, John Musgrave and R.H. Reade.

71. *Annual Report*, 1882, p.7.

72. Ibid., 1883, p.4; 1884, p.4.

73. *Belfast Industrial Exhibition and Bazaar* catalogue, Ulster Hall, 1876, pp.54–5.

74. *Opening Art Exhibition* catalogue, Belfast Free Public Library, 1888, p.49.

75. *Annual Report*, 1871, p.7.

76. Ibid., 1873, p.6.

77. Ibid., 1875, p.7.

78. *Annual Report*, 1877, p.6.

79. Ibid., 1878, p.8; 1881, p.7; 1886, pp.10–11.

80. Reports of attendance at board meetings were published in the *Annual Reports*, 1882–92 and for 1898 and 1899. Between 1882 and 1892, Gray attended 165 meetings, Lynn 10 and Musgrave 21.

81. *Annual Reports*, 1882, p.8; 1891, p.7; 1878, p.19.

82. Ibid., 1871, p.2; 1887, p.3.

83. Ibid., 1871, p.2; 1883, p.2; 1901, p.2. The amount was £43 14s 6d.

84. Ibid., 1878, p.2; 1901, p.2.

85. The amount was £25 4s 0d.

86. The figure was £24 3s 6d.

87. The amounts were £132 7s 0d and £44 15s 0d.

88. *Annual Report*, 1901, p.12. He was a board member from 1874 to 1899.

89. Ibid., 1871, p.2; 1882, p.2; 1888, p.2; 1893, p.2; 1895, p.2; 1901, p.2.

90. Ibid., 1898, p.2; 1899, p.2; 1900, p.2.

91. The contributions of the various artists and amateurs were as follow: Allan, £2; Blackwood, £3; Boyd, £1; Moore, £12 12s 0d; Stannus, £12 6s 0d; Taylor, £5 5s 0d; Thompson, £15.

92. William Gray, *Science and Art in Belfast* (Belfast: reprinted from *Northern Whig*, 1904), pp.69–77, 141–71; Kenneth Jamison, *Belfast Art College Association, Retrospective Exhibition 1849–1960* (Belfast, 1960), pp.4–6. Gray's account, though rambling and disjointed, remains the fullest source of information on events surrounding the establishment of the 'Tech'.

93. Had the rate been struck in 1891, the amount raised would have been £2,987. The other establishments were the Technical School in Hastings Street and the Working Men's Institute (Schools of Science and Technology).

94. The bodies concerned included the School of Art, the various technical schools, the Working Men's Institute and the Chamber of Commerce; also the Bleachers' Association, the Flaxspinners' Association, the Linen Merchants' Association and the Power-Loom Manufacturers' Association.

95. See Mike Catto, 'A Normal School', *Art and Design*

*Matters*, exhibition catalogue, Ulster Museum, 1994, pp.30–51 for details of the College of Art and its successors.

96. The following artists also attended: David Gould, Sarah Cecilia Harrison, Frederick W. Hull, Georgina Moutray Kyle, John Langtry Lynas, William Gibbes Mackenzie, John McBurney, the Morrow brothers (Albert, Edwin, George, Henry and Jack), Anne Marjorie Robinson, Seamus Stoupe, George Waters, David Wilson. All are dealt with in John Hewitt and Theo Snoddy, *Art in Ulster: 1* (Belfast: Blackstaff Press, 1977).

## CHAPTER NINE

1. *Belfast Working Men's Institute and Temperance Hall Exhibition* catalogue, 1871–72, p.vi (hereafter *Working Men's Institute and Temperance Hall* catalogue).
2. Jonathan Bardon, *Belfast: An Illustrated History* (Belfast: The Blackstaff Press, 1982), p.22. Ten years later, the workforce comprised almost 75,000 people – 42,000 men and nearly 33,000 women; see Emrys Jones, 'Belfast', in T.W. Moody and J.C. Beckett (eds), *Ulster since 1800: Second Series: A Social Survey* (London: BBC, 1957), p.93.
3. Peter Bailey, *Leisure and Class in Victorian England: Rational Recreation and the Contest for Control, 1830–1885* (London, Toronto and Buffalo: Routledge and Kegan Paul, University of Toronto Press, 1978), *passim*; F.M.L. Thompson, *The Rise of Respectable Society: A Social History of Victorian Britain 1830–1900* (London: Fontana, 1988), pp.271–2; Charles More, *The Industrial Age: Economy and Society in Britain 1750–1985* (London and New York: Longman, 1989), pp.189–90.
4. See *Problems of a Growing City: Belfast 1780–1870* (Belfast: Public Record Office Northern Ireland, 1973), pp.186–8, 196, 199; also Eileen Black, *The People's Park: The Queen's Island, Belfast 1849–1879* (Belfast: Linen Hall Library, 1988). The first institute for the town's working men – the Belfast Mechanics' Institute – was opened in 1825 but appears to have been short lived (*Problems of a Growing City*, pp.80–3).
5. The group, under the presidency of the Marquess of Donegall, comprised the following: James Bristow, James Carlisle, Lord Dufferin, Adam Duffin, William Ewart, Jr, A.F. Herdman, Bernard Hughes, Charles Lanyon, William Malcolmson, Dr Henry Murney, Joseph J. Murphy, Jonathan Richardson, John Suffern, Elias H. Thompson, William Valentine (council members); Lord Cairns, Marriott R. Dalway, John Lytle, Thomas

McClure, John G. Richardson, Dr William B. Ritchie (trustees); Robert Anderson, Thomas H. Brown, Lawson A. Browne, John Coates, Thomas Gaffikin, Thomas Greer, H. Charles Knight, G.D. Leathem, Alex. S. Mayne, John R. Neill, John Pyper, John Reid, John Simms, Hugh J. Wright (general committee). Thomas Gaffikin was honorary secretary and Edward Allworthy secretary.
6. *Working Men's Institute and Temperance Hall* catalogue, p.iii.
7. Ibid.
8. Ibid.
9. *NW*, 16 May 1870. Charters had also made the largest donation – £500 – towards the Institute.
10. *Working Men's Institute and Temperance Hall* catalogue, p.iv.
11. *BNL*, 19 March, 1 June 1870. A catalogue of the exhibition has not been located.
12. *NW*, 22 July 1869.
13. *BNL*, 9 April 1870. Also on the executive committee were Thomas Brown, Thomas H. Browne, Joseph Cappo, William Dawkins Cramp, Alexander Crawford, Francis Dalzell Finlay, William Girdwood, W.D. Henderson, John Hagan, George Horner, Frederick Harry Lewis, R. McCalmont, John Reid, George Reilly, A. O'D. Taylor.
14. Ibid. The other patrons were John Browne, Jr, Dr Samuel Browne, William Coates, James Porter Corry, Alexander Crawford, William Johnston (Ballykilbeg), James Kennedy, Frederick Harry Lewis, Thomas McClure, Alderman Mullan, Dr Ritchie, William Spotten, John Suffern, David Taylor. Johnston and McClure were members of parliament.
15. *BNL*, 9, 23 April, 7 May 1870. The classification of sections was as follows: animal, vegetable and mineral; architectural embellishments and building materials; machinery and tools; textiles; furniture and upholstery; ceramic art including glass, porcelain, china and earthenware; sculpture, painting, photography, archaeology, geology and natural history; stationery, illuminating, printing and bookbinding. Quotation from *BNL*, 9 April 1870.
16. *NW*, 18 May 1870.
17. According to the *BNL* of 7 May 1870, a resolution was passed by the executive committee on 6 May that 'no medal or award be made by jurors except to working men, exhibitors of work executed by themselves'. It seems that only a selection of the prize-winning articles were forwarded to London, although details on this point are unclear (*NW*, 6, 13, 27 June 1870).

18. *BNL*, 23 April 1870.
19. *NW*, 13 April 1870; *BNL*, 1 June 1870.
20. *BNL*, 23 April, 7, 18, 23 May 1870; *NW*, 9, 27 April, 2, 4, 9, 23 May 1870.
21. For information on the bust, see Eileen Black, *A Sesquicentennial Celebration: Art from The Queen's University Collection*, Ulster Museum, 1995 (Queen's University of Belfast, 1995) pp.52, 53, 117.
22. *NW*, 23 May 1870.
23. Ibid., 24 May 1870.
24. *BNL*, 28 May 1870.
25. Ibid., 9 April, 1, 6 June 1870; *NW*, 6 June 1870.
26. *NW*, 20 June 1870.
27. Ibid., 27 June, 1, 4, 6, 8 July 1870.
28. Ibid., 27 June 1870.
29. *NW*, 22 June, 1 July 1870.
30. Ibid., 17 Oct. 1870. Strangely, the donation does not appear in the school's *Annual Report* for 1871.
31. *NW*, 11 July 1870; *Art-Journal*, Aug. 1870, p.253.
32. The four major shows of the 1850s were the *Exhibition of Modern Works of Painting and Sculpture*, 1850–51; the Belfast Fine Arts Association exhibition, 1852; the Belfast Fine Arts Society exhibitions, 1854 and 1859.
33. *Working Men's Institute and Temperance Hall* catalogue, p.vii.
34. Ibid., p.iv; also *BNL*, 20 Oct. 1871.
35. *Working Men's Institute and Temperance Hall* catalogue, pp.iv, vii.
36. The other trustees were Lord Cairns, Marriott R. Dalway and Dr William B. Ritchie.
37. Also on the council were James Bristow, James Carlisle, William Ewart, Jr, A.F. Herdman, Bernard Hughes, Charles Lanyon, William Malcolmson, Dr Henry Murney, Joseph J. Murphy, John Suffern, Elias H. Thompson.
38. *Working Men's Institute and Temperance Hall* catalogue, p.v.
39. The members of parliament were Marriott R. Dalway, William Johnston and Thomas McClure.
40. The mayor made the opening speech. This was followed by addresses from Thomas Gaffikin, chairman of the Institute's general committee; William McDade, who represented the working men; Dr James Moore, chairman of the exhibition committee and Lord Dufferin.
41. *Working Men's Institute and Temperance Hall* catalogue, pp.viii–ix. The ode was set to music by B. Hobson Carroll, a well-known local composer and musician.
42. The others were Robert Boag, Francis Dalzell Finlay, William Guthrie, James Alexander Henderson, D.W. Johnston, William Henry Lynn, W.H. Patterson, John Arnott Taylor.
43. The list is too long to detail; see *Working Men's Institute and Temperance Hall* catalogue, p.xi.
44. *BNL*, 15 Nov. 1871.
45. *Working Men's Institute and Temperance Hall* catalogue, p.8.
46. According to the *NW* of 20 Nov. 1871, there were 4,098 visitors during the first four days. See also *BNL*, 28 Nov. 1871.
47. *BNL*, 16 Jan. 1872.
48. *Belfast Industrial Exhibition and Bazaar*, Ulster Hall, 1876, catalogue, p.4 (hereafter *Industrial Exhibition and Bazaar* catalogue); *BNL*, 24 May 1876.
49. *BNL*, 1 Oct. 1875. This contains a report of the Institute's third annual meeting. By this point, membership figures were 473 and the total number of visitors since its opening, 29,104.
50. Ibid. The meeting, chaired by James Alexander Henderson, was held on 11 August (1875). Henderson, one of the Institute's firmest supporters, had been requested to preside by the establishment's committee.
51. *BNL*, 17 Aug. 1875.
52. Ibid., 10 Sept. 1875.
53. *Industrial Exhibition and Bazaar* catalogue, p.5. The other committee members were Robert Boag (mayor), Thomas H. Browne, Edward Porter Cowan, James Alexander Henderson, D.W. Johnston, John McKenzie, George Morrow, W.H. Patterson. Cowan, Henderson and Lanyon are known to have owned art collections.
54. Ibid., p.3.
55. Included were such as Dr Thomas Andrews, vice-president of Queen's College and industrialists like Victor Coates, Edward Harland and John Horner.
56. *Industrial Exhibition and Bazaar* catalogue, pp. 7–8. There were 33 patronesses, headed by the Duchess of Abercorn and at least 133 committee members (two or more sisters were designated 'The Misses' and listed as a single individual, hence the uncertainty as to numbers).
57. *BNL*, 21 Sept. 1875. By late March 1876, the amount raised was a little over £1,266 (*BNL*, 25 March 1876).
58. Ibid., 10 Sept. 1875. The owner was Edward Porter Cowan.
59. Ibid.
60. *Industrial Exhibition and Bazaar* catalogue, pp.38, 41–2. There is no correspondence regarding the loan in the Wallace Collection archives (letter of 22 Feb. 1995 from Robert Wenley).

61. Ibid., pp.47–8, 56.
62. In early May 1876, the queen informed James Porter Corry, a member of parliament for Belfast, that she was sending items to the exhibition (*BNL*, 3 May 1876). There is no information in the Royal Collection Trust regarding the loan (letter of 27 Sept. 1995 from Charles Noble).
63. *Industrial Exhibition and Bazaar* catalogue, pp.48, 56. According to the *BNL* of 26 May 1876, the queen also lent paintings; however, this appears to be incorrect, as there are none listed in the catalogue.
64. *BNL*, 14 April, 24 May 1876 (quotation in issue of 14 April).
65. Ibid., 24 May 1876. The Duke of Abercorn was on an official visit to the north of Ireland. For details, see *BNL*, 23–6 May 1876.
66. The 'Ode to Industry' was composed by Dr Walker, with music by Sir Robert P. Stewart (*BNL*, 23 May 1876).
67. The Turner was entitled *Scarborough* in the catalogue. Wallace's loan comprised Wallace Collection nos. P651, P654, P655, poss. P656, P659, P661, P662, P664, P666, P667, P668, P669, P672, P674, P680, P681, P685, P689, P690, P691, P697, P698, P703, P704, P708, P709, P710, P712, P713, P714, P715, P716, P717, P718, P719, P720, P721, P722, P723, P725, P730, P738, P744, P745, P746, M24, M25 and four others.
68. *Industrial Exhibition and Bazaar* catalogue, pp. 47–8. The Old Masters were Canaletto, Ludovico Carracci, Aelbert Cuyp, Frédéric Moucheron, Balthasar Paul Ommeganck, Jan Steen and David Teniers. Five of these attributions have been revised since 1876, as follow: Canaletto, *Venice: the Piazza San Marco looking West* (557–1870) is by a follower; Carracci, *The Virgin with the Infant Jesus* (1357–1869), early nineteenth-century copy of Italian School, seventeenth-century; Cuyp, *The Maas in Winter with the Huis Te Merwerde* (507–1870), nineteenth-century copy; Moucheron, *Rocky Landscape* (581–1870), manner of; Steen, *A Family Merrymaking* (536–1870) is by Jan Molenaer. The attributions of Ommeganck, *Landscape with Cattle* (570–1870) and Teniers, *Rocky Landscape with Figures* (1349–1869) remain unchanged; see C.M. Kauffmann: *Catalogue of Foreign Paintings: I: Before 1800*, (Victoria and Albert Museum, 1973), pp.55, 81, 157; *Catalogue of Foreign Paintings: II: 1800–1900* (Victoria and Albert Museum, 1973), pp.80, 193–4, 269. Information from Sonia Solicari (letters of Dec. 2002, undated and 30 Jan. 2003).
69. The four other artists were George Clint, Richard Redgrave, Thomas Unwins and Thomas Webster.
70. *Industrial Exhibition and Bazaar* catalogue, pp.44–5. The others were William Collins, Edward William Cooke, William Daniell, Antony Vandyke Copley Fielding, Aaron Penley, Nicholas Pocock, John Skinner Prout, David Roberts, Paul Sandby, Dominic Serres.
71. *BNL*, 24 May 1876.
72. *NW*, 24 June 1876.
73. *BNL*, 15 Aug. 1876.
74. Ibid., 19 Dec. 1876.
75. *Belfast Art and Industrial Exhibition* catalogue, 1895, p.18.
76. *BNL*, 15 Aug. 1876.
77. Ibid. Professor Andrews was vice-president of Queen's College; see Black, *A Sesquicentennial Celebration: Art from The Queen's University Collection*, pp.36–7, 111.
78. *NW*, 5, 7 Dec. 1868; *BNL*, 7 Dec. 1868.
79. *BNL*, 12 Sept. 1865.
80. Thomas Kelly, *A History of Public Libraries in Great Britain 1845–1975* (London: Library Association, 1977), p.23.
81. Ibid., p.10; also W.A. Munford, *William Ewart MP: Portrait of a Radical* (London: Grafton and Co., 1960), p.117.
82. Kelly, *A History of Public Libraries in Great Britain*, p.23.
83. Munford, *William Ewart MP: Portrait of a Radical*, pp.127–34, 140–1; Kelly, *A History of Public Libraries in Great Britain*, p.20.
84. Kelly, *A History of Public Libraries in Great Britain*, p.23.
85. Maura Neylon and Monica Henchy, *Public Libraries in Ireland* (Dublin: University College, Dublin, School of Librarianship, 1966), pp.10–12.
86. *BNL*, 5 Jan. 1871.
87. *Problems of a Growing City*, p.199 (32).
88. *BNL*, 13 Nov. 1871.
89. *NW*, 4 Oct. 1875.
90. *BNL*, 2 Jan. 1877.
91. Ibid., 3 April 1877.
92. Ibid., 2 May 1877.
93. As, for example, in *BNL*, 5 May; *NW*, 5 May, 6 Nov., 7 Nov.
94. *Belfast Government School of Art Annual Report*, 1877, p.6.
95. *BNL*, 29, 30 Sept. 1879.
96. Ibid., 6 Oct. 1879.
97. Ibid.
98. Ibid., 17 Oct. 1879.
99. *BNL*, 21, 30 Oct., 5 Dec. 1879.
100. Ibid., 1 Jan. 1880.
101. Ibid., 18 Nov. 1880.
102. There is no information in the Wallace Collection

archives as to Wallace having been approached to assist these Belfast schemes (letter of 29 Sept. 1995 from Robert Wenley).

103. *NW*, 19, 23 Nov. 1880.
104. *Art-Journal*, Dec. 1880, p.375.

CHAPTER TEN

1. *NW*, 15 Oct. 1888.
2. Hooke's portraits were as follows: Philip Johnston, unveiled 1874; Dr Samuel Browne, placed in the council chamber in 1877; Sir John Savage, placed in the council chamber in 1880; John Browne and Samuel McCausland, both unveiled in 1882.
3. Jones's portraits were of James Alexander Henderson, unveiled 1876 and Robert Boag, placed in the council chamber in 1877.
4. *BNL*, 2 March 1883.
5. The committee comprised John Browne, Thomas Gaffikin, James Haslett, James Alexander Henderson, Sir John Preston, Sir John Savage, Sir David Taylor (mayor).
6. *NW*, 24 Dec. 1883.
7. The term 'municipal picture gallery' was used in reference to the council chamber in the *NW* of 11 Dec. 1886.
8. *BNL*, 26 Oct., 2 Nov. 1886.
9. *NW*, 10, 11 Dec. 1886.
10. Ibid., 20 Dec. 1886; *BNL*, 23 Dec. 1886.
11. *BNL*, 14 April, 20 Sept. 1887.
12. *BNL*, 8 April 1887; *NW*, 11 Oct. 1888.
13. *NW*, 29 March, 10 Aug. 1887.
14. He seems to have envisaged blocking the windows and installing skylights in the roof. In his letter of 10 August, he claimed that he had persuaded the mayor and council of a borough in England (unnamed) to adopt this course of action, to great success.
15. *NW*, 10 Aug. 1887.
16. Ibid.
17. See *BNL*, 28 May 1887 for Ward's account of the events pertaining to this. George Chambers, *Faces of Change: The Belfast and Northern Ireland Chambers of Commerce and Industry 1783–1983* (Belfast: The Northern Ireland Chamber of Commerce and Industry, 1984), p.195 contains only a brief reference to it. William Johnston of Ballykilbeg, Conservative member for South Belfast, had raised the matter with the government some time before 1887 but nothing had come of it (*BNL*, 10 July, 1888; *NW* 10 July 1888).
18. *BNL*, 28 May 1887.
19. The conference was on 16 May (1887).
20. The text of the memorial appears in the *BNL* of 16 June 1887.
21. Ibid.
22. Ibid., 10 July 1888; *NW*, 10 July 1888.
23. *BNL*, 3 Jan. 1881. Cowan, who served on the fine art committee of the industrial exhibition of 1876, lent a number of British and Continental nineteenth-century paintings to the show, including works by William Powell Frith, Howard Helmick and Erskine Nicol.
24. *NW*, 3, 4 Jan. 1881 (quotation in latter).
25. Ibid., 30 March 1881.
26. *BNL*, 21 April 1881; *NW*, 21 April 1881.
27. *NW*, 23 April 1881.
28. *BNL*, 3 May 1881. The other members of the deputation were Dr Barnett, James Musgrave, W.H. Patterson, R.H. Reade and Francis Davis Ward.
29. Ibid.
30. *BNL*, 2 July 1881. There is little information available on the free public library movement in Belfast City Council archives; the Minute Books 1883–88 contain only brief reports of the library committee. The main source material on the subject remains the local press.
31. *NW*, 3 April 1882.
32. Ibid., 10 April 1882.
33. *BNL*, 19 May 1882; *NW*, 19 May 1882.
34. *NW*, 19 May 1882 (both quotations).
35. *BNL*, 2 June 1882. The other members included R. Anderson, Rev. Beattie, Joseph Bowman, D. Burden, Robert Carswell, Dr Coe, Dr Dickey, Dr Drennan, Robert Dunn, George Fisher, William Greenhill, Rev. A. Gordon, Dr Harkin, Edward Hughes, H. Hyndman, W.R. Jackson, Otto Jaffé, Jules Lowenthal, Thomas McClelland, Dr McMurtry, M. Maunsell, W.C. Mitchell, Samuel Monroe, Professor Park, W.H. Patterson, R.W. Pring, William Swanston, Joseph Wright.
36. Ibid.
37. Ibid., 13 June 1882.
38. *NW*, 14 June 1882.
39. Ibid., 2 Sept. 1882.
40. *BNL*, 30 Oct. 1882.
41. Ibid., 25 Oct. 1882.
42. Ibid.
43. According to the *NW* of 9 Nov. 1882, 10,207 voting papers were distributed. Of these, 8,620 were collected: 5,238 were in favour, 1,425 were against, 1,894 were returned without being filled in and 63 were spoiled.
44. *BNL*, 9 Nov. 1882.
45. Ibid., 2 Dec. 1882.
46. Ibid., 2 Feb. 1883.
47. Quotation from above.

48. *BNL*, 30 April 1883.
49. Ibid., 1 May 1883. The amount of £15,000 for the library was mentioned at the council's meeting of early April (*BNL*, 3 April 1883).
50. *BNL*, 2 June 1883; *NW*, 2 July 1883.
51. *BNL*, 8 Aug. 1883; *NW*, 22 Sept. 1883. The former paper reported that there were 'some sixty competition plans' being assessed.
52. *NW*, 11, 22 Sept. 1883. For information on Lynn, see Martyn Anglesea, 'The Lynn Brothers, Architect and Sculptor', *Irish Arts Review*, Yearbook 1989–90, pp.254–62.
53. *NW*, 22 Sept. 1883.
54. Ibid.
55. Ibid.
56. *BNL*, 24 Sept. 1883.
57. Ibid., 1 Jan. 1884.
58. Ibid., 4 Dec. 1883. The deputation also included Joseph Bowman, John Shaw Brown, W.H. Patterson, Mr Mitchell and John Vinycomb. Bowman and Mitchell were there on behalf of the United Trades Council.
59. Ibid.
60. *BNL*, 1 Jan. 1884. Throughout the newspaper coverage of the free public library movement, the terms 'art gallery', 'picture gallery' and 'art museum' are used interchangeably and sometimes confusingly.
61. *NW*, 1 May 1884.
62. *BNL*, 2 May 1884.
63. William Gray, *Science and Art in Belfast* (Belfast: reprinted from *Northern Whig*, 1904), p.125.
64. *BNL*, 19 June 1884; *NW*, 19 June 1884.
65. It is unclear whether Gray attended the ceremony. The *BNL* of 19 June includes a William Gray in a list of guests; however, in a letter to the same newspaper of 21 August, Gray stated, with some bitterness, that he had not received an invitation to the ceremony. His conclusion was that he had been 'intentionally slighted'.
66. Details of the row can be found in *BNL* 16, 20, 23 Dec. 1884, 2, 15, 16, 19, 24, 26, 27, 28 Jan., 2, 3, 5, 19, 23, 24 Feb. 1885; *NW*, 1, 2, 14, 15, 19, 21, 22 Jan., 3, 23 Feb. 1885.
67. *NW*, 3 July, 5 Aug. 1885; see Hugh Russell, *The Day the Library Opened* (Belfast: Belfast Public Libraries, 1988), unpaginated; Gordon Wheeler, 'A History of Belfast Central Library', *Linen Hall Review*, 5, 2 (Summer 1988), p.5. The latter, though a useful history of the library to the present day, is limited in detail as to the free public library movement and the provision of the art gallery and museum.
68. *BNL*, 19 Dec. 1885.
69. *NW*, 5 Aug. 1885 (quotation); *BNL*, 3 Sept. 1885.
70. As, for example, in *NW*, 16, 18, 20 March, 4 May, 9, 11 Oct. 1886.
71. Ibid., 6, 7 Jan. 1887 (quotation in former).
72. *BNL*, 2 Aug. 1887, 16 Jan. 1888.
73. Ibid., 28 Feb., 1 March 1888 (quotation in latter); *NW*, 28, 29 Feb., 1, 2 March 1888.
74. There is extensive coverage of the event in the *BNL* and *NW* of 15 Oct. 1888.
75. *NW*, 15 Oct. 1888 (both quotations).
76. The text of the royal charter is in *BNL*, 9 Nov. 1888.
77. Ibid., 31 Aug. 1888.
78. *BNL*, 9 Oct. 1888.
79. *Opening Art Exhibition*, Belfast Free Public Library, 1888, catalogue, p.2 (hereafter *Opening Art Exhibition* catalogue).
80. *BNL*, 18 Sept., 18 Oct. 1888; *NW*, 18 Oct. 1888.
81. *NW*, 24 Oct. 1888. The figure of 32,000 represented the six viewing days between 17th and 23rd October, inclusive. (The 21st October was a Sunday.) On Saturday 20th there were about 7,500 visitors.
82. *BNL*, 2 Nov. 1888.
83. *NW*, 3 Dec. 1888.
84. *BNL*, 30 Nov.1888.
85. B.R. Mitchell and Phyllis Deane, *Abstract of British Historical Statistics* (Cambridge: Cambridge University Press, 1962), p.25. According to the charter memorial of June 1887 (*BNL*, 16 June 1887), the population at that point was over 230,000.
86. *NW*, 29 Nov. 1888.
87. Eileen Black, *A Catalogue of the Permanent Collection: 4: Irish Oil Paintings, 1831–1900* (Ulster Museum, 1997), pp.22–3, 110.
88. For the Dunville donation, see *NW*, 2 July 1887. The other three works were a bust of Queen Victoria, by Sir Joseph Edgar Boehm, presented by Lady Harland by 17 August 1888 (*BNL*, 17 Aug. 1888) and two statues presented by Henry Matier by 2 October 1888 (ibid., 2 Oct. 1888).
89. The four works presented by 3 December 1888 were *Earl Cairns* by Samuel Ferres Lynn, presented by William Henry Lynn; *Miss Mary Anderson* by Albert Bruce-Joy, donated by the sculptor himself and two views of old Belfast, given by Alexander MacLaine (*NW*, 3 Dec. 1888).
90. *NW*, 29 Nov., 1 Dec. 1888.
91. Ibid., 1 Dec. 1888.

CHAPTER ELEVEN
1. William Gray in *NW*, 18 July 1890.
2. Ibid., 1 April, 1 June 1889.

3. Belfast City Council, Library Committee Minute Book, Oct. 1888–July 1900, meeting of 15 November 1888 (hereafter Library Committee Minute Book).
4. *NW*, 24 Jan., 23 March 1889.
5. Ibid., 26 Jan., 1 April 1889.
6. Ibid., 1 April 1889.
7. Library Committee Minute Book, meeting of 13 June 1889.
8. Ibid.
9. Ibid., meeting of 8 August 1889.
10. Ibid., meetings of 24 October, 7 November 1889.
11. Library Committee Minute Book, meetings of 7, 14 November 1889. The selection probably included *Peace* and *War*, after Antoine-Louis Barye, *David with the Head of Goliath*, after Antonin Mercié and *La Syrène*, after Denys Pierre Puech.
12. Ibid., meeting of 19 December 1889. The works were busts of *Berenice* and *Dionysus*. Other possible acquisitions were *Dante Alighieri*, after Guglielmo della Porta and *Scipio Africanus*, after a Roman Antique original.
13. Details of the four are as follow: *The Landing of King William III at Torbay*, by J.W. Carmichael (Library Committee Minute Book, meeting of 29 August 1889). This has since been recatalogued as *George I arriving at the Nore in 1714*, by William Stuart; a portrait of Lady Haslett by an unspecified painter and *Robert Langtry* by Samuel Hawksett (ibid., both at meeting of 10 October 1889); *George Benn* by Richard Hooke (ibid., meeting of 6 March 1890).
14. *NW*, 29 April, 1 June, 2 Dec. 1889, 1 Feb., 1 March, 24 April 1890.
15. *NW*, 2 May 1890; Library Committee Minute Book, meeting of 30 April 1890.
16. *BNL*, 17 July 1890; *NW*, 17 July 1890.
17. *BET*, 17 July 1890.
18. *BNL*, 17 July 1890. The painting remained in the Belfast Museum and Art Gallery's collection until c.1930. According to the establishment's committee minutes for 18 October and 1 November 1929, a letter had been received from Dr S.W. Allworthy, stating that the trustees of the late Mr Allworthy [presumably Edward Allworthy] would be pleased to have the picture returned to the family. This was agreed to.
19. The mayor, Charles C. Connor, had been unable to attend.
20. Gordon Wheeler, 'A History of Belfast Central Library', *Linen Hall Review*, 5, 2 (Summer 1988), p.5.
21. See Chapter Ten, note 89.
22. *NW*, 18 July 1890.
23. Ibid.
24. See Noel Nesbitt, *A Museum in Belfast* (Belfast: Ulster Museum, 1979) for a useful history of the Ulster Museum and its predecessors.

# Bibliography

**Manuscript Sources**

Belfast City Council, Library Committee Minute Book, October 1888–July 1900.
British Library, Graves papers, Add. MSS. 46140.
Houghton Library, Harvard, Percy-Robinson papers, MS. Eng. 734.3.
Linen Hall Library, Belfast: Robert Young, 'Recollections of a Monogenerean', c.1906–7.
National Art Library, Victoria and Albert Museum, Cole Papers, 55.AA and Box VII 97E.
National Library of Ireland, Petrie papers, MSS.791.
Public Record Office Northern Ireland (PRONI), Belfast College of Technology papers, uncatalogued.
PRONI, Minute Book of the Anacreontic Society, 1838–63, D297/1.
PRONI, Donegall papers, D509.
PRONI, Downshire papers, D671.
PRONI, Drennan letters, T765.
PRONI, letters to Dr William Drennan, D456.
PRONI, Dufferin papers, D1071.
PRONI, Getty scrapbooks, D3695.
PRONI, L'Estrange and Brett papers, D1905.
PRONI, Londonderry papers, D654.
PRONI, Royal Belfast Academical Institution papers, SCH 524.
PRONI, Tennent papers, D1748.
PRONI, Young and MacKenzie papers, D2194.

**Printed Sources**

*Reports and Proceedings*
*Belfast Government School of Design Annual Reports*, 1852, 1853 and 1854 (National Art Library, Victoria and Albert Museum).
*First–Seventh Report of the Department of Science and Art*, 1854–60 (National Library of Ireland).
*Belfast Government School of Art Annual Reports*, 1870–1900 (Belfast Central Library).
*Royal Dublin Society Proceedings*, vol.64–5, 1 November 1827–16 July 1829 (Royal Dublin Society).

*Newspapers*
(Belfast Central Library; Linen Hall Library; National Library of Ireland)

*Belfast Commercial Chronicle*, 1836–37, 1842–48, 1851, 1854, January–August 1855.
*Belfast Daily Mercury*, January–June 1856, January–July 1858.
*Belfast News-Letter*, 1760–1888 (excluding 1844–48, 1851, January–August 1855).
*Northern Whig*, 1824–August 1826, May 1827–1888 (excluding 1854).

*Periodicals*
*Art-Union*, 1839–48 (National Art Library, Victoria and Albert Museum).
*Art-Journal*, 1849–80 (excluding 1851) (Belfast Central Library; National Art Library, as above, for 1851).
*Magazine of Art*, 1878–88 (Trinity College, Dublin).

*Books*
Agnew, Jean (ed.), *The Drennan-McTier Letters 1776–1793* (Dublin: The Women's History Project/Irish Manuscripts Commission, 1998).
*An Account of the System of Education in the Belfast Academical Institution* (Belfast: Joseph Smyth, 1818).
Anglesea, Martyn, *The Royal Ulster Academy of Arts* (Belfast: The Royal Ulster Academy of Arts, 1981).
Archer, John H. (ed.), *Art and Architecture in Victorian Manchester* (Manchester: Manchester University Press, 1985).
Bailey, Peter, *Leisure and Class in Victorian England: Rational Recreation and the Contest for Control, 1830–1885* (London, Toronto and Buffalo: Routledge and Kegan Paul, University of Toronto Press, 1978).
Bardon, Jonathan, *Belfast: An Illustrated History* (Belfast: The Blackstaff Press, 1982).
Bardon, Jonathan, *A History of Ulster* (Belfast: The Blackstaff Press, 1992).
Barratt, Carrie Rebora, *Queen Victoria and Thomas Sully* (Princeton, NJ: Princeton University Press/Metropolitan Museum of Art, 2000).
Bell, Quentin, *The Schools of Design* (London: Routledge and Kegan Paul, 1963).
Benn, George, *History of the Town of Belfast* (Belfast: A. Mackay, Jun., 1823; reprinted Ballynahinch, Co. Down: Davidson Books, 1979).

Benn, George, *History of Belfast* (London: Marcus Ward & Co., 1877).

Black, Eileen, *The People's Park: The Queen's Island, Belfast 1849–1879* (Belfast: Linen Hall Library, 1988).

Black, Eileen (ed.), *Celebrating Ulster Art: 10 Years of the W. and G. Baird Calendar* (Belfast: W. & G. Baird Ltd., 1996).

Breeze, George, *Society of Artists in Ireland: Index of Exhibits, 1765–80* (Dublin: National Gallery of Ireland, 1985).

Brett, C.E.B., *Buildings of Belfast 1700–1914* (London: Weidenfeld and Nicolson, 1967; revised ed., Belfast: The Friar's Bush Press, 1985).

Brewer, John, *The Pleasures of the Imagination: English Culture in the Eighteenth Century* (London: Harper Collins, 1997).

Budge, Ian and Cornelius O'Leary, *Belfast: Approach to Crisis: A Study of Belfast Politics, 1613–1970* (London and Basingstoke: The Macmillan Press Ltd., 1973).

Carey, W.P. [William], *Some Memoirs of the Patronage and Progress of the Fine Arts in England and Ireland … with Anecdotes of Lord de Tabley* (London: Saunders and Ottley, 1826).

Carey, W.P. [William], *Observations on the Primary Object of the British Institution and of the Provincial Institutions for the Promotion of the Fine Arts* (Newcastle: T. & J. Hodgson, 1829).

Casteras, Susan P. and Colleen Denney (eds), *The Grosvenor Gallery: A Palace of Art in Victorian England* (New Haven and London: Yale University Press, 1996).

Chambers, George, *Faces of Change: The Belfast and Northern Ireland Chambers of Commerce and Industry 1783–1983* (Belfast: The Northern Ireland Chamber of Commerce and Industry, 1984).

Chart, D.A. (ed.), *The Drennan Letters* (Belfast: HMSO, 1931).

Crookshank, Anne and The Knight of Glin, *The Painters of Ireland c.1660–1920* (London: Barrie & Jenkins, 1978).

Crookshank, Anne and The Knight of Glin, *The Watercolours of Ireland: Works on Paper in Pencil, Pastel and Paint c. 1600–1914* (London: Barrie & Jenkins, 1994).

Crookshank, Anne and The Knight of Glin, *Ireland's Painters 1600–1940* (New Haven and London: Yale University Press, 2002).

Darcy, C.P., *The Encouragement of the Fine Arts in Lancashire 1760–1860* (Manchester: The Chetham Society, 1976).

Davis, Bertram H., *Thomas Percy: A Scholar-Cleric in the Age of Johnson* (Pennsylvania: University of Pennsylvania Press, 1989).

Deane, Arthur (ed.), *The Belfast Natural History and Philosophical Society Centenary Volume 1821–1921* (Belfast: W. Erskine Mayne, 1924).

Dyson, Anthony, *Pictures to Print: The Nineteenth-century Engraving Trade* (London: Farraud Press, 1984).

Elzea, Betty, *The Wards and the Sloans* (Delaware Art Museum, Occasional Paper No. 3, 1990).

Ensor, Sir Robert, *England 1870–1914* (Oxford: Clarendon Press, 1936).

Fawcett, Trevor, *The Rise of English Provincial Art: Artists, Patrons and Institutions outside London, 1800–1830* (Oxford: Clarendon Press, 1974).

Feaver, William, *The Art of John Martin* (Oxford: Clarendon Press, 1975).

Ford, John, *Ackermann 1783–1983: The Business of Art* (London: Ackermann, 1983).

Frazer, Hugh, *Essay on Painting* (Belfast: M. Jellett and Dublin: James Burnside, 1825).

Gaffikin, Thomas, *Belfast Fifty Years Ago: Now, 1894, 70 Years Ago* (Belfast: James Cleeland, 1894).

Gillett, Paula, *The Victorian Painter's World* (Gloucester: Alan Sutton, 1990).

Gray, William, *Science and Art in Belfast* (Belfast: reprinted from *Northern* Whig, 1904).

Hall, Mr and Mrs S.C., *Ireland: its Scenery, Character, etc.* (London: Virtue and Co., 1841–43), 3 vols.

Hewitt, John and Theo Snoddy, *Art in Ulster: 1* (Belfast: Blackstaff Press, 1977).

Holmes, R. Finlay, *Henry Cooke* (Belfast, Dublin, Ottawa: Christian Journals Ltd., 1981).

Hoppen, K. Theodore, *The Mid-Victorian Generation 1846–1886* (Oxford: Clarendon Press, 1998).

Hudleston, C. Roy and R.S. Boumphrey, *Cumberland Families and Heraldry with A Supplement to An Armorial for Westmorland and Lonsdale* (The Cumberland and Westmorland Antiquarian and Archaeological Society, 1978).

Hyde, Ralph, *Panoramania!* (London: Trefoil Publications Ltd., 1988).

Irwin, David and Francina, *Scottish Painters at Home and Abroad 1700–1900* (London: Faber and Faber, 1975).

Jamieson, John, *The History of the Royal Belfast Academical Institution 1810–1960* (Belfast: William Mullan and Son, 1959).

Johnson, James, *A Tour in Ireland: with Meditations and Reflections* (London: S. Highley, 1844).

Jordan, Alison, *Margaret Byers: Pioneer of Women's Education and Founder of Victoria College, Belfast* (Belfast: The Institute of Irish Studies, The Queen's University of Belfast, 1990).

Kelly, Thomas, *A History of Public Libraries in Great*

*Britain 1845–1975* (London: Library Association, 1977).

Kennedy, S.B., *Irish Art and Modernism 1880–1950* (Belfast: The Institute of Irish Studies, The Queen's University of Belfast, 1991).

King, Lyndel Saunders, *The Industrialization of Taste: Victorian England and the Art Union of London* (Ann Arbor: UMI Research Press, 1985).

Kohl, J.G., *Ireland: Dublin, the Shannon, Limerick, Cork and the Kilkenny Races, the Round Towers, the Lakes of Killarney, the County of Wicklow, O'Connell and the Repeal Association; Belfast and the Giant's Causeway* (London: Chapman and Hall, 1843).

Lanham, W.S., *The History of James Thom The Ayrshire Sculptor* (publication details unavailable).

Larmour, Paul, *Belfast: An Illustrated Architectural Guide* (Belfast: Friar's Bush Press, 1987).

Larmour, Paul, *The Arts and Crafts Movement in Ireland* (Belfast: Friar's Bush Press, 1992).

Maas, Jeremy, *Gambart: Prince of the Victorian Art World* (London: Barrie & Jenkins, 1975).

Macleod, Dianne Sachko, *Art and the Victorian Middle Class: Money and the Making of Cultural Identity* (Cambridge, New York, Melbourne: Cambridge University Press, 1996).

*McComb's Guide to Belfast* (Belfast: William McComb, 1861; republished by S.R. Publishers Ltd., East Ardsley, Wakefield, 1970).

Maguire, W.A., *Living like a Lord: The Second Marquis of Donegall 1769–1844* (Belfast: Appletree Press, 1984).

Maguire, W.A., *Belfast* (Keele: Ryburn Publishing, Keele University Press, 1993).

Maguire, W.A., *A Century in Focus: Photography and Photographers in the North of Ireland 1839–1939* (Belfast: The Blackstaff Press/Museums and Galleries of Northern Ireland, 2000).

Malcomson, A.P.W. (ed.), *The Extraordinary Career of The 2nd Earl of Massereene, 1743–1805* (Belfast: HMSO, 1972).

Meenan, James and Desmond Clarke (eds), *The Royal Dublin Society 1731–1981* (Dublin: Gill and Macmillan, 1981).

Millin, S. Shannon, *Sidelights on Belfast History* (Belfast and London: W. & G. Baird, Ltd., 1932).

Mitchell, B.R. and Phyllis Deane, *Abstract of British Historical Statistics* (Cambridge: Cambridge University Press, 1962).

More, Charles, *The Industrial Age: Economy and Society in Britain 1750–1985* (London and New York: Longman, 1989).

Munford, W.A., *William Ewart MP: Portrait of a Radical* (London: Grafton and Co., 1960).

Nesbitt, Noel, *A Museum in Belfast* (Belfast: Ulster Museum, 1979).

Neylon, Maura and Monica Henchy, *Public Libraries in Ireland* (Dublin: University College, Dublin, School of Librarianship, 1966).

O'Byrne, Cathal, *As I Roved Out* (Dublin: At the Sign of the Three Candles, 1946).

Porter, J.L., *The Life and Times of Henry Cooke, D.D., LL.D.* (London: John Murray, 1871).

*Problems of a Growing City: Belfast 1780–1870* (Belfast: Public Record Office Northern Ireland, 1973).

Proctor, E.K., *Belfast Scenery in Thirty Views, 1832* (Belfast: Linen Hall Library reprint, 1983).

Robinson, Thomas Romney, *Juvenile Poems* (Belfast: J. Smyth & D. Lyons, 1806).

Russell, Hugh, *The Day the Library Opened* (Belfast: Belfast Public Libraries, 1988), unpaginated pamphlet.

Strachey, Ray, *The Cause: A Short History of the Women's Movement in Great Britain* (London: Virago, 1979).

Strickland, W.G., *A Dictionary of Irish Artists* (Dublin and London: Maunsel & Co., Ltd., 1913), 2 vols.

Thackeray, W.M., *The Irish Sketch Book 1842* (Belfast and Dover, New Hampshire: The Blackstaff Press, 1985).

Thompson, F.M.L., *The Rise of Respectable Society: A Social History of Victorian Britain 1830–1900* (London: Fontana, 1988).

Treuherz, Julian, *Victorian Painting* (London: Thames and Hudson, 1993).

Turpin, John, *A School of Art in Dublin since the Eighteenth Century* (Dublin: Gill & Macmillan, 1995).

Walker, Brian and Hugh Dixon, *In Belfast Town 1864–1880: Early Photographs from the Lawrence Collection* (Belfast: The Friar's Bush Press, 1984).

Williamson, George C. (ed.), *Bryan's Dictionary of Painters and Engravers* (London: G. Bell and Sons, Ltd., 1918–19), 5 vols.

Wilson, Rev. James Hall, *The Late Prince Consort: Reminiscences of His Life and Character* (London: F.W. Partridge and Co., 1862).

Wilson, Simon, *Tate Gallery: An Illustrated Companion* (London: Tate Gallery, 1989).

Young, Andrew McLaren, Hamish Miles, Margaret MacDonald and Robin Spencer, *The Paintings of James McNeill Whistler* (New Haven and London: Yale University Press, 1980).

*Catalogues*

Anglesea, Martyn, *Andrew Nicholl 1804–1886* (Ulster Museum, 1973).

Anglesea, Martyn, *James Moore 1819–1883* (Ulster Museum, 1973).

Anglesea, Martyn, *Portraits and Prospects: British and Irish Drawings and Watercolours from the Collection of the Ulster Museum* (Ulster Museum, 1989).

*Belfast Art and Industrial Exhibition*, 1895.

Belfast Association of Artists exhibitions of 1836, 1838.

*Belfast Industrial Exhibition and Bazaar*, Ulster Hall, 1876.

*Belfast Working Men's Institute and Temperance Hall Exhibition*, 1871–72.

Bennett, Mary, *Millais, PRB, PRA*, Walker Art Gallery (Liverpool, 1967).

Black, Eileen, *James Glen Wilson R.N. (1827–1863) Landscape and Marine Painter* (Ulster Museum, 1980).

Black, Eileen, *Samuel McCloy (1831–1904) Subject and Landscape Painter* (Lisburn Museum, 1981–82).

Black, Eileen, *Paintings, Sculptures and Bronzes in the Collection of The Belfast Harbour Commissioners*, Ulster Museum, 1983 (Belfast Harbour Commissioners, 1983).

Black, Eileen, *A Catalogue of the Permanent Collection: 3: Irish Oil Paintings, 1572–c.1830* (Ulster Museum, 1991).

Black, Eileen, *A Sesquicentennial Celebration: Art from The Queen's University Collection*, Ulster Museum, 1995 (Queen's University of Belfast, 1995).

Black, Eileen, *A Catalogue of the Permanent Collection: 4: Irish Oil Paintings, 1831–1900* (Ulster Museum, 1997).

Brown, David Blayney, *Catalogue of the Earlier British Drawings in the Ashmolean Museum* (Oxford, 1982).

*Catalogue of Paintings at Belvoir Park*, 1865.

*Catalogue of Water Colour Drawings By the late Andrew Nicholl, R.H.A.*, 55, Donegall Place, Belfast, 26 May 1886.

Chapel, Jeannie, *Victorian Taste: The Complete Catalogue of Paintings at the Royal Holloway College* (London, 1982).

Davies, Martin, *National Gallery: Catalogue of French School, Early 19th Century, etc.* (London, 1970).

Dyson, Herman, *John Prescott Knight RA: A Catalogue*, Stafford Historical and Civic Society, 1971.

Haworth-Booth, Mark (ed.), *The Golden Age of British Photography 1839–1900*, Victoria and Albert Museum; Philadelphia Museum of Art; The Museum of Fine Arts, Houston; The Minneapolis Institute of Fine Arts; The Pierpoint Morgan Library, New York; Museum of Fine Arts, Boston, 1984–86.

Ingamells, John, *The Wallace Collection Catalogue of Pictures: British, German, Italian, Spanish* (London, 1985).

Jamison, Kenneth, *Belfast Art College Association, Retrospective Exhibition 1849–1960* (Belfast, 1960).

Kauffmann, C.M., *Catalogue of Foreign Paintings: 1: Before 1800*, Victoria and Albert Museum (London, 1973).

Kauffmann, C.M., *Catalogue of Foreign Paintings: II: 1800–1900*, Victoria and Albert Museum (London, 1973).

Kauffmann, C.M., *Catalogue of Paintings in the Wellington Museum* (London, 1982).

Le Harivel, Adrian (ed.), *National Gallery of Ireland: Illustrated Summary Catalogue of Prints and Sculpture* (Dublin, 1988).

Maguire, W.A., *Up in Arms: The 1798 Rebellion in Ireland: A Bicentenary Exhibition* (Ulster Museum, 1998).

Millar, Oliver, *The Victorian Pictures in the Collection of Her Majesty the Queen* (Cambridge, 1992).

Murray, Peter, *Catalogue of the Crawford Municipal Art Gallery, Cork* (unpublished MS.).

Murray, Peter, compiler, *Illustrated Summary Catalogue of the Crawford Municipal Art Gallery* (Cork, 1991).

*Opening Art Exhibition*, Belfast Free Public Library, 1888.

Ormond, Richard, *Sir Edwin Landseer* (Philadelphia Museum of Art and Tate Gallery, 1981–82).

Parkinson, Ronald, *Catalogue of British Oil Paintings 1820–1860*, Victoria and Albert Museum (London, 1990).

Pointon, Marcia, *Mulready*, Victoria and Albert Museum (London, 1986).

*The Pre-Raphaelites*, Tate Gallery (London, 1984).

*Royal Irish Institution Catalogue*, 1814.

Sterling, Charles and Margaretta M. Salinger, *French Paintings: A Catalogue of the Collection of the Metropolitan Museum of Art* (New York, 1966).

*The Crystal Palace Exhibition Illustrated Catalogue* (London, 1851; facsimile, London and Toronto, 1970).

*Third Annual Exhibition of Paintings in Connexion with the Art Union of Belfast*, 1868.

Treble, Rosemary, *Great Victorian Pictures: Their Paths to Fame* (Arts Council of Great Britain, 1978).

Usherwood, Paul and Jenny Spencer-Smith, *Lady Butler: Battle Artist 1846–1933* (National Army Museum, 1987).

*Wallace Collection: Catalogue of Pictures and Drawings* (London, 1968).

Waterfield, Giles (ed.), *Palaces of Art: Art Galleries in Britain 1790–1990* (Dulwich Picture Gallery and National Gallery of Scotland, 1991–92).

*Articles*

Adams, J.R.R., 'Popular Art in Belfast 1824–1836', *Ulster Folklife*, 29 (1983), pp.43–53.

Adams, Ronald, 'Andrew Nicholl', *Irish Arts Review*, 1, 4 (Winter 1984), pp.29–34.

Anglesea, Martyn, 'Andrew Nicholl and his Patrons in Ireland and Ceylon', *Studies*, (Summer 1982), pp.130–51.

Anglesea, Martyn, 'Introduction', *Andrew Nicholl's Paintings of the Antrim Coast in 1828*, Glens of Antrim Historical Society (Belfast: The Universities Press Ltd., 1982), unpaginated.

Anglesea, Martyn, 'Francis McCracken: Pre-Raphaelite Patron or Speculator?' (unpublished MS., 1984).

Anglesea, Martyn, 'A Pre-Raphaelite Enigma in Belfast', *Irish Arts Review*, 1, 2 (Summer 1984), pp.40–5.

Anglesea, Martyn, 'The Lynn Brothers, Architect and Sculptor', *Irish Arts Review*, Yearbook (1989–90), pp.254–62.

Anglesea, Martyn, 'A Series of Letters relating to John Rogers Herbert, Francis McCracken, John Clarke, Thomas Creswick and others' (unpublished MS., 1992).

Armstrong, D.L., 'Social and Economic Conditions in the Belfast Linen Industry 1850–1900', *Irish Historical Studies*, VII, 28 (Sept. 1951), pp.225–69.

Batt, Narcissus, 'Belfast Sixty Years Ago: Recollections of a Septuagenarian', *Ulster Journal of Archaeology*, II, 2 (Jan. 1896), pp.92-5.

Beckett, J.C., 'Belfast to the End of the Eighteenth Century', in J.C. Beckett *et al.*, *Belfast: The Making of the City* (Belfast: Appletree Press, 1983), pp.13–26.

Black, Eileen, 'Isabella Tod and the Movement for the Higher Education of Women in Belfast, 1867–82' (unpublished dissertation, Open University, 1982).

Black, Eileen, 'Of Art and Artists', in J.C. Beckett *et al.*, *Belfast: The Making of the City* (Belfast: Appletree Press, 1983), pp.83–97.

Black, Eileen, 'Sydney Mary Thompson (Madame Christen)', in *Irish Women Artists from the Eighteenth Century to the Present Day*, exhibition catalogue (National Gallery of Ireland and Douglas Hyde Gallery, 1987), p.189.

Black, Eileen, 'James Glen Wilson (1827–1863): An Irish Artist in Australia', *Familia*, 2, 3 (1987), pp.37–46.

Black, Eileen, 'James Glen Wilson 1827–1863', in Joan Kerr (ed.), *The Dictionary of Australian Artists: Painters, Sketchers, Photographers and Engravers to 1870* (Melbourne, Oxford, Auckland, New York: Oxford University Press, 1992), pp.866–7.

Black, Eileen, 'Practical Patriots and True Irishmen:

The Royal Irish Art Union 1839–59', *Irish Arts Review*, 14, Yearbook (1998), pp.140–6.

Boyle, Emily, '"Linenopolis": The Rise of the Textile Industry', in J.C. Beckett *et al.*, *Belfast: The Making of the City* (Belfast: Appletree Press, 1983), pp.41–55.

Brenan, James, 'Art Instruction in Ireland', *Ireland: Industrial and Agricultural: Handbook for The Irish Pavilion, Glasgow International Exhibition*, 1901 (Dublin: Department of Agriculture and Technical Instruction, 1901).

Catto, Mike, 'A Normal School', *Art and Design Matters*, exhibition catalogue (Ulster Museum, 1994), pp.30–51.

de Courcy, Catherine, 'The History of the Royal Hibernian Academy of Arts', in Ann M. Stewart, *Royal Hibernian Academy of Arts: Index of Exhibitors 1826–1979* (Dublin: Manton Publishing, 1985), 3 vols, pp.xi–xix.

Dixon, Roger, '"By Appointment to Emperors": Marcus Ward and Company of Belfast', in John Gray and Wesley McCann (eds), *An Uncommon Bookman: Essays in Memory of J.R.R. Adams* (Belfast: Linen Hall Library, 1996), pp.34–46.

Fenlon, Jane, 'The Painter Stainers Companies of Dublin and London, Craftsmen and Artists 1670–1740', in Jane Fenlon, Nicola Figgis and Catherine Marshall (eds), *New Perspectives: Studies in Art History in Honour of Anne Crookshank* (Dublin: Irish Academic Press, 1987), pp.101–8.

Gracey, Diane, 'The Decline and Fall of Marcus Ward', *Irish Booklore*, 1, 2 (Aug. 1971), pp.186–202.

Gracey, Diane, 'Marcus Ward', *Irish Booklore*, 2, 1 (Spring 1972), pp.156–8.

Graham-Dixon, Andrew, 'Cruikshank and the Demon Drink', *Sunday Telegraph* magazine, 20 May 2001, pp.30–3.

Green, E.R.R., 'Thomas Percy in Ireland', *Ulster Folklife*, 15–16 (1970), pp.224–32.

Hewitt, John, 'Painting and Sculpture in Ulster', in Sam Hanna Bell, Nesca A. Robb, John Hewitt (eds), *The Arts in Ulster: A Symposium* (London: Harrap, 1951), pp.71–95.

Hewitt, John, 'The Northern Athens and After', in J.C. Beckett *et al.*, *Belfast: The Making of the City* (Belfast: Appletree Press, 1983), pp.71–82.

Jones, Emrys, 'Belfast', in T.W. Moody and J.C. Beckett (eds), *Ulster since 1800: Second Series: A Social Survey* (London: BBC, 1957), pp.90–8.

Kennedy, S.B., 'Introduction', in Ann M. Stewart, *Irish Art Loan Exhibitions 1810–1960* (Dublin: Manton Publishing, 1990), pp.vii–x.

King, Anthony, 'George Godwin and the Art Union of London 1837–1911', *Victorian Studies*, 8, 2 (Dec. 1964), pp.101–30.

Ley, Henry, 'Copy of Titian's Altarpiece at Queen's University', *The Queen's University Association Annual Record* (1970–71), pp.56–7.

Luddy, Maria, 'Isabella M.S. Tod', in Mary Cullen and Maria Luddy (eds), *Women, Power and Consciousness in 19th Century Ireland* (Dublin: Attic Press, 1995), pp.197–230.

Macleod, Dianne Sachko, 'Private and Public Patronage in Victorian Newcastle', *Journal of the Warburg and Courtauld Institutes*, 52 (1989), pp.188–208.

Maguire, W.A., 'High Street, 1786, by John Nixon', text accompanying a Linen Hall Library reproduction, 1984.

Maguire, W.A., 'Banker and Absentee Landowner: William Tennent in County Fermanagh, 1813–32', *Clogher Record*, XIV, 3 (1993), pp.7–28.

McBain, J., 'James Thom, Sculptor', *Burns Chronicle and Club Directory* (1916), pp.61–71.

McClelland, Aiken, 'Amyas Griffith', *Irish Booklore*, 2, 1 (Spring 1972), pp.6–21.

McDowell, R.B., 'Parliamentary Independence, 1782–9'; also, 'The Age of the United Irishmen, Reform and Reaction, 1789–94' and 'The Age of the United Irishmen: Revolution and the Union, 1794–1800', in T.W. Moody and W.E. Vaughan (eds), *A New History of Ireland: IV: Eighteenth-Century Ireland 1691–1800* (Oxford: Clarendon Press, 1986), pp.265–88, 289–338, 339–73.

Sweetnam, Robin, 'The Development of the Port', in J.C. Beckett *et al.*, *Belfast: The Making of the City* (Belfast: Appletree Press, 1983), pp.57–70.

Taft, Kendall B., 'Adam and Eve in America', *The Art Quarterly*, XXIII, 3 (Summer 1960), pp.171–9.

Turpin, John, 'The Royal Dublin Society and its School of Art, 1849–1877', *Dublin Historical Record*, XXXVI (Dec. 1982), pp.2–20.

Turpin, John, 'The School of Design in Victorian Dublin', *Journal of Design History*, 2, 4 (1989), pp.243–56.

Turpin, John, 'Irish Art and Design Education from the Eighteenth Century to the Present' (unpublished MS., 1991).

Weinberg, Gail S., '"An Irish Maniac": Ruskin, Rossetti and Francis McCracken', *The Burlington Magazine* (Aug. 2001), pp.491–3.

Wheeler, Gordon, 'A History of Belfast Central Library', *Linen Hall Review*, 5, 2 (Summer 1988), pp.4–8.

Young, Robert, 'Recollections of a Monogenerean' (unpublished MS., Linen Hall Library, c.1906–7).

*Theses*

Addison, David, 'Picture Collecting in Bristol and Gloucestershire c.1800–c.1860' (unpublished M.Litt. dissertation, Bristol University, 1993).

Artley, Alexandra Frances, 'Yorkshire Newspapers 1740–1800 as a Source of Art History' (unpublished M.Phil. dissertation, University of Leeds, 1970–71).

Black, Eileen, 'The Development of Belfast as a Centre of Art 1760–1888' (unpublished Ph.D. dissertation, The Queen's University of Belfast, 1998).

Coan, C.A.E., 'Birmingham Patrons, Collectors and Dealers 1830–1880' (unpublished M.A. dissertation, University of Birmingham, 1980).

Crawford, W.H., 'Economy and Society in Eighteenth-Century Ulster' (unpublished Ph.D. dissertation, The Queen's University of Belfast, 1982).

Gamble, E. Norman, 'The Business Community and Trade of Belfast 1767–1800' (unpublished Ph.D. dissertation, Trinity College, Dublin, 1978).

Smiles, Samuel A., 'Plymouth and Exeter as Centres of Art 1820–1865' (unpublished Ph.D. dissertation, University of Cambridge, 1982).

# Credits

Armagh County Museum, fig. 5 reproduced with the kind permission of the Trustees of the Museums and Galleries of Northern Ireland; Ashmolean Museum, University of Oxford, pl. 4; fig. 73 used with the permission of Belfast Public Libraries. Photograph from the Welch Collection, Belfast Central Library; figs. 56 and 67 courtesy of Belfast City Council; figs. 19 and 61 and pls. 6 and 13 reproduced courtesy of Belfast Harbour Commissioners; Birmingham Museums and Art Gallery, pl. 23; Bradford Art Galleries and Museums, fig. 64; figs. 25, 34 and 35 © Copyright The Trustees of The British Museum; Diageo plc, pl. 18; Glasgow Museums, fig. 27; Guildhall Art Gallery, Corporation of London, UK/www.bridgeman.co.uk, fig. 59 and pl. 20; Irish Linen Centre and Lisburn Museum Collection, fig. 72; Tyne and Wear Museums, Laing Art Gallery, fig. 65; Manchester Art Gallery, pl. 27; figs. 7-9 courtesy of the Director, National Army Museum, London; fig. 54 © National Gallery, London; fig. 32 courtesy of the National Gallery of Ireland; National Gallery of Victoria, Melbourne, Australia, pls. 19 and 25; figs. 48, 55 and 57 courtesy of the National Library of Ireland; National Portrait Gallery, London, pl. 22; pl.3 by permission of the Office of Public Works, Dublin; private collections, figs. 23, 33 and 46 and pl. 2; figs. 30 and 71 collection of Queen's University, Belfast; The Royal Collection © 2005, Her Majesty Queen Elizabeth II, figs. 52 and 60; Royal Holloway and Bedford New College, Surrey, UK/www.bridgeman.co.uk, pl. 24; Tate, London 2005, figs. 49, 62, 68 and 69 and pls. 14, 21, 26 and 28; Ulster Museum, figs. 1, 2, 3, 6, 11, 13, 15, 16, 17, 18, 20, 21, 24, 29, 36, 45, 47, 50, 51, 58, 66, 70 and 74 and pls. 1, 5, 7, 8, 9, 10, 11, 12, 15 and 16 reproduced with the kind permission of the Trustees of the Museums and Galleries of Northern Ireland; University of Aberdeen, fig. 26; V and A Images/Victoria and Albert Museum, fig. 53; fig. 31 and pls. 29 and 30 by kind permission of the Trustees of the Wallace Collection, London; York Museums Trust (York Art Gallery), pl. 17. Permission to quote from Robert Young, 'Recollections of a Monogenerean' courtesy of the Linen Hall Library, Belfast; permission to quote from the Petrie Papers courtesy of the Council of Trustees of the National Library of Ireland.

# Index

265

# Index

# Index

## Index

**Index**